Vito Acconci//Giorgio Agamben//Francis Alÿs//Arjun Appadurai//Hannah Arendt//Artist Placement Group// Michael Asher//Marc Augé//Wim Beeren//Josephine Berry Slater//Bik Van der Pol//Daniel Birnbaum//Brett Bloom//Robin Bone//George Brecht//Ava Bromberg// Marcus Brüderlin//Susan Buck-Morss//Daniel Buren// Victor Burgin//Jon Bywater//Michel de Certeau// Adam Chodzko//Matthew Coolidge//Douglas Crimp// Tacita Dean//Guy Debord//Gilles Deleuze//T.J. Demos// Rosalyn Deutsche//Charles Esche//Graeme Evans// Patricia Falguières//Hal Foster//Tony Foster//Michel Foucault//Andrea Fraser//Hamish Fulton//Caroline Goodden//Dan Graham//Renée Green//Group Material// Félix Guattari//Hou Hanru//Jonathan Harvey//Mark Hutchinson//Robert Irwin//Mary Jane Jacob//Lu Jie// Allan Kaprow//Geeta Kapur//Július Koller//Vasif Kortun// Hari Kunzru//Miwon Kwon//Langlands & Bell//Ligna// James Lingwood//Lucy R. Lippard//Peter Liversidge// George E. Marcus//Doreen Massey//Gordon Matta-Clark// Cildo Meireles//Ivo Mesquita//James Meyer//Jonathan Monk//Robert Morris//Constant Nieuwenhuys//Brian O'Doherty//Gabriel Orozco//Craig Owens//Adrian Piper//Seth Price//Walid Ra'ad//Jane Rendell//Paul Rooney//Martha Rosler//Osvaldo Sanchez//Georg Schöllhammer// Phyllida Shaw//Simon Sheikh// Situationist International//Tony Smith//Robert Smithson// Shep Steiner//Jan Verwoert//Peter Weibel//Lawrence Weiner//Krzysztof Wodiczko//Sally Yard//Qiu Zhijie

Situation

Whitechapel Gallery
London
The MIT Press
Cambridge, Massachusetts

Edited by Claire Doherty

SITUATION

Documents of Contemporary Art

Co-published by Whitechapel Gallery
and The MIT Press

First published 2009
© 2009 Whitechapel Gallery Ventures Limited
All texts © the authors or the estates of the
authors, unless otherwise stated

Whitechapel Gallery is the imprint of Whitechapel
Gallery Ventures Limited

ISBN 978-0-85488-173-4 (Whitechapel Gallery)
ISBN 978-0-262-51305-0 (The MIT Press)

A catalogue record for this book is available from
the British Library

Library of Congress Cataloging-in-Publication Data

Situation / edited by Claire Doherty.
 p. cm. — (Whitechapel, documents
of contemporary art)
 Includes bibliographical references and index.
 ISBN 978-0-262-51305-0 (pbk. : alk. paper)
 1. Arts, Modern—20th century. 2. Avant-garde
(Aesthetics)—History—20th century. I. Doherty,
Claire.
 NX456.S538 2009
 709.04—dc22

 2009015617

10 9 8 7 6 5 4 3

Series Editor: Iwona Blazwick
Commissioning Editor: Ian Farr
Project Editor: Sarah Auld
Design by SMITH
Justine Schuster
Printed and bound in China

Cover, Javier Téllez, *One Flew over the Void (Bala
Perdida)* (2005). Single channel video projection of
action performed on the border of Mexico and the
United States. © Javier Téllez.

Whitechapel Gallery Ventures Limited
77-82 Whitechapel High Street
London E1 7QX
whitechapelgallery.org
To order (UK and Europe) call +44 (0)207 522 7888
or email MailOrder@whitechapelgallery.org
Distributed to the book trade (UK and Europe only)
by Central Books
www.centralbooks.com

The MIT Press
55 Hayward Street
Cambridge, MA 02142
MIT Press books may be purchased at special
quantity discounts for business or sales
promotional use. For information, please email
special_sales@mitpress.mit.edu or write to Special
Sales Department, The MIT Press, 55 Hayward
Street, Cambridge, MA 02142

Documents of Contemporary Art

In recent decades artists have progressively expanded the boundaries of art as they have sought to engage with an increasingly pluralistic environment. Teaching, curating and understanding of art and visual culture are likewise no longer grounded in traditional aesthetics but centred on significant ideas, topics and themes ranging from the everyday to the uncanny, the psychoanalytical to the political.

The Documents of Contemporary Art series emerges from this context. Each volume focuses on a specific subject or body of writing that has been of key influence in contemporary art internationally. Edited and introduced by a scholar, artist, critic or curator, each of these source books provides access to a plurality of voices and perspectives defining a significant theme or tendency.

For over a century the Whitechapel Gallery has offered a public platform for art and ideas. In the same spirit, each guest editor represents a distinct yet diverse approach – rather than one institutional position or school of thought – and has conceived each volume to address not only a professional audience but all interested readers.

Series Editor: Iwona Blazwick; Commissioning Editor: Ian Farr; Project Editor: Sarah Auld; Editorial Advisory Board: Achim Bordchardt-Hume, Roger Conover, Neil Cummings, Mark Francis, David Jenkins, Kirsty Ogg, Gilane Tawadros

There is a kind of complexity which comes from taking an otherwise completely normal, conventional, albeit anonymous situation and defining it, re-translating it into overlapping and multiple readings of conditions past and present.

Gordon Matta-Clark, Statement from interview with Donald Wall, *Arts Magazine*, May 1976

PLACE AND LOCALITY

Claire Doherty
Introduction//Situation

It is autumn 2007 and the frenzy of the summer's contemporary art Grand Tour in Europe (Venice, Basel, Kassel, Münster) has given way to eagerness for a critical verdict. *Artforum* and *frieze*, arguably two of the most commercially successful Euro-American art magazines, are poised to run their autumn editions and by chance, an identical image is selected for both front covers. It is an aerial shot of two men in the process of being photographed at the axis of Bruce Nauman's *Square Depression* in Münster. Cropped so as to decontextualize the 50 square metres of white concrete from its surroundings, the image presents itself as an ideal representation of the climax of the Grand Tour – the moment at which the end of the journey in search of the 'authentic' work of art is performed for the camera; epitomising the somewhat reactionary curatorial stance of Robert Storr, who, in his assertion of experiencing 'Art in the Present Tense' in Venice that summer, maintained: '[Biennials] are places in which virtually anyone within reach can restore the aura that some have feared art has lost forever but which those who are alert can still summon for themselves in the presence of a unique image or form.'[1]

Storr appears to be self-consciously channelling Walter Benjamin here, who asserted 'the here and now of the original is the prerequisite to the concept of authenticity'.[2] The authenticity of the fixed and knowable site is promoted in that duplicated cover image by the lines of *Square Depression*'s axis which lead one to a defined point of destination, affording the art pilgrim the opportunity to declare '*I am standing in the Bruce Nauman! I have arrived! I am here!*'

Though *Square Depression* was critically celebrated as 'a template for Rosalind Krauss' diagram of sculpture in the expanded field: (not-) landscape / sculpture / (not-) architecture',[3] Münster offered the visitor few other locatable points of resolution that summer. The experience was closer to what Jane Rendell has referred to as the explosion of Krauss' expanded field of sculpture.[4] More often than not the search for the authentic site of a work was frustrated, characterized by dislocation and displacement. Site was dispersed across location and time. Works were *situational* rather than site-specific, bearing a closer affinity with Michael Asher's historically cumulative intervention *Installation Münster (Caravan)* (the placement of an ordinary 'recognizably West German trailer' in a different location each week for the duration of each edition of Sculpture Projects Münster since 1977)[5] than to the iconic enactment of the site-specific in Nauman's long-awaited commission.

The four manifestations of Sculpture Projects Münster, from the *Platzsuche* ('a search for place') of 1977 to the *Location Narratives* of 1987, and the conviviality and public services that characterized the 1997 edition, might represent a genealogy of site-specificity, but by 2007, the impetus of place, locality, time, context and space, rather than a fixed, physical notion of site, seemed more urgent a set of co-ordinates for the majority of the commissioned artists. Many chose to reflect upon their complicit relationship with the touristic aspirations of the exhibition and more broadly the Grand Tour. In doing so, they contested and frustrated the expectations of the art tourist, producing what we might term situation-specific, rather than site-specific projects.

Such works and processes share the situational characteristics of contemporaneity, defined recently by Terry Smith as 'prioritizing the moment over time, direct experience of multiplicitous complexity over the singular simplicity of distanced reflection'.[6] These properties are displayed by a complex network of artworks, projects, events, interventions, happenings, small gestures and spectacular intrusions over time, from the constructed situations of the Situationist International to contemporary performative acts such as Ligna's *Radio Ballet*, and over place, from Javier Téllez's *One Flew over the Void*, across the San Diego/Tijuana border, to Francis Alÿs' geological displacement in the sand dunes outside Lima, Peru, in *When Faith Moves Mountains*. Often temporary and interventionist, invariably now performed by individuals other than the artist, mobilizing and demanding different kinds of public engagement, such works often result from a commission, as part of broader, place-based, scattered-site exhibitions. Yet such situation-producing works contest a literal reading of the specifics of place as fixed and stable, causing a destabilizing effect theorized by art historian Miwon Kwon as being in 'the wrong place'.[7]

This volume is an attempt to consider the genesis of 'situation', as a convergence of theorizations of site, non-site, place, non-place, locality, public space, context and time, and as a means of rethinking the ways in which contemporary artists respond to, produce and destabilize place and locality.

Two key principles guide the book's selection and form. Firstly, this is not a chronological survey of situation-specificity, though I have drawn upon the canonical genealogy of site-specificity to establish the terms on which site has been proposed, revised and rejected historically. Groupings of specific approaches and ideas have been gathered together, punctuated by contemporary artists' texts and interdisciplinary considerations, but the key ideas of the specifics of site and location, contemporaneity, engagement and interruption, public space and publicness, and place as an event-in-progress, appear throughout all five thematic sections, with cross-referencing occurring across time and space.

Secondly, the volume is underpinned by a curatorial perspective. The collection seeks to review the motivations and assumptions of the place-based commissioning which has come to dominate large-scale exhibitions and public art programmes internationally. We might ask, if place-making and the production of new localities are increasingly one of the primary motivations for curators and commissioners, how and where does artistic engagement with place begin? How might we understand or describe the potential for artistic agency in specific places? Do the curatorial systems, refined over the last twenty years, to support artistic engagement with specific places, and in particular public space, truly acknowledge the conflictual and changing nature of public space and place itself, and if so, might the term situation (a set of conditions in time and place) offer an alternative to the exhausted notion of site?

The Limits of Site. The first section begins with Jane Rendell's consideration of the situated critic – a vital prologue to a book of documents such as this, and provoking me to register my own European/North American bias from the outset. There follows an extensive section which revisits canonical texts beginning with the displacement of attention from 'work to frame'. Robert Morris' trilogy of texts considers the shift from 'self-important object' to spatial situation, positing the binary opposition of contained space/open field-type situation. Here the gallery wall is introduced as literal and metaphorical limit of phenomenological experience. Brian O'Doherty asserts that 'the wall becomes a membrane through which aesthetic and commercial values osmotically exchange'. Michael Asher's sandblasting of the wall (Galleria Toselli, Milan, 1973) exposes the gallery as signifying container – such actions eventually taken to the extreme with the displacement of the white cube in its entirety to public space by Elmgreen and Dragset some 25 years later.

At this point, this volume might have taken a very different direction – towards the contestations of institutional critique and its curatorial assimilation in the form of New Institutionalism – but instead, my primary focus has been the consideration and theorizations of the world outside the 'stage door' (Kaprow), the social and political context of the street or urban environment (Matta-Clark, Buren) or, in Robert Smithson's words, the open limits or edge, rather than the closed limits or centre of the gallery.

Smithson's indexical theorization of site (non-gallery) and nonsite (gallery-based) operates as a focal point for several texts that grapple with what James Meyer refers to as the 'vectored and discursive notion of "place"' to which the book continually returns. At the same time, we see the emergence of what Allan Kaprow calls 'situational models' in the urban environment,[8] which acknowledge the impossibility of escaping critical limits imposed upon art and artists (Buren) or overthrowing the economy (Burgin) but which seek out new relationships with it. Gordon Matta-Clark and Caroline Goodden's *Food* store at the corner of Prince

and Wooster, SoHo, New York, in the early 1970s, and some ten years later and a few blocks north, Group Material's store on East 13th Street are primary examples of what Nikos Papastergiadis has recently called 'small gestures in specific places' which act as 'circuit breakers in the closed system of habitual equivalence between signs', where the politics of the practice is situational.[9]

Just as the self-initiated activities of Group Material and their New York contemporaries (e.g. Fashion Moda and Colab) were being established in the early 1980s,[10] so Richard Serra's site-dominant *Tilted Arc* was being installed in Federal Plaza in Lower Manhattan. Whilst these situational works might be considered to be similarly interventionist, they are fundamentally distinct in their modes of engagement, in their treatment of potential publics, authorship and the temporality of the work itself. And here emerges one of the most critical questions in the consideration of art practices which engage directly with 'the world outside', namely the ethics of engagement with the everyday, and the potential (as Mark Hutchinson proposes in the following section) for transformative practice. This preoccupation with modes of interaction forms the basis of Robert Irwin's typology of site-related art practices and Peter Weibel's mid 1990s attempt to formulate a new genre of 'context art'. But if we consider the practices of Weibel's coterie of contextual artists – in particular Christian Philipp Müller's border crossings, alongside the neo-conceptualism of British artists such as Adam Chodzko and Jonathan Monk, and the narrative audio works of artists such as Paul Rooney and Janet Cardiff – we might identify that artists have become just as interested in the points at which a single site fractures, through the production or invocation of what Foucault termed 'heterotopias', as they have in the processes of interaction with a predefined location. The limits of site are finally transgressed here in the summoning of the viewer/visitor to an apparently singular space which opens up into multiple spaces and places. As Robert Smithson suggests: '… once you get there, there's no destination … the site is evading you all the while it's directing you to it.'

Fieldwork. Tony Smith's infamous recounting of his night-time journey to the unfinished New Jersey Turnpike has become a talisman for conceptual art. But what if we recontextualize this statement by considering it alongside a series of artist testimonies about the journey beyond the limits of the familiar? Like those of Tacita Dean, Adam Chodzko and Langlands & Bell, Smith's statement is recounted as anecdote, in this case some 15 years or so after the event.[11] As the territories become increasingly contested and remote through this series of texts, so the question of the reliability of the witness becomes tantamount. The documentary impulse of fieldwork is particularly prevalent in the comparison of the activities of the Center for Land Use Interpretation (CLUI) and the fictional Beirut Al-Hadath Archive. As the philosopher Giorgio Agamben has asserted:

'whoever assumes the charge of bearing witness in their name knows that he or she must bear witness in the name of the impossibility of bearing witness.'

Hal Foster's 'The Artist as Ethnographer' is central to the discourse which has arisen around the ethics of artists' fieldwork and engagement with quasi-anthropologically predetermined communities. Considered here alongside Kwon's identification of the institutional systems which produce the itinerant artist and Deleuze and Guattari's identification of the nomadic condition, Foster's text problematizes the artist as participant-observer, invited to work 'on location', a phenomenon that can be seen to have arisen specifically in the mid 1990s. This problematic has led to a dynamic series of critical exchanges on the dialectical conditions of social engagement over the past five years.[12] But what might a consideration of situation contribute to this ongoing dilemma for the artist as fieldworker? We might consider two distinct effects of deterritorialization: firstly, we should remember that the mobilization of the artist is socially, culturally and politically determined (as Bone and Steiner, and later Doreen Massey will attest). Secondly, the mode of complicit engagement, as proposed by anthropologist George Marcus, might provide us with a more sophisticated understanding of fieldwork as a relational, self-reflexive process, one which necessarily implicates an *elsewhere* as well as a *there*, as Jon Bywater and Jan Verwoert also discuss.

This consideration of complicity is by no means new, as the documents of the Artist Placement Group (APG), now held in the Tate Archive in London, prove. One of the artists who participated in the APG programmes, Ian Breakwell, writing in *Art Monthly* in 1980 on his DHSS placement in Broadmoor Special Hospital suggested: '[T]he success of a placement cannot be measured merely by the degree of mutual backslapping between the host organization and the artist ... In a placement the "artwork" is not the end product but the whole process.'[13] Jon Bywater's description of the poowhiri, the Maori welcome ceremony in New Zealand, offers a reconsideration of the conditions of exchange, and as Mark Hutchinson suggests, this mode of interaction ultimately determines the possibilities for transformative practice and artistic agency.

Action and Public Space. The third section intersects with two other volumes in this series (*Participation* and *The Everyday*), yet here the activities of the Situationist International and New York happenings are reconsidered specifically within the historically bounded categories of public art and public space. For Hannah Arendt, the public sphere operates in distinct contrast to private space and provides a *common world* for potential political action; for Michel de Certeau, public space 'is a practiced place'; for Rosalyn Deutsche, it is a contested zone and site of spatial struggle, and for Simon Sheikh, it is 'fragmented, consisting of a number of spaces and/or formations that sometimes connect, sometimes close off, and that are in conflictual and contradictory relations to each other'.

The intersection between artistic actions and these fragmented, contested spaces results in what curator Nato Thompson has termed 'tactical practices'.[14] What connects Guy Debord's and Allan Kaprow's somewhat playful tactics, Július Koller's anti-happenings, Cildo Meireles' insertions, Ligna's choreographed performances and Etoy's digital hijacking is a desire to engage critically and performatively with multiple public spaces often through unannounced activities. As Adrian Piper proposes, they seek to avoid the production of 'an audience-versus-performer separation' which occurs in the announcement of an event. They expose the public domain, as Joshua Decter has proposed, as 'a readymade domain: over-regulated, patrolled, increasingly securitized and surveyed, a place-holder for the eventual arrival, or appearance of what might be described as "public art"'[15] But the potential agency of such art practices in public space must now be called into question compared to the effectiveness of emergent forms of self-organized cultural activity such as flash mobbing.

What might distinguish such tactical art practices from these stunts is their potential to be critical within a pervasive agonistic public sphere, defined by Chantal Mouffe as 'the battleground where different hegemonic projects are confronted, without any possibility of final reconciliation'.[16] We might understand them as critical spatial practices, a term defined by Jane Rendell to supersede the term 'public art', or 'illocutionary acts' as defined by John L. Austin as acts which are clearly performed and which involve an affirmation or promise, a threat, a warning or command, and for which the public is continuously reformed and readdressed.[17]

Works as diverse as Amy Balkin's *This is the Public Domain*, Pawel Althamer's *Real-Time Movie* (a scripted moment of real time at Borough Market, London, promoted through a film trailer on You Tube and across cinemas) and Téllez's *One Flew Over the Void,* are all capable of operating through the dispersed media of collective public spaces identified by Seth Price, but occur as critical spatial practices, or illocutionary acts, to disrupt Mouffe's agonistic public sphere.

Place and Locality. The fourth section moves from space to a progressive notion of place in a period of what geographer David Harvey has referred to as unparalleled 'time-space compression'. Doreen Massey's 'A Global Sense of Place' is central here to an understanding of place as 'a constellation of social relations, meeting and weaving together at a particular locus'. This notion of place in a 'constant sense of becoming through practice and practical knowledge'[18] is bound to the production of localities and is the contextual counterpoint to the debates surrounding the encounter between outsider and insider in the fieldwork section.

What emerges from the conjunction of writings by Appadurai, Kapur and Lippard with the work of Allora & Calzadilla, Jacir and Tiravanija (along with other collectives such as Raqs Media Collective and Multiplicity, and the curatorial

initiatives of Ursula Biemann) is the emergence of a new mobilities paradigm where local identities once located in particular places are now increasingly seen as 'hybrid', 'diasporic' or 'trans-national'.[19] This is evidenced in the call-centre construction of local knowledge in Raqs Media Collective's 2003 work *A/S/L* and more recently in Danny Boyle's Oscar-winning film *Slumdog Millionaire. The land* in Chiang Mai and *Park Fiction* in Hamburg operate as activations of the intersection between place and mobility through cumulative art programmes in a specific location over time, corresponding to geographer Tim Cresswell's assertion that 'place is constituted through reiterative social practice'.[20]

In the UK, the contribution of contemporary art to the establishment of place identity is calibrated by government funding bodies through its potential impact on economic, environmental and social regeneration, as outlined in a report prepared for the Department of Culture, Media and Sport in 2004.[25] Bruce Ferguson, Reesa Greenberg and Sandy Nairne identified the harnessing of curatorial strategies for a region's economic and political gain in their influential article 'Mapping International Exhibitions', itself originally published to coincide with a European Capital of Culture programme of events in Antwerp in 1993: 'The locale of an exhibition is embraced in its title as a rhetorical manoeuvre to appropriate cultural status, the meanings and the myths that attend the collective imagination attached to the city, region or country named ...' [21]

The Curatorial Imperative. Today this curatorial manoeuvre is repeated across the globe, where the rhetoric of place-making has led to the dominance of place-based event-exhibitions and public art initiatives. The rise to prominence of such curatorial ventures can be traced to the early 1970s, from *Sonsbeek 71*, Arnhem, and the first Sculpture Projects Münster in 1977, through the mid 1990s with *Project Unité*, Firminy (1991) and *Places with a Past: New Site-specific Art*, Charleston (1992) to the contemporary proliferation of place-based biennial or triennial exhibitions. But as Jan Verwoert suggests, there is a noticeable shift in these curatorial propositions, from a responsive to a productive mode, in the performance of the local by the international and the international by the local.

The relationship between the duplicated front cover images of *Artforum* and *frieze* and the cover image for this volume offers one potential way of viewing the future for productive curatorial models in relation to situational, critical spatial art practices. If we understand place as an unstable, shifting set of political, social, economic and material relations, and locality as produced and contested through a set of conditions that we might describe as situation, our experience of works which truly produce remarkable engagements with place will be characterized by a sense of *dislocation* – encouraging us no longer to look with the eyes of a tourist, but to become implicated in the jostling contingency of mobilities and relations that constitute contemporaneity.

1 Robert Storr, *Think with the Senses Feel with the Mind: Art in the Present Tense* (New York: Rizzoli, 2007). [*for works cited by title only below please see bibliography*]

2 Walter Benjamin, 'The Work of Art in the Age of Mechanical Reproduction', in *Illuminations*, ed. Hannah Arendt (New York: Schocken Books, 1969) 214–15.

3 Polly Staple, 'Expanded Fields', *frieze*, issue 109 (September 2007).

4 Jane Rendell, *Art and Architecture: A Place Between*, 43.

5 See Michael Asher, 'July 3–November 13, 1977, Skulptur, Westfälischer Landesmuseum für Kunst und Kulturgeschichte, Münster, West Germany', in Benjamin H.D. Buchloh, ed., *Michael Asher: Writings, 1973–1983, on Works, 1969–1979*, 166–71.

6 Terry Smith, et al., *Antinomies of Art and Culture*, 8.

7 Miwon Kwon, 'The Wrong Place', 32–43.

8 Allan Kaprow, 'The Education of the Un-Artist, Part III', 131–3.

9 Nikos Papastergiadis, 'Spatial Aesthetics: Rethinking the Contemporary' in Terry Smith, op cit., 363–81.

10 See Julie Ault, *Alternative Art New York, 1965–1985* (University of Minnesota Press, 2002).

11 The New Jersey Turnpike was constructed between 1950 and 1952.

12 See articles by Claire Bishop and Grant Kester in *Artforum* (February/May 2006).

13 Ian Breakwell, 'From the Inside: A Personal History of Work on Placement with the Department of Health and related work, 1976–1980', *Art Monthly*, no. 40 (1980), 3–4.

14 Nato Thompson, *The Interventionists*.

15 Joshua Decter, 'Transitory Agencies and Situational Engagements: The Artist as Public Interlocutor?' in Osvaldo Sanchez, et al., eds, *InSite_05: Situational Public*, 294.

16 Chantal Mouffe, 'Artistic Activism and Agonistic Spaces', *Art & Research*, vol. 1, no. 2, Summer 2007, available at <http://www.artandresearch.org.uk/v1n2/mouffe.html>

17 See J.L. Austin, *How to Do Things with Words* (Cambridge, Mass: Harvard University Press, 1962).

18 Tim Cresswell, 'Mobilizing Place, Placing Mobility: The Politics of Representation in a Globalized World', 26.

19 Cresswell, op cit.

20 Ibid., 26.

21 Bruce W. Ferguson, Reesa Greenberg and Sandy Nairne, 'Mapping International Exhibitions', 135–152.

CONTEXT

IS

HA / LF

THE

WORK

Artist Placement Group (APG), statement of methodology, in *Structure in Events*, 1972

Jane Rendell
Site-Writing//2005

[...] In postmodern feminism new ways of knowing and being have been discussed in spatial terms, using words such as 'mapping', 'locating', 'situating', 'positioning' and 'boundaries'. Employed as critical tools, spatial metaphors constitute powerful political devices for examining the relation between identity and place. Where I am makes a difference to who I can be and what I can know. For example, Donna Haraway's 'situated knowledges', Jane Flax's 'standpoint theory' and Elspeth Probyn's notion of 'locality', all use 'position' to negotiate such ongoing theoretical disputes as the essentialism/constructionism debate.[1] In bell hooks' passionate claim for the margin to be understood and occupied as a place of radical difference, the exploration of race, class and gender identities is explicitly spacialized.[2] And in Rosi Braidotti's figure of the 'nomadic subject', a spatial state of movement describes an epistemological condition, a kind of knowingness (or unknowingness) that refuses fixity.[3] I am interested in how art criticism can engage with these concerns and investigate the spatial and often changing positions between works, the sites they are located in and the standpoints we occupy as critics materially, conceptually and ideologically.

When Hal Foster discusses the need to rethink critical distance, he points to the different distances produced by the optical and the tactile, but warns of the dangers of both dis-identification and over-identification with the object of study.[4] Foster rejects those who lament the end of 'true criticality' as well as those who see critical distance as 'instrumental mastery in disguise'. But despite advocating the need to think through questions of critical distance, Foster ends his reflection still proposing that the critic's role is to judge and make decisions without discussing the particularities of these modes of operation.[5]

Howard Caygill presents us with a different point of view, one that discerns between discriminations and judgements. For Caygill, in immanent critique the criteria for making judgements are discovered or invented through the course of criticism.[6] Caygill argues that there is no position outside the work from which the critic may make a judgement; rather, a critic may make a discriminate judgement by adopting a position at a moment of externality where the work 'exceeds itself' and 'abuts on experience'. Strategic critique may use such moments in order to locate the work, and although Caygill does not acknowledge them as such, such procedures are intrinsically spatial: 'Strategic critique moves between the work and its own externality situating the work in the context of experience, and being in its turn situated by it.'[7]

In art criticism few critics have taken a close interest in the experience of an encounter with a work. Mieke Bal is an exception. As Norman Bryson points out, Bal's work is rhetorical; she considers visual art through narrative and structures her own narratives through processes of focalization.[8] Yet despite Bal's ability to 'write' the encounter with a work of art, writing does not engage with the spaces of such encounters. When Nicolas Bourriaud calls for a 'relational aesthetics', he tends to locate the relational in the open-ended condition found in works by certain artists rather than in the spatial aspects of critical negotiation.[9] From the close-up to the glance, from the caress to the accidental brush, my interest in the site of encounter with art investigates the spatial qualities of relations.

To move beyond notions of judgement and discrimination in criticism to consider questions of relation and encounter, involves objective and subjective modes of enquiry as well as the taking of distant and intimate positions. Italo Calvino has explicitly explored the relation the writer has to his/her writing in terms of different subject identities or 'I's.[10] And Roland Barthes has described his choice of authorial voice in terms of four regimes: including an 'I', the pronoun of the self, a 'he', the pronoun of distance, and a 'you', a pronoun which can be used in a self-accusatory fashion or to separate the position of the writer from the subject.[11] Feminists in cultural, literary and postcolonial criticism, such as Hélène Cixous and Gloria Anzaldua, have woven the autobiographical into the critical in their texts, combining poetic writing with theoretical analysis to articulate hybrid voices.[12] Yet fewer writers have acknowledged the position of the writing subject, the place of the personal and the role of the autobiographical in art criticism.

From those who theorize to those who tell stories, from those who list items to those who describe personal memories, from dictionary definitions to records of informal conversations, from artists' statements to critics' observations, from the walk through the gallery to an alternative space from which to imagine a work, my interest is the multiplicity of voice and the variation of standpoint. Such an approach can draw upon the remembered, the dreamed and the imagined, as well as observations of the 'real', and challenges criticism as a form of knowledge with a singular and static point of view located in the here and now.

What happens when discussions concerning site-specificity extend to involve art criticism, and the spatial qualities of the writing become as important in conveying meaning as the content of the criticism?[13] My suggestion is that this kind of criticism has concerns that go beyond writing 'about' art. In operating as a mode of practice in its own right, this critical writing questions the terms of reference that relate the critic to the artwork positioned 'under' critique. This writing is spatial, it is an active writing that constructs as well as traces the sites between critic and writer, artist and artwork, viewer and reader. [...]

1 [footnote 2 in source] See Jane Flax, *Thinking Fragments: Psychoanalysis, Feminism and Postmodernism in the Contemporary West* (Berkeley and Los Angeles: University of California Press, 1991) 232; Donna Haraway, 'Situated Knowledges: The Science Question in Feminism and the Privilege of Partial Knowledge', in *Feminist Studies*, vol. 14, no. 3 (Fall 1988) 575–603, especially 583–8; and Elspeth Probyn, 'Travels in the Postmodern: Making Sense of the Local', in Linda Nicholson, ed., *Feminism/Postmodernism* (London and New York: Routledge, 1990) 176–89.

2 [3] See bell hooks, *Yearnings: Race, Gender and Cultural Politics* (London: Turnaround Press, 1989).

3 [4] See Rosi Braidotti, *Nomadic Subjects* (New York: Columbia University Press, 1994).

4 [5] Hal Foster, *The Return of the Real: The Avant-Garde at the End of the Century* (Cambridge, Massachusetts: The MIT Press, 2001) 223–4.

5 [6] Ibid., 225–6.

6 [7] Howard Caygill, *Walter Benjamin: The Colour of Experience* (London and New York: Routledge, 1998) 34; 79.

7 [8] Ibid., 64.

8 [9] Norman Bryson, 'Introduction: Art and Intersubjectivity', in Mieke Bal, *Looking in: The Art of Viewing* (Amsterdam: G+B International, 2001) 12.

9 [10] Nicolas Bourriaud, *Relational Aesthetics* (Dijon: Les Presses du réel, 2002).

10 [11] See Italo Calvino, *Literature Machine* (London: Vintage, 1997) 15.

11 [12] See Roland Barthes, *The Grain of the Voice: Interviews 1962–80* (Berkeley and Los Angeles: University of California Press, 1991) 215–16.

12 [13] See Gloria Anzaldua, *Borderlands/La Frontera: The New Mestizo* (San Francisco: Lute Books, 1999); and Hélène Cixous, 'Sorties', trans. Betsy Wing, in Susan Sellers, ed., *The Hélène Cixous Reader* (London and New York: Routledge, 1994).

13 [14] On art and site-specificity see for example, Alex Coles, ed., *Site Specificity: The Ethnographic Turn* (London: Black Dog Publishing, 2000); Nick Kaye, *Site-Specific Art: Performance, Place and Documentation* (London and New York: Routledge, 2000); Miwon Kwon, *One Place after Another: Site Specific Art and Locational Identity* (Cambridge, Massachusetts: The MIT Press, 2002).

Jane Rendell, extract from 'Site-Writing', in Sharon Kivland, Jasper Joseph-Lester and Emma Cocker, eds, *Transmission: Speaking and Listening*, vol. 4 (Sheffield: Site Gallery, 2005) 169–71. This text originated as part of the lecture series *Transmission*, convened by the Contemporary Fine Art course at Sheffield Hallam University. The concept and practice of site-writing is extended in Jane Rendell, *Site-Writing: The Architecture of Art Criticism* (London: IB Tauris, 2009).

Robert Morris
Blank Form//1961

From the subjective point of view there is no such thing as nothing – Blank Form shows this, as well as might any other situation of deprivation.

So long as the form (in the broadest possible sense: situation) is not reduced beyond perception, so long as it perpetuates and upholds itself as being object in the subject's field of perception, the subject reacts to it in many particular ways when I call it art. He reacts in other ways when I do not call it art. Art is primarily a situation in which one assumes an attitude of reacting to some of one's awareness as art. [...]

Robert Morris, extract from 'Blank Form' (1961), in Jackson MacLow and La Monte Young, eds, *An Anthology of chance operations, concept art, anti-art, indeterminacy, plans of action, diagrams, music, dance constructions, improvisation, meaningless work, natural disasters, compositions, mathematics, essays, poetry* (1962, unpublished) n.p. Special Collections, Research Library, Getty Research Institute, Los Angeles.

Robert Morris
Notes on Sculpture, Part II//1966

[...] The better new work takes relationships out of the work and makes them a function of space, light and the viewer's field of vision. The object is but one of the terms in the newer aesthetic. It is in some way more reflexive, because one's awareness of oneself existing in the same space as the work is stronger than in previous work, with its many internal relationships. One is more aware than before that he himself is establishing relationships as he apprehends the object from various positions and under varying conditions of light and spatial context. Every internal relationship, whether set up by a structural division, a rich surface, or what have you, reduces the public, external quality of the object and tends to eliminate the viewer to the degree that these details pull him into an intimate relation with the work and out of the space in which the object exists. [...]

[T]he space of the room itself is a structuring factor both in its cubic shape and in terms of the kinds of compression different sized and proportioned

rooms can effect upon the object-subject terms. That the space of the room becomes of such importance does not mean that an environmental situation is being established. The total space is hopefully altered in certain desired ways by the presence of the object. It is not controlled in the sense of being ordered by an aggregate of objects or by some shaping of the space surrounding the viewer. These considerations raise an obvious question. Why not put the work outside and further change the terms? A real need exists to allow this next step to become practical. Architecturally designed sculpture courts are not the answer, nor is the placement of the work outside cubic architectural forms. Ideally, it is a space without architecture as background and reference, which would give different terms to work with. [...]

While the work must be autonomous in the sense of being a self-contained unit for the formation of the gestalt, the indivisible and undissolvable whole, the major aesthetic terms are not in but dependent upon this autonomous object and exist as unfixed variables that find their specific definition in the particular space and light and physical viewpoint of the spectator. Only one aspect of the work is immediate: the apprehension of the gestalt. The experience of the work necessarily exists in time. *The intention is diametrically opposed to Cubism with its concern for simultaneous views in one plane.* Some of the new work has expanded the terms of sculpture by a more emphatic focusing on the very conditions under which certain kinds of objects are seen. The object itself is carefully placed in these new conditions to be but one of the terms. The sensuous object, resplendent with compressed internal relations, has had to be rejected. That many considerations must be taken into account in order that the work keeps its place as a term in the expanded situation hardly indicates a lack of interest in the object itself. But the concerns now are for more control of and/or cooperation of the entire situation. Control is necessary if the variables of object, light, space and body are to function. The object itself has not become less important. It has merely become less *self*-important. [...]

Robert Morris, extracts from 'Notes on Sculpture Part 2', in *Artforum*, vol. 5, no. 2 (October 1966) 20-23, republished in David Hulks, Alex Potts and John Wood, eds, *Modern Sculpture Reader* (Leeds: Henry Moore Institute, 2007) 238–9.

Robert Morris
The Present Tense of Space//1978

What I want to bring together for my model of 'presentness' is the intimate inseparability of the experience of physical space and that of an ongoing immediate present. Real space is not experienced except in real time. The body is in motion, the eyes make endless movements at varying focal distances fixing on innumerable static or moving images. Location and point of view are constantly shifting at the apex of time's flow. Language, memory, reflection and fantasy may or may not accompany the experience. Shift to recall the spatial experience: objects and static views flash into the mind's eye. A series of stills replaces the filmic real-time experience. Shift the focus from the exterior environment to that of the self in a spatial situation, and a parallel, qualitative break in experience between the real time 'I' and the reconstituting 'me' prevails [...]

In perceiving an object, one occupies a separate space – one's own space. In perceiving architectural space, one's own space is not separate, but coexistent with what is perceived. In the first case, one surrounds; in the second, one is surrounded. This has been an enduring polarity between sculptural and architectural experience. [...]

Anything that is known behaviourally rather than imagistically is more time-based, more a function of duration than what can be grasped as a static whole. Our model of presentness begins to fill out. It has a location in behaviour facilitated by certain spaces that bind time more than images. [...]

Within the many examples [of recent works] it is possible to find this spatial focus biased toward one or the other of two generic types of spaces: those articulated within contained structures and those operating in an open 'field' type situation. One could almost term these 'noun' and 'verb' type spaces. [...]

It should be remembered that work which has a holistic structure originated inside gallery spaces and was later enlarged and transferred in the mid 1960s to exterior sites. It is wrong to describe gallery and museum spaces as 'spatial' in the sense in which I have been using the term. Such rooms are anti-spatial or non-spatial in terms of any kind of behavioural experience, for they are as holistic and as immediately perceived as the objects they house. These enclosed areas were designed for the frontal confrontation of objects. The confrontation of the independent object doesn't involve space. The relationship of such objects to the room nearly always has had to do with its axial alignment to the confines of the walls. Thus the holistic object is a positive form within the negative, but equally holistic space of the room. The one echoes the other's form: a tight if

somewhat airless solution. Claims for the independent object were actually claims for a hidden relation: that of the object to the three-dimensional rectilinear frame of the room. It might be said that such a space both preceded and generated the so-called independent object. Little wonder that the gestalt object when placed outside seldom works. [...]

Robert Morris, extracts from 'The Present Tense of Space', in *Art in America* (January–February 1978) 70; 72; 76; reprinted in *Continuous Project Altered Daily: The Writings of Robert Morris* (Cambridge, Massachusetts: The MIT Press, 1994).

Brian O'Doherty
Inside the White Cube//1976

[...] With postmodernism, the artist and audience are more like each other. The classic hostility is mediated, too often, by irony and farce. Both parties show themselves highly vulnerable to context, and the resulting ambiguities blur their discourse. The gallery space shows this. In the classic era of polarized artist and audience, the gallery space maintained its status quo by muffling its contradicitons in the prescribed socio-aesthetic imperatives. For many of us, the gallery space still gives off negative vibrations when we wander in. Aesthetics are turned into a kind of social elitism – the gallery space is *exclusive*. Isolated in plots of space, what is on display looks a bit like valuable scarce goods, jewelry or silver: aesthetics are turned into commerce – the gallery space is *expensive*. What it contains is, without initiation, well-nigh incomprehensible – art is *difficult*. Exclusive audience, rare objects difficult to comprehend – here we have a social, financial and intellectual snobbery which models (and at its worst parodies) our system of limited production, our modes of assigning value, our social habits at large. Never was a space, designed to accommodate the prejudices and enhance the self-image of the upper middle classes, so efficiently codified.

The classic modernist gallery is the limbo between studio and living room, where the conventions of both meet on a carefully neutralized ground. There the artist's respect for what he has invented is perfectly superimposed on the bourgeois desire for possession. For a gallery is, in the end, a place to sell things – which is OK. The arcane social customs surrounding this – the stuff of social comedy – divert attention from the business of assigning material value to that which has none. Here the hostile artist is a commercial *sine qua non*. By gassing

up his self-image with obsolete romantic fuel, he provides his agent with the means to separate artist and work, and so facilitate its purchase. The artist's irresponsible persona is a bourgeois invention, a necessary fiction to preserve some illusions from too uncomfortable an examination – illusions shared by artist, dealer and public. [...]

With postmodernism, the gallery space is no longer 'neutral'. The wall becomes a membrane through which aesthetic and commercial values osmotically exchange. As this molecular shudder in the white walls becomes perceptible, there is a further inversion of context. The walls assimilate; the art discharges. How much can the art do without? This calibrates the degree of the gallery's mythification. How much of the object's eliminated content can the white wall replace? Context provides a large part of late modern and postmodern art's content. This is seventies art's main issue, as well as its strength and weakness.

The white wall's apparent neutrality is an illusion. It stands for a community with common ideas and assumptions. Artist and audience are, as it were, invisibly spread-eagled in 2-D on a white ground. The development of the pristine, placeless white cube is one of modernism's triumphs, a development commercial, aesthetic and technological. In an extraordinary striptease, the art within bares itself more and more, until it presents formalist end-products and bits of reality from outside, 'collaging' the gallery space. The wall's content becomes richer and richer (maybe a collector should buy an 'empty' gallery space). The mark of provincial art is that it has to include too much: the context can't replace what is left out; there is no system of mutually understood assumptions.

The spotless gallery wall, though a fragile evolutionary product of a highly specialized nature, is impure. It subsumes commerce and aesthetics, artist and audience, ethics and expediency. It is in the image of the society that supports it, so it is a perfect surface off which to bounce our paranoias. That temptation should be resisted. The white cube kept philistinism at the door and allowed modernism to bring to an endpoint its relentless habit of self-definition. It hot-housed the serial jettisoning of content. Along the way numerous epiphanies were purchased, as epiphanies can be, by suppression of content. If the white wall cannot be summarily dismissed, it can be understood. This knowledge changes the white wall, since its content is composed of mental projections based on unexposed assumptions. The wall is our assumptions. It is imperative for every artist to know this content and what it does to his/her work.

The white cube is usually seen as an emblem of the estrangement of the artist from a society to which the gallery also provides access. It is a ghetto space, a survival compound, a proto-museum with a direct line to the timeless, a set of conditions, an attitude, a place deprived of location, a reflex to the bald curtain

wall, a magic chamber, a concentration of mind, maybe a mistake. It preserved the possibility of art but made it difficult. It is mainly a formalist invention, in that the tonic weightlessness of abstract painting and sculpture left it with a low gravity. Its walls are penetrable only by the most vestigial illusionism. Was the white cube nurtured by an internal logic similar to that of its art? Was its obsession with enclosure an organic response, encysting art that would not otherwise survive? Was it an economic construct formed by capitalist models of scarcity and demand? Was it a perfect technological shrinkage resulting from specialization or a Constructivist hangover from the twenties that became a habit, then an ideology? For better or worse it is the single major convention through which art is passed. What keeps it stable is the lack of alternatives. A rich constellation of projects comments on matters of location, not so much suggesting alternatives as enlisting the gallery space as a unit of aesthetic discourse. Genuine alternatives cannot come from within this space. Yet it is the not ignoble symbol for the preservation of what society finds obscure, unimportant and useless. It has incubated radical ideas that would have abolished it. The gallery space is all we've got, and most art needs it. Each side of the white cube question has two, four, six sides. […]

Brian O'Doherty, extracts from *Inside the White Cube: The Ideology of the Gallery Space* (Santa Monica: The Lapis Press, 1976; reprinted 1986) 76–7; 79–81.

Michael Asher
Galleria Toselli, Milan//1973

[…] My proposal for this exhibition [at Galleria Toselli, Milan] was to have the walls and ceiling sandblasted, so that every trace of the many layers of white paint which had been applied over the years would be removed and the underlying plaster exposed. Once the proposal was approved, work began immediately. It required the labour of four people for four days to complete the paint-removal operation and the following clean-up.

Sandblasting revealed a brown plaster surface on the walls and ceiling. The columns and ceiling beam were a lighter brown than the plastered-wall sections between the columns. Just as there were regular chromatic variations in the brown plaster of the sections between the columns, the opposite wall also had regular tonal variations, indicating where windows had been filled in some time

after construction of the building. On the same wall, a darker horizontal plane along the floor was possibly a sign of moisture below street level.

Hardware in the gallery was also sandblasted: two pipes entering through the ceiling and passing through the wall at a 45-degree angle, and an electrical conduit near the door. Once the gallery was sandblasted, only natural light was used to light the interior.

What was explicit in the floor – the uncoated concrete – had been implicit in the wall and ceiling surfaces before sandblasting. Once the plaster had been exposed, the walls and ceiling had the same property as the floor – no coating. The walls, ceiling and floor were thereby identified in terms of a common condition, and this established a surface continuity.

The work cast the gallery in its most rudimentary state, appearing to be either under construction with its surfaces yet unfinished, or at a stage of dismantlement that would uncover the record of the gallery's past. The bare plaster was reminiscent of a construction site before any finishing coats of paint have been applied to interior surfaces. In addition, the wall between the columns, which was filled in with one kind of plaster, and the filled-in windows, where another kind of plaster was used, served as a possible historical document.

The variations in brown earthen chroma were visually rich compared to the consistent white of the gallery container. These brown hues – paradoxically, once used in the visual arts – were particularly surprising here since the usual surface colour for gallery display is white paint. In this work, a large exhibition space had been totally stripped of all the conventional coatings that had built up over the years on its display surface. The brown plaster surfaces resembled the common, indigenous outdoor plaster walls of the community. The previously concealed plaster essentially brought inside an outdoor material, disclosing a relationship between the gallery and its surroundings.

The complete material withdrawal – a process of subtraction – was also a process of addition, since the exposed plaster could also be viewed as an added material. The withdrawal of the white paint, in this case, became the objectification of the work.

For the realization of this proposal the gallery had temporarily to dispense with its conventional display surfaces for a material alteration or withdrawal. This was a strategy I had not used in any of my previous work. It meant that the gallery had to forego a certain amount of its property in exchange for a work of art which appropriated and dismantled the gallery's display surfaces. In addition, should the new display surfaces turn out to be nonfunctional for the purpose of display in future exhibitions, the exchange also committed the gallery owner to reconvert and restore the surfaces to conditions which would allow for conventional usage. [...]

The white display surfaces – one of the fundamental elements normally taken for granted and suppressed as part of the presentation of works in a gallery – had been withdrawn. A feeling of relief, resulting from the recognition of traditionally suppressed visual elements, activated a perceptual and cognitive process. The ideological deconstruction of the architectural surfaces of the commercial gallery occurred simultaneous to their material deconstruction.

If viewers assumed that the space had been liberated from the white paint support, they had only to view the plaster to appreciate an inherent paradox: the plaster, as another support surface (another coating), was as much an integral part of the gallery as the white paint. [...]

Michael Asher, extracts from chapter on Galleria Toselli, Milan, in Michael Asher, *Writings 1973–1983 on Works 1969–1979*, written in collaboration with and edited by Benjamin H.D. Buchloh (Halifax: Nova Scotia College of Art and Design/Los Angeles: The Museum of Contemporary Art, 1983) 88–93.

Markus Brüderlin
Work on the White Cube//2001

The Delocation of the White Cube

In their *Dug Down Gallery/Powerless Structure* of 1998, the artists [Elmgreen & Dragset] exported the ideal model of a gallery space from the protective zone of the museum into the wilderness of public space, where they lowered it into a pit dug in the lawn outside the building. Whereas the cell of the White Cube transformed everything placed inside it into art, the banished White Cube was compelled to assert itself as an object of art on hostile ground, not as an enclosed cube but as an open container that exposed its insides defencelessly under the open sky. Hurrying passers-by cast brief glances (and probably other things) into the pristine white of the cell, with its reception table and the empty showroom stand. One can easily imagine what this container looked like after four weeks of exposure to the whims of pedestrians and the rugged climate of Iceland!

As a logical sequel to this exportation of the White Cube into the everyday context, Elmgreen & Dragset brought an aspect of the everyday into the museum. In *Queer Bar/Powerless Structures*, the cube-shaped form of a bar in a gay club was transferred into the exhibition space. In a direct reference to the White Cube, the artists turned everything inside out, placing the beer taps outside and and the bar stools for guests in the inaccessible interior. This

paradoxical negation of the utilitarian function of a place of communication had its correlative in a social phenomenon specific to Nordic countries. Liberal legislatures there were among the first to recognize gay marriages, but in doing so, they devastated the bar scene. By granting them middle-class legitimacy, they turned outsiders in the communicative context into self-enclosed small families who preferred to spend their evenings at home. The association of this process of desocialization with the isolation of the white gallery space could be an allusion to the avant-garde which experienced a similar fate in the White Cube. After all, the neutralization of the exhibition wall resulted in a very similar sterilization of art, as critics have consistently pointed out. [...]

Markus Brüderlin, extract from 'Work on the White Cube', in *Taking Place* (Zürich: Kunsthalle Zürich/Copenhagen: Danish Contemporary Art Foundation/Ostfildern-Ruit: Hatje Cantz, 2001) 98–9.

Gordon Matta-Clark
Statement//1976

[...] The whole question of the gallery space and the exhibition convention is a profound dilemma for me. [...] And even though my work has always stressed an involvement with spaces outside the studio-gallery context, I have put objects and documentation on display in gallery spaces. All too often there is a price to pay due to exhibition conditions: my kind of work pays more than most just because the installation materials end up making confusing reference to what was not there. But for me, what was outside the display became more and more the essential experience. [...] The choice of dealing with either the urban environment in general or building structures specifically alters my whole realm of experience and shifts it away from the grand theme of vast natural emptiness which, for Earth artists, was literally like drawing on a blank canvas. [...] I have chosen not isolation from the social conditions, but to deal directly with social conditions, whether by physical implication, as in most of my building works, or through more direct community involvement, which is how I want to see the work develop in the future. I think that differences in context is my primary concern – and a major separation from Earth art: In fact, it is the attention paid to specific, occupied areas of the community. [...]

Gordon Matta-Clark, extract from interview with Donald Wall, *Arts*, vol. 50, no. 9 (May 1976) 76–7.

Daniel Buren
Critical Limits//1973

The Museum/Gallery has become the general frame, container of all art as it exists. It is at once the centre and the backdrop of art, at once its figure and its ground. The Museum/Gallery becomes the common revelator [sic] to all forms of art and art appears as the product of two limits that did not seem to concern it: the Museum/Gallery and the cultural limits ... these limits are both the point of departure and the point of arrival of art [...]

One must realize that parallel to the escape from Museums/Galleries whose vicious presence we have otherwise observed, there exists a more general escape from the urban environment. There is no doubt that the limits imposed by the culture, as represented by the city and urban society, have been perceived. And quite obviously, as ever, as soon as frames, limits, are perceived as such, in art, one rushes for ways to bypass them. In order to do this, one takes off for the country, maybe even for the desert, to set up one's easel. But it is no longer a matter of applying paint to canvas as if it were extracted from the landscape. The conquest is now made directly on nature itself. One flees the city to propagate one's disease across the countryside. This remark is not intended to defend nature but to denounce the cowardly vanity of the country aesthete. However, in relation to art and its limits, the fleeing artist we are talking about cheats no more nor less than his past colleagues. In doubt, we will simply say that it has not been proven that anybody should be held responsible for his own stupidity. [...]

To pretend to escape from these limits is to reinforce the prevailing ideology which expects diversion from the artist. Art is not free, the artist does not express himself freely (he cannot). Art is not the prophecy of a free society. Freedom in art is the luxury/privilege of a repressive society.

Art whatever it may be is exclusively political. What is called for is the *analysis of formal and cultural limits* (and not one *or* the other) within which art exists and struggles.

These limits are many and of different intensities. Although the prevailing ideology and the associated artists try in every way to camouflage them, and although it is too early – the conditions are not met – to blow them up, the time has come to unveil them.

Daniel Buren, extracts from 'Critical Limits' (October 1970), in Daniel Buren, *Five Texts* (New York: John Weber Gallery/London: Jack Wendler Gallery, 1973) 47; 48; 52.

George Brecht
Relocation//1973

RELOCATION
(limited to five per year. A signed and numbered Certificate of Relocation is provided with each realization of the work.)

Bounds (which may be of any extent) are set by the subscriber. Once set, a relocation within the bounds is arranged.

Inquiries: G. Brecht, Fluxus, P.O. Box 180, New York 13, N.Y.

George Brecht, *Water Yam. Fluxus no. C, Card no. 88: Relocation* (Fluxus, New York; London: John Gosling, 1973).

Robert Smithson
Statement//1969

[...] The points of collection tend to be scattered throughout the site, yet there's no possible way of defining those points. So if you go to the sites, there's no evidence other than the site; you're sort of thrown off the nonsite. This is the coming together of those particular points. And those points tend to cover the land masses so that, in a sense, all this terrain will be homogenized. Taking this rather unbounded area and then transferring it into a boundary situation so that the points tend to obliterate the land expanses in the nonsites. Then, there's a kind of balance between the containment and the aspect of scattering; there's an overlap, you know, you're being directed to sites that are in no way graspable in terms of preconceived systems. There's no way you can locate the point, even though there is an indication of the point. Really once you get out there you're on your own, in terms of the site, so that the nonsite just directs you out there, but once you get there, there's no destination. Or if there is information, the information is so low level that it doesn't focus on any particular spot, ... so the site is evading you all the while it's directing you to it. ... The containment is an abstraction, but the containment doesn't really find anything. There is no object

to go toward. In the very name 'nonsite' you're really making a reference to a particular site but that particular site evades itself, or it's incognito. You're on your own. You're groping out there. There's no way to find what's out there. Yet you're directed out there. The location is held in suspense. The nonsite itself tends to cancel out the site. Although it's in the physical world, it's not there. [...]

Robert Smithson, extract from interview with Dennis Wheeler (Vancouver, 1969–70), in Jack Flam, ed., *Robert Smithson: The Collected Writings* (Berkeley and Los Angeles: University of California Press, 1996) 218.

Robert Smithson
Dialectic of Site and Nonsite//1972

Site	Nonsite
1. Open Limits	Closed Limits
2. A Series of Points	An Array of Matter
3. Outer Coordinates	Inner Coordinates
4. Subtraction	Addition
5. Indeterminate Certainty	Determinate Uncertainty
6. Scattered Information	Contained Information
7. Reflection	Mirror
8. Edge	Centre
9. Some Place (physical)	No Place (abstract)
10. Many	One

Robert Smithson, extract from footnotes, 'The Spiral Jetty' (1972); reprinted in Robert Smithson, *The Collected Writings*, ed. Jack Flam, revised edition (Berkeley and Los Angeles: University of California Press, 1996) 152–3.

Craig Owens
Earthwords//1992

Significantly, these remarks ['Dialectic of Site and Nonsite'], which reveal the textuality of the nonsite, occur in a footnote appended to Smithson's text on the *Spiral Jetty*, itself a graphic document inscribed on the surface of the Great Salt Lake. Like the nonsite, the *Jetty* is not a discrete work, but one link in a chain of signifiers which summon and refer to one another in a dizzying spiral. For where else does the *Jetty* exist except in the film which Smithson made, the narrative he published, the photographs which accompany that narrative, and the various maps, diagrams, drawings, etc., he made about it? Unintelligible at close range, the spiral form of the *Jetty* is completely intuitable only from a distance, and that distance is most often achieved by imposing a *text* between viewer and work. Smithson thus accomplishes a radical dislocation of the notion of point-of-view, which is no longer a function of physical position, but of the *mode* (photographic, cinematic, textual) of confrontation with the work of art. The work is henceforth defined by the position it occupies in a potentially infinite chain extending from the site itself and the associations it provokes – 'in the end I would let the site determine what I would build' (Robert Smithson, *The Collected Writings*, 111) – to quotations of the work in other works. [...]

Smithson's desire to lodge his work in a specific site, to make it appear to be rooted there, is a desire for allegory. All of Smithson's work acknowledges as part of the work the natural forces through which it is reabsorbed into its setting. When the Great Salt Lake rose and submerged the *Spiral Jetty*, the salt deposits left on its surface became yet another link in the chain of crystalline forms which makes possible the description of the *Jetty* as a text.

This desire to embed a work in its context characterizes postmodernism in general and is not only a response to the 'homelessness' of modernist sculpture;[1] it also represents and explains the strategic importance of allegory at this moment in history. [...]

1 [footnote 15 in source] Rosalind Krauss, 'Sculpture in the Expanded Field', *October*, no. 8 (Spring 1979) 33–6.

Craig Owens, extracts from 'Earthwords', in Craig Owens, *Beyond Recognition: Representation, Power and Culture*, ed. Scott Bryson, Barbara Kruger, Lynne Tillman and Jane Weinstock (Berkeley and Los Angeles: University of California Press, 1992) 47–8.

James Meyer
The Functional Site, or, The Transformation
of Site Specificity//1995

[...] The primary distinction I wish to make concerns two notions of site: a *literal* site and a *functional* site. The literal site is, as Joseph Kosuth would say, *in situ*; it is an actual location, a singular place.[1] The artist's intervention conforms to the physical constraints of this situation, even if (or precisely when) it would subject this to critique. The work's formal outcome is thus determined by a physical place, by an understanding of the place as actual. Reflecting a perception of the site as unique, the work is itself 'unique'. It is thus a kind of monument, a public work commissioned *for* the site. [...]

In contrast, the functional site may or may not incorporate a physical place. It certainly does not *privilege* this place. Instead, it is a process, an operation occurring between sites, a mapping of institutional and textual filiations and the bodies that move between them (the artist's above all). It is as an informational site, a palimpsest of text, photographs and video recordings, physical places, and things: an allegorical site, to recall Craig Owens' term, aptly coined to describe Robert Smithson's polymathic enterprise, whose vectored and discursive notion of 'place' opposes Richard Serra's phenomenological model.[2] It is no longer an obdurate steel wall, attached to the plaza for eternity. On the contrary, the functional work refuses the intransigence of literal site specificity. It is a temporary thing, a movement, a chain of meanings and imbricated histories: a place marked and swiftly abandoned. The mobile site thus courts its destruction; it is wilfully temporary; its nature is not to endure but to *come down*. [...]

1 See Joseph Kosuth, '1975', in *Art after Philosophy and After: Collected Writings, 1966–1990*, ed. Gabriel Guercio (Cambridge, Massachusetts: The MIT Press, 1991) 134.

2 [footnote 5 in source; here abbreviated for space reasons] See Craig Owens, 'Earthwords', in *Beyond Recognition: Representation, Power and Culture* (Berkeley: University of California Press, 1992) 40–51. [...] [See also] Rosalind Krauss, 'Richard Serra: A Translation', in *The Originality of the Avant-Garde and Other Modernist Myths* (Cambridge, Massachusetts: The MIT Press, 1985) 260–74, and Yve-Alain Bois, 'A Picturesque Stroll around Clara-Clara', in *October: The First Decade*, ed. Annette Michelson, et al. (Cambridge, Massachusetts: The MIT Press, 1987) 342–72. [...] Richard Serra, *Writings, Interviews* (Chicago: University of Chicago Press, 1994) 129.

James Meyer, extract from 'The Functional Site; or, The Transformation of Site Specificity' (1995); in Erika Suderburg ed., *Space, Site, Intervention: Situating Installation Art* (Minneapolis: University of Minnesota Press, 2000) 24–5.

Francis Alÿs
On *When Faith Moves Mountains*//2002

On 11 April 2002, 500 volunteers were supplied with shovels and asked to form a single line at the foot of a giant sand dune in Ventanilla, an area outside Lima. This human comb pushed a certain quantity of sand a certain distance, thereby moving a 1600-foot-long sand dune about 4 inches from its original position.

Lima, a city of nine million people, is situated on a strip of land along the Pacific coast of Peru. It is surrounded by enormous sand dunes on which shanty towns have sprung up, populated by economic immigrants and political refugees who escaped the civil war of the 1980s and 1990s between the army and guerrilla groups like Shining Path. After a week of scouting, we chose the Ventanilla dunes, where more than 70,000 people live with no electricity or running water.

When Faith Moves Mountains is a project of linear geological displacement. It has been germinating ever since I first visited Lima, with the curator and critic Cuauhtemoc Medina. We were there for the last Lima Bienal, in October 2000, about a year before the Fujimori dictatorship finally collapsed. The city was in turmoil. There were clashes on the street and the resistance movement strengthened. It was a desperate situation, and I felt that it called for an 'epic response, a *beau geste*', at once futile and heroic, absurd and urgent. Insinuating a social allegory into those circumstances seemed to me more fitting than engaging in some sculptural exercise.

When Faith Moves Mountains attempts to translate social tensions into narratives that in turn intervene in the imaginal landscape of a place. The action is meant to infiltrate the local history and mythology of Peruvian society (including its art histories), to insert another rumour into its narratives. If the script meets the expectations and addresses the anxieties of that society at this time and place, it may become a story that survives the event itself. At that moment, it has the potential to become a fable or an urban myth. As Medina said while we were in Lima, 'Faith is a means by which one resigns oneself to the present in order to invest in the abstract promise of the future.' The dune moved: This wasn't a literary fiction; it really happened. It doesn't matter how far it moved, and in truth only an infinitesimal displacement occurred – but it would have taken the wind years to move an equivalent amount of sand. So it's a tiny miracle. The story starts there. The interpretations of it needn't be accurate, but must be free to shape themselves along the way.

This process can also operate on the narratives of art history, not to mention those of the art world. *Paradox of Praxis* (1997), a piece in which I pushed a large

block of ice through the streets of Mexico City until it melted into a puddle of water, was a settling of accounts with Minimalist sculpture. Sometimes, to make something is really to make nothing; and paradoxically, sometimes to make nothing is to make something.

Similarly, *When Faith Moves Mountains* is my attempt to deromanticize Land art. When Richard Long made his walks in the Peruvian desert, he was pursuing a contemplative practice that distanced him from the immediate social context. When Robert Smithson built the *Spiral Jetty* on the Salt Lake in Utah, he was turning civil engineering into sculpture and vice versa. Here, we have attempted to create a kind of Land art for the land-less, and, with the help of hundreds of people and shovels, we created a social allegory. This story is not validated by any physical trace or addition to the landscape. We shall now leave the care of our story to oral tradition, as Plato says in the Republic. Only in its repetition and transmission is the work actualized. In this respect, art can never free itself from myth. Indeed, in modem no less than premodern societies, art operates precisely within the space of myth.

In this sense, myth is not about the veneration of ideals – of pagan gods or political ideology – but rather an active interpretive practice performed by the audience, who must give the work its meaning and its social value. After all, isn't the story of modern and contemporary art and its cult of the object really just a myth of materialism, of matter as an ideal? For me, it is a refusal to acknowledge the transitory, a failure to see that art really exists, so to speak, in transit.

Francis Alÿs, 'Francis Alÿs Talks About *When Faith Moves Mountains*', *Artforum* (Summer 2002) 147

Allan Kaprow
Untitled Manifesto//1966

[…] Art and life are not simply commingled; the identity of each is uncertain. To pose these questions in the form of acts that are neither artlike nor lifelike while locating them in the framed context of the conventional showplace is to suggest that there really are no uncertainties at all; the name on the gallery or stage door assures us that whatever is contained within is art, and everything else is life. […]

Allan Kaprow, extract from untitled manifesto, in *Manifestos. A Great Bear Pamphlet* (New York: Something Else Press, 1966) 21–3.

Victor Burgin
Situational Aesthetics//1969

Some recent art, evolving through attention both to the conditions under which objects are perceived and to the processes by which aesthetic status is attributed to certain of these, has tended to take its essential form in message rather than in materials. In its logical extremity this tendency has resulted in a placing of art entirely within the linguistic infrastructure which previously served merely to support art. In its less hermetic manifestations art as message, as 'softwear', consists of sets of conditions, more or less closely defined, according to which particular concepts may be demonstrated. This is to say, aesthetic *systems* are designed, capable of generating objects, rather than individual objects themselves. Two consequences of this work process are: the specific nature of any object formed is largely contingent upon the details of the situation for which it is designed; through attention to time, objects formed are intentionally located partly in real, exterior, space and partly in psychological, interior, space. [...]

It seems rather less likely that the new work will result in the overthrow of the economy than that it will find a new relationship with it; one based, perhaps, in the assumption that art is justified as an *activity* and not merely as a means of providing supplementary evidence of pecuniary reputability. As Brecht observed, we are used to judging a work by its suitability for the apparatus. Perhaps it is time to judge the apparatus by its suitability for the work. [...]

Victor Burgin, extracts from 'Situational Aesthetics', *Studio International*, vol. 178, no. 915 (October 1969) 118-21.

FOOD'S FAMILY FISCAL FACTS

Investment	$63,000.00	4 ½	tons various flours for bread	41,272	customers
Gross Sales	104,120.72	16,000	oranges squeezed	1,083	glasses broken
Total Income	167,120.72	379	lbs rabbits stewed	47	dogs asked to leave
		1,690	lbs celery chopped	153	chairs broken
		3,050	lbs carrots juiced	15	bottles of champagne disappeared
		1,914	lbs butter	3	unfulfilled promises by good friends
Salaries	37,700.29	108	lbs tongue	1	closing order from health department
Food	37,007.10	37	bunches dill	113	roaches left lying in the back room
Paper Goods	1,647.65	2,300	tortillas pressed	0	internal fights
Rent	6,000.00	4,081	lbs chickens succumbed	3 ¾	lbs keys lost
Telephone	207.70	708	lbs fish fucked	1	truck ruined
Con Edison	1,222.45	1,554	lettuce heads	2	rebellions:
Office Stuff	514.50	15,660	potential chickens cracked		The Dishwasher Rebellion of Feb '72
Insurances	1,167.00	435	gallons Tilly's organic apple juice		The Radio Rebellion of May '72
Licenses	125.00	17,760	yards spaghetti steamed	5	floods by Marco
Repairs	1,010.24	2	acres of mushrooms	31	tons of garbage trucked to Gansevoort Pier
Legal	1,397.00	5,890	onions peeled	243	cubic yds garbage removed by Pasquale Bros.
Laundry	732.25	220	bunches parsley sprinkled delicately	7	made up Social Security numbers
Waste	396.50	17	lbs sassafras, root-powder-leaf, gumboed	3	citations granted by City
Advertising	1,321.64	16	oz wasabi powder exploded	1,175	notices taped to windows
Dues & Subscriptions	00.00	1,879	lbs pork stuffed	84%	workers are artists
Trucking	350.37	1,480	lbs lamb led astray	3,913	shirts, aprons & towels dirtied
Miscellaneous	501.27	4,529	lbs beef bullied	1	box toothpicks used
Book-keeping	2,975.00	26	lbs poppy seeds	3	items salvaged from restaurant
Payroll Taxes	3,050.28	5	cubic feet bay leaves	?	brandied people as opposed to pears
Other Taxes	276.80	43	lbs seaweed	174	days Glaza tied up in front
Sales Taxes	7,288.45	2	jars peanut butter	9	people growled at by him
Bank Charges	89.08	29	boxes brown buckwheat groats	99	workers
Consultant Fees	100.00	1,111	lbs duck baked	99	cut fingers
Rubber Checks	196.16	1	cubic foot sage	7	butterflies used to mend cuts
Construction & Destruction	28,696.77	100	lbs sunflower seeds	213	people needed to get it together keep it together
Kitchen Equipment & Supplies	33,147.28	442	lbs bell peppers		
Total Expenditure	167,120.72	5,568	loaves of bread baked	3,082	free dinners given

Group Material
Caution! Alternative Space//1982

If a more inclusive and democratic vision for art is our project, then we cannot possibly rely on winning validation from bright, white rooms and full-colour repros in the art world glossies. To tap and promote the lived aesthetic of a largely 'non-art' public – this is our goal, our contradiction, our energy. Group Material wants to occupy the ultimate alternative space – that wall-less expanse that bars artists and their work from the crucial social concerns of the American public.

Extract from Group Material, 'Caution! Alternative Space' (New York, 1982); reprinted in Kristine Stiles and Peter Selz, eds, *Theories and Documents of Contemporary Art* (Berkeley and Los Angeles: University of California Press, 1996) 895.

Robert Irwin
Being and Circumstance//1985

To help sort out some of the confusion of ambitions and practices, let me rough out some general working categories for public/site art, in terms of how we generally process (recognize, understand) them. (Note: there are no value judgements intended here, only distinctions.) Put simply, we can say that any given work falls into one of the following four categories:

1. Site dominant
This work embodies the classical tenets of permanence, transcendent and historical content, meaning, purpose; the art-object either rises out of, or is the occasion for, its 'ordinary' circumstances – monuments, historical figures, murals, etc. These 'works of art' are recognized, understood and evaluated by referencing their content, purpose, placement, familiar form, materials, techniques, skills, etc. A Henry Moore would be an example of site-dominant art.

2. Site adjusted
Such work compensates for the modern development of the levels of meaning-content having been reduced to terrestrial dimensions (even abstraction). Here

consideration is given to adjustments of scale, appropriateness, placement, etc. But the 'work of art' is still either made or conceived in the studio and transported to, or assembled on, the site. These works are, sometimes, still referenced by the familiarity of 'content and placement' (centred, or on a pedestal, etc.), but there is now a developing emphasis on referencing the oeuvre of the individual artist. Here, a Mark di Suvero would be an example.

3. Site specific
Here the 'sculpture' is conceived with the site in mind; the site sets the parameters and is, in part, the reason for the sculpture. This process takes the initial step towards sculpture's being integrated into its surroundings. But our process of recognition and understanding of the 'work of art' is still keyed (referenced) to the oeuvre of the artist. Familiarity with his or her history, lineage, art intent, style, materials, techniques, etc., are presupposed; thus, for example, a Richard Serra is always recognizable as, first and foremost, a Richard Serra.

4. Site conditioned/determined
Here the sculptural response draws all of its cues (reasons for being) from its surroundings. This requires the process *to begin* with an intimate, hands-on reading of the site. This means sitting, watching and walking through the site, the surrounding areas (where you will enter from and exit to), the city at large or the countryside. Here there are numerous things to consider: what is the site's relation to applied and implied schemes of organization and systems of order, relation, architecture, uses, distances, sense of scale? For example, are we dealing with New York verticals or big sky Montana? What kinds of natural events affect the site – snow, wind, sun angles, sunrise, water, etc.? What is the physical and people density? The sound and visual density (quiet, next-to-quiet, or busy)? What are the qualities of surface, sound, movement, light, etc.? What are the qualities of detail, levels of finish, craft? What are the histories of prior and current uses, present desires, etc.? A quiet distillation of all of this – while directly experiencing the site – determines all the facets of the 'sculptural response': aesthetic sensibility, levels and kinds of physicality, gesture, dimensions, materials, kind and level of finish, details, etc.; whether the response should be monumental or ephemeral, aggressive or gentle, useful or useless, sculptural, architectural, or simply the planting of a tree, or maybe even doing nothing at all.

Here, with this fourth category of site-conditioned art, the process of recognition and understanding breaks with the conventions of abstract referencing of content, historical lineage, oeuvre of the artist, style, etc., implicit in the other three categories, and crosses the conventional boundaries of art vis-a-vis architecture, landscape, city planning, utility, and so forth,

reducing such *quantitative* recognitions (measures and categories) to a secondary importance.

We now propose to follow the principles of phenomenal, conditional and responsive art by placing the individual observer in context, at the crux of the determining process, insisting that he or she use all the same (immediate) cues the artist used in forming the art-response to form his or her operative-response (judgements): 'Does this "piece", "situation" or "space" make sense? Is it more interesting, more beautiful? How do I feel about it? And what does it mean to me?' Earlier, I made the point that you cannot correctly call anything either free or creative if the individual does not, at least in part, determine his or her own meaning. What applied to the artist now applies to the observer. And in this responsibility of the individual observer we can see the first social implication of a phenomenal art.

Being and circumstance, then, constitute the operative frame of reference for an extended (phenomenal) art activity, which becomes a process of reasoning between our mediated culture (being) and our immediate presence (circumstance). *Being* embodies in you the observer, participant or user, your complete genetic, cultural and personal histories as 'subsidiary' cues bearing on your 'focal' attending (experiencing) of your circumstances, again in a 'from-to relation'. *Circumstance*, of course, encompasses all of the conditions, qualities and consequences making up the real context of your being *in* the world. There is embedded in any set of circumstances and your being in them the dynamic of a past and future; what was; how it came to be; what it is; what it may come to be.

If all of this seems a bit familiar, it should. No one 'invents' a new perceptual consciousness. This process of being and circumstance is our most basic perceptual (experiencing) action, something we already do at every moment in simply coming to know the nature of our presence, and we almost always do so without giving the wonder of it a second thought. Once again this 'oversight' speaks not of its insignificance; on the contrary, it speaks of its extraordinary sophistication. What I am advocating is simply elevating this process, this reasoning, to a role of importance that matches its innate sophistication. It should be noted that it is upon this 'reasoning' process that all of our subsequent logics (systems) are instinctively patterned – although this generally goes unacknowledged. But with one modification (gain and loss): to cut the world down to a manageable size, our logics hold their components to act as a kind of truth, locking them in as a matter of style into a form of *permanence*. Conversely, the process of reasoning, our being and circumstance (which I am here proposing), is free of such abstraction and can account for that most basic condition (physic) of the universe – *change* ...

The wonder of it all is that what looked like a diminishing horizon – the art-object's becoming so ephemeral as to threaten to disappear altogether – has, like

some marvellous philosophical riddle, turned itself inside out to reveal its opposite. What appeared to be a question of object/non-object has turned out to be a question of seeing and not seeing, of how it is we actually perceive or fail to perceive 'things' in their real contexts. Now we are presented and challenged with the infinite, everyday richness of 'phenomenal' perception (and the potential for a corresponding 'phenomenal art', with none of the customary abstract limitations as to form, place, materials, and so forth) – one which seeks to discover and value the potential for experiencing beauty in everything. [...]

Robert Irwin, 'Being and Circumstance: Notes Toward a Confidential Art', in *Being and Cirumstance* (Larkspur Landing, Calif.: Lapis Press, 1985) 9–29; republished in Kristine Stiles and Peter Selz, eds, *Theories and Documents of Contemporary Art* (Berkeley and Los Angeles: University of California Press, 1996) 572–4.

Peter Weibel
Context Art: Towards a Social Construction of Art//1994

In his essay for the catalogue *Über Kunst: Künstlertexte zum veränderten Kunst Verständnis nach 1965* (*On Art: Artists' Writings on the Changed Notion of Art after 1965* [Cologne, 1974]), Paul Maenz writes: 'Clearly the work needs the "art frame", the "context", the "systems" by which it can function as a work of art (exhibitions, art publications, cultural institutions, etc).' Following on from this, the next sentence caused a significant uproar: 'If an artwork is not bound out of necessity to a particular aesthetic form, it then becomes defined by its context. Is then not the context, about which only superficial details are known, of the most interest? Would then not the context itself be the more appropriate subject matter of the investigation?' The first to take this step and make context, i.e. the social, technical, spatial and ideological conditions of art's production, the actual subject of artistic investigation were artists such as Daniel Buren, Marcel Broodthaers, Hans Haacke, Michael Asher and John Knight, and then later and most extensively, artists of the 1990s.

Certain categories of context art, such as site-specific art, derive from Minimalism and the spatial presence of works of minimalist art, for example Carl Andre's Timber Pieces (1968), which took their form from the architecture of the spaces in which they were exhibited, as did his scatter pieces (for example *The Spill* [1966], scattered artefacts and linen bags) and the Earthworks (1968)

of Robert Morris. Text, applied onto walls, floors and buildings, that takes meaning from its reference to physical space, as seen in the work of Lawrence Weiner, is a further development of site-specific conceptual art. As early as 1964, Hans Hollein took photographs of land forms that he described as sites for non-buildings. Douglas Huebler's Location Pieces, particularly his *Site Sculpture Project* (1968), made direct reference to site and site-specificity, in the title alone. Flavin's light installations remained as pieces of art for the duration of the exhibition only. Alongside site-specific works, Huebler also developed time-specific works, or duration pieces. His statement 'I prefer, simply, to state the existence of things in terms of time and/or space', refers directly to temporal and spatial structures. Huebler used a concrete spatio-temporal unity to probe how meaning is formed. His photographic documentation and contextual processes question whether an image is fictitious, constructed or real. In this dialectical situation, constants become variables. His Variable Pieces arose in 1970 out of these concerns:

> What has interested me all along is not the pronouncement of meaning but pointing toward the way meaning is formed. A play between the literal and the referential; a mixture of truth and fiction. As the locating of 'everything else' increasingly occurred in social space, it became clear that not only had all subject matter opened up to be used; the use of much more than simple phenomena was positively indicated. I began to use 'human systems' as kinds of cultural ready-mades: behaviour, fantasies, attitudinal clichés. These editions possess a structured randomness wherein 'constants' and 'variables' contend to occupy the 'centre', thereby providing a dialectical situation.[1]

Minimalism's orientation towards context, already extended by Dan Graham to include a series of urban structures, gave impetus to Robert Smithson. He searched for sites in industrial wastelands that lay outside traditional art contexts and named them 'nonsites' ... Smithson formed a critique of the institutional settings of modern art and the consumer culture of galleries and museums with a post-studio practice that pushed the boundaries of art outside the studio, to include multiple forms of representation that could be projected onto the arena of the landscape, rather than a canvas. [...]

Smithson's site-specific projects were at first developed to operate outside the traditional (art) contexts of the museum and the gallery. He developed the concepts of dislocation and displacement, two key concepts also of the 1990s, as a method of site-specific art in order to develop a post-industrial concept of place: 'We live in frameworks and are surrounded by frames of references', he wrote in 1970–71.[2] Smithson widened art's

terms of reference by introducing a new discourse to art and thus nudging art closer to reality. [...]

Gordon Matta-Clark took Smithson's strategies of dislocation and displacement to an urban context. He had seen the contradictions inherent in Smithson's work, as already criticized by Buren, namely that by exhibiting documentation of their work in galleries, Land artists were reinstating their work back into an institutional context. Simply fleeing into nature could not annul the political implications of the gallery. Thus Matta-Clark brought history, city and architecture together: 'There is a kind of complexity, which comes from taking an otherwise completely normal, conventional, albeit anonymous situation and redefining it, retranslating it into overlapping and multiple readings of conditions past and present.' His cuts reveal the hidden layers and histories of the building's construction. He followed the objectives of conceptual art: 'My intervention can transform into an act of communication.' His architectural deconstructions complied with the linguistic paradigms of earlier contextual art: 'It's like juggling with syntax, or disintegrating some kind of established sequences of parts.' For Matta-Clark, the International Style of modern architecture was a development of 'postwar American imperialism. The state of that architecture reflects the iconography of the Western corporate axis. ... By undoing a building there are many aspects of the social conditions against which I am gesturing.'[3] [...]

What is today known as 'context' or 'discourse' was earlier known as 'frame'. Hans Haacke created seven pieces during 1970–75, fittingly titled *Framing and Being Framed*, that formed a fundamental position in the history of contextual art. Works that consisted of compiling the profiles of gallery visitors (John Weber Gallery, 1972); conducting research into the institutional and commercial affiliations of the board of trustees at the Guggenheim Museum, New York (1974); or chronicling the provenance of Manet's still life *Bunch of Asparagus* (Project 74, Cologne) displaced traditional notions of what art should be. [...] But Haacke went further than the analysis of issues immanent to art alone. At the 'Information' exhibition (The Museum of Modern Art, New York, 1970), he asked visitors whether they would vote again for Senator Rockefeller, given that he had not been opposed to Nixon's policies on the war in Vietnam. His study of real estate transactions in New York, *Shapolsky et al. Manhattan Real Estate Holdings, a Real-Time-Social-System, as of May 1, 1971*, became his best-known work, due to the fact that Haacke's scheduled exhibition at the Guggenheim Museum was cancelled because of it. In 1986 Haacke published the article 'Museums: Managers of Consciousness'. Thus Haacke problematized the question of art's autonomy and the ideological function of the institutions that support, or rather produce art. In his article 'Hans Haacke and the Cultural Logic

of Postmodernism', Fredric Jameson defined this kind of art practice as 'institutional critique or institutional analysis'. He commended the way Haacke's work transformed art's 'extrinsic' determinants into the 'intrinsic' content of a new artistic language. Institutional critique in the form of such 'artistic languages' meant a reinvention of conceptual art practices, namely 'to reinvent a new and heightened, dialectically transformed practice of auto-referentiality'. Benjamin Buchloh's influential article 'Conceptual Art 1962–1969: From the Aesthetics of Administration to the Critique of Institutions' (*October*, Winter 1990) arose out of such discussions. With his research into the economic and ideological 'support structures' of art, Haacke exposed for the first time art's 'operating systems' and introduced a specific 'contextual quality' to art.[4] From 1965, Haacke developed a model for his practice based on the general systems theory of the biologist L.V. Bertalanffy, thus distancing his art from formal concerns. Each system needs to distinguish itself from its environment. While it is, on the one hand, autonomous, it also relies on its environment. Thus Haacke rejected the ideas of 'content free art' and took art's contexts and surroundings into consideration.

For his exhibition at the Guggenheim Museum, Haacke planned to show physical, biological and social systems in order to demonstrate both their auto-referentiality and their dependence on environment and context, and to reveal art itself as a constructed social system. The expression 'Real Time Social System', a term which Haacke borrowed from the language of computer networking, indicates how concerned Haacke was to push the discourse of art closer to the 'real world', to the discourses of ecology, industry, economics and politics, etc. It is through such concerns that Haacke has become a central figure within the realms of contextual art. [...]

Daniel Buren also explored the question of art's frames of reference (the frame). In his work since 1965, 'context' has taken a central position, whereas an 'artistic text' has become minimal (reduced to black and white stripes on various materials). The relationship between text and context, 'framed' and 'unframed' is ambivalent in his work, as it is in Derrida's notion of deconstruction. In the exhibition 'Within and Beyond the Frame' (John Weber Gallery, New York, 1973), half of his black and white stripes (there were 19 of them altogether) were placed inside the gallery and the other half were suspended above the street, and therefore outside the gallery framework. On the other hand, Buren consistently refers to the fact that much art is always already historically framed, i.e. contextualized. The empty spaces that his stripe-walls leave behind in the museum, where the original art object is omitted, show a desire for his own work to be seen as 'unframed', whilst simultaneously referring to the framing conditions of all art, his own included. Buren's work is about showing, firstly,

that perception is no longer to be determined a priori, as argued by Kant, but is socially and historically constructed, as understood by Foucault; and secondly that art, as influenced by Wittgenstein's language-games, is an art-game that itself operates within a system of rules. For him it is about exposing the framing conditions and operating systems in the artwork itself. This occurs through a formal separation of the painting and the canvas. As a result, his work became extremely site-oriented (accordingly his works were often titled *In Situ*). As in the work of Michael Asher, his installations are immediately, directly, physically and conceptually linked with the site in which they occur. Frame, place and cultural context form an inseparable unit: 'Any object placed on exhibition in a museum space is framed not only physically by the museum architecture but also (and certainly not the less) by the cultural context which a museum signifies.' He saw the strategies of the Land artists, such as Smithson, that escaped the institution by fleeing into the landscape, as an evasion of the problem, as romantic escapism, or an 'artistic safari'. The exposure of the 'frame' (or context) can only occur within the 'frame'. Because 'the prevailing ideology and the associated artists try in every way to camouflage them, and although it is too early – the conditions are not met – to blow them up, the time has come to unveil them'. In the same way that Broodthaers wanted to 'unveil' reality, Buren wanted to expose the frameworks of formal and cultural settings: 'The museum/gallery for lack of being taken into consideration is the framework, the habit ... the inescapable "support" on which art history is painted.'[5] If for Bentham the fictions were impossible, but unavoidable, for Buren it was context.[6]

The inseparability of site and cultural context is also at the heart of Michael Asher's work. Asher, however, went further than mere site-specific critique and 'situational aesthetics'[7] to investigate the transformation of objects of utilitarian value into objects of exchange value. Asher rejected the process of abstraction that objects undergo when invested with exchange value; or rather he exposed the process through his site-specific interventions, mostly through a process of subtraction. He later went on to develop an additive method in his analysis of institutional frameworks: ('As historical conditions change, it becomes questionable whether situational aesthetics can still be successfully applied and remain operative.' Michael Asher, 1983).[8] [...]

In his essay 'From Work to Frame', Craig Owens describes some of the artists who during the 1970s and 1980s continued the work of *Framed and being Framed* (Haacke, 1975) and carried on working *Within and Beyond the Frame* (Buren, 1973), regardless of the return of art to the old models and myths. He relocates the postmodern 'displacement' (in Derrida's definition of the term) from artwork to art context (frame) in the work of Allan McCollum, Louise Lawler, Martha Rosler, Mary Kelly and Allan Sekula. These artists, and others

such as Stephen Willats,[9] Victor Burgin and Barbara Bloom, form the second generation of the history of contextual art. In her photo and video works, Martha Rosler has not only examined the conditions of site-specific art, but also the social conditioning of subjects, particularly in her photo-text work *The Bowery in Two Inadequate Descriptive Systems* (1975). [...]

Today there is a third generation of contextual artists, who from the marginalized positions and concerns of art in the 1960s and 1970s have formed a central position in the 1990s.[10] Of course, alongside this new third generation there are also artists who can be indirectly related to contextual art, for example, Lorna Simpson, Betty Parsons, Rirkrit Tiravanija, Bethan Huws and Renée Kool, each of whom instigate experiences in their work. To this group can also be counted Michael Klier, Art Club 2000, Jon Tower, Mel Chin, Maria Eichhorn (who in 1993 arranged a children's workshop at the Künstlerhaus Stuttgart), and also Kirsten Mosher, who set up fictional parking meters in order to expose the reality of the state's occupation of public spaces. Christine Borland, Gavin Turk, Jorge Pardo, Kate Ericson and Mel Ziegler, amongst others, all try to incorporate social realities into their artwork. Readymades belong to everyone (Philippe Thomas). Simon Linke, who since 1988 has been painting art advertisements (usually text) in art magazines, Philippe Parreno and Philippe Cazal, amongst others, analyse art's mediation and distribution. Lois Renner begins with a fictionalization of the studio, the place of production, and then continues on to the entire nexus of the practice of painting, sculpture, photography, and art's installation and locality. [...]

The difference between current and earlier contextual art is that the 'critical boundaries' have been pushed back and extended, in that not only has art as a medium of free expression been problematized, but that through the exposing of art's frameworks, artists have begun resolutely to take part in other discourses (ecology, ethnology, architecture and politics) and the boundaries of art's institutions have thus significantly expanded.

The critique of representation became the critique of power and culture, and above all of reality, as constructed by various discourses. Therefore, by unveiling the construction of art and reality (through various 'fictitious' discourses), reality, section by section, is recovered. It is no longer solely about the critique of art's systems but the critique of reality and the analysis and creation of social processes. During the 1990s, discourses usually considered extrinsic to art were increasingly incorporated into discussions about art. Artists are now becoming independent agents of social processes, partisans of the real. The interaction between artist and social situation, between art and extra-artistic context has led to a new form of art, where both come together: context art. The objective of the social structure of art is participation in the social structure of reality.

1 Douglas Huebler, cited in Elaine E. King, *Douglas Huebler 10 +* (Evanston, Illinois: Dittmar Memorial Gallery, Northwestern University, 1980); see also Ronald J. Onorato, *Douglas Huebler* (La Jolla: La Jolla Museum of Contemoporary Art, 1988).

2 Robert Smithson, in Nancy Holt, ed., *The Writings of Robert Smithson* (New York: New York University Press, 1979).

3 Gordon Matta-Clark, cited in Liza Béar, 'Gordon Matta-Clark: Splitting the Humphrey Street Building', *Avalanche* (New York, December 1974).

4 Kaspar König, ed., *Hans Haacke/Framing and Being Framed: 7 Works, 1970–75* (Halifax, Nova Scotia: Nova Scotia College of Art and Design, 1975).

5 Quotations from Daniel Buren, 'Beware!', *Studio International*, vol. 179, no. 920 (1970) 100–104; Daniel Buren, 'Critical Limits', in *Five Texts* (New York: John Weber Gallery, 1973) 38.

6 [In an early bibliographical note Weibel refers to Charles Kay Ogden (his philosophical writings and connection to the circle around Bertrand Russell) and in this context, Jeremy Bentham's *Theory of Legislation* and *Theory of Fictions*, both edited by Ogden.] [trans.]

7 Victor Burgin's term, see his 'Situational Aesthetics', *Studio International* (October 1969).

8 Michael Asher, *Writings 1973–1983 on Works 1969–1979*, ed. Benjamin H.D. Buchloh (Halifax, Nova Scotia: Nova Scotia College of Art and Design, 1983).

9 [In terms of the paradigm of his work Stephen Willats is associated with the conceptual 'second generation', from the mid 1970s onwards; however his ideas and practice, including participatory projects with the residents of housing estates, were formulated from 1965 onwards.]

10 [The exhibition 'Kontext Kunst: Art of the 1990s' at the Neue Galerie in Graz included the work of Weibel's 'third generation of contextual artists, notably Fareed Armaly, Tom Burr, Clegg & Guttmann, Meg Cranston, Mark Dion, Peter Fend, Andrea Fraser, Regina Möller, Reinhard Mucha, Christian Philipp Müller, Dan Peterman, Florian Pumhösl, Julia Scher and Heimo Zobernig. For a critical account of Weibel's curatorial stance, see Philipp Kaiser, 'Müller's Worlds' published at http://www.christianphilippmueller.net, 2007.]

Peter Weibel, extracts from 'Kontextkunst. Zur sozialen Konstruktion von Kunst', in Peter Weibel, ed., *Kontext Kunst* (Cologne: DuMont, 1994) 45; 48; 49; 52–3; 56; 57. Translated by Frances Loeffler, 2009.

Michel Foucault
Other Spaces//1967

First there are the utopias. Utopias are sites with no real place. They are sites that have a general relation of direct or inverted analogy with the real space of Society. They present society itself in a perfected form, or else society turned upside down, but in any case these utopias are fundamentally unreal spaces.

There are also, probably in every culture, in every civilization, real places – places that do exist and that are formed in the very founding of society – which are something like counter-sites, a kind of effectively enacted utopia in which the real sites, all the other real sites that can be found within the culture, are simultaneously represented, contested and inverted. Places of this kind are outside of all places, even if it may be possible to indicate their location in reality. Because these places are absolutely different from all the sites that they reflect and speak about, I shall call them, by way of contrast to utopias, heterotopias. [...]

Third principle. The heterotopia is capable of juxtaposing in a single real place several spaces, several sites that are in themselves incompatible. Thus it is that the theatre brings onto the rectangle of the stage, one after the other, a whole series of places that are foreign to one another; thus it is that the cinema is a very odd rectangular room, at the end of which, on a two-dimensional screen, one sees the projection of a three-dimensional space, but perhaps the oldest example of these heterotopias that take the form of contradictory sites is the garden. We must not forget that in the Orient the garden, an astonishing creation that is now a thousand years old, had very deep and seemingly superimposed meanings. The traditional garden of the Persians was a sacred space that was supposed to bring together inside its rectangle four parts representing the four parts of the world, with a space still more sacred than the others that were like an umbilicus, the navel of the world at its center (the basin and water fountain were there); and all the vegetation of the garden was supposed to come together in this space, in this sort of microcosm. As for carpets, they were originally reproductions of gardens (the garden is a rug onto which the whole world comes to enact its symbolic perfection, and the rug is a sort of garden that can move across space). The garden is the smallest parcel of the world and then it is the totality of the world. The garden has been a sort of happy, universalizing heterotopia since the beginnings of antiquity (our modern zoological gardens spring from that source).

Fourth principle. Heterotopias are most often linked to slices in time – which is to say that they open onto what might be termed, for the sake of symmetry,

heterochronies. The heterotopia begins to function at full capacity when men arrive at a sort of absolute break with their traditional time. This situation shows us that the cemetery is indeed a highly heterotopic place since, for the individual, the cemetery begins with this strange heterochrony, the loss of life, and with this quasi-eternity in which her permanent lot is dissolution and disappearance.

From a general standpoint, in a society like ours heterotopias and heterochronies are structured and distributed in a relatively complex fashion. First of all, there are heterotopias of indefinitely accumulating time, for example museums and libraries. Museums and libraries have become heterotopias in which time never stops building up and topping its own summit, whereas in the seventeenth century, even at the end of the century, museums and libraries were the expression of an individual choice. By contrast, the idea of accumulating everything, of establishing a sort of general archive, the will to enclose in one place all times, all epochs, all forms, all tastes, the idea of constituting a place of all times that is itself outside of time and inaccessible to its ravages, the project of organizing in this way a sort of perpetual and indefinite accumulation of time in an immobile place, this whole idea belongs to our modernity. The museum and the library are heterotopias that are proper to western culture of the nineteenth century.

Opposite these heterotopias that are linked to the accumulation of time, there are those linked, on the contrary, to time in its most flowing, transitory, precarious aspect, to time in the mode of the festival. These heterotopias are not oriented toward the eternal, they are rather absolutely temporal [*chroniques*]. Such, for example, are the fairgrounds, these marvellous empty sites on the outskirts of cities that teem once or twice a year with stands, displays, heteroclite objects, wrestlers, snakewomen, fortune-tellers, and so forth. Quite recently, a new kind of temporal heterotopia has been invented: vacation villages, such as those Polynesian villages that offer a compact three weeks of primitive and eternal nudity to the inhabitants of the cities. You see, moreover, that through the two forms of heterotopias that come together here, the heterotopia of the festival and that of the eternity of accumulating time, the huts of Djerba are in a sense relatives of libraries and museums. for the rediscovery of Polynesian life abolishes time; yet the experience is just as much the rediscovery of time, it is as if the entire history of humanity reaching back to its origin were accessible in a sort of immediate knowledge. [...]

Michel Foucault, extract from 'Des Espaces Autres', lecture for the Cercle d'études architecturale, 14 March 1967; first published in *Architecture/Mouvement/Continuité*, no. 5 (October 1984); trans. Jay Miskowiec, at http://foucault.info/documents/heteroTopia/foucault.heteroTopia.en.html

Adam Chodzko
Better Scenery//2000

Text on sign in Sainsbury's car park, London:

BETTER SCENERY

From Flagstaff, Arizona, take route 89 northeast, then route 510 east, then 505 northeast for 7 miles until you reach a left turn soon after passing Maroon Crater. Follow this dirt track (the 244A) for 6 miles northeast passing the volcanic formations of The Sproul and the Merriam Crater on your right. Half a mile beyond a small well take the track that heads north towards Little Roden Spring. After exactly 6.7 miles a rough, overgrown cinder track leads off to the left. Head west along this for a quarter of a mile until you reach a fence post. Then walk 100 yards 160° south SE. At this point stop and face due east (visible on the horizon are the Roden Crater and the glow of pink rocks in the Painted Desert).

Situated here, in this place, is a sign which describes the location of this sign you have just finished reading.

Text on sign in Arizona desert:

BETTER SCENERY

Heading north out of London along the west side of Regent's Park is the Finchley Road (A41). Follow it through St John's Wood and half a mile beyond to Swiss Cottage. From here, bearing north-west for a quarter-of-a-mile the Finchley Road veers towards West Hampstead. Keep Holy Trinity Church and the Laser Eye Clinic to your right and Finchley Road Underground station to your left. Then take a left turn, following the graceful curvature of the prodigious, concrete and glass, O2 building. This takes you down a steeply inclined unmarked road which opens out to an expansive tarmac car park bordered to the north and south by the tracks of railway lines.

Situated here, in this place, is a sign which describes the location of this sign you have just finished reading.

Adam Chodzko, *Better Scenery* (2000).

Paul Rooney
Let Me Take You There//2003

Let Me Take You There: an audio guide for a field in Calderdale, narrated by Alain Chamois, fanzine writer.

Please make your way to a field in Calderdale, Yorkshire, in the north of England, preferably in winter, and bring a camera if you have one. Please avail yourself of stout footwear. Once you arrive in Calderdale go to Hebden Bridge, and make your way to the Hardcastle Craggs National Trust car park. Outside of the car park, and over the bridge, is a toilet building, and to the right of this a steep path marked 'Calderdale Way'. Make your way along this path until you reach a large iron gate marked 'Haworth Old Road'. Lift up the chain that holds the gate and make your way along this path for around a hundred metres until you reach the fifth telegraph pole on your left. As you stop on the path turn to your right and you will see a steeply inclined field with a stone wall at its far end, with tall trees behind the wall. Please stay here for the full duration of this guide.

Winter photographs well in this northern field. You will be fortunate if it snows when you visit this area, as snow has a beautiful pristine purity in and of itself, and here it throws up dramatic contrasts between dark and light. It simplifies the landscape: trees and stone walls become writing on a white page. Time freezes in winter, and death is always present, but this condition is also pregnant with future growth, the spring rebirth that hibernates and waits under the frozen land, like the photographed moment seeded within the photograph itself. What follows are some winter reminiscences related to this field.

There was a documentary shown in 1980 by Granada Television, from the arts series *Celebration*, about two northern landscape photographers. Part of the programme documents the photographer Charlie Meecham taking a five by four plate camera photograph of the landscape near his home in Hebden Bridge, a few miles south of Top Withens, the landscape inspiration for Emily Brontë's *Wuthering Heights*.

Charlie says at one point during the programme: 'I am trying to produce an image that is not really about photography at all, it's about ... what *atmosphere* I'm trying to pick up on. ... It doesn't necessarily even have to be good light. I mean that's probably a terrible day to make that image, it's very dark, shadowy, very bleak. You could have some nice leaves on the trees. I don't know, you could make it look much more cheerful, but that probably wouldn't help the atmosphere of it.'

At the start of the documentary, Charlie and the narrator of the programme, Daniel Meadows, venture out into the snow covered valley to search for

inspiration. Charlie has short dark hair that probably looks darker than it is against the snow and has a small face with small but handsome features. Daniel, who is considerably taller than Charlie, has slightly longer, slightly lighter brown hair and has a longer nose and face. Suddenly Charlie stops in front of a scene, which the TV camera does not show us, and says, 'Yes. Try one.'

He takes off his backpack carrying his plate camera and tripod.

Daniel asks, 'Do you want a hand?'

But a curt 'No', is the simple reply.

Then Daniel says, 'What are you looking at here? What can you see that other people wouldn't see?'

Charlie looks back at the scene, which we also see on camera for the first time, and says, 'There are two things vertical, two vertical elements … and a very strong horizontal. Very pure, very pure. …'

Daniel says, 'The trees and the spiky bits of grass are the verticals.'

Charlie continues, half-ignoring Daniel, 'Yes, yes … and also monochromatic, very little colour. In fact what colour there is is going to be lost.'

The location that Charlie was about to photograph is the field, wall and trees straight ahead of you. Charlie's view of it then was almost black and white, and split into two nearly equal halves. The top half consisted of tall trees behind a low stone wall; the side of a steep hill can be seen through the trees, and part of a grey sky above them. The bottom of the scene was filled only by snow punctuated by vegetation. It makes me think of a fragment of a diary I read once, describing a train journey into exile, through the frozen Russian landscape that defeated Napoleon and Hitler. Leon Trotsky was expelled from the Soviet Union in 1928, and on the way to his ship in Odessa his train was stopped on a sideline for twelve days,

… near a dead little station … He relates to his diary … *There it sank into a coma between two thin stretches of woods … Our engine keeps rolling backwards and forwards to avoid freezing … We do not know where we are.*

Charlie's view of the field you are standing in may have been very similar to the view out of Trotsky's train window during those twelve days. Days in which the whole of history seemed paused. Frozen.

As the documentary continues, we watch Charlie assembling his plate camera and tripod. The TV camera position is at the side of Charlie's camera so we look at right angles to the view being photographed, which remains out of sight. Charlie wears a green khaki boiler suit with lapels, and as the TV camera views his upper body, he resembles a Russian soldier on the frozen steppes.

As he turns a screw attaching the camera to the tripod Charlie says, 'This sometimes becomes a little tricky when your hands are really cold. I've tried various techniques of using mittens and fingerless gloves and suchlike. But it

doesn't usually work. Usually I'm back on …' Assembling the back of the camera, he forgets to finish the sentence, and then blows hard into the camera body to remove dust.

'What happens if it starts to rain Charlie?' Daniel says.

'I have to work very quickly' he replies, leaning over to the front of the camera, his hands almost affectionately cupped round the whole of its body. He pulls out its lens, and adjusts the tripod so that the camera is head high. He sniffs, and as our camera looks at a level gauge on the tripod, says, 'I try always to get everything dead level, again in an attempt to try and make things as accurate as possible, rather than distort, which is very easy to do photographically. Fortunately this has got spirit levels on it so you can do quite a lot of things with it.'

The TV camera pans over the assembled plate camera, and pans out to see Charlie cover himself with a grey blanket and approach the back of his camera.

I saw a gig by the band Rooney that involved a similar blanket. The singer Dermot Bucknall, during a gig in Mytholmroyd, also near Hebden Bridge, draped a blanket over his head during one of their songs. He had a habit at this point, it was around February 1994, of using his alleged talent as a medium on stage. At this particular performance, as the band played on behind him, Dermot kneeled on the stage with the blanket over his head and mic, and proceeded to shout out fragments of information. Eventually the information became more focused, Dermot seemed to have become a vessel for another's voice: 'I am an angel … Clarence, yes, Clarence … I saved Jimmy Stewart from suicide, on that snowy night in Bedford Falls. I specialize in saving suicides … I can see a field in Calderdale and the stone wall is the same, those tall trees have not changed … it is winter there, there is snow all around. Let me take you there …'

He then shouted even louder than before: 'Let me take you there.' Then Dermot suddenly screamed at the top of his voice some lyrics from the 1984 party hit *Atmosphere*, by the northern comic Russ Abbott: *Oh what an atmosphere, / I love a party with a happy atmosphere. / So let me take you there, / And you and I'll be dancing in the cool night air.*

The band stopped playing at this point, as if too concerned for the wellbeing of their singer to concentrate on anything else. The audience, only forty people at the most, also became silent at Dermot's chilling screams. For a moment, perhaps thirty seconds, the room was utterly still and quiet, I felt as if I was watching a bootleg video of the gig and had pressed the pause button by mistake.

'Oh yes, that's not looking too bad at all.' Charlie says underneath his blanket, looking at the inverted image and adjusting the camera as he does so.

Still under the blanket he tries to explain his relationship to the image that we cannot see, and says, 'Now I can't lift the front too far, because you've got

quite a long coverage on the vertical side, so I do have to actually bring the camera over a bit, which is a nuisance. But I can bring it forward again, which helps to bring in the foreground as being in focus. Now I've got to go even more … and even that's too high, you can see the lens cutting it out … that's better. Still not sure this is working: bring back forward.' He takes the blanket off and moves away from the camera, retrieving a magnifying glass from his bag. The TV camera then closes in from the side on Charlie looking through the magnifying glass at his framed image.

'Quite a broad exposure range', he says, as he assesses his exposure meter, pointing it at his hand, at the snow, and at the trees in the distance. He then says, 'Because I'm going to have to allow one thing or the other to go. I want to keep the snow white, but keep as much detail as possible.'

There is a poem by Ted Hughes called *Six Young Men*, about another photograph taken in Calderdale. It describes an image of six youths sitting in the landscape near Hebden Bridge just before the First World War, before they all went to Rochdale, a few miles to the south, and joined The Lancashire Fusiliers. Hughes writes: *Six months after this picture they were all dead. / All are trimmed for a Sunday jaunt. I know / That bilberried bank, that thick tree, that black wall / Which are there yet and not changed …*

In winter 1979, the same winter that the Granada documentary was filmed, another six young men went to Cargo Studios in Rochdale to record some songs. They were the four members of the band Joy Division as well as their manager Rob Gretton and producer Martin Hannett. One of the songs recorded that winter was called *Ice Age*, a remnant from their punk days, and one a new song, *Atmosphere*. In little more than two years the band had moved on from their punk beginnings to the remarkable achievement of the *Atmosphere* recording. The song has an air of perfection about it, it seems almost unimprovable, and for this reason was described by music journalist Paul Morley as 'The end of pop'. The writer and record producer Richard Cook wrote of it as: '… in some ways the last Joy Division song … it sounds symmetrical, pristine in detail, entirely finished.'

The singer sings of remorse and dread over the frozen washes of synthesizer chords, produced by Hannett to sound like musical blankets of snow. The singer's voice is all the more unsettling for its coldness; its emotional numbness. The run off grooves of *Atmosphere*'s eventual twelve-inch release read: 'HERE ARE THE YOUNG MEN, BUT WHERE HAVE THEY BEEN.'

Sylvia Plath, in the poem *Tulips*, written in the last year of her life, decribes lying in numb hospital whiteness: *The tulips are too excitable, it is winter here. / Look how white everything is, how quiet, how snowed in. / … My husband and child smiling out of the family photo; / Their smiles catch on to my skin, little smiling hooks.*

The husband in the photograph is poet Ted Hughes. A week after Sylvia's suicide, as Britain was in the grip of one of the century's harshest winters, she was buried in the village where Hughes' parents came from, Heptonstall, a mile from Hebden Bridge. As a final act of faith, the poem she placed last in her final sequence of poems, *Wintering*, a poem about hanging on through the winter, finishes with the word 'spring'. Ted Hughes rearranged the order of the poems for publication after her death, however, removing this final note of optimism.

In the Granada documentary, the camera cuts to a shot of Daniel looking admiringly on; head propped on his fist. Charlie takes a transparency from his bag as we hear the sound of dogs in the distance. He slots the transparency into the camera, checks the camera lens for obstructions, removes the back of the transparency plate and presses the shutter. The TV picture then fades to a shot of the finished photograph, as we hear the sound of distant barking gradually fading.

At that Rooney gig, the silence of the room was eventually broken by Dermot rising from his kneeling position, still covered by the blanket, and walking off the stage, bumping into the drummer's cymbals as he did so. This was followed by whispered chattering from the audience and the usually unnoticed sound of hands caressing guitar necks, squeaking their metal strings, the hum of amplifiers, and the sustained icy shiver of cymbals. The band looked at each other briefly then left the stage, to neither applause nor obvious disapproval.

The Joy Division song *Atmosphere* ends with a crystal ring of chimes, like the aural equivalent of frosted branches suddenly shifted by a gust of wind. Richard Cook wrote that 'the tremble in the closing chords brings a shiver as one recalls the sleeve of the reissued twelve-inch: a snow scene, empty, virginally white'. Six months after recording the song in that wintry Pennine studio, the singer, Ian Curtis, was dead. The photograph referred to by Cook, on the cover of the *Atmosphere* twelve-inch released in September 1980, four months after Curtis' suicide, is Charlie's photograph: the taking of which is documented in the Granada programme, the subject of which is straight ahead of you. The photograph, which is placed in the centre of the record cover on a white ground, is almost black and white, and split into two nearly equal halves. The top half consists of tall trees behind a low stone wall, the side of a steep hill can be seen through the trees, and part of a grey sky above them. The bottom of the image is filled only by the writing of vegetation on the blank page of the snow.

Thank you for coming to this field and listening to this guide. Please take a photograph of the field before you go, and have a safe journey home.

Paul Rooney, 'Let Me Take You There', 2003.

Meeting #61, #62 Luxor (main entrance) 3900 S. Las Vegas Blvd. Las Vegas USA, November 21, 2010, sunset

وادي الملوك (المدخل الرئيسي) الأقصر (الضفة الغربية) مصر ٢١ تشرين الثاني (نوفمبر) ٢٠١٠ مغيب الشمس

Jonathan Monk, *Meeting #61, #62,* [Egyptian venue: Valley of the Kings] Morning Star/Lisson Gallery, 2001

I ordered my horse to be brought from the stables. The servant did not understand my orders. So I went to the stables myself, saddled my horse, and mounted.

In the distance I heard the sound of a trumpet, and I asked the servant what it meant. He knew nothing and had heard nothing.

At the gate he stopped me and asked: 'Where is the master going?' 'I don't know', I said, 'just out of here, just out of here. Out of here, nothing else, it's the only way I can reach my goal.' 'So you know your goal?' he asked. 'Yes', I replied, 'I've just told you. Out of here – that's my goal.'

Franz Kafka, from *The Departure*; among Mike Nelson's selections in the book *A Forgotten Kingdom*, 2001

Tony Smith
I View Art as Something Vast//1966

[...] When I was teaching at Cooper Union in the first year or two of the 1950s, someone told me how I could get onto the unfinished New Jersey Turnpike. I took three students and drove them somewhere in the Meadows to New Brunswick. It was a dark night and there were no lights or shoulder markers, lines, railings, or anything at all except the dark pavement moving through the landscape of the flats, rimmed by hills in the distance, but punctuated by stacks, towers, fumes and coloured lights. This drive was a revealing experience. The road and much of the landscape was artificial, and yet it couldn't be called a work of art. On the other hand, it did something for me that art had never done. At first I didn't know what it was, but its effect was to liberate me from many of the views I had had about art. It seemed that there had been a reality there which had not had any expression in art. The experience on the road was something mapped out but not socially recognized. I thought to myself, it ought to be clear that's the end of art. Most painting looks pretty pictorial after that. There is no way you can frame it, you just have to experience it. [...]

Tony Smith, from interview with Samuel Wagstaff, *Artforum*, vol. 5, no. 4 (December 1966) 14–19.

Hamish Fulton
Isle of Arran//1970

IN THE SPRING OF 1970 I VISITED THE ISLE OF ARRAN OFF THE WEST COAST OF SCOTLAND. ONE DAY I DECIDED TO SWIM THE HALF MILE STRETCH OF SEA BETWEEN KINGS CROSS ON ARRAN AND THE LIGHTHOUSE ON HOLY ISLAND. I HAD NEVER BEEN TO HOLY ISLAND. AS I WAS SWIMMING CLOSE TO THE ROCKS BY THE LIGHTHOUSE I SAW A MAN AND A WOMAN WALKING OVER THE ROCKS TOWARDS ME. THEY GAVE ME A HAND OUT ONTO THE LAND. THE MAN WAS MY GEOGRAPHY TEACHER FROM SCHOOL WHOM I HAD NOT SEEN FOR SIX YEARS. HE IS NOW THE LIGHTHOUSE KEEPER ON THE ISLAND.

Hamish Fulton, *Isle of Arran* (1970), in *Interfunktionen*, no. 6 (1971).

Adam Chodzko
Out of Place//2000

I treat the making of an artwork as a certain kind of looking: the production of a vision within the public sphere. I see this public space as being networked by communication, desire, exchange and engagement. I see this network as being very flexible and constantly changing and contingent. Therefore it can be played with and transformed to propose new possibilities of space.

My art is not just about looking, but *about* looking *for* something; searching for something that is missing at present. This notion of 'looking for' takes place partly in public space but also in interior space: the imagination of the inhabitants of that public space. As an example, a public space could simply be a network of people who all happened to dream two nights ago about a fox. They do not know each other, nor do they know that each shared the same elements in a dream. After recognizing the existence of this public space, a less literal notion of it must also acknowledge all the people whose dreams did *not* feature a fox.

The idea of 'looking for something' proposes an expansion of vision to accommodate that which we did not previously know or perhaps what we previously did not want to know. What are we looking for in public space? Absorption through kinship and intimacy? Or are we seeking confirmation of our difference, and entering public space wanting separation, the definition of a unique identity for ourselves? These questions are constantly niggling me and, floundering around for answers, I often return to the first piece of art I was conscious of liking – Pieter Bruegel the Elder's *Landscape with the Fall of Icarus* (*c.* 1558). It's a painting of a public space. It appears to be an everyday pastoral scene but becomes contaminated as soon as Icarus is spotted, in the form of his barely perceptible legs sticking out of the sea. Once the little legs are noticed, this absolutely transforms everything. The painting requires us to expand our looking, to expand our field of vision to let in something which should not be there, which is just on the edge of vision. Something should not be there either because it is lacking or because it is excessive; it does not yet exist. So perhaps we can acknowledge these flaws or glitches in public space through art-making and, beyond that, in the way we live our lives.

Through art these punctures, things which should not be there, become holes, apertures for looking, within public space. They may perhaps allow us to see clearly but briefly for a while. Walter Benjamin refers to this 'flaw' as a 'trace', when he explores the notion of detective stories, which equally connect to the idea of 'looking for something'. For Benjamin, detective stories are a cultural

form that identifies ways of recovering an individual after his or her disappearance into the crowded populace of a newly industrialized society. [...]

Around 1990, I started not only looking for these flaws but also trying to place them into public space. I began by doing extremely simple advertisements in classified advertising papers like *Loot*. It was free to advertise. I would describe an object or a possibility that could not really exist. I began by describing art objects that I would quite like to make but which were not feasible. Some were virtually meaningless, for example, 'millenarian heterogeneous apparition, unstructured model. Three metres long, with a slight defect', which I advertised in the scientific apparatus section. Basically it was describing *nothing*. The idea was to put art objects out into public space as descriptions, or possibilities, to be encountered accidentally in the course of searching for something else – a coffee table, a car, a book, etc. Instead of them being spectacular, they were just these small but very odd signals that you would stumble across. [...]

Adam Chodzko, extract from 'Out of Place', in John Carson and Susannah Silver, eds, *Out of the Bubble: Approaches to 'Contextual Practice'* (London: The London Institute and Central Saint Martins College of Art and Design, 2000) 32; revised by the artist, 2009.

Tacita Dean
Tristan de Cunha//2005

I sit in urban safety imagining my journey to Tristan da Cunha. I have known about this island for many years, since studying the trade routes in the Southern Atlantic and the rough and fearsome seas of the Roaring Forties. They call it the remotest island on earth because it is nearly three thousand kilometres off the nearest coast and only one boat goes there a year out of the Cape of Good Hope. It is a volcano, risen out of the ocean, where less than three hundred people still live – all descendants of the sea's itinerants – the shipwrecked and the runaways and the naval loners restless at home. They come from the stock of old seafaring nations, like the English and the Dutch, the American and the Italian, and they still have only seven family names between them.

For a long time, I have wanted to go there: to arrive on that boat, the RMS St Helena, and to leave on it again a year later. I see it as my big project: my observation post in the roughest seas on the planet, where the weather is cruel

and where the skies are filled with albatross instead of herring gulls. I began to have dreams about Tristan da Cunha. I dreamt about waiting for the post to arrive. Once, when letters were being distributed into piles on tables, it occurred to me, quite suddenly and as if in panic even in my dream, that the boat that had brought the letters had to be *the* boat: the boat that meant my year was over and that I could go home. My concentration on all those letters I could not send as well as those I could not receive, made me begin to imagine a year in the plod of time and in the minutiae of all that news I could not get.

But this fantasy belongs to the analogue world: the world where you could still get lost. It belongs to a time before we began endlessly and futilely communicating with each other, when people expected to wait a year for a letter. I read now that a satellite public phone has been installed in the only village on Tristan da Cunha, and that the governor has email and that from time to time cruise ships, on their way to Antarctica, stop by when the weather lets them anchor. Maybe getting lost, or rather disappearing out of sight, has become an anachronism in our communication-crazed world. Is this why being hostage to such remoteness is so attractive to me when, truth be told, I am a coward to such loneliness?

I recollect a story from childhood, where the hero, in order to remedy something I can no longer recall, had to walk upon land *where no man had ever trod.* I remember being troubled by this. Where might such land be? Was it under the sea, or in the desert or on top of a mountain? How would we know if man had ever walked there? Did the riddle perhaps mean new land: land that had come up from the centre of the Earth: land made of lava? Or was it land fallen from the sky, like ice land? Was it on the moon, or now that that has been vanquished, Mars? I don't remember the end of the story. What I am remembering though, as I struggle to understand this part of me that craves the distant elsewhere, is that the riddle of the untrodden land might have planted a seed.

And like one of those gifts of synchronicity that answers you out of nowhere, I decided, just after having written the above paragraph, to look at Antoine de Saint-Exupery's book *Wind, Sand and Stars* for some inspiration on where to go with this text. I opened the book at random and read straight away about his forced landing on an isolated plateau in the Sahara: '*Without question, I was the first human being ever to wander over this ... this iceberg ... I was thrilled by the virginity of a soil which no step of man or beast had sullied. I lingered there, startled by this silence that never had been broken. The first star began to shine, and I said to myself that this pure surface had lain here thousands of years in sight only of the stars.*'

So I realize, suddenly, what it is at the heart of this draw to the Earth's edges – to the desert and to the sea, or to the ice at the bottom of the world, or the

volcano risen out of the ocean. In these places, we are not bound by the rules of human time; we can be free of a history that cannot mark a surface in constant flux like that of the sea or the shifting dunes of the desert, or one brutalized by weather or extremity. In these places, we can imagine millennia; we can imagine prehistory and can see the future.

As Saint-Exupery walks his untrodden desert plateau, he finds in the sand a black stone, like lava stone, which has fallen from the sky, and the more he wanders the more of them he finds. *'And here is where my adventure became magical, for in a striking foreshortening of time that embraced thousands of years, I had become witness of this miserly rain from the stars. The marvel of marvels was that there on the rounded back of the planet, between this magnetic sheet and those stars, a human consciousness was present in which as in a mirror that rain could be reflected.'*

Tacita Dean, 'Tristan de Cunha', *Artforum*, vol. 43, no. 10 (Summer 2005) 275.

Langlands & Bell
Afghan Diary//2002

Sunday 13 10 02

At breakfast in our hotel we overhear an American couple enthusiastically discussing a girls' sewing school they visited the previous day. So they can support themselves and their families, the girls are taught how to make clothes. While half the girls learn to use the sewing machines, the other half pedal away on Chinese bicycles connected to a generator to provide the power. It is such a powerful image and sounds so resourceful that we ask the Afghan lady who took the couple, if we might also visit the school. She turns on us immediately 'What are you doing in Afghanistan?' she demands. We explain that we are researching a commission for the Imperial War Museum in London, about the aftermath of September 11 and the war in Afghanistan. 'The Afghan people are fed up to death with researches and investigations. We need help or money – not more investigations!' she declares, and walks straight out. The two American academics are as taken aback as we are by the vehemence of her response, and apologize to us after she leaves. We have already seen enough to think that what she said was entirely reasonable.

Despite all the loud promises of money made on the international circuit, the Afghan people see little evidence of it on the ground. Partially as a result of this,

the warlords are regaining their hold over the country because they appear to some to offer the best options for employment and individual advancement.

Still smarting from our encounter with the Sewing School mistress we visit the International Committee of the Red Cross HQ for a personal security briefing. The main tenets of the briefing are: watch where you tread at all times, stick to roads and paths which you know to be in use, do not find yourself outside after dark. On the way to the ICRC we spend some time taking photographs of the painted signs outside the offices of the many non-governmental organizations based in the area. We are astonished at how many there are. When we ask, the ICRC is able to give us the definitive list of all the NGOs in Kabul (120 international NGOs alone). There are so many that one wonders what they are all doing. After the series of catastrophes which have befallen the country in the last twenty three years Afghanistan desperately needs all the help it can get in almost every field, but there are times when it starts to seems like a final revenge. First you saturate a country with high tech weaponry, then you bomb the place to bits, and finally when it's down on it's knees and completely flattened, you send in the NGOs in Timberland boots and brand new jeeps. As we leave the ICRC we come across a dog dying in an open drain. There doesn't seem to be an NGO for abandoned dogs yet but it may not be far off.

Monday 22 10 02

We rise at 4 a.m., intending to get a good start on the road to Jalabad. We have been told we have a five and a half hour drive to our destination in front of us, and we have to return to Kabul before dark the same day. Suddenly Waiz the hotel owner emerges, torch in hand from his barred room, insisting that it is too early and too dangerous to leave the building. As soon as he goes back to bed, we persuade the doormen sleeping downstairs to open up and let us out. We get into the jeep and set off along the deserted roads in the dark. At the border of the district of Kabul, we are stopped by some Afghan National Army soldiers who at first refuse to let us pass. After scrutinizing our passports for so long that we fear they might not be returned to us, they are finally persuaded that we are foreigners, and we can proceed. We do not understand the logic in this, but we don't question it.

As dawn breaks we find ourselves in some of the bleakest terrain we have so far encountered. This is despite the fact that we are on one of the most important roads in the whole country, and the main artery by which the city of Kabul is supplied. Our jeep heaves and grinds its way among the boulders, raising clouds of dust as it goes. Eventually the gorge widens into a valley and we reach the town of Sarobi. A name that chills the blood of westerners in Afghanistan, since four western journalists passing through the town in

November 2001 were stopped, hauled out of the vehicle in which they were travelling and shot dead. [...]

After passing many villages and qala (traditional fortified houses) the landscape opens out into a dry stony plain; that gives onto a wide sparsely cultivated valley, ringed by high mountains, which finally becomes the shallow muddy lake of the Darunta reservoir. Rounding a bend in the road just outside the small village of Daruntah, we come to a checkpoint manned by a gang of local Militia. The boys are sitting under a shade of rush thatch on the roof of a small ruined house, with a machine gun on a tripod, guarding a turning off the road. We think this is likely to be the entrance to the house we are looking for: one that was previously occupied by Osama Bin Laden. We pull up, and Malik our translator asks if we may visit the house. They say that we may, but we should pay a 'security fee' and take one of them with us or the rest of their unit in the house may shoot without warning. One of the boys picks up a Kalashnikov and climbs silently into the front of jeep beside Malik and Akbar. We drive down the track and around a bend, passing under another, unmanned, machine gun post. We pull up in a compound below a house with a smashed mobile rocket launcher listing in front of it. A group of young men armed with rifles emerges from the house, followed by a commander who is probably in his late twenties or early thirties, but so marked by experiences we cannot fathom, that he could be almost any age. We explain that we are interested in taking some photos of the house and its surroundings. They ask us why we want the photos, but when we explain that we are researching a commission for a museum in London, they lose interest and tell us to go ahead.

The house has a spectacular view. It is situated on a rocky promontory projecting into the lake surrounded by tall mountains. The ground is littered with discarded spent and live munitions, and abandoned military vehicles, and rusting hardware. It is a modest three-room house in the local vernacular, with a small terrace and an external kitchen, that was probably originally built as a farmhouse. There is also a small mosque overlooking the house, and a strange bomb shelter/bunker behind it. The men tell us that Bin Laden added the mosque and the bunker specifically for his own use. The mosque is conventionally constructed out of local stone and rendered concrete, but the bunker is rather unusual. It is partially excavated and set into the ground. The walls are made from stacked wooden ammunition boxes filled with rocks and earth. The roof is earth and stone set on branches and topped off with a few old tyres. Bin Laden took up residence in the house when he moved to Afghanistan from Sudan in May 1996. He stayed until September 1997 when the activity of American agents in nearby Peshawar, Pakistan, apparently induced him to seek greater safety in Kandahar. On 9 October 2001, when the Taliban refused to

surrender Bin Laden to the Americans, the site was partially bombed by American B52s. While we are taking photographs, a pair of American Black Hawk helicopters appear from behind the mountains and pass low over the house ... probably just checking to see who is currently in residence.

Langlands & Bell, extract from 'Afghan Diary' [documenting the making of their project *The House of Osama Bin Laden*], in *Untitled*, no. 30 (Summer 2003) 12–13.

Matthew Coolidge
The Center for Land Use Interpretation//2006

[...] The work of the Center is about humans and the land they inhabit and transform. It is about how we, individually and collectively, interact with each other and with our surroundings. Think of a 'typical' American life as moving between such land-use sites as hospitals, houses, schools, parks, roads, parking lots, churches, factories, office buildings, job sites, shopping centers, restaurants and cemeteries. Such a life might also directly or indirectly be supported by places like landfills, utility corridors, airports, shipping terminals, power plants, subway tunnels, oil fields, bombing ranges and golf courses. And so on.

The marks we leave on the ground can be intentional, incidental or accidental. They can be vast in scale, like a housing development, or hardly noticeable, like pipe casing or a switchbox. All of this can be read, like a text, a text that tells stories about our culture and society. Learning how to read this text, learning the vocabulary of the language of land use and teaching it to others, is one way of describing what the Center does. The shared space of the earth is physically and metaphorically what unites us, and until we colonize space, what we have here on this planet is all we have to work with. So it makes sense to investigate the human experience from the ground up.

Surely, there are others at work in this arena. Archaeologists excavate the past from the ground, historians assimilate moments into patterns, and cultural theorists apply the structures of history to the present. Elsewhere on the ground, geologists study the subsurface, geomorphologists scrutinize the surface and geographers examine the systems of human and non-human activities. All of their readings help us to understand how we got to this point and how things look from their point of view. But there are other parts of the spectrum of perception which have been left unexplored by scholars, scientists

and other specialists – dimensions that are only hinted at in the great museums of the land.

The answers to much of what remains unclear to us are exposed for all to see, though often hidden, as it were, in plain sight. They can often be found in the overlooked quotidian elements that surround us, too banal-seeming to have value in any larger equation. Yet these are the building blocks of existence. Often, due to the fashion of the day, some things are perceived as being ugly, so we turn away from them; as a result they remain a mystery for us to come back to another time. Even more often, whole avenues of experience lie unexplored because no one has yet wandered down these roads with the attentiveness they deserve.

The Center's role is partly to explore these corridors and vistas and to trip over the protruding artefacts of the present on the way to explaining the extraordinary conditions we all find ourselves in all the time. As we stumble over the obvious, we ask ourselves, 'What is that thing anyway, and how did it get there?' The results are compiled, sorted, processed, and stored in our Land Use Database. The database is the foundation of the organization, an informational bedrock. It is from this collection that we draw in order to produce our programming. [...] It is an inventory of examples. Its utility would be limited if it were unfiltered and exhaustive – too much information can be as obfuscating as too little. The Center applies the 'unusual and exemplary' criteria in order to limit the information that is preserved. [...]

The Center regards a site as 'unusual' if it stands out as unique, extraordinary, singular, rare or exceptional. An example might be a piece of land art or a plutonium processing facility. A site is considered 'exemplary' if it serves well to represent a more common type of land use, if it is especially articulate, descriptive, coherent or concise. Or if it represents an apogee of its type: perhaps it's the first, the largest, the smallest, or has some other superlative quality. In this case, it is selected to exemplify that form of land use. [...]

Matthew Coolidge, extract from *Overlook: Exploring the Internal Fringes of America with the Center for Land Use Interpretation* (New York: Metropolis Books, 2006) 16–17; 19.

Giorgio Agamben
The Witness and the Archive//1999

[...] In Latin there are two words for 'witness'. The first word *testis*, from which our word 'testimony' derives, etymologically signifies the person who, in a trial or lawsuit between two rival parties, is in the position of a third party (*terstis*). The second word, *superstes*, designates a person who has lived through something, who has experienced an event from beginning to end and can therefore bear witness to it. [...]

The witness usually testifies in the name of justice and trust and as such his or her speech draws consistency and fullness. Yet here the value of testimony lies essentially in what it lacks; at its centre it contains something that cannot be borne witness to and that discharges the survivors of authority. The 'true' witnesses, the 'complete witnesses', are those who did not bear witness and could not bear witness ... Whoever assumes the charge of bearing witness in the name of the impossibility of bearing witness. [...]

Giorgio Agamben, extracts from 'The Witness and the Archive', *Remnants of Auschwitz* (New York: Zone Books, 1999) 6; 34.

Walid Ra'ad
The Beirut Al-Hadath Archive//1999

[...] In January 1975, we recruited one hundred photographers to photograph every street, storefront, building, sign, vegetation, moving vehicle and other spaces of aesthetic, national, political, popular, functional and cultural significance in Beirut. In April 1975, the Lebanese civil war started. This development divided the Lebanese capital in half, and travel between the city's various parts became extremely difficult and dangerous. To facilitate the work of our photographers and to hinder the uses of our images by any of the warring parties, we equipped our photographers with our own designed and manufactured camera and film, a photographic process that produces a 76.2 x 50.8 mm positive image. Furthermore, we required our photographers to note accurately the time they produced their images, and to accompany every

photograph with three street addresses, only one of which corresponded to the actual place where the image was produced. The correct street address was not to be revealed by the photographers to the organization. We also donated every photograph to influential individuals, cultural organizations and other institutions in and outside of Lebanon.

The enclosed images are 18 of the 27 images of storefronts produced in section 28 of Beirut at 8:34 AM on 12 January 1977.

Our initiative continues to this day. [...]

Extract from 'Mission Statement' by Fouad Boustani, the first part of Walid Ra'ad's photo-text work *The Beirut Al-Hadath Archive*, reproduced in *Rethinking Marxism*, no. 11 (1999) 15.

Hal Foster
The Artist as Ethnographer//1996

[...] Recently the old artist envy among anthropologists has turned the other way: a new ethnographer envy consumes many artists and critics. If anthropologists wanted to exploit the textual model in cultural interpretation, these artists and critics aspire to fieldwork in which theory and practice seem to be reconciled. Often they draw indirectly on basic principles of the participant-observer tradition, among which James Clifford notes a critical focus on a particular institution and a narrative tense that favours 'the ethnographic present'.[1] Yet these borrowings are only signs of the ethnographic turn in contemporary art and criticism. What *drives* it?

There are many engagements of the other in twentieth-century art, most of which are primitivist, bound up in the politics of alterity [...] So what distinguishes the present turn, apart from its relative self-consciousness about ethnographic method? First, as we have seen, anthropology is prized as the science of *alterity*; in this regard it is, along with psychoanalysis, the lingua franca of artistic practice and critical discourse alike. Second, it is the discipline that takes *culture* as its object, and this expanded field of reference is the domain of postmodernist practice and theory (thus also the attraction to cultural studies and, to a lesser extent, new historicism). Third, ethnography is considered *contextual*, the often automatic demand for which contemporary artists and critics share with other practitioners today, many of whom aspire to fieldwork in the everyday. Fourth, anthropology is thought to arbitrate the *interdisciplinary*,

another often rote value in contemporary art and criticism. Fifth, the recent *self-critique* of anthropology renders it attractive, for it promises a reflexivity of the ethnographer at the centre even as it preserves a romanticism of the other at the margins. For all these reasons rogue investigations of anthropology, like queer critiques of psychoanalysis, possess vanguard status: it is along these lines that the critical edge is felt to cut most incisively.

Yet the ethnographic turn is clinched by another factor, which involves the double inheritance of anthropology. In *Culture and Practical Reason* (1976) Marshall Sahlins argues that two epistemologies have long divided the discipline: one stresses symbolic logic, with the social understood mostly in terms of exchange systems; the other privileges practical reason, with the social understood mostly in terms of material culture.[2] In this light anthropology *already* participates in the two contradictory models that dominate contemporary art and criticism: on the one hand, in the old ideology of the text, the linguistic turn in the 1960s that reconfigured the social as symbolic order and/or cultural system and advanced 'the dissolution of man', 'the death of the author', and so on; and, on the other hand, in the recent longing for the referent, the turn to context and identity that opposes the old text paradigms and subject critiques. *With a turn to this split discourse of anthropology, artists and critics can resolve these contradictory models magically, they can take up the guises of cultural semiologist and contextual fieldworker, they can continue and condemn critical theory, they can relativize and recentre the subject, all at the same time.* In our current state of artistic-theoretical ambivalences and cultural-political impasses, anthropology is the compromise discourse of choice.[3] [...]

Just as appropriation art in the 1980s became an aesthetic genre, even a media spectacle, so new site-specific work often seems a museum event in which the institution *imports* critique, whether as a show of tolerance or for the purpose of inoculation (against a critique undertaken by the institution, within the institution). Of course this position within the museum may be necessary to such ethnographic mappings, especially if they purport to be deconstructive: just as appropriation art, in order to engage media spectacle, had to participate in it, so new site-specific work, in order to remap the museum or to reconfigure its audience, must operate inside it. This argument holds for the most incisive of these projects, such as *Mining the Museum* by Fred Wilson and *Aren't They Lovely?* by Andrea Fraser (both 1992).

In *Mining the Museum*, sponsored by the Museum of Contemporary Art in Baltimore, Wilson acted as an archaeologist of the Maryland Historical Society. First he explored its collection (an initial 'mining'). Then he reclaimed representations evocative of histories, mostly African-American, not often displayed as historical (a second 'mining'). Finally he refrained still other

representations that have long arrogated the right to history (for example, in an exhibit labelled 'Metalwork 1793–1880', he placed a pair of slave manacles – a third 'mining' that exploded the given representation). In so doing Wilson also served as an ethnographer of African-American communities lost, repressed, or otherwise displaced in such institutions. Andrea Fraser performed a different archaeology of museum archives and ethnography of museum cultures. In *Aren't They Lovely?* she reopened a private bequest to the art museum at the University of California at Berkeley in order to investigate how the heterogeneous domestic objects of a specific class member (from eyeglasses to Renoirs) are sublimated into the homogenous public culture of a general art museum. Here Fraser addressed institutional *sublimation*, whereas Wilson focused on institutional *repression.* Nonetheless, both artists play with museology first to expose and then to reframe the institutional codings of art and artefacts – how objects are translated into historical evidence and/or cultural exempla, invested with value, and cathected by viewers.

However, for all the insight of such projects, the deconstructive-ethnographic approach can become a gambit, an insider game that renders the institution not more open and public but more hermetic and narcissistic, a place for initiates only where a contemptuous criticality is rehearsed. So, too [...] the ambiguity of deconstructive positioning, at once inside and outside the institution, can lapse into the duplicity of cynical reason in which artist and institution have it both ways – retain the social status of art and entertain the moral purity of critique, the one a complement or compensation for the other.

These are dangers of site-specific work inside the institution; others arise when this work is sponsored outside the institution, often in collaboration with local groups. Consider the example of 'Project *Unité*', a commission of forty or so installations for the Unité d'Habitation in Firminy (France) during the summer of 1993. Here the quasi-anthropological paradigm operated on two levels: first, indirectly, in that this dilapidated housing project designed by Le Corbusier was treated as an ethnographic site (has such modern architecture become exotic in this way?); and then, directly, in that its largely immigrant community was offered to the artists for ethnographic engagement. One project suggests the pitfalls of such an arrangement. Here the neo-conceptual team Clegg & Guttmann asked the Unité residents to contribute casettes for a discotheque, which were then edited, compiled and displayed according to apartment and floor in a model of the building as a whole. Lured by collaboration, the inhabitants loaned these cultural proxies, only to have them turned into anthropological exhibits. And the artists did not question the ethnographic authority, indeed the sociological condescension, involved in this facilitated self-representation.

This is typical of the quasi-anthropological scenario. Few principles of the ethnographic participant-observer are observed, let alone critiqued, and only limited engagement of the community is effected. Almost naturally the project strays from collaboration to self-fashioning, from a decentring of the artist as cultural authority to a remaking of the other in neo-primitivist guise. Of course this is not always the case: many artists have used these opportunities to collaborate with communities innovatively, to recover suppressed histories that are sited in particular ways, that are accessed by some more effectively than others. And symbolically this new site-specific work can reoccupy lost cultural spaces and propose historical counter-memories. [...]

1 [footnote 29 in source] See James Clifford, *The Predicament of Culture: Twentieth-Century Ethnography, Literature and Art* (Cambridge, Massachusetts: Harvard University Press, 1988) 30–32. 'The ethnographic present' is passé in anthropology.

2 [31] Marshall Sahlins, *Culture and Practical Reason* (Chicago: University of Chicago Press, 1976). This critique was written in the heyday of poststructuralism, and Sahlins, then close to Jean Baudrillard, favoured (linguistic) symbolic logic over (Marxian) practical reason. 'There is no material logic apart from the practical interest', Sahlin writes, 'and the practical interest of man in production is symbolically constituted' (207). 'In Western culture', he continues, 'the economic is the main site of symbolic production. For us the production of goods is at the same time the privileged mode of symbolic production and transmission. The uniqueness of bourgeois society consists not in the fact that the economic system escapes symbolic determination, but that the economic symbolism is structurally determining' (211).

3 [32] The role of ethnographer also allows the critic to recoup an ambivalent position between academic and other subcultures as critical, especially when the alternatives seem limited to academic irrelevance or subcultural affirmation.

Hal Foster, extracts from 'The Artist as Ethnographer', *The Return of the Real* (Cambridge, Massachusetts: The MIT Press, 1996) 181; 183; 191–7.

Renée Green
Secret (*Project Unité*, Firminy)//1992

The process of thinking about how to approach working in Firminy at the *Unité* [*d'habitation*, designed by Le Corbusier] has been going on for over a year for me. My solution to this invitation to participate in this project reflects the continuation of that thinking process.

One of the most pressing questions I had was: what does it mean to do a site-specific work, and how is it possible to do or make something which has any effect on an environment unfamiliar to one, or which has a significant effect upon oneself. Ultimately I think the latter half of the above question is the recurring beginning for me, because whatever is done or made reflects oneself, even when another environment is meant to be a focus. How literally one brings this subjective perspective to the forefront of course varies.

I decided to begin with my discomfort with the *Unité* surroundings. I tried to imagine the ideal way it could function, based on Le Corbusier's intentions, and also tried to think of what would have happened if my family were to inhabit an apartment, or if I were to inhabit one. I was thinking of Michel de Certeau's statement about space and place. Place implies a fixed location, 'the elements taken into consideration and beside one another', each situated in its own 'proper and distinct location', whereas space is defined as a 'practiced place'. 'Space', de Certeau elaborates, 'occurs as the effect produced by the operations that orient it, situate it, temporalize it, and make it function in a polyvalent unity of conflictual programmes or contractual proximities.'

The *Unité* structure therefore provided the place, and I saw my contact with the place as forming the space in which to work. After mulling over a number of possible approaches I decided that I would inhabit one of these apartments to the maximum extent possible in the closed area, knowing that it is a temporary act, but one intended as a meditation on different histories and trajectories, that of the architecture itself, Le Corbusier, my family, other families, myself and the surrounding landscape. A preoccupation of mine, in this and some previous work, has been: how does one designate a private space for reflection in a public space? This was one of my first thoughts as I walked through the various apartments last year. I imagined someone reaching adolescence searching for a location in the apartment in which they could live out certain activities typical of that time of life, like playing loud music and collecting things, like posters or stickers, for example. The pristine aspects of the rooms, as is evident by the remains of some previous tenants, would have to be sacrificed for the traces of living.

My plan is to live out a monk-like aspect of an ideal artist's existence in the cellular structure I've been assigned. A vow of silence may or may not be maintained. This will consist of creating a small private tent space from which to read from books related in some way to Le Corbusier and ideas of space (a currently very popular topic) and to reflect and write continual impressions. The surrounding landscape will be observed and sketched and/or photographed. Encounters with the current inhabitants will be recorded. The result of each day's production will fill the apartment and will be open to the public when I'm not there, and selections will be translated and posted in public spaces. [...]

Renée Green, extract from 'Secret', in *Project Unité*, curated by Yves Aupetitalot (Firminy, France, 1992) n.p.

George E. Marcus
The Uses of Complicity in the Changing *Mise en Scène* of Anthropological Fieldwork//1997

Rapport: Report, talk. Reference, relationship; connection, correspondence, conformity. A state in which mesmeric action can be exercised by one person on another. | *Collaboration*: United labour, co-operation; especially in literary, artistic or scientific work. | *Collaborate*: To work in conjunction with another. | *Complicity*: The state of being an accomplice; partnership in an evil action. State of being complex or involved. | *Complice*: One associated in any affair with another, the latter being regarded as the principal. [from *Oxford English Dictionary* definitions] [...]

The range of definitions given in the OED for the word rapport – from 'talk' to 'relationship' to 'conformity' to the unusual meaning of 'a state in which mesmeric action can be exercised by one person on another' – aptly conveys the mix of senses of this key figure within the ideology of anthropological practice. Of course, behind this figure are the immensely complex stories, debates, views and critiques that surround the relationships that anthropological fieldwork imposes. Since the 1960s, this probing of fieldwork relationships has moved from informal, ethos-building professional talk – a regulative ideal – to a more formal articulation found in both reflections on fieldwork and essays on anthropology's distinctive method, discussions in which Clifford Geertz himself has been a seminal, though ambivalent, voice.

Until recently, much of this discussion has assumed the essential desirability and achievability of rapport – it remains the favoured condensed view and disciplinary emblem of the ideal condition of fieldwork – even while the path to rapport seems always to have been fraught with difficulties, uncertainties, happenstance, ethical ambiguity, fear and self-doubt. However, there are now signs of the displacement of this foundational commonplace of fieldwork, given the changing *mise en scène* in which anthropological research is now frequently being constituted. It is probably a healthy sign that no replacement figure, as such, is emerging to take rapport's place. Rather, a deep reassessment of the nature of fieldwork is beginning to occur as a result of defining the different conditions in which it must be designed and conceptualized.

Purely as a means of lending perspective to and representing the set of changes that are affecting anthropological practice and the way that it is thought about, I have chosen in this essay to emphasize the concept of complicity. Indeed, many fieldwork stories of achieving rapport are in some way entangled with acts of complicity. But while complicity has a certain kinship of meaning with rapport, it is also its 'evil twin', so to speak. (In this regard, I appreciate the OED's definitions of complicity as including both the 'state of being complex or involved' and 'partnership in an evil action'.) In no way am I promoting complicity as a candidate for a new shorthand or commonplace of disciplinary practice in our changed circumstances – its 'dark' connotations certainly don't lend it to that use. Rather, a focus on the term will serve as a device for tracing a certain critique, or at least complexation, of the valorized understanding of fieldwork relationships from within the reigning figure of rapport to an alternative conception of fieldwork relationships in which the figure of rapport has lost much of its power as a regulative ideal. [...]

The transformation of complicity that I want to trace, from its place in the shadows of the more positive and less ethically ambiguous notion of rapport to its emergence as a primary figure in the ideology of fieldwork, is occasioned by the changing conditions of fieldwork itself and of its objects of study. These changing conditions are effectively stimulating the traditional *mise en scène* of fieldwork to be turned inside out within the professional ideology, and it is the figure of complicity that focuses this change.

Discontinuity in cultural formations – their multiple and heterogeneous sites of production – has begun to force changes in the assumptions and notions that have constructed the traditional *mise en scène* of fieldwork. Anthropologists, of course, continue to work intensively and locally with particular subjects – the substance of ethnographic analysis requires this – but they no longer do so with the sense that the cultural object of study is fully accessible within a particular site, or without the sense that a site of fieldwork anywhere is integrally and

intimately tied to sites of possible fieldwork elsewhere. The intellectual environment surrounding contemporary ethnographic study makes it seem incomplete and even trivial if it does not encompass within its own research design a full mapping of a cultural formation, the contours of which cannot be presumed but are themselves a key discovery of ethnographic inquiry. The sense of the object of study being 'here and there' has begun to wreak productive havoc on the 'being there' of classic ethnographic authority. [...]

Once released from this *mise en scène*, complicity looks quite different. The focus on a particular site of fieldwork remains, but now one is after a distinctly different sort of knowledge, one for which metaphors of insideness or the crossing of cultural boundaries are no longer appropriate.

In any particular location certain practices, anxieties and ambivalences are present as specific responses to the intimate functioning of non-local agencies and causes – and for which there are no convincing common-sense understandings. The basic condition that defines the altered mise en scène for which complicity rather than rapport is a more appropriate figure is an awareness of existential doubleness on the part of both anthropologist and subject; this derives from having a sense of being here where major transformations are under way that are tied to things happening simultaneously elsewhere, but not having a certainty or authoritative representation of what those connections are. Indeed, there are so many plausible explanations for the changes, no single one of which inspires more authority than another, that the individual subject is left to account for the connections – the behind-the-scenes structure – and to read into his or her own narrative the locally felt agency and effects of great and little events happening elsewhere. [...]

In terms of the traditional *mise en scène* of fieldwork, most anthropologists have always understood themselves as being both inside and outside the sites in which they have been participant observers. That is, they have never naïvely thought that they could simply 'go native' and are critical of those among them who are so naïve. Rather, they understand well that they always remain marginal, fictive natives at best. Still, they have always operated on the faith, necessary for the kind of knowledge that they produce, that they could be relatively more insiders than outsiders if only by mastering the skills of translation, sensitivity and learned cultural competencies – in short, that they could achieve rapport.

In contrast, while it begins from the same inside-outside boundary positioning, investment in the figure of complicity does not posit the same faith in being able to probe the 'inside' of a culture (nor does it presuppose that the subject herself is even on the 'inside' of a culture, given that contemporary local knowledge is never only about being local). The idea of complicity forces the recognition of ethnographers as ever-present markers of 'outsideness'. Never

stirring from the boundary, their presence makes possible certain kinds of access that the idea of rapport and the faith in being able to get inside (by fiction à la Geertz, by utopian collaboration à la James Clifford, or by self-deception à la Renato Rosaldo) does not. It is only in an anthropologist-informant situation in which the outsideness is never elided and is indeed the basis of an affinity between ethnographer and subject that the reigning traditional ideology of fieldwork can shift to reflect the changing conditions of research.

What ethnographers in this changed *mise en scène* want from subjects is not so much local knowledge as an articulation of the forms of anxiety that are generated by the awareness of being affected by what is elsewhere without knowing what the particular connections to that elsewhere might be. The ethnographer on the scene in this sense makes that elsewhere present. It is not that this effect of fieldwork is currently unrecognized in anthropology, but it is always referenced in terms of an ethical discourse, and this frame does not get at what the more generative sense of the idea of complicity seeks to document.

This version of complicity tries to get at a form of local knowledge that is about the kind of difference that is not accessible by working out internal cultural logics. It is about difference that arises from the anxieties of knowing that one is somehow tied into what is happening elsewhere, but, as noted, without those connections being clear or precisely articulated through available internal cultural models. In effect, subjects are participating in discourses that are thoroughly localized but that are not their own. Douglas Holmes uses the term 'illicit discourse' to describe this phenomenon, in which fragments of local discourses have their origins elsewhere without the relationship to that elsewhere being clear. This uncertainty creates anxiety, wonder and insecurity, in different registers, both in the ethnographer and in her subjects.

This recognition of a common predicament is the primary motivation for thinking about the changed conception of fieldwork relationships in terms of complicity. It would be possible to understand our emphasis on the figure of complicity as the achievement of a different kind of rapport, but it would be a mistake to identify it with the precise construction of that figure in the traditional mode. The investment in the figure of complicity rests on highlighting this contemporary external determination of local discourses, marked and set off by the fieldworker's presence but free of the figures of rapport and collaboration that have traditionally characterized fieldwork. Free of these, complicity between an ethnographer whose outsideness is always prominent and a subject who is sensitive to the outside helps to materialize other dimensions that the dialogue of traditional fieldwork, conceived as taking place inside rapport, cannot get at as well. Only thus do we escape the tendency to see change as a disruption of what was there before – a disruption of a world

in which the anthropologist might have been more comfortable and on the 'prior-ness' of which he or she can still rely in exercising the assumptions of the traditional *mise en scène* of fieldwork, even in a site undergoing massive and long-term changes. In such cases, the formative expressions of anxiety that construct cultures in change and boundaries between cultures are likely to be either missed or rationalized in terms of prior cultural logics. Only when an outsider begins to relate to a subject also concerned with outsideness in everyday life can these expressions be given focal importance in a localized fieldwork that, in turn, inevitably pushes the entire research programme of the single ethnographic project into the challenges and promises of a multi-sited space and trajectory – a trajectory that encourages the ethnographer literally to move to other sites that are powerfully registered in the local knowledge of an originating locus of fieldwork. This is what the notion of complicity as an aid in the rethinking of fieldwork potentially offers. [...]

With theoretical meta-narratives and frames of world-systems processes now under prominent debate and reformulation, a broader contextual framing for any location of fieldwork is less available to ethnographers. The shifting boundaries of the ethnographic project, as described above, are moving speculatively into this broader frame itself, treating it ethnographically through the multi-sited trajectory of research. This is partly because of the noted inadequacy and loss of authority of both older and new formulations of meta-narratives – like colonialism (or postcolonialism), Marxist political economy and globalization (an as-yet poorly theorized, but apparently necessary, concept in wide currency) – and partly because of the changing nature of the kind of material sought from and offered by fieldwork subjects who think in terms of their connections beyond the local. [...]

The changing contextualization for assessing the ethical implication of complicity as the normal characterization of contemporary fieldwork relationships is reflected in the shifting power valences of these relationships, as the fieldworker moves from site to site, and the often ethically ambiguous management by the fieldworker of the accumulation of these developing relationships in specific situations. Of course, ethnographers have often been faced with such ethical issues within the villages and communities in which they have worked, but in multi-sited research, the broader context is in a sense entirely of the ethnographer's and his informants' own making, rather than attributable to more abstract and already morally loaded forces such as capitalism and colonialism. So, within the boundaries of a single project, the ethnographer may be dealing intimately and equivalently with subjects of very different class circumstances – with elites and subalterns, for instance – who may not even be known directly to

one another or have a sense of the often indirect effects that they have on each other's lives. [...]

What complicity stands for as a central figure of fieldwork within this multi-sited context of research, and particularly as characterizing those relationships that work effectively to generate the kind of knowledge engaged with the outside that I evoked earlier, is an affinity, marking equivalence, between fieldworker and informant. This affinity arises from their mutual curiosity and anxiety about their relationship to a 'third' – not so much the abstract contextualizing world system but the specific sites elsewhere that affect their interactions and make them complicit (in relation to the influence of that 'third') in creating the bond that makes their fieldwork relationship effective. [...] Complicity here rests in the acknowledged fascination between anthropologist and informant regarding the outside 'world' that the anthropologist is specifically materializing through the travels and trajectory of her multi-sited agenda. [...]

The shared imagination between anthropologist and informant that creates a space beyond the immediate confines of the local is also what projects the traditional site-specific *mise en scène* of fieldwork outward toward other sides. The loaded and more commonly acknowledged ethical implication of complicity glides here into its cognitive implication for the design and purview of fieldwork, turning the traditional *mise en scène* inside out. It will be recalled that for Rosaldo, the recognition of fieldwork as complicity was a stopping point for ethnography, a possibly paralysing insight revealing how anthropology in its most self-justifying rhetoric participates in the broader context of an 'evil partnership' with colonialism. In contrast, complicity as a defining element of multi-sited research is both more generative and more ambiguous morally; it demands a mapping onto and entry of the ethnographic project into a broader context that is neither so morally nor so cognitively determined as it appeared in previous critiques of rapport. [...]

George E. Marcus, extracts from 'The Uses of Complicity in the Changing *Mise en Scène* of Anthropological Fieldwork', in *Representations*, no. 59, *Special Issue: The Fate of 'Culture': Geertz and Beyond* (Summer 1997) 85–108; reprinted in George E. Marcus, *Ethnography through Thick and Thin* (Princeton: Princeton University Press, 1998) 105; 117; 118–23.

Miwon Kwon
One Place after Another//1997

Itinerant Artists

The increasing institutional interest in site-oriented practices that mobilize the site as a discursive narrative is demanding an intensive physical mobilization of the artist to create works in various cities throughout the cosmopolitan art world. Typically, an artist (no longer a studio-bound object maker, primarily working on-call) is invited by an art institution to execute a work specifically configured for the framework provided by the institution (in some cases the artist may solicit the institution with a proposal). Subsequently, the artist enters into a contractual agreement with the host institution for the commission. There follows repeated visits to or extended stays at the site; research into the particularities of the institution and/or the city within which it is located (its history, constituency of the [art] audience, the installation space); consideration of the parameters of the exhibition itself (its thematic structure, social relevance, other artists in the show); and many meetings with curators, educators and administrative support staff, who may all end up 'collaborating' with the artist to produce the work. The project will likely be time-consuming and in the end will have engaged the 'site' in a multitude of ways, and the documentation of the project will take on another life within the art world's publicity circuit, which will in turn alert another institution for another commission.

Thus, if the artist is successful, he or she travels constantly as a freelancer, often working on more than one site-specific project at a time, globe-trotting as a guest, tourist, adventurer, temporary in-house critic, or pseudo-ethnographer[1] to São Paulo, Munich, Chicago, Seoul, Amsterdam, New York, and so on. Generally, the *in situ* configuration of a project that emerges out of such a situation is temporary, ostensibly unsuitable for re-presentation anywhere else without altering its meaning, partly because the commission is defined by a unique set of geographical and temporal circumstances and partly because the project is dependent on unpredictable and unprogrammable on-site relations. But such conditions, despite appearances to the contrary, do not circumvent the problem of commodification entirely because there is a strange reversal now wherein the artist approximates the 'work', instead of the other way around, as is commonly assumed (that is, art work as surrogate of the artist). Perhaps because of the 'absence' of the artist from the physical manifestation of the work, the *presence* of the artist has become an absolute *prerequisite* for the execution/presentation of site-oriented projects. It is now the *performative*

aspect of an artist's characteristic mode of operation (even when collaborative) that is repeated and circulated as a new art commodity, with the artist functioning as the primary vehicle for its verification, repetition and circulation. [...]

Concurrent with, or because of, these methodological and procedural changes, there is a re-emergence of the centrality of the artist as the progenitor of meaning. This is true even when authorship is deferred to others in collaborations, or when the institutional framework is self-consciously integrated into the work, or when an artist problematizes his/her own authorial role. On the one hand, this 'return of the author' results from the thematization of discursive sites, which engenders a misrecognition of them as 'natural' extensions of the artist's identity, and the legitimacy of the critique is measured by the proximity of the artist's personal association (converted to expertise) with a particular place, history, discourse, identity, etc. (converted to thematic content). On the other hand, because the signifying chain of site-oriented art is constructed foremost by the movement and decisions of the artist,[2] the (critical) elaboration of the project inevitably unfolds around the artist. That is, the intricate orchestration of literal and discursive sites that make up a nomadic narrative requires the artist as a narrator-protagonist. In some cases, this renewed focus on the artist leads to a hermetic implosion of (auto)biographical and subjectivist indulgences, and myopic narcissism is misrepresented as self-reflexivity. This being so, one of the narrative trajectories of all site-oriented projects is consistently aligned with the artist's prior projects executed in other places, generating what might be called a fifth site – the exhibition history of the artist, his/her *vitae*. [...]

Just as the shifts in the structural reorganization of cultural production alter the form of the art commodity (to services) and the authority of the artist (to 'reappeared' protagonist), values like originality, authenticity and singularity are also reworked in site-oriented art – evacuated from the artwork and attributed to the site – reinforcing a general cultural valorization of places as the locus of authentic experience and coherent sense of historical and personal identity.[3] [...]

Certainly, site-specific art can lead to the unearthing of repressed histories, provide support for greater visibility of marginalized groups and issues, and initiate the re(dis)covery of 'minor' places so far ignored by the dominant culture. But in as much as the current socio-economic order thrives on the (artificial) production and (mass) consumption of difference (for difference's sake), the siting of art in 'real' places can also be a means to *extract* the social and historical dimensions *out* of places to variously serve the thematic drive of an artist, satisfy institutional demographic profiles, or fulfil the fiscal needs of a city.

Significantly, the appropriation of site-specific art for the valorization of urban identities comes at a time of a fundamental cultural shift in which

architecture and urban planning, formerly the primary media for expressing a vision of the city, are displaced by other media more intimate with marketing and advertising. In the words of urban theorist Kevin Robins, 'As cities have become ever more equivalent and urban identities increasingly "thin", ... it has become necessary to employ advertising and marketing agencies to manufacture such distinctions. It is a question of distinction in a world beyond difference.'[4] Site specificity in this context finds new importance because it supplies distinction of place and uniqueness of locational identity, highly seductive qualities in the promotion of towns and cities within the competitive restructuring of the global economic hierarchy. Thus, site specificity remains inexorably tied to a process that renders particularity and identity of various cities a matter of product differentiation. [...] Under the pretext of their articulation or resuscitation, site-specific art can be mobilized to expedite the *erasure* of differences via the commodification and serialization of places.

The yoking together of the myth of the artist as a privileged source of originality with the customary belief in places as ready reservoirs of unique identity belies the compensatory nature of such a move. For this collapse of the artist and the site reveals an anxious cultural desire to assuage the sense of loss and vacancy that pervades both sides of this equation. In this sense, Craig Owens was perhaps correct to characterize site specificity as a melancholic discourse and practice,[5] as was Thierry de Duve, who claimed that 'sculpture in the last twenty years is an attempt to reconstruct the notion of site from the standpoint of having acknowledged its disappearance.'[6]

1 [footnote 29 in source] See Hal Foster, 'The Artist as Ethnographer', *The Return of the Real* (Cambridge, Massachusetts: The MIT Press, 1996) [...].

2 [37] According to James Meyer, a site-oriented practice based on a functional notion of a site 'traces the *artist's* movements through and around the institution'; 'reflect[s] the specific interests, educations and formal decisions of the producer'; and 'in the process of deferral, a signifying chain that traverses physical and discursive borders', the functional site 'incorporates the body of the artist'. Emphasis added. See Meyer, 'The Functional Site, or, The Transformation of Site Specificity' (1995); reprinted since this text in Erika Suderburg, ed., *Space, Site, Intervention: Situating Installation Art* (Minneapolis: University of Minnesota Press, 2000).

3 [40] This faith in the authenticity of place is evident in a wide range of disciplines. In urban studies, see Dolores Hayden, *The Power of Place: Urban Landscapes as Public History* (Cambridge, Massachusetts: The MIT Press, 1995). In relation to public art, see Ronald Lee Fleming and Renata von Tscharner, *Placemakers: Creating Public Art That Tells You Where You Are* (Boston, San Diego and New York: Harcourt Brace Jovanovich, 1981). See also Lucy R. Lippard, *The Lure of the Local: The Sense of Place in a Multicentred Society* (New York: The New Press, 1997).

4 [44] Kevin Robins, 'Prisoners of the City: Whatever Can a Postmodern City Be?', in *Space and Place: Theories of Identity and Location*, ed. Erica Carter, James Donald and Judith Squires (London: Lawrence and Wishart, 1993) 306.

5 [46] Addressing Robert Smithson's *Spiral Jetty* and the *Partially Buried Woodshed*, Craig Owens has made an important connection between melancholia and the redemptive logic of site specificity in 'The Allegorical Impulse: Toward a Theory of Postmodernism', *October*, no. 12 (Spring 1980) 67–86.

6 [47] Thierry de Duve, 'Ex Situ', *Art & Design*, no. 5–6 (May–June 1993) 25.

Miwon Kwon, extracts from 'One Place after Another: Notes on Site-Specificity', *October*, no. 80 (Spring 1997) 100–102; 103–6.

Gilles Deleuze and Félix Guattari
On Nomadology//1980

[...] The nomad has a territory; he follows customary paths; he goes from one point to another; he is not ignorant of points (water points, dwelling points, assembly points, etc.). But the question is what in nomad life is a principle and what is only a consequence. To begin with, although the points determine paths, they are strictly subordinated to the paths they determine, the reverse of what happens with the sedentary. The water point is reached only in order to be left behind; every point is a relay and exists only as a relay. A path is always between two points, but the in-between has taken on all the consistency and enjoys both an autonomy and a direction of its own. The life of the nomad is the intermezzo. Even the elements of his dwelling are conceived in terms of the trajectory that is forever mobilizing them. The nomad is not at all the same as the migrant; for the migrant goes principally from one point to another, even if the second point is uncertain, unforeseen, or not well localized. But the nomad goes from point to point only as a consequence and as a factual necessity; in principle, points for him are relays along a trajectory. [...]

Second, even though the nomadic trajectory may follow trails or customary routes, it does not fulfil the function of the sedentary road, which is to *parcel out a closed space to people*, assigning each person a share and regulating the communication between shares. The nomadic trajectory does the opposite: it *distributes people (or animals) in an open space*, one that is indefinite and non-communicating. The *nomos* came to designate the law, but that was originally

because it was distribution, a mode of distribution. It is a very special kind of distribution, one without division into shares, in a space without borders or enclosure. The *nomos* is the consistency of a fuzzy aggregate: it is in this sense that it stands in opposition to the law or the *polis*, as the back country, a mountainside, or the vague expanse around a city ('either nomos or polis'). Therefore, and this is the third point, there is a significant difference between the spaces: sedentary space is striated, by walls, enclosures and roads between enclosures, while nomad space is smooth, marked only by 'traits' that are effaced and displaced with the trajectory. Even the lamellae of the desert slide over each other, producing an inimitable sound. The nomad distributes himself in a smooth space; he occupies, inhabits, holds that space; that is his territorial principle. It is therefore false to define the nomad by movement. Arnold Toynbee is profoundly right to suggest that the nomad is on the contrary *he who does not move.* Whereas the migrant leaves behind a milieu that has become amorphous or hostile, the nomad is one who does not depart, does not want to depart, who clings to the smooth space left by the receding forest, where the steppe or the desert advances, and who invents nomadism as a response to this challenge. Of course, the nomad moves, but while seated, and he is only seated while moving (the Bedouin galloping, knees on the saddle, sitting on the soles of his upturned feet, 'a feat of balance'). The nomad knows how to wait, he has infinite patience. Immobility and speed, catatonia and rush, a 'stationary process', station as process – these traits of Heinrich von Kleist's are eminently those of the nomad. It is thus necessary to make a distinction between *speed* and *movement:* a movement may be very fast, but that does not give it speed; a speed may be very slow, or even immobile, yet it is still speed. Movement is extensive; speed is intensive. Movement designates the relative character of a body considered as 'one', and which goes from point to point; *speed, on the contrary, constitutes the absolute character of a body whose irreducible parts (atoms) occupy or fill a smooth space in the manner of a vortex*, with the possibility of springing up at any point. (It is therefore not surprising that reference has been made to spiritual voyages effected without relative movement, but in intensity, in one place: these are part of nomadism.) In short, we will say by convention that only nomads have absolute movement, in other words, speed; vortical or swirling movement is an essential feature of their war machine.

It is in this sense that nomads have no points, paths or land, even though they do by all appearances. If the nomad can be called the Deterritorialized par excellence, it is precisely because there is no reterritorialization *afterward* as with the migrant, or upon *something else* as with the sedentary (the sedentary's relation with the earth is mediatized by something else, a property regime, a State apparatus). With the nomad, on the contrary, it is deterritorialization that

constitutes the relation to the earth, to such a degree that the nomad reterritorializes on deterritorialization itself. It is the earth that deterritorializes itself, in a way that provides the nomad with a territory. The land ceases to be land, tending to become simply ground *(sol)* or support. The earth does not become deterritorialized in its global and relative movement, but at specific locations, at the spot where the forest recedes, or where the steppe and the desert advance. Pierre Hubac is right to say that nomadism is explainable less by universal changes in climate (which relate instead to migrations) as by the 'divagation of local climates'. The nomads are there, on the land, wherever there forms a smooth space that gnaws, and tends to grow, in all directions. The nomads inhabit these places; they remain in them, and they themselves make them grow, for it has been established that the nomads make the desert no less than they are made by it. They are vectors of deterritorialization. They add desert to desert, steppe to steppe, by a series of local operations whose orientation and direction endlessly vary. The sand desert has not only oases, which are like fixed points, but also rhizomatic vegetation that is temporary and shifts location according to local rains, bringing changes in the direction of the crossings. The same terms are used to describe ice deserts as sand deserts: there is no line separating earth and sky; there is no intermediate distance, no perspective or contour; visibility is limited; and yet there is an extraordinarily fine topology that relies not on points or objects but rather on haecceities, on sets of relations (winds, undulations of snow or sand, the song of the sand or the creaking of ice, the tactile qualities of both). It is a tactile space, or rather 'haptic', a sonorous much more than a visual space. The variability, the polyvocality of directions, is an essential feature of smooth spaces of the rhizome type, and it alters their cartography. The nomad, nomad space, is localized and not delimited. What is both limited and limiting is striated space, the *relative global:* it is limited in its parts, which are assigned constant directions, are oriented in relation to one another, divisible by boundaries, and can interlink; what is limiting (*limes* or wall, and no longer boundary) is this aggregate in relation to the smooth spaces it 'contains', whose growth it slows or prevents, and which it restricts or places outside. Even when the nomad sustains its effects, he does not belong to this relative global, where one passes from one point to another, from one region to another. Rather, he is in a *local absolute*, an absolute that is manifested locally, and engendered in a series of local operations of varying orientations: desert, steppe, ice, sea. [...]

Gilles Deleuze and Félix Guattari, extract from *Mille plateaux: Capitalisme et schizophrénie* (Paris: Éditions de Minuit, 1980); trans. Brian Massumi, *A Thousand Plateaux: Capitalism and Schizophrenia* (Minneapolis: University of Minnesota Press, 1987) 380–82 [footnotes not included].

Gabriel Orozco
Interview with Benjamin Buchloh//1998

Gabriel Orozco [...] I like to see my work as the result, or a byproduct, or a leftover of specific situations. That's probably why I cannot separate photography from my sculptural practice. I don't know in advance whether I will need to use photography or whether it will, in the end, become an object. What I am doing, how it ends up as a sign, is all about language, but sometimes it becomes a physical thing, sometimes it is just photography.

Benjamin Buchloh Like *Turista Maluco* (1991) [a photograph recording the placement of single oranges on the tables of a closed outdoor market]: would that be a good example of a photograph that was taken to document an action?

Orozco Yes.

Buchloh So there is no hierarchy between the actual performance and the photographic record? Isn't the installation of the oranges the real work and the photograph just a document?

Orozco In social terms, the work was there, in Cachoeira (Brazil), and four people saw it. That was the action. But then the work really starts to function as a sign in more general terms, and circulating to more people through photography. So maybe we have to ask whether four people were enough to name it a 'work'? But then, when a thousand people have seen the photograph, is that something else, like the news in the newspaper?

Buchloh So what is the sculpture?

Orozco The sculpture is not the photograph, that I'm sure of. I reduce the size of my photographs to the minimum, they are all the same size. I'm not interested in any physical, object-based photography. I don't believe that photography is sculptural like that.

Buchloh You don't think photography can record sculptural, spatial and object relations or social relations of public space?

Orozco As an idea?

Buchloh Yes, like in Douglas Huebler's work when he considered spatial distances, travelling time and social forms of interaction as sculptural constituents ...

Orozco If it's just a question of recording a perception, the sculptural object is not necessary [...] I always think of my photography like a shoe box, and in that sense I really think it's irrelevant if it's a huge photo mural or if it's a small place. You can travel through space and time, be transported; the size doesn't matter. I don't see any sculptural attributes to photography. These attributes relate to what is happening and if the idea is strong enough in terms of time and space. [...]

It can be demagogic to work for a context. The problem in general is to try to say something important for the people in a particular context. Who has the right to have an opinion on other countries just like that? I'm very much aware that I'm a visitor or an immigrant, so I don't feel the right to make any statements about other cultures. But at the same time, I'm living in a culture and I'm a political person, and I have opinions. But it's so hard for me to have an opinion about my own country. What is the authority that an artist has suddenly to display ...

Buchloh Are there criteria that would make context-specificity problematic?

Orozco There are many. We don't believe in universalism any more. We are aware of differences and cultural specificities.

Buchloh On what grounds could culture claim to be context specific under these conditions of global object production?

Orozco Artists have their own culture, trying to deal with their history.

Buchloh Don't we somehow have to clarify how residual forms of identity formation function, defining what one would consider regionally, nationally or culturally authentic? What makes you a Mexican artist?

Orozco I never really understood internationalism or globalization, and at the same time, I don't understand locality itself.

Buchloh I was trying to clarify how you position yourself with regard to the demand for regionally specific culture. On the one hand, people want you to be the new Mexican artist; on the other, you have to confront the new demand for a nomadic, globalist culture, which people have tried to impose on you, in

particular by saying: 'This is the quintessential, end-of-the-century artist whose work is continuously shifting and moving between all cultures.' I think both propositions are basically unacceptable.

Orozco They are. I'm not a nomad. Maybe an immigrant, but a much more privileged immigrant. Nomad is too glamorous a term for me. From Mexico they are trying to tell me I have to be Mexican. Here they are telling me I must not be Mexican. I don't feel any nostalgia for my nationality in that way – I love my country of course. I really stopped talking about that because in Mexico it is such an important issue; everyone is talking about nationalism, being Mexican, being international. I refuse to talk about this in a polemical way because I think I will define it through my work little by little. I have no idea who I am and who I will be in terms of what it is to be a Mexican, or what it is to be a global or a local artist or not. What is interesting now is how the artist behaves in the world, how he lives, what position he takes politically. Now we are producing work living in different countries and having quite close relations to different countries.

Buchloh There are some works that are manifestly site and context specific, like *Until You Find Another Yellow Schwalbe* (1995) and *La DS* (1993), and then there is other work like the cast aluminium sculptures *The Pinched Stars* (1997) where it is absolutely not evident how they are context specific or what history or situation they relate to. The presence of a regional tradition and the presence of a global universality have to be confirmed and denied at the same time in the work, I think that's what your work is doing. [...]

Orozco I work in a context but also I work for me, out of that context; in the context but against the context. You are working in a place but you are also working in a macro situation for your own work in relation to yourself and language in general. [...]

Gabriel Orozco and Benjamin H.D. Buchloh, extracts from interview in *Clinton is Innocent* (Paris: Musée d'Art Moderne de la Ville de Paris, 1998) 31; 33; 39; 85; 87; 99.

Robin Bone and Shep Steiner
We Field Workers//2007

Fall has arrived and a new term in the American Academy has begun; so too has a new flurry of visa problems. For foreign nationals living within the borders of Empire, epics are made of this stuff. As Canadian citizens we are able to work in the United States of America under the North American Free Trade Agreement (NAFTA). The treaty and its extension, the Trade National (TN) Visa facilitates and serves the legitimate entrance requirements and purposes of a wide range of workers seeking employment in the United States. In secondary inspection from Tijuana to Sweetgrass, officers from 'Homeland Security' are confronted by university professors to grape-pickers alike.

We field workers from Canada and Mexico may enter the United States to work with a letter from our prospective employer, proper credentials, supporting documentation and a small processing fee of $50 US; $100 US for Mexicans. The conditions for application and entrance are clear, but things never go smoothly. The machine of state is calibrated to sputter and kick. On a government website, it is suggested that a lawyer costing $1,000 may be helpful. The term of one's stay is one calendar year.

I mention all of this because setting up life in the United States, on a yearly basis, has become a habit. We have tested out the possibilities of setting up life in California, in Georgia, and finally in Florida. Our little travelling community of two – one an art historian, the other a physical therapist – prefers California. It feels more like home, but even putting down roots in the sunshine state can be difficult. Organic metaphors neither sprout nor proliferate inside machines. Things grow rather more fitfully in cracks, where odd pools form from leaky roofs, and in corners where a little light breaks through. The other thing that has become a habit of sorts is entering the country under duress; experiencing first-hand the variable contingencies of state and an unwieldy bureaucracy with changeable standards for admission; and finally, encountering an unpredictable mix of border guards whose temperaments range from the militant to that of the good Samaritan.

In any case a pattern has begun to develop. Thanks to a string of both unbending and helpful officers at a Port of Entry in Montana, we have come to realize that it is an unwritten policy of the United States to refuse visas to field workers on the first attempt. In as much as setting up community within the borders of Empire has of necessity to occur on the second attempt at entry. Which does not mean a misinterpretation of the laws of state on the first bid has

been overcome for clarity, enlightenment and a correct interpretation of those laws on the second go-round. No, an event of another kind entirely has happened, a material event, call it reading according to the letter of the Law, a moment of trauma proper, when the contingency of all community is recognized as such and settled in.

And so we often imagine a conversation taking place between migrant workers from Mexico and Canada. They are speaking across the wide chasm of the United States. At first they are shouting, for each had been refused entry to the country that separates them, but having been granted entrance on their second attempt and now with each quite near the other, their voices become hushed. They are hopeful. It is only a narrow ditch which now divides them, and the day's work lies ahead of them. Fresh from their encounters with officers who have treated them both ill and well they talk of another place with great opportunity.

'It lies', one says, 'beyond the borders of rightful entry and wrongful denial.'

'It is a field', says the other. 'Let us meet there and together do our field work under the midday sun.'

Robin Bone and Shep Steiner, 'We Field Workers', in Can Altay, ed., *Ahali: A Journal for Setting a Setting*, self-published to accompany exhibition at Spike Island, Bristol, England (2007) n.p.

Jon Bywater
Interrupting Perpetual Flight//2006

Standing in the morning sun outside Hoani Waititi marae in Waitakere, in my hometown in the North Island of Aotearoa New Zealand, I am thinking of a BBC news infographic. The trigger is the figure of the migratory bird.

When visitors are formally welcomed by Maori, indigenous New Zealanders, onto a marae or community meeting place, the figure of the migratory bird is invoked across the marae atea, the highly charged space in front of a whare hui, the meeting house. Participating in such a welcome as a visitor, I am interpellated as a bird by the karanga, the first call from the host side. The karanga, performed by a woman, traditionally a kuia, a woman elder, is high pitched. Its commencement dissolves the everyday social space of conversation and distraction as the tapping of a glass or a clearing of the throat might at closer quarters and in different circumstances. Across the distance of the open ground in front of the house, it can sound powerfully disembodied, the impersonal voice of

ceremony focusing attention and invoking a particular kind of awareness. Although I only know a few words of Te Reo Maori, the Maori language, in the tuned, chanted call I recognize the term manuhiri naming me. Usually translated into English simply as 'visitors', I hear in it the Maori word manu, bird; a word I know first from local place names. It is as a freshly landed bird that I hear myself called forward.

During the Northern summer in 2005 outbreaks of bird flu have been confirmed in Russia and Khazakstan, and fears reinforced that the deadly H_1N_5 virus might be spread further through avian migratory routes from South-East Asia where it first emerged in late 2003. I picture in my mind's eye the BBC News diagram I have viewed on their website, depicting a structure for this potential global circulation. It abstracts the seasonal movements of bird populations into a set of coloured ribbons, reducing the limits of generalized flyways. Looping elegantly across the world map, free of but determined by land like the edges of meteorological pressure systems but diachronic and predictable, these flight paths represent patterns of exchange presumably older than the oldest human trade routes. At this time, from Aotearoa New Zealand, the diagram that illustrates what could form the roots of a global pandemic still seems reassuringly remote. It occurs to me less as urgent and factual than it does as an image of the interdependence of the human and non-human worlds with geography. It is at once an urgent reminder of the importance of place and relations between places, the crucial importance of geography and of the limits and endless displacements of the nation state whose boundaries the birds so obviously ignore. The two images of birds – myself, here, as manuhiri and the remote traffic of Asian species — repeat to me the question: what does it mean to be from a place?

Decades of feminist and anti-colonial practice evince that while any bounded identity — such as being from somewhere — looms as potentially restrictive, 'essentializing' or 'othering', the particularities of place and personal history — where it is we are coming from — are crucial to those core processes of cultural production and reception, meaning and understanding. The rhetorics and tensions that surround the complex relationship between tradition, location and identity, and the questions of how these things do and should matter in the practice and production of art often settle conceptually around this dynamic. To be identified or identifiable in a non-hegemonic or sub-dominant position is a necessary, and perhaps inevitable evil. My experience of the Maori process of the poowhiri, the formal welcome I have begun to describe, offers me a particular way of thinking about place-based identity. I want to explore provisionally how this tikanga — Maori for a philosophy, protocol or praxis — might allow me to begin to think around or outside this kind of dilemma in the naming of difference, say between acknowledgement and 'pigeonholing'.

Welcome Ceremony

Anana! kua whakatangata taua manu. (Wow! That bird just assumed human form.)
— *Ngaa Mahi A Ngaa Tupuna*, 1928

The term manuhiri is not the only Maori expression that names people as birds. The phrases 'manu a Taane' and 'manu a Tiki', for example, can each denote a man. Indeed, in Maori tradition other living things, fish and birds can also be considered kin. In the wider Pacific-language group the word manuhiri relates to the Hawaiian malihini, meaning newcomer, stranger, and to the Tahitian manihini, meaning visitor or guest; these derive 'all perhaps ultimately from Proto-Polynesian manu, bird (figuratively applied to humans)' as an American dictionary has it. Another discussion of its etymology suggests that it might mean 'birds cloaked by the first light', perhaps involving the concept hihiri, having or demanding energy, in this case rendered as 'the first piercing rays of light that shoot across the globe in an instant'. The usual name for the process of welcome I have begun to describe is related: poowhiri or taawhiri, both words meaning to welcome or beckon, are also relating to the noun whirl, meaning a flock (of birds). The first syllable 'poo–' can mean gathering together; 'taa–' is a kind of action and a causative prefix, as well as a noun denoting a flock of certain kinds of bird. So the name for the ceremony could be elaborated as the place or action of bringing a flock together.

The poowhiri is one of the most visible aspects of contemporary tikanga Maori. Its ubiquity is measured by the fact that the newly formed Maori Party, which gained parliamentary seats in New Zealand's 2005 general election, has sought an inquiry into its appropriate use in state institutions. It is a dialectically structured exchange between two groups, a formalized means of squaring-off with people you don't know, a welcome of visitors by local hosts. As it proceeds, the negotiation formally shifts the status of the newly arrived from manuhiri to share with their hosts one of tangata whenua, literally 'people of the land'. As such, it happens on the terms of the hunga kaainga or tangata whenua, the locals. Different marae will hold to variations on the kawa or etiquette, but the generalized modern form is widely standardized: a karanga calls on the manuhiri, and a challenge is made to them and accepted by them. In the whaikoorero — the oratory that takes place during the mihimihi, the speeches from either side that follow — part of the orators' skill lies in the matching of energies between the two parties. These are some of the ways the tensions between the groups are managed, by making them explicit and balancing them in a set, reciprocal format. To end the formalities, both parties literally share breath with one another, each person pressing noses together in a hongi with every member of the other group. To return to the everyday or noa state, to bring back the chatter and informality,

food and drink are shared. Marking the new unity, the term whanau, extended family, is commonly applied to a group who are gathered for a hui, a marae-based discussion. So if the poowhiri is the bringing together of a flock, it is also about removing the bird status.

From a territorial tradition, Maori culture gives central importance to place. The marae is the physical focal point of contemporary Maori communities, and usually specific to a hapu or iwi (sub-tribe or one of the main, regional tribal groupings), but also now in some, especially urban, cases inter-tribal. To be tangata whenua at a marae in the first sense is to be from there, to be part of a kin group that holds mana (ancestral power, authority, control) over a territory. The word whenua also names the placenta, so the connotation is that the land sustains the people connected to it. In contemporary usage all Maaori are tangata whenua in Aotearoa, but whenua traditionally refers to a more specific area. It is in an honorary or provisional sense that manuhiri become tangata whenua through the poowhiri, taking on the responsibilities to their location, and hence of potentially being hosts. Many other important Maori values intersect with the concept of being 'of the land', such as manaaki, the duty to host (whereby individual self-esteem [mana] and group harmony result from caring about and supporting one another); any tangata whenua, even the newly welcomed, is expected to assume the role of host to any further visitors who may arrive during their stay. [...]

The importance of place in situating Maori interlocutors shows up in [the protocols of peepeha and whakapapa that link landscape and genealogy]. The substance of the mihimihi, the speechmaking during the poowhiri, will contain these kinds of identifications. Each side acknowledges a greater context for the encounter, all that has gone before and that is to come, as well as the immediate kaupapa or reason for the meeting. In this way, we might say, the poowhiri activates and copes with differences by marking them. (Outside of the poowhiri, in less formal situations, the practice of whakawhanaugatanga means Maori people meeting one another will prioritize finding out where someone is from and to whom they are related.)

My account of these practices and values is reductive and from a non-Maori perspective. It also anticipates a brief speculative analysis. Although the poowhiri exceeds my interpretation, I do not want to treat it first as something irreducibly local — or to mistake it for anything exotic, original and authentic — but rather to understand it as a contemporary experience that might extend my thinking on the global circulation of contemporary art. Considered (reductively) as a protocol for engaging with people on place-defined terms, or generally, for encountering an other, simple analogies and transpositions might bring us back to thinking about the practice of art, and how where you are from matters in the context of art. [...]

Acts of Identification

An identity is questioned [when] ... the stranger enters the gates, never, thereafter, to be a stranger: the stranger's presence making you the stranger, less to the stranger than to yourself.
– James Baldwin, *The Devil Finds Work,* 1972

The process of the poowhiri, the invocation of the non-local other in the figure of a bird and its return to being a person by being located in and made responsible to place and genealogy, shares with a Maori worldview the general feature of reminding the participants of everything that makes them who they are, and placing them in a larger economy of people and life force. Coming from a small, nuclear, immigrant European family, the idea of being implicated so closely in such a genetic account of myself has sat awkwardly with the individualist culture of my paakehaa (non-Maori) upbringing. Where I might expect to find the oppressive weight of tradition imposing an identity, I find instead what seems like an effective tool to be used in the negotiation of one's difference. The identifications required in the poowhiri are importantly and distinctively active. In every rehearsal of one's identification, the small gap, the play or give between being determined by a pre-given identity and creatively making it anew is activated.

The poowhiri allows for mutual relations in which the difference of the other is sustained. The concept of manuhiri means there is always an other. There is no pretence that the other is not wholly other, or that the parties are on equal terms, or already have 'common ground'. One thing that could be further explored is that the experiential, spatialized encounter of the poowhiri is important to the discursive forms of the marae, and their integration of affect and thought. The movements and architecture involved in the process are part of what can create a kind of seriousness in the ensuing dialogue that comes with the humility of being part of something larger. The marae atea relates to a relational conception of space, theorized by architect Albert Refiti: 'The centre as a limit in Polynesian thinking is the point of extreme transparency where the private individual becomes obliterated. It is the domain where what is termed in Samoa the va resides. So what is central to any sense of space in Polynesia is the va or the in-between space, a relational opening up inhabited by deities/ community/ land/ family.' [...]

Being identified by the other as other reminds me of the importance of working to recognize my own difference, strangeness, inhumanity and absolute otherness, even if or especially when I occupy a position that is dominant or 'central', as I do in Aotearoa as paakehaa.

Site specificity and relational aesthetics, for example, mean that the question of what it means to be from a place has only become more important to the way the practice and production of art are understood since the heyday of identity-driven art practice in the 1990s. How can my experience of the transition from manuhiri to tangata whenua help me to think about a world where even something as banal as the default formula for wall labels and contributors' notes acknowledges the provisional nature of our relationships to place: so-and-so is (a such-and-such) artist based in such-and-such a place? Initiatives such as Lisette Lagnado's Bienal de São Paulo, abandoning national representation, can be thought through the ideas I have begun to express here, in that it will remove a huge institutional prompt for this passive kind of 'representing' and create a space within which artists can identify actively and individually. [...]

Jon Bywater, extracts from 'Interrupting Perpetual Flight: A Local Practice of Locational Identification', in *Afterall*, no. 13 (Spring 2006) 101–3; 105–6 [footnotes not included; Maori words are not italicized as te reo is an official language in New Zealand, where the text was written].

Artist Placement Group
The Incidental Person/Approach to Government//1977

[...] For the Artist/Incidental Person functioning within organizational contexts certain provisions become necessary. In order to be free of the local sectional interests and objectives the individual Incidental Person has to: 1) outline his own programme of work and needs; 2) be accorded a professional status level with other professional people, and be paid on that level; 3) acquire some diplomatic concessions; this on the grounds that the work is fundamentally in the public interest and service, without being subordinated to corporate objectives as seen by the existing executives in corporation, government or department of government; 4) have a certain command of media and indicators of his/her own devising that will be workable and effective within the context of the association. [...]

Artist Placement Group (APG), extract from 'The Incidental Person/Approach to Government/ APG addresses itself to the German Federal Republic, the German Democratic Republic and to other members of the EEC/ Free International University, Kassel, June 1977', in APG, *Kunst als Soziale Strategie* (Bonn: Bonner Kunstverein, 1977). Courtesy of the Tate Archives, London.

Mark Hutchinson
Four Stages of Public Art//2002

It was Walter Benjamin who said that we must respond to the aestheticization of politics with the politicization of aesthetics. This, of course, was an urgent cry in the face of fascism. This politicization, I think, must be, amongst other things, an analysis of how the practice of art is weighed down by the kind of world in which it is made. Benjamin and Adorno ceaselessly reiterated that art, just like everything else, is shot through with the unfreedoms of an unfree society. Any politics of art worth its name must have an idea of how art is denied potential: of how economic, ideological and practical factors limit what it is thinkable for art to do and to be. So any politics of art needs some idea of how art transforms itself.

Following the philosopher Roy Bhaskar,[1] I want to think about such transformative practice as a process of negating inhibitions and prohibitions. One of the things I find useful about Bhaskar is that he does not see the limits of unfreedom in positive terms (as mere facts) but as absences: absences of freedoms, possibilities and potentials. Therefore, his ideas of transformation and agency revolve around the process of absenting absences [...]

This essay is going to use Roy Bhaskar's formulation of a four-stage dialectic to draw distinctions between four stages of public art.[2] These are not temporal stages in the sense that stage one was over before stage two began, etc. They are historical in that they trace a process of transformations in the possibilities for public art (and implicitly for art per se). To use Bhaskarian language, I want to analyse public art as an open system with emergent properties [...]

Public art seems to make an explicit commitment to a relationship with the world. Which bit of the world may vary considerably, from, say, James Turrell's inaccessible crater in the desert to Antony Gormley's unavoidable *Angel of the North* (1994–98, Gateshead, England), in full view of the motorway. But all art in the public sphere has to exist (and is seen to exist) in the same world as everything else, in one way or another. Putting art in a public place can make visible an artist's assumptions and commitments. Different types of public art show how art conceives of possible (and the possibility of) relationships with a potential audience or audiences. Different forms of art and objects in different locations encourage or dissuade various forms of looking and engagement.

The First Moment
The first stage, or first moment, in Bhaskar's dialectic is non-unity. The idea of difference, or alterity (Bhaskar's preferred term), is essential to get the dialectic

going. In contrast with the start of the Hegelian dialectic, which begins with unity, for Bhaskar everything is always already tinged with negativity: things are not what they are not. It is the distinctions between things, their lack of homogeneity, which is necessary even to make observations of the world. Non-unity is the necessary first step for any process of transformation. [...] An example of a first moment of practice might be a positivist anthropologist's descent upon an exotic community. Such an individual would note the differing social and cultural roles of members of the community; the nuances of behaviour; the different layers of social structure; etc. What such an anthropologist would not observe or analyse would be his or her own presence: the ways he or she formed relationships with, affected, and was affected by, the community in question.

The first stage of public art is putting some art in some public place. Like the first-order anthropologist, this is characterized by an unquestioned confidence in the project and the separation of the protagonist from the place of reception. [...] First-stage public art need not be patronising and authoritarian but the logic of the dislocation of the making of the art from the complexities of its reception makes such offence possible.

The Second Edge

The second stage, or second edge, of Bhaskar's dialectic is negation. This is not necessarily the destruction of the first stage but rather the realization and undoing of its absences, lacks, silences and so forth. This is the relationship between subject and object becoming visible.

The object of study can be affected by the process of being studied, just as the student can be affected by the object of study. At the second edge agency becomes reciprocal. Where the first moment is marked by confidence in seeing differences and the detachment of what is seen, the second edge questions what those differences are and how they are made. The process has become self-reflexive. For our hypothetical anthropologist, this is the realization that his or her very presence affects the behaviour of the persons he or she is studying. It could also be those being studied responding to the presence of the anthropologist: perhaps behaving in ways which they think the anthropologist expects or likes. The anthropologist, in turn, is likely to abandon his or her stance of detachment, with its model of objective interpretation, and instead immerse his or her self in the practices of the community being studied. [...]

In terms of public art, the second stage is the negation of the idea of art's detachment from everything else. At the second edge detachment is transformed into reflexivity. The relationship between the art and the public realm in which it

is placed becomes visible and troubling. This is the negation of the unquestioning and untroubled confidence in the efficacy of public art production.

The negation of the art of the public artist, qua independent, self-determining producer, can take many forms. One bureaucratic response is to turn the artist into a technician. 'The public', in the particular form of community groups and the like, are encouraged to make their own art under the guidance of an artist-cum-teacher. Such an artist is not employed to make art but to be an expert, who might run workshops and so on. Such ideas of 'community art' are a reaction to the perceived top-down imposition of an external culture upon an indigenous population; community art attempts to replace this alien art with something internal to the community in question. The underlying principle is that only the members of a community are capable of making cultural goods that are meaningful and sensitive to the needs of that community. Whilst negating the colonialism of the first moment of public art, such strategies carry forward an undifferentiated and essentializing idea of both what art is and what an audience for public art might be and want. This is an inversion in the same way that nationalism is an inversion of colonialism. [...]

The Third Level

The third stage, or third level, in Bhaskar's dialectic is totality. This is the unity of the first two stages. Whereas negation implies the recognition of the agency of the other, totality implies a reciprocal relationship between subjects. As Bhaskar puts it, this is unity-indifference and difference-in-unity. Totality is a term of self-consciousness, of self-reflexive awareness; it is also a term of interaction: the unity of theory and practice. Totality is dialogical and reciprocal. For our budding anthropologist, this means a dialogue with the community he or she is visiting. This is in contrast with the first-order, theoretical anthropologist's observations from outside; and the second stage, practical anthropologist's participation from inside. Both of these are monological and monovalent, confining themselves to the intrinsic limits of a particular set of meanings, whether in discourse or practice. The idea of dialogue, however, implies the acceptance of a structured and differentiated reality, where one level of reality or explanation does not necessarily exclude another.

For public art, this implies a détente between the meanings of the artist and the meanings of the public. Such art would be responsive both to its own constitution as public art and to the context of its display. This context is not so much physical as social and cultural. That is, the artist is responsive to the sense of place in terms of its various occupants and meanings, rather than to its spatial characteristics. This totality assumes a public unified through difference: a multiple and diverse public but not a segregated one. [...]

This distinction, I hope, will separate out differing types of so-called site-specific work. The *Angel of the North* is intentionally site-specific in that Gormley came up with the idea of the monument by researching into the skills available after the closure of the shipbuilding yards, and the materials available that would once have been used for shipbuilding, etc. But any potential dialogue with this 'specificity' is denied by its conversion into aesthetic form of Gormley's choice. In contrast, Jeremy Deller's *Battle of Orgreave* (2001), a re-enactment of a key incident of the miner's strike (1984), was not only physically and historically specific but dialogical. It involved negotiations between the artist, re-enactment groups, the local community, original participants in the miner's strike – both miners and policemen, and the local authority. These dialogues were not only necessary in order to produce the re-enactment but were part of the work. There were also differing audiences for the work: those interested in art mixing with those interested in politics; visitors mixing with locals; etc. The poignancy of the work was very different, I assume, for those who were not involved in the strike and those for whom it is personal history. None of which, necessarily, makes this work good, or any better than anything else. However, I think it does means that it is dealing with the idea of public art with more sophisticated criteria than first- or second-stage public art. [...]

The Fourth Dimension

Totality is not the end of the story for Bhaskar. The dialectical process ends up by being opened out again. The fourth stage, or fourth dimension, in Bhaskar's dialectic is agency. Agency is the practice of transformation, which is to say that it is self-transformation. Whereas totality is the unity of theory and practice, agency is the unity of theory and practice in practice. More than reflexive awareness it is reflexive transformation.

Agency is transformative practice; that is, practice which transforms itself. At every stage Bhaskar's dialectic is soaked in negativity: the process of transformation is a process of removing absences, lacks, constraints, deceptions, and so on: the absenting of constraining ills (or absences). For Bhaskar the logic and tendency of dialectic is freedom. At this stage of the dialectic I cannot tell you what anthropology might be like because the dialectic process would change what anthropology is and can be: it would be a transformed, transformative practice. Perhaps anthropology, thus transformed, would no longer be an academic discipline and become something akin to citizenship or political action.

The fourth stage of public art, too, is transformative practice, which includes transforming the possibilities of what public art might be. Art would be an art that changes what art is. This is in contrast with a first-order idea of change. [...] [T]his fourth dimension is public art that potentially transforms itself;

transforms its publics; allows itself to be transformed by its publics; and allows these relationships and definitions to be transformed, too. This is bringing into doubt (because agency is radically uncertain) what various art and various audiences (and the relationships between them) can and might be. In a radically open system you never know what you might become (or indeed what you might already have become).

Such art might, then, be hard to see and to judge because it will be transforming what counts as seeing and judging. What art might be, and become, is open ended. In a radically open system, what radical art is, is open to radical transformation in practice.

1 Roy Bhaskar, *Dialectic,the Pulse of Freedom*, Verso, London, 1993.

2 Of course the trouble with dialectic is that once you start looking for it you see it everywhere. Every stage of a dialectic process is itself dialectical, and so on, like zooming in on a fractal pattern. Nevertheless, I shall resist the temptation to put provisos at every turn.

Mark Hutchinson, extracts from 'Four Stages of Public Art', in *Third Text*, vol. 16, no. 4 (2002) 429–38.

THE STREETS SHALL BE OUR PALETTES

THE SQUARES SHALL BE OUR BRUSHES—

Vladimir Mayakovsky, from the poem 'Order to the Army of Art', 1918

ACTION AND PUBLIC SPACE

Hannah Arendt
The Public Realm//1958

The term 'public' signifies two closely interrelated but not altogether identical phenomena:

It means, first, that everything that appears in public can be seen and heard by everybody and has the widest possible publicity. For us, appearance – something that is being seen and heard by others as well as by ourselves – constitutes reality. Compared with the reality which comes from being seen and heard, even the greatest forces of intimate life – the passions of the heart, the thoughts of the mind, the delights of the senses – lead an uncertain, shadowy kind of existence unless and until they are transformed, de-privatized and de-individualized, as it were, into a shape to fit them for public appearance. The most current of such transformations occurs in storytelling and generally in artistic transposition of individual experiences. But we do not need the form of the artist to witness this transfiguration. Each time we talk about things that can be experienced only in privacy or intimacy, we bring them out into a sphere where they will assume a kind of reality which, their intensity notwithstanding, they never could have had before. The presence of others who see what we see and hear what we hear assures us of the reality of the world and ourselves, and while the intimacy of a fully developed private life, such as had never been known before the rise of the modern age and the concomitant decline of the public realm, will always greatly intensify and enrich the whole scale of subjective emotions and private feelings, this intensification will always come to pass at the expense of the assurance of the reality of the world and men.

Indeed, the most intense feeling we know of, intense to the point of blotting out all other experiences, namely, the experience of great bodily pain, is at the same time the most private and least communicable of all. Not only is it perhaps the only experience which we are unable to transform into a shape fit for public appearance, it actually deprives us of our feeling for reality to such an extent that we can forget it more quickly and easily than anything else. There seems to be no bridge from the most radical subjectivity, in which I am no longer 'recognizable', to the outer world of life. Pain, in other words, truly a borderline experience between life as 'being among men' (*inter homines esse*) and death, is so subjective and removed from the world of things and men that it cannot assume an appearance at all.

Since our feeling for reality depends utterly upon appearance and therefore upon the existence of a public realm into which things can appear out of the

darkness of sheltered existence, even the twilight which illuminates our private and intimate lives is ultimately derived from the much harsher light of the public realm. Yet there are a great many things which cannot withstand the implacable, bright light of the constant presence of others on the public scene; there, only what is considered to be relevant, worthy of being seen or heard, can be tolerated, so that the irrelevant becomes automatically a private matter. This, to be sure, does not mean that private concerns are generally irrelevant; on the contrary, we shall see that there are very relevant matters which can survive only in the realm of the private. [...]

[T]he term 'public' signifies the world itself, in so far as it is common to all of us and distinguished from our privately owned place in it. This world, however, is not identical with the earth or with nature, as the limited space for the movement of men and the general condition of organic life. It is related, rather, to the human artefact, the fabrication of human hands, as well as to affairs which go on among those who inhabit the man-made world together. To live together in the world means essentially that a world of things is between those who have it in common, as a table is located between those who sit around it; the world, like every in-between, relates and separates men at the same time.

The public realm, as the common world, gathers us together and yet prevents our falling over each other, so to speak. What makes mass society so difficult to bear is not the number of people involved, or at least not primarily, but the fact that the world between them has lost its power to gather them together, to relate and to separate them. The weirdness of this situation resembles a spiritualistic séance where a number of people gathered around a table might suddenly, through some magic trick, see the table vanish from their midst, so that two persons sitting opposite each other were no longer separated but also would be entirely unrelated to each other by anything tangible. [...]

Hannah Arendt, extract from 'The public realm: the common', *The Human Condition* (Chicago: University of Chicago Press, 1958) 50–53.

Guy Debord
Preliminary Problems in Constructing a Situation//1958

The construction of situations begins beyond the ruins of the modern spectacle. It is easy to see how much the very principle of the spectacle - non-intervention - is linked to the alienation of the old world. Conversely, the most pertinent revolutionary experiments in culture have sought to break the spectators' psychological identification with the hero so as to draw them into activity. [...] The situation is thus designed to be lived by its constructors. The role played by a passive or merely bit-part playing 'public' must constantly diminish, while that played by those who cannot be called actors, but rather, in a new sense of the term, 'livers', must steadily increase.

Report on the Construction of Situations

Our conception of a 'constructed situation' is not limited to an integrated use of artistic means to create an ambiance, however great the force or spatio-temporal extent of that ambiance might be. A situation is also an integrated ensemble of behaviour in time. It is composed of actions contained in a transitory décor. These actions are the product of the décor and of themselves, and they in their turn produce other décors and other actions.

How can these forces be oriented? We are not going to limit ourselves to merely empirical experimentation with environments in quest of mechanistically provoked surprises. The really experimental direction of situationist activity consists in setting up, on the basis of more or less clearly recognized desires, a temporary field of activity favourable to these desires. This alone can lead to the further clarification of these simple basic desires, and to the confused emergence of new desires whose material roots will be precisely the new reality engendered by situationist constructions.

We must thus envisage a sort of situationist-oriented psychoanalysis in which, in contrast to the goals pursued by the various currents stemming from Freudianism, each of the participants in this adventure would discover desires for specific ambiances in order to fulfil them. Each person must seek what he loves, what attracts him. (And here again, in contrast to certain endeavours of modern writing – Michel Leiris, for example – what is important to us is neither our individual psychological structures nor the explanation of their formation, but their possible application in the construction of situations.) Through this method one can tabulate elements out of which situations can be constructed, along with projects to dynamize these elements.

This kind of research is meaningful only for individuals working practically toward a construction of situations. Such people are pre-situationists (either spontaneously or in a conscious and organized manner) in as much as they have sensed the objective need for this sort of construction through having recognized the present cultural emptiness and having participated in recent expressions of experimental awareness. They are close to each other because they share the same specialization and have taken part in the same historical avant-garde of that specialization. It is thus likely that they will share a number of situationist themes and desires, which will increasingly diversify once they are brought into a phase of real activity.

A constructed situation must be collectively prepared and developed. It would seem, however, that, at least during the initial period of rough experiments, a situation requires one individual to play a sort of 'director' role. If we imagine a particular situation project in which, for example, a research team has arranged an emotionally moving gathering of a few people for an evening, we would no doubt have to distinguish: a director or producer responsible for coordinating the basic elements necessary for the construction of the décor and for working out certain interventions in the events (alternatively, several people could work out their own interventions while being more or less unaware of each other's plans); the direct agents living the situation, who have taken part in creating the collective project and worked on the practical composition of the ambiance; and finally, a few passive spectators who have not participated in the constructive work, who should be forced into action.

This relation between the director and the 'livers' of the situation must naturally never become a permanent specialization. It's only a matter of a temporary subordination of a team of situationists to the person responsible for a particular project. These perspectives, or the provisional terminology describing them, should not be taken to mean that we are talking about some continuation of theatre. Pirandello and Brecht have already revealed the destruction of the theatrical spectacle and pointed out a few of the requirements for going beyond it. It could be said that the construction of situations will replace theatre in the same sense that the real construction of life has increasingly tended to replace religion. [...]

In our time functionalism (an inevitable expression of technological advance) is attempting entirely to eliminate play. The partisans of 'industrial design' complain that their projects are spoiled by people's playful tendencies. At the same time, industrial commerce crudely exploits these tendencies by diverting them to a demand for constant superficial renovation of utilitarian products. We obviously have no interest in encouraging the continuous artistic renovation of refrigerator designs. But a moralizing functionalism is incapable of

getting to the heart of the problem. The only progressive way out is to liberate the tendency toward play elsewhere, and on a larger scale. Short of this, all the naïve indignation of the theorists of industrial design will not change the basic fact that the private automobile, for example, is primarily an idiotic toy and only secondarily a means of transportation. As opposed to all the regressive forms of play – which are regressions to its infantile stage and are invariably linked to reactionary politics – it is necessary to promote the experimental forms of a game of revolution. […]

Guy Debord, extracts from 'Preliminary Problems in Constructing a Situation', *Internationale Situationiste*, no. 1 (Paris, June 1958); trans. Ken Knabb, in idem, ed., *Situationist International Anthology* (Berkeley: Bureau of Public Secrets, 1982; revised edition 2006).

Situationist International
The Theory of Moments and the Construction of Situations//1960

At the level of everyday life this intervention would be translated as a better allocation of its elements and its instants as 'moments', so as to intensify the vital productivity of everydayness, its capacity for communication, for information, and also and above all for pleasure in natural and social life. The theory of moments, then, is not situated outside of everydayness, but would be articulated along with it by uniting with critique to introduce therein what its richness lacks. It would thus tend, at the core of the everyday and in a particular new form of pleasure linked to the totality, to go beyond the old oppositions of lightness and heaviness, of seriousness and the lack of seriousness.
– Henri Lefebvre, *La Somme et la reste*

In the programatic thinking outlined above by Henri Lefebvre the problems of the creation of everyday life are directly affected by the theory of moments, which defines as 'modalities of presence' a 'plurality of relatively privileged moments'. What relation do these 'moments' have to the situations the Situationist International has set out to define and construct? What use can be made of the relationship between these concepts to realize the common revendications which are now emerging?

 The situation, as a created, organized moment (Lefebvre expresses this desire: 'The free act defined as the capacity … to change a "moment" in

metamorphosis, and perhaps to create one') includes perishable instants – ephemeral and unique. It is a totalizing organization controlling (favouring) such chance instants. From the perspective of the Lefebvrian moment, the constructed situation, then, is pitted against the instant, but at an *intermediary stage* between instant and moment. And so, while repeatable to a certain degree (as direction, 'way'), it is not in itself repeatable as the 'moment'. Like the moment, the situation 'can be extended in time or be condensed'. But it seeks to found itself on the objectivity of artistic production. Such artistic production breaks radically with durable works. It is inseparable from its immediate consumption as a use value essentially foreign to conservation as a commodity.

The difficulty for Henri Lefebvre is to draw up a *list* of his moments (why cite ten of these and not fifteen, or twenty-five, etc.?). The difficulty with the 'situationist moment' is, on the contrary, to mark its precise end, its transformation into a different term within a series of situations – the latter perhaps constituting a Lefebvrian moment – or even into dead time.

In effect, the 'moment' posited as a rediscoverable general category involves, in the long term, the establishment of an increasingly complete list. Less differentiated, the situation lends itself to an infinite number of combinations. A situation, and its cut-off point, cannot be so precisely defined. What will characterize the situation is its very praxis, its intentional formation.

For example, Lefebvre speaks of the 'moment of love'. From the point of view of the creation of moments, from the situationist point of view, one must envisage the moment of a particular love, of the love of a particular person. Which means: of a particular person in particular circumstances.

The maximum 'constructed moment' is the *series of situations* attached to a single theme – that love for a particular person – (a 'situationist theme' is a *realized* desire). In comparison to Henri Lefebvre's moment, this one is particularized and unrepeatable; yet greatly extended and relatively durable in comparison to the unique-ephemeral instant.

In analysing the 'moment' Lefebvre has revealed many of the fundamental conditions of the new field of action across which a revolutionary culture may now proceed; as when he remarks that the moment tends towards the absolute and departs from it. The moment, like the situation, is *simultaneously* proclamation of the absolute and awareness of passing through it. It is, in actual fact, on the path towards a unity of the structural and the conjunctural; and the project for a constructed situation could also be defined as an attempt at structuring the conjunction.

The 'moment' is mainly temporal, forming part of a zone of temporality, not pure but dominant. Articulated in relation to a given place, the situation is completely spatio-temporal (cf. Asger Jorn on the space-time of a life; André

Franklin on the planification of individual existence). Moments constructed into 'situations' might be thought of as moments of rupture, of acceleration, *revolutions in individual everyday life.* On a more extended – more social – spatial ievel, an urbanism which almost exactly corresponds to Lefebvre's moments, and to his idea of choosing these and leaving them behind at will, has been proposed in the 'states-of-the-soul quarters' (cf. Gilles Ivain, 'Formulary for a New Urbanism', *Internationale Situationniste*, no. 1), disalienation being the explicit goal behind the arrangement of the 'Sinister Quarter'.

Lastly, the problem of the *encounter* in the theory of moments, and of an operational formulation of the construction of situations, suggests the following question: What admixture, what interactions ought to occur between the flux (and resurgence) of the 'natural moment', in Henri Lefebvre's sense, and certain artificially *constructed* elements, introduced into this flux, perturbing it, quantitatively and, above all, qualitatively?

Situationist International (unsigned), 'The Theory of Moments and Construction of Situations', *Internationale Situationiste*, no. 4 (Paris, June 1960) 10–11; trans. in Libero Andreotti and Xavier Costa, eds, *Theory of the Dérive and other Situationist Writings on the City* (Barcelona: Museu d'Art Contemporani de Barcelona, 1997) 100–101.

Allan Kaprow
Happenings in the New York Scene//1961

If you haven't been to the Happenings, let me give you a kaleidoscope sampling of some of their great moments.

Everybody is crowded into a downtown loft, milling about, like at an opening. It's hot. There are lots of big cartons sitting all over the place. One by one they start to move, sliding and careening drunkenly in every direction, lunging into one another, accompanied by loud breathing sounds over four loudspeakers. Now it's winter and cold and it's dark, and all around little blue lights go on and off at their own speed while three large brown gunny sack [burlap/hessian] constructions drag an enormous pile of ice and stones over bumps, losing most of it, and blankets keep falling over everything from the ceiling. A hundred iron barrels and gallon wine jugs hanging on ropes swing back and forth, crashing like church bells, spewing glass all over. Suddenly, mushy shapes pop up from the floor and painters slash at curtains dripping with action.

A wall of trees tied with coloured rags advances on the crowd, scattering everybody, forcing them to leave. There are muslin telephone booths for all with a record player or microphone that tunes you in to everybody else. Coughing, you breathe in noxious fumes, or the smell of hospitals and lemon juice. A nude girl runs after the racing pool of a searchlight, throwing spinach greens into it. Slides and movies, projected over walls and people, depict hamburgers: big ones, huge ones, red ones, skinny ones, flat ones, etc. You come in as a spectator and maybe you discover you're caught in it after all, as you push things around like so much furniture. Words rumble past, whispering, deedaaa, baroom, love me, love me; shadows joggle on screens; power saws and lawn mowers screech just like the IRT [subway] at Union Square. Tin cans rattle and you stand up to see or change your seat or answer questions shouted at you by shoeshine boys and old ladies. Long silences when nothing happens, and you're sore because you paid $1.50 contribution, when bang! there you are facing yourself in a mirror jammed at you. Listen. A cough from the alley. You giggle because you're afraid, suffer claustrophobia, talk to someone nonchalantly, but all the time you're *there*, getting into the act … Electric fans start, gently wafting breezes of New-Car smell past your nose as leaves bury piles of a whining, burping, foul, pinky mess.

So much for the flavour. Now I would like to describe the nature of Happenings in a different manner, more analytically – their purpose and place in art.

Although widespread opinion has been expressed about these events, usually by those who have never seen them, they are actually little known beyond a small group of interested persons. This small following is aware of several different kinds of Happenings. There are the sophisticated, witty works put on by the theatre people; the very sparsely abstract, almost Zen-like rituals given by another group (mostly writers and musicians); and those in which I am most involved: crude, lyrical, and very spontaneous. This kind grew out of the advanced American painting of the last decade, and those of us involved were all painters (or still are). There is some beneficial exchange among the three, however. [...]

Happenings are events that, put simply, happen. Though the best of them have a decided impact – that is, we feel, 'here is something important' – they appear to go nowhere and do not make any particular literary point. In contrast to the arts of the past, they have no structured beginning, middle or end. Their form is open-ended and fluid; nothing obvious is sought and therefore nothing is won, except the certainty of a number of occurrences to which we are more than normally attentive. They exist for a single performance, or only a few, and are gone forever as new ones take their place.

These events are essentially theatre pieces, however unconventional. That they are still largely rejected by devotees of the theatre may be due to their uncommon power and primitive energy, and to their derivation from the rites of

American Action Painting. But by widening the concept 'theatre' to include them (like widening the concept 'painting' to include collage), we can see them against this basic background and understand them better.

To my way of thinking, Happenings possess some crucial qualities that distinguish them from the usual theatrical works, even the experimental ones of today. First, there is the *context*, the place of conception and enactment. The most intense and essential Happenings have been spawned in old lofts, basements, vacant stores, natural surroundings and the street, where very small audiences, or groups of visitors, are commingled in some way with the event, flowing in and among its parts. There is thus no separation of audience and play (as there is even in round or pit theatres); the elevated picture-window view of most playhouses is gone, as are the expectations of curtain openings and *tableaux vivants* and curtain closings …

The sheer rawness of the out-of-doors or the closeness of dingy city quarters in which the radical Happenings flourish is more appropriate, I believe, in temperament and un-artiness, to the materials and directness of these works. The place where anything grows up (a certain kind of art in this case), that is, its 'habitat', gives to it not only a space, a set of relationships to the various things around it, and a range of values, but an overall atmosphere as well, which penetrates it and whoever experiences it. Habitats have always had this effect, but it is especially important now, when our advanced art approaches a fragile but marvellous life, one that maintains itself by a mere thread, melting the surroundings, the artist, the work and everyone who comes to it into an elusive, changeable configuration. […]

Allan Kaprow, extract from 'Happenings in the New York Scene', *ARTnews*, vol. 60, no. 3 (1961) 36–9; 58–62; reprinted in Allan Kaprow, *Essays on the Blurring of Art and Life* (Berkeley and Los Angeles: University of California Press, 2003) 15–18.

Július Koller
Anti-Happening (Subjective Objectivity System)//1965

Subjective cultural activity creates a new objective cultural reality through a cultural demarcation in the whole spatio-temporal and psycho-physical reality, as well as through the cultural anti-artistic grasp of reality. Subjectively-objective civilian culture represents a programme of cultural synthesis of art and life; it develops from directing artistic actions towards a cultural shaping of the subject, consciousness, way of life, environment, surroundings, and the real world. Cultural demarcation becomes part of the cultural context through textual information (announcement).

Július Koller, *Anti-Happening (Subjective Objectivity System)*, manifesto (Bratislava, 1965). Translation courtesy The Július Koller Society, 2009.

Georg Schöllhammer
On Július Koller//2003

[...] In Koller's manifesto, a performative act of designation, a conscious act of subjectification through the designation, an act of cultural demarcation at the level of production, so to speak, contravenes the myth of the regaining of innateness in dramatic self-performance, of the foundation of identity in a liberating psychodramatic act, as imagined by the protagonists of Happenings developed from Fluxus. Yet it was at the level not only of aesthetic acts, but of the analysis of the status of the art work as object that Koller's stance contradicted the mental worlds that were common at that time. Contrary to Duchamp's transposition of any arbitrary object into the art sphere through simple displacement, Koller's strategy consists of using real objects, the real world, everyday life as a given programme for an automatically aesthetic and endless operation – an aesthetic displacement intended to put an end to aesthetics, but which enables a general aestheticization of the world at the same time – because, in fact, potentially every object could enter into this virtual performance.

With a formulation that one could also regard as determinative for the Situationist International, Koller suggests that the textual existence of a poetic

impulse cannot develop the full potential of its radical, anti-hegemonic power. Instead, this power, this potential, can only come into full effect in the realm of concrete action, in an act of designation. Or indeed in a cultural strategy that seeks inclusion in a cultural system, from which the happening seeks its vanishing point, reverses it and represents it as one that is purely definitionally textual, which could be transformed into a system of designation. Koller makes this distinction and transforms the anthropological process into a significatory process: the Anti-Happening.

The Anti-Happening demonstrates conceptual acts or objects. It presents them and thus creates situations – cultural situations. This act of demonstration designates a situation as a cultural space and makes use of a non-fixing concept of the formation of identity. The performative act that Koller poses with his demonstration operations thinks about forms of the functional or emotional utilization and occupation of a place or a situation and makes the exquisite malleability and the rigidness of spatial conventions visible to viewers at the same time. [...]

Georg Schöllhammer, extract from 'Engagement instead of Arrangement: Július Koller's Erratic Work on the Re-conception of Aesthetic Space', in Július Koller, *Univerzálne Futurologické Operácie* (Cologne: Kölnicher Kunstverein/Verlag der Buchhandlung Walther König, 2003).

Michel de Certeau
'Spaces' and 'Places'//1980

At the outset, I shall make a distinction between space (*espace*) and place (*lieu*) that delimits a field. A place (*lieu*) is the order (of whatever kind) in accord with which elements are distributed in relationships of coexistence. It thus excludes the possibility of two things being in the same location (*place*). The law of the 'proper' rules in the place: the elements taken into consideration are *beside* one another, each situated in its own 'proper' and distinct location, a location it defines. A place is thus an instantaneous configuration of positions. It implies an indication of stability.

A *space* exists when one takes into consideration vectors of direction, velocities and time variables. Thus space is composed of intersections of mobile elements. It is in a sense actuated by the ensemble of movements deployed within it. Space occurs as the effect produced by the operations that orient it, situate it, temporalize it, and make it function in a polyvalent unity of conflictual

programmes or contractual proximities. On this view, in relation to place, space is like the word when it is spoken, that is, when it is caught in the ambiguity of an actualization, transformed into a term dependent upon many different conventions, situated as the act of a present (or of a time), and modified by the transformations caused by successive contexts. In contradistinction to the place, it has thus none of the univocity or stability of a 'proper'.

In short, *space is a practiced place.* Thus the street geometrically defined by urban planning is transformed into a space by walkers. In the same way, an act of reading is the space produced by the practice of a particular place: a written text, i.e. a place constituted by a system of signs.

Merleau-Ponty distinguished a 'geometrical' space ('a homogeneous and isotropic spatiality', analogous to our 'place') from another 'spatiality' which he called an 'anthropological space'. This distinction depended on a distinct problematic, which sought to distinguish from 'geometrical' univocity the experience of an 'outside' given in the form of space, and for which 'space is existential' and 'existence is spatial'. This experience is a relation to the world; in dreams and in perception, and because it probably precedes their differentiation, it expresses 'the same essential structure of our being as a being situated in relationship to a milieu' – being situated by a desire, indissociable from a 'direction of existence' and implanted in the space of a landscape. From this point of view 'there are as many spaces as there are distinct spatial experiences'.[1] The perspective is determined by a 'phenomenology' of existing in the world.

In our examination of the daily practices that articulate that experience, the opposition between 'place' and 'space' will rather refer to two sorts of determinations in stories: the first, a determination through objects that are ultimately reducible to the *being-there* of something dead, the law of a 'place' (from the pebble to the cadaver, an inert body always seems, in the West, to found a place and give it the appearance of a tomb); the second, a determination through *operations* which, when they are attributed to a stone, tree or human being, specify 'spaces' by the actions of historical *subjects* (a movement always seems to condition the production of a space and to associate it with a history). Between these two determinations, there are passages back and forth, such as the putting to death (or putting into a landscape) of heroes who transgress frontiers and who, guilty of an offence against the law of the place, best provide its restoration with their tombs; or again, on the contrary, the awakening of inert objects (a table, a forest, a person that plays a certain role in the environment) which, emerging from their stability, transform the place where they lay motionless into the foreignness of their own space.

Stories thus carry out a labour that constantly transforms places into spaces or spaces into places. They also organize the play of changing relationships

between places and spaces. The forms of this play are numberless, fanning out in a spectrum reaching from the putting in place of an immobile and stone-like order (in it, nothing moves except discourse itself, which, like a camera panning over a scene, moves over the whole panorama), to the accelerated succession of actions that multiply spaces (as in the detective novel or certain folktales, though this spatializing frenzy nevertheless remains circumscribed by the textual place). It would be possible to construct a typology of all these stories in terms of identification of places and actualization of spaces. But in order to discern in them the modes in which these distinct operations are combined, we need criteria and analytical categories – a necessity that leads us back to travel stories of the most elementary kind. [...]

1 [footnote 7 in source] Maurice Merleau-Ponty, *Phénoménologie de la perception* (Paris: Gallimard, 1976) 324–44.

Michel de Certeau, extract from *L'Invention du quotidien. vol. 1. Arts de faire* (Paris: Union Générale d'Éditions, 1980); trans. Steven Rendall, *The Practice of Everyday Life* (Berkeley and Los Angeles: University of California Press, 1984) 117–18.

Adrian Piper
Concretized Ideas I've Been Working Around//1971

[...] Preserving the impact and uncategorized nature of the confrontation. Not overly defining myself to viewers as artwork by performing any unusual or theatrical *actions* of any kind. These actions tend to define the situation in terms of the pre-established categories of 'guerrilla theatre', 'event', 'happening', 'streetwork', etc., making disorientation and catalysis more difficult. For example, *Catalysis III*, in which I painted a set of clothing with sticky white paint with a sign attached saying 'WET PAINT', then went shopping at Macy's for some gloves and sunglasses; *Catalysis V*, in which I recorded loud belches made at five-minute intervals, then concealed the tape recorder on myself and replayed it at full volume while reading, doing research, and taking out some books and records at Donnell Library. For the same reason I don't announce most of these works, as this immediately produces an audience-versus-performer separation and has the same effect psychologically as a stage surrounded by rows of chairs has physically.

Art contexts per se (galleries, museums, performances, situations) are becoming increasingly unworkable for me; they are being overwhelmed and infiltrated by bits and pieces of other disintegrating structures: political, social psychological, economic. They preserve the illusion of an identifiable, isolatable situation, much as discrete forms do, and thus a prestandardized set of responses. Because of their established functional identities, they *prepare* the viewer to be catalyzed, thus making actual catalysis impossible (rather than its more comfortable illusion, which consists of filling in the particulars of an aesthetic experience, the general outlines of which are predetermined). Alternative contexts I've been using include subways, buses, Macy's, Union Square [...]

Eliminating as many decision-making steps, procedures and controls as possible. This has a necessary psychological function for me in that it decreases or eliminates the separation between original conception and the final form of an idea; the immediacy of conception is retained in the process/product as much as possible. [...]

Adrian Piper, extract from 'Concretized Ideas I've Been working Around' (January 1971), in *Out of Order, Out of Sight. Volume II: Selected Writings in Art Criticism 1967–1992* (Cambridge, Massachusetts: The MIT Press, 1996) 43–5.

Cildo Meireles
Notes on *Insertions into Ideological Circuits*//1994

[...] Between 1968 and 1970 I knew I was beginning to touch on something interesting. I was no longer working with metaphorical representations of situations but with the real situation itself. Furthermore, the kind of work I was making had what could be described as a 'volatilized' form. It no longer referred to the cult of the isolated object; it existed in terms of what it could spark off in the body of society. This was what one had in one's head at that time: the necessity of working with the idea of the public.

Today there is the danger of making work knowing exactly who will be interested in it. The idea of the public, which is a broad, generous notion, has been replaced, through a process of deformation, by the idea of the consumer, that section of the public which has acquisitive power. The *Insertions into Ideological Circuits* arose from the need to create a system for the circulation and exchange of information that did not depend on any kind of centralized

control. This would be a form of language, a system essentially opposed to the media of press, radio and television – typical examples of media that actually reach an enormous audience but in the circulation systems of which there is always a degree of control and channelling of the information inserted. In other words, in those media the 'insertion' is performed by an elite that has access to the levels on which the system is developed: technological sophistication involving huge amounts of money and/or power.

The *Insertions into Ideological Circuits* took shape as two projects: the *Coca-Cola Project* and the *Cédula Project* with bank notes.[1] The work began with a text I wrote in April 1970 which sets out this position:

1 In society there are certain mechanisms for circulation (circuits).
2 These circuits clearly embody the ideology of the producer, but at the same time they are passive when they receive insertions into their circuits.

The *Insertions into Ideological Circuits* also arose from the recognition of two fairly common practices: chain letters (letters you may receive, copy and send on to other people) and messages in bottles, flung into the sea by victims of shipwrecks. Implicit in these practices is the notion of a circulating medium, a notion crystallized most clearly in the case of paper money and, metaphorically, in returnable containers (soft drink bottles, for example). The important thing in the project was the introduction of the concept of 'circuit', isolating it and fixing it. It is this concept that determines the dialectical content of the work, while interfering with each and every effort contained within the very essence of the process (the medium). In other words, the container always carries with it an ideology … An 'insertion' into this circuit is always a form of counter-information.

An insertion capitalizes on the sophistication of the medium in order to achieve an increase in equality of access to mass communication. Also, it brings about a transformation of the original ideological propaganda inherent in the circuit – whether produced by industry or the state. The effect of this ideological circuit is like an anaestheticization of public consciousness. The process of insertion thus contrasts awareness (a result of the insertion) with anaesthesia (the property of the existing circuit). Awareness is seen as a function of art and anaesthesia as a product of the alienation inherent in industrialized capitalism.

1 *Cédula* [lit. 'schedule'] a generic term for diverse legal documents as well as bank notes.

Cildo Meireles, extract from 'Notes on Insertions into Ideological Circuits, 1970–75' (1994), in *Cildo Meireles*, ed. Nuria Enguita (Valencia: IVAM Centre Julio González, 1994).

Constant Nieuwenhuys
New Babylon//1974

[...] They wander through the sectors of New Babylon seeking new experiences, as yet unknown ambiances. Without the passivity of tourists, but fully aware of the power they have to act upon the world, to transform it, recreate it. They dispose of a whole arsenal of technical implements for doing this, thanks to which they can make the desired changes without delay. Just like the painter, who with a mere handful of colours creates an infinite variety of forms, contrasts and styles, the New Babylonians can endlessly vary their environment, renew and vary it by using their technical implements. This comparison reveals a fundamental difference between the two ways of creating. The painter is a solitary creator who is only confronted by another person's reactions once the creative act is over. Among the New Babylonians, on the other hand, the creative act is also a social act: as a direct intervention in the social world, it elicits an immediate response. The artist's individual creation seems, to other's eyes, to escape all constraint and ripen in isolation. And it is only much later, when the work acquires an undeniable reality, that it will have to confront society. At any given moment in his creative activity, the New Babylonian is himself in direct contact with his peers. Each one of his acts is public, each one acts on a milieu which is also that of the others and elicits spontaneous reactions. All action, then, loses its individual character. On the other hand, each reaction can provoke others in turn. In this way interventions form chain reactions that only come to an end when a situation that has become critical 'explodes' and is transformed into another situation. The process escapes one person's control, but it matters little knowing who set it off and by whom it will be inflected in turn. In this sense the critical moment (the climax) is an authentic collective creation. The yardstick, the space-time framework, of the New Babylonian world is the rhythm in which each moment succeeds the last. [...]

Constant Nieuwenhuys, extract from *New Babylon* (The Hague: Haags Gemeentemuseum, 1974).

Krzysztof Wodiczko
Strategies of Public Address:
Which Media, Which Publics?//1987

Before I attempt to characterize briefly the strategies of public art today in light of public practices of the avant-garde of the past, I must express my critical detachment from what is generally called 'art in public places'. This bureaucratic-aesthetic form of public legitimation may allude to the idea of public art as a social practice but in fact has very little to do with it. Such a 'movement' wants first to protect the autonomy of art (bureaucratic aestheticism), isolating artistic practice from critical public issues, and then to impose this purified practice on the public domain (bureaucratic exhibitionism) as proof of its accountability. Such work functions at best as liberal urban decoration.

To believe that the city can be affected by open-air public art galleries or enriched by outdoor curatorial adventures (through state and corporate purchases, lendings and displays) is to commit an ultimate philosophical and political error. For, since the eighteenth century at least, the city has operated as a grand aesthetic curatorial project, a monstrous public art gallery for massive exhibitions, permanent and temporary, of environmental architectural 'installations'; monumental 'sculpture gardens'; official and unofficial murals and graffiti; gigantic 'media shows'; street, underground and interior 'performances'; spectacular social and political 'happenings'; state and real-estate 'land art projects'; economic events, actions and evictions (the newest form of exhibited art), etc. To attempt to 'enrich' this powerful, dynamic art gallery (the city public domain) with 'artistic art' collections or commissions – all in the public's name – is to decorate the city with a pseudo-creativity irrelevant to urban space and experience alike; it is also to contaminate this space and experience with the most pretentious and patronizing bureaucratic-aesthetic environmental pollution. Such beautification is uglification; such humanization provokes alienation; and the noble idea of public access is likely be received as private excess.

The aim of critical public art is neither a happy self-exhibition nor a passive collaboration with the grand gallery of the city, its ideological theatre and architectural-social system. Rather, it is an engagement in strategic challenges to the city structures and mediums that mediate our everyday perception of the world: an engagement through aesthetic-critical interruptions, infiltrations and appropriations that question the symbolic, psycho-political and economic operations of the city.

To further clarify my position, I must also express my critical detachment from the apocalyptic visions of urban design and environment suggested by Jean

Baudrillard in terms of 'cyberblitz' and 'hyperreality': however brilliant his metaphorical-critical constructs may be, they cannot account for the complexity of symbolic, social and economic life in the contemporary public domain.

For Baudrillard the Bauhaus proposed 'the dissociation of every complex subject-object relation into simple, analytic, rational elements that can be recombined in functional ensembles and which then take on status as the environment'.[1] Today, however, we are beyond even this: '[W]hen the still almost artisanal functionalism of the Bauhaus is surpassed in the cybernetic and mathematical design of the environment ... we are beyond the object and its function ... Nothing retains the place of the critical, regressive-transgressive discourse of Dada and of Surrealism.' And yet this total vision omits the powerful symbolic articulation of two economically related but distinct zones in the contemporary city: state architecture and real-estate architecture. The two work in tandem: state architecture appears solid, symbolically full, rooted in sacred historic ground, while real-estate architecture develops freely, appropriating, destroying, redeveloping, etc. A monstrous evicting agency, this architecture imposes the bodies of the homeless onto the 'bodies' – the structures and sculptures – of state architecture, especially in those ideological graveyards of heroic 'history' usually located in downtown areas.

Now in the current attempts to revitalize – to gentrify – the downtowns, cities legally protect these graveyards as meaningful ideological theatre, not as places of 'cyberblitz' where 'the end of signification' has been reached. In this regard Marc Guillaume is only partially correct when he states that the contemporary downtown is just a 'signal system' for touristic consumption:

> The obsession with patrimony, the conservation of a few scattered centres, some monuments and museographic remains, are just such attempts [to compensate for the loss of social representation in urban architecture]. Nonetheless, they are all in vain. These efforts do not make a memory; in fact they have nothing to do with the subtle art of memory. What remains are merely the stereotypical signs of the city, a global signal system consumed by tourists.[2]

And yet it is still possible to establish a critical dialogue with state and real-estate architecture or even, as described by Guillaume, with monuments to pseudomemory. Not only is it still possible, it is urgently needed – that is, if we are to continue the unfinished business of the situationist urban project:

> People will still be obliged for a long time to accept the era of reified cities. But the attitude with which they accept it can be changed immediately. We must spread skepticism toward those bleak, brightly coloured kindergartens, the new

dormitory cities of both East and West. Only a mass awakening will pose the question of a conscious construction of the urban milieu ...

The basic practice of the theory of unitary urbanism will be the transcription of the whole theoretical lie of urbanism, détourned [diverted, appropriated] for the purpose of de-alienation: we constantly have to defend ourselves from the poetry of the bards of conditioning – to jam their messages, to turn their songs inside out.[3]

Of course, the situationist project of intervention now requires critical evaluation; some of its methods and aims seem too utopian, totalitarian, naïve or full of avant-garde aestheticism to be accepted today. In this respect we can learn much from past and present avant-garde practices, which I will schematize below in terms of their relationships to the cultural system of art and its institutions; the larger system of culture and its institutions; the system of 'everyday life'; and mass or public spectacle and the city.

Historic Avant-Garde (1910–1940s): Futurism, Dada, Suprematism, Constructivism, Surrealism. Artistic interventions against art and its institutions; critical and self-critical manifestations of the rejection of its cultural system. Discovery of direct public address: e.g. futurist synthetic theatre, evenings, actions and manifestos. Discovery of media art; discovery of critical public art as contestation. Roots of situationist aestheticism (rejected by new avant-garde as well as by engaged and neo avant-gardes).

Socially Engaged Avant-Garde (1920–1930s): Bertolt Brecht, George Grosz, Vladimir Tatlin, El Lissitzky, Aleksandr Vertov, Alexsandr Bogdanov, Varvara Stepanova, Lynbov Popova, Galina and Olga Chichagova, John Heartfield, etc. Critical-affirmative action on culture and its institutions; critical transformation of the institutions of the cultural system of art. Engagement in mass publications, design, education systems, film (Kino-Pravda, Kino-Oko), opera, radio, theatre ('epic' form, 'estrangement' technique), agit-prop, proletcult, spectacles, Novy Lef (Sergei Tretiakov's affirmative intervention). Roots of present affirmative interest in media cultural programmes and public domain; also roots of situationist interruption and *détournement.*

Critical Neo-Avant-Garde (1960–1970s): Daniel Buren, support-surface artists, Hans Haacke, etc. (Missing reference [sic]: British Pop art.) Critical-affirmative action on art and its institutions; critical and self-critical manipulation of its cultural system. Artistic attack on art as myth of bourgeois culture; critical exposure of structural ideological links between institutions of bourgeois art and culture – politics, ethics, philosophy, etc. Critical infiltration of museums as official public spectacle, but no significant attempts to enter mass spectacle, popular culture, public design.

Situationist Cultural Avant-Garde as Revolutionary Force (1960–70s): Henri Lefebvre, Situationist International, Guy Debord, etc. (Missing references [sic]: Fluxus, Punk rock). Cultural revolutionary intervention in everyday life and its institutions (environment, popular media, etc.); critical and self-critical abandonment of art as cultural system and of avant-garde art as specialized procedure. Public intervention against spectacle; tendency toward alternative spectacle. Creation of situations 'concretely and deliberately constructed by the collective organization of a unitary ambience and game of events'; manipulation of popular culture against mass culture. Organization of *dérive* (drift), urban wanderings to contest modern structures, dominant architecture, city planning (surrealist tactics). Influence of postmarxist cultural studies and sociology; the city as 'rediscovered and magnified' festival to overcome conflict between everyday life and festivity. Attack on passive reception of the city: 'Our first task is to enable people to stop identifying with their surroundings and with model patterns of behaviour'.

Present Critical Public Art: New Avant-Garde as 'Intelligence': Barbara Kruger, Dara Birnbaum, Alfredo Jaar, Dennis Adams, Dan Graham, etc; also Public Art Fund (New York), Public Access (Toronto), Artangel Trust (London), etc. Critical-affirmative action on everyday life and its institutions (education, design, environment, spectacle and mass media, etc.), critical transformation of culture from within. Critical collaboration with institutions of mass and public media, design and education in order to raise consciousness (or critical unconscious) regarding urban experience: to win time and space in information, advertising, billboards, lightboards, subways, public monuments and buildings, television cable and public channels, etc. Address to passive viewer, alienated city-dweller. Continuous influence of cultural studies enhanced by feminist critique of representation.

1 Jean Baudrillard, 'Design and Environment or How Political Economy Escalates into Cyberblitz', in *For a Critique of the Political Economy of the Sign* (St Louis: Telos Press, 1981) 185–203.
2 Marc Guillaume, in *Zone*, 1/2 (1986) 439.
3 See *Situationist International Anthology*, ed. Ken Knabb (Berkeley: Bureau of Public Secrets, 1981).

Krzysztof Wodiczko, 'Strategies of Public Address: Which Media, Which Publics?', in Hal Foster, ed., *Discussions in Contemporary Culture*, no. 1. (New York: Dia Foundation, 1987) 41–5.

Douglas Crimp
Redefining Site Specificity//1993

The site was an old warehouse on the Upper West Side in Manhattan used by the Leo Castelli Gallery for storage; the occasion, an exhibition organized by minimal sculptor Robert Morris; the moment, December 1968. There, strewn upon the cement floor, affixed to or leaning against the brick walls, were objects that defied our every expectation regarding the form of the work of art and the manner of its exhibition. [...]

Of the things in that warehouse, certainly none was more defiant of our sense of the aesthetic object than Richard Serra's *Splashing*. Along the juncture where wall met floor, Serra had tossed molten lead and allowed it to harden in place. The result was not really an object at all; it had no definable shape or mass; it created no legible image. We could, of course, say that it achieved the negation of categories that Donald Judd had, some years earlier, ascribed to 'the best new work': 'neither painting nor sculpture'. And we could see that by effacing the line where the wall rose up perpendicular to the floor, Serra was obscuring a marker for our orientation in interior space, claiming that space as the ground of a different kind of perceptual experience. Our difficulty with *Splashing* was in trying to imagine its very possibility of continued existence in the world of art objects. There it was, attached to the structure of that old warehouse on the Upper West Side, condemned to be abandoned there forever or scraped off and destroyed. For to remove the work meant certainly to destroy it.

'To remove the work is to destroy the work.' It is with this assertion that Richard Serra sought to shift the terms of debate in a public hearing convened to determine the fate of *Tilted Arc*.[1] Serra's sculpture had been commissioned by the General Services Administration (GSA) Art-in-Architecture Program and permanently installed in the plaza of Jacob K. Javits Federal Building in Lower Manhattan during the summer of 1981. In 1985, a newly appointed GSA regional administrator presumed to reconsider its presence there, to ask whether it might be 'relocated' elsewhere. In testimony after testimony at that hearing, artists, museum officials and others pleaded the case for site specificity that Serra's assertion implied.

The work was conceived for the site, built on the site, had become an integral part of the site, altered the very nature of the site. Remove it, and the work would simply cease to exist. But, for all its passion and eloquence, the testimony failed to convince the adversaries of *Tilted Arc*. To them the work was in conflict with its site, disrupted the normal views and social functions of the plaza, and,

indeed, would be far more pleasant to contemplate in a landscape setting. There, presumably, its size would be less overwhelming to its surroundings, its rust-coloured steel surface more harmonious with the colours of nature.

The larger public's incomprehension in the face of Serra's assertion of site specificity is the incomprehension of the radical prerogatives of a historic moment in art practice. 'To remove the work is to destroy the work' was made self-evident to anyone who had seen *Splashing's* literalization of the assertion, and it is that which provided the background of *Tilted Arc* for its defenders. But they could not be expected to explain, within the short time of their testimonies, a complex history that had been deliberately suppressed. The public's ignorance is, of course, an enforced ignorance, for not only is cultural production maintained as the privilege of a small minority, but it is not in the interests of the institutions of art and the forces they serve to produce knowledge of radical practices even for their specialized audience. And this is particularly the case for those practices whose goal is a materialist critique of the presuppositions of those very institutions. Such practices attempt to reveal the material conditions of the work of art, its mode of production and reception, the institutional supports of its circulation, the power relations represented by these institutions – in short, everything that is disguised by traditional aesthetic discourse. Nevertheless, these practices have subsequently been recuperated by that very discourse as reflecting just one more episode in a continuous development of modern art. Many of *Tilted Arc's* defenders, some representing official art policies, argued for a notion of site specificity that reduced it to a purely aesthetic category. As such, it was no longer germane to the presence of the sculpture on Federal Plaza. The specificity of *Tilted Arc's* site is that of a particular public place. The work's material, scale and form intersect not only with the formal characteristics of its environment but also with the desires and assumptions of a very different public from the one conditioned to the shocks of the art of the late 1960s. Serra's transfer of the radical implications of *Splashing* into the public realm, deliberately embracing the contradictions this transfer implies, is the real specificity of *Tilted Arc*. […]

Tilted Arc was built on a site that is public in a very particular sense. It inhabited a plaza flanked by a government office building housing federal bureaucracies and by the United States Court of International Trade. The plaza adjoins Foley Square, the location of New York City's federal and state courthouses. *Tilted Arc* was thus situated in the very centre of the mechanisms of state power. The Jacob K. Javits Federal Building and its plaza are nightmares of urban development, official, anonymous, overscaled, inhuman. The plaza is a bleak, empty area, whose sole function is to shuttle human traffic in and out of the buildings. Located at one corner of the plaza is a fountain that cannot be used, since the wind-tunnel effect of the huge office tower would drench the

entire plaza with water. Serra's *Tilted Arc,* a 12-foot-high steel-plate wall, 120 feet long and tilted slightly toward the office building and the trade courthouses, swept across the centre of the plaza, dividing it into two distinct areas. Employing material and form that contrasted radically with both the vulgarized International Style architecture of the federal structures and the beaux-arts design of the old Foley Square courthouses, the sculpture imposed a construction of absolute difference within the conglomerate of civic architecture. It engaged the passer-by in an entirely new kind of spatial experience that was counterposed against the bland efficiency established by the plaza's architects. Although *Tilted Arc* did not disrupt normal traffic patterns – the shortest routes to the streets from the buildings were left clear – it did implant itself within the public's field of vision. Soliciting, even commanding attention, the sculpture asked the office workers and other pedestrians to leave their usual hurried course and follow a different route, gauging the curving planes, volumes, and sight lines that marked this place as the place of sculpture.

In reorienting the use of Federal Plaza from a place of traffic control to one of sculptural place, Serra once again used sculpture to hold its site hostage, to insist on the necessity for art to fulfil its own functions rather than those relegated to it by its governing institutions and discourses. For this reason, *Tilted Arc* was considered an aggressive and egotistical work, with which Serra placed his own aesthetic assumptions above the needs and desires of the people who had to live with his work. But in so far as our society is fundamentally constructed on the principle of egotism, the needs of each individual coming into conflict with those of all other individuals, Serra's work did nothing other than present us with the truth of our social condition. The politics of consensus that ensures the smooth functioning of our society is dependent on the shared belief that all individuals are unique but can exist in harmony with one another by assenting to the benign regulation of the state. The real function of the state, however, is not the defence of the citizen in his or her true individuality but the defence of private property – the defence, that is, precisely of the conflict between individuals.[2] Within this politics of consensus, the artist is expected to play a leading role, offering a unique 'private sensibility' in a manner properly universalized so as to ensure feelings of harmony. The reason Serra is accused of egotism, when other artists who put their 'private sensibilities in public places' are not, is that his work cannot be seen to reflect his private sensibility in the first place. And once again, when the work of art refuses to play the prescribed role of falsely reconciling contradictions, it becomes the object of scorn. A public that has been socialized to accept the atomization of individuals and the false dichotomy of private and public spheres of existence cannot bear to be confronted with the reality of its situation. And when the work of public art

rejects the terms of consensus politics within the very purview of the state apparatus, the reaction is bound to be censorial. Not surprisingly, the coercive power of the state, disguised as democratic procedure, was soon brought to bear on *Tilted Arc*. At the show trial staged to justify the work's removal, the most vociferous opposition to the work came not from the public at large but from representatives of the state, from judges of the courts and heads of federal bureaucracies whose offices are in the Federal Building.[3] [...]

If a public sculpture can have projected on it such an explicit statement of the contempt in which the public is held by the state, it has served a historical function of great consequence. We now have written into the public record, for anyone who wishes to read it, the fact that the 'federal sector' expects only the worst from us, that we are all considered potential loiterers, graffiti scribblers, drug dealers, terrorists. When *Tilted Arc* is converted, in the paranoid vision of a state security guard, into a 'blast wall', when the radical aesthetics of site-specific sculpture are reinterpreted as the site of political action, public sculpture can be credited with a new level of achievement. That achievement is the redefinition of the site of the work of art as the site of political struggle. Determined to 'be vulnerable and deal with the reality of his living situation', Richard Serra has found himself again and again confronted with the contradictions of that reality. Unwilling to cover up those contradictions, Serra runs the risk of uncovering the true specificity of the site, which is always a political specificity.

1 Serra's actual assertion on this occasion was, 'To remove *Tilted Arc*, therefore, is to destroy it'; see Clara Weyergraf-Serra and Martha Buskirk, eds, *The Destruction* of *Tilted Arc: Documents* (Cambridge, Massachusetts: The MIT Press, 1991) 67. [...]

2 [footnote 31 in source] On this subject, the central texts are the early writings of Karl Marx on the state and civil society; see especially 'On the 'Jewish Question',' in Karl Marx, *Early Writings*, trans. R. Livingstone and G. Benton (New York: Vintage Books, 1975) 211–41. See also Gramsci's reinterpretation of the relation between state and civil society and the importance of consensus.

3 [32] To anyone who followed the case closely, the public hearing on *Tilted Arc* was a mockery. The hearing was presided over, and the four other panellists were selected by, William J. Diamond, Regional Administrator of the General Services Administration, who had publicly asked for the removal of *Tilted Arc* and who had circulated petitions and solicited testimonies favouring its removal. And although two-thirds of the people testifying at the hearing favoured retaining *Tilted Arc* on Federal Plaza, Diamond's panel nevertheless recommended removal to the GSA. For a complete account of the *Tilted Arc* case, including Serra's unsuccessful attempts to reverse the GSA decision in court, see Weyergraf-Serra and Buskirk, *The Destruction of Tilted Arc*, op. cit.

Douglas Crimp, extracts from *On the Museum's Ruins* (Cambridge, Massachusetts: The MIT Press, 1993) 150–54, 176–81; 182.

Rosalyn Deutsche
Uneven Development: Public Art in New York City//1988

The Social Uses of Space

Public artists seeking to reveal the contradictions underlying images of well-managed or beautiful cities also explore relations between art and urbanism. Their interdisciplinary ventures differ, however, from the new collaborative and useful ones. Instead of extending the idealist conception of art to the surrounding city, they combine materialist analyses of art as a social product with materialist analyses of the social production of space. As a contribution to this work, urban studies has much to offer, since it analyses the concrete mechanisms by which power relations are perpetuated in spatial forms and identifies the precise terms of spatial domination and resistance. Over the last twenty years, the 'social production of space' has become the object of an impressive body of literature generated by urbanists in many fields – geography, sociology, urban planning, political economy. Critical spatial theories share a key theme with critical aesthetic thought, and the two have unfolded along a similar trajectory. Initially, each enquiry questioned the paradigm dominating its respective discipline. Just as materialist art practice challenged formalist dogma, critical urban studies questioned mainstream idealist perspectives on urban space.[1] 'The dominant paradigm', as sociologist Marc Gottdiener summarizes it,

> loosely identified as urban ecology, explains settlement space as being produced by an adjustment process involving large numbers of relatively equal actors whose interaction is guided by some self-regulating invisible hand. This 'organic' growth process – propelled by technological innovation and demographic expansion – assumes a spatial morphology which, according to ecologists, mirrors that of lower life forms within biological kingdoms. Consequently, the social organization of space is accepted by mainstreamers as inevitable, whatever its patterns of internal differentiation.[2]

The ecological perspective views forms of metropolitan social life in terms of the adaptation of human populations to environments, in which certain processes tend to remain constant and invariable. Employing biologistic analogies, it attributes patterns of urban growth to 'laws' of competition, dominance, succession and invasion, and thus explains the form of the city as a product of semi-natural processes. Even when the ecological legacy of environmental determinism has been complicated or discarded altogether, many tendencies

within urban studies continue to view space as an objective entity against which subjectivities are measured and therefore to marginalize the wider social system as cause of urban spatial form. But just as critical art practice in the late 1960s and 1970s sought to de-fetishize the ideological art object, critical urban studies did the same with the ideological spatial object – the city as an ecological form. The two inquiries investigated the ways in which social relations produce, respectively, art and the city.

Having insisted, however, on the relationship between society and art, on the one hand, or space, on the other, both critiques rejected the notion that this relationship is one of simple reflection or interaction. If formalism re-entered aesthetic discourse in the notion that art inevitably mirrors society, so idealism returned to spatial discourse in the formulation that space simply reflects social relations. But 'two things can only interact or reflect each other if they are defined in the first place as separate', observes urban geographer Neil Smith.

> Even having taken the first step of realization, then, we are not automatically freed from the burden of our conceptual inheritance; regardless of our intentions, it is difficult to start from an implicitly dualistic conception of space and society and to conclude by demonstrating their unity.[3]

Indeed, by means of such separations, not only are space and art endowed with identities as discrete entities, but social life appears to be unsituated, to exist apart from its material forms. Space and art can be rescued from further mystification only by being grasped as socially produced categories in the first instance, as arenas where social relations are reproduced and as, themselves, social relations. […] Henri Lefebvre, originator of the phrase 'the production of space', attributes the significance of space, in part, to changes in the organization of production and accumulation under late capitalism. New spatial arrangements assure capitalism's very survival. Because, according to Lefebvre, production is no longer isolated in independent units within space but, instead, takes place across vast spatial networks, 'the production of things in space' gives way to 'the production of space'.[4] Due to this growth and to revolutions in telecommunications and information technology, 'the planning of the modern economy tends to become spatial planning'.[5] The implications of this fundamental premise are clear. Individual cities cannot be defined apart from the spatial totality – the relations of spaces to one another within and between various geographic levels: global, regional, urban. The spatial restructuring of New York – a process at the urban level – can only be comprehended within the global context: the internationalization of capital, new international division of labour, and new international urban hierarchy.[6] […]

[T]he concept of abstract space, together with that of uneven development, specifies the terms, distilled from concrete events, of urban spatial struggle. Materialist analyses of space enable us to evaluate the consequences of cultural practices, such as the new public art, engaged in that struggle on the side of real estate and state domination. They also indicate the points where public art can enter the arena of urban politics in order to resist that domination, perhaps facilitating the expression of social groups excluded by the current organization of the city. Participation in urban design and planning enmeshes public art, unwittingly or not, in spatial politics. But public art can also appropriate the city, organized to repress contradictions, as a vehicle for illuminating them. It can transform itself into a spatial praxis, which Edward Soja has clarified as 'the active and informed attempt by spatially conscious social actors to reconstitute the embracing spatiality of social life'.[7] Against aesthetic movements that design the spaces of redevelopment, interventionist aesthetic practice might – as it does with other spaces – redesign these sites. For if official public art creates the redeveloped city, art as spatial praxis approaches this city in the cautious manner of the cultural critic described by Walter Benjamin. Confronted with 'cultural treasures' – 'documents of civilization' – Benjamin's critic unveils the barbarism underlying their creation by brushing their history 'against the grain'.[8] [...]

1 [Footnote 42 in source] See, e.g. Manuel Castells, *The Urban Question: A Marxist Approach* (1977); M. Gottdiener, *The Social Production of Urban Space* (1985); Peter Saunders, *Social Theory and the Urban Question* (1981); Edward W. Soja, 'The Spatiality of Social Life', in Derek Gregory and John Urry, eds, *Social Relations and Spatial Structures* (1985).

2 [43] M. Gottdiener, *The Social Production of Urban Space* (Austin: University of Texas, 1985) 264.

3 [44] Neil Smith, *Uneven Development: Nature, Capital and the Production of Space*, 77.

4 [46] Henri Lefebvre, 'Space: Social Product and Use Value', in J.W. Freiburg, ed., *Critical Sociology: European Perspectives* (New York: Irvington Publishers, 1979) 285.

5 [47] Ibid., 286

6 [48] See R.B. Cohen, 'The New International Division of Labour, Multinational Corporations and Urban Hierarchy', in Michael Dear and Allen J. Scott, eds, *Urbanization and Urban Planning in Capitalist Society* (London and New York: Methuen, 1981) 287–315.

7 [57] Edward W. Soja, 'The Spatiality of Social Life: Towards a Transformative Retheorization', in Gregory and Urry, eds, *Social Relations and Spatial Structures*.

8 [58] Walter Benjamin, 'Theses on the Philosophy of History' (1940), in *Illuminations*, trans. Harry Zohn (New York: Schocken Books, 1969) 257.

Rosalyn Deutsche, extracts from 'Uneven Development: Public Art in New York City', in *October*, vol. 47 (Winter 1988) 23–4; 25; 29–30; republished in Rosalyn Deutsche, *Evictions: Art and Spatial Politics* (Cambridge Massachusetts: The MIT Press, 1996).

Vito Acconci
Leaving Home: Notes on Insertions into the Public//2000

A museum is a 'public place', but only for those who choose to be a museum public. A museum is a 'simulated' public space: it's auto-directional and uni-functional, whereas a 'real' public space is multi-directional and omni-functional. When you go to a railroad station, you go to catch a train; but, in the meantime, you might be browsing through a shop, or having a drink in a bar, or sitting in a lounge. When you go to a museum, on the other hand, all you are doing is going to the museum. In order to go to the museum, you have to be a museum-goer; you go to the museum in order to continue to be a museum-goer.

What do museum-goers want?

What are you doing here anyway?

The built environment is built because it's been allowed to be built; it's been allowed to be built because it stands for and reflects an institution or a dominant culture. The budget for architecture is a hundred times the budget for public art, because a building provides jobs and products and services that augment the finances of a city. Public art comes in through the back door, like a second-class citizen. Instead of bemoaning this, public art can use this marginal position to present itself as the voice of marginal cultures as the minority report, as the opposition party. Public art exists to thicken the plot.

Public space is made and not born. What's called 'public space' in a city is produced by a government agency (in the form of a park) or by a private corporation (in the form of a plaza in front of an office building, or an atrium inside the building). What's produced is a 'product': it's bartered, by the corporation, in exchange for air rights, for the rights to build their building higher – it's granted, by the government agency, to people as a public benefit, as part of a welfare system. What's produced is a 'production': a spectacle that glorifies the corporation or the state, or the two working together. The space, then, is *loaned to* the public, bestowed on the public – the people considered as an organized community, members of the state, potential consumers. Public space is a contract: between big and small, parent and child, institution and individual. The agreement is that public space belongs to them, and they in turn belong to the state.

The building of spaces in the city has already been assigned to established disciplines: the vertical is allotted to architecture, the horizontal to landscape

architecture, and the network of lines between and through them to engineering. The city has all the design it needs for another category – 'public art' – to have a function in the design of city spaces, 'art' has to be brought back to one of its root meanings: 'cunning'. Public art has to squeeze in and fit under and fall over what already exists in the city. Its mode of behaviour is to perform operations – what appear to be unnecessary operations – upon the built environment: it adds to the vertical, subtracts from the horizontal, multiplies and divides the network on in-between lines. These operations are superfluous, they replicate what's already there and make it proliferate like a disease. The function of public art is to de-design. [...]

Time is fast, and space is slow. Space is an attempt to place time and understand time; space is a need to have something to see and solid ground to stand on; space is a desire to follow the course of events, and to believe in cause and effect. The electronic age obliterates space and overlaps places. You travel by airplane: you're in one place, then it's all white outside the window, and then – zap! – you're in another place, with nothing in between. You're switching channels on a TV set, rewinding and fast-forwarding a videotape, instead of watching a movie from beginning to end. The electronic age establishes the primacy of time. The video game versus the pinball machine. The push button phone versus the rotary phone. The digital watch versus a clock whose hands travel around a field in which each individual second has a place. In a fast time, public space – in the form of an actual place with boundaries – is a slowing-down process, an attempt to stop time and go back in history and revert to an earlier age. The plaza, bounded by buildings and owned by a corporation, is a nostalgia for nineteenth-century nationalism.

On the one hand, our projects *perform a* site: it's as if we're trying to coax the project out of the site, as if it's been there all the time – the site provides not only the place for the project but also the matter of the project – the project is built *with the* site, *by means* of the site – the architecture grows out of the space around it. On the other hand, it's as if our projects build a scaffolding over the site: it's this scaffolding that can support another site, either on top of or within the old one – a future city, a city in the air, precisely because it *wasn't* there all the time.

Vito Acconci, excerpted statements from 'Leaving Home: Notes on Insertions into the Public', lecture for the International Congress on 'Public Art' at the Academy of Fine Arts (Munich, February 2000); in Florian Matzner, ed., *Public Art: A Reader* (Ostfildern-Ruit: Hatje Cantz Verlag, 2004) 29–30; 31.

Simon Sheikh
In the Place of the Public Sphere?
or, The World in Fragments//2004

[...] Just as contemporary art practices have shown that neither the work nor the spectator can be formally defined and fixed, we have also come to realize that the conception of a public sphere, the arena in which one meet and engage, is likewise dematerialized and/or expanded. We no longer conceive of the public sphere as an entity, as one location and/or formation as suggested in Jürgen Habermas' famous description of the bourgeois public sphere. Jürgen Habermas' sociological and philosophical investigation of the emergence of the so-called 'public sphere', most often categorized and criticized for being normative and idealist, is basically a reconstruction of the ideals and self understanding of the emergent bourgeois class – positing a rational subject capable of public speaking outside of itself, *in* society and *of* society. Thus the separation between *the private* (the family and the house: property), *the state* (institutions, laws) and *the public* (the political and the cultural).[1]

Instead, we have to think of the public sphere as fragmented, as consisting of a number of spaces and/or formations that sometimes connect, sometimes close off, and that are in conflictual and contradictory relations to each other. And we have, through the efforts of Oskar Negt and Alexander Kluge, come to realize that our interactions as subjects with the public spheres are dependent on experiences. There not only exist public spheres and ideals thereof but also counter-publics. By placing the emphasis on the notion of experience, Negt and Kluge do not only point to the inequality of access to the public sphere in Habermasian terms; this also allows them to analyse modes of behaviour and possibilities for speech and action in different spaces. In their analysis both the workplace and the home are seen as 'public', ie. spaces organizing collective experience. And they attempt to posit a specific but plural public sphere that can be termed 'proletarian', in opposition to the normative 'bourgeois' public sphere.[2]

Counter-publics can be understood as particular parallel formations of a minor or even subordinate character where other or oppositional discourses and practices can be formulated and circulated. Where the classic bourgeois notion of the public sphere claimed universality and rationality, counter-publics often claim the opposite, and in concrete terms often entail a reversal of existing spaces into other identities and practices, as in, most famously, the employment of public parks as cruising areas in gay culture. Here, the architectural framework, set up for certain types of behaviour, remains unchanged, whereas the usage of this framework is drastically altered: Acts of privacy are performed

in public.[3] According to Michael Warner, counter-publics have many of the same characteristics as normative or dominant publics – existing as an imaginary address, a specific discourse and/or location, and involving circularity and reflexivity – and are therefore always already as much relational as they are oppositional. The notion of 'self-organization', for example, in recent art history – in itself most often an oppositional term, and certainly one filled with credibility – is thus not itself a counter-public. Indeed, self-organization is a distinction of any public formation: that it constructs and posits itself as a public through its specific mode of address. Rather, the counter-public is a conscious mirroring of the modalities and institutions of the normative public, but in an effort to address other subjects and indeed other imaginaries:

> Counter-publics are 'counter' [only] to the extent that they try to supply different ways of imagining stranger sociability and its reflexivity; as publics, they remain oriented to stranger circulation in a way that is not just strategic but constitutive of membership and its affects.[4]

If we can, then, only talk about the public sphere in the plural, and in terms of relationality and negotiation, it becomes crucial to understand, place and reconfigure art's spaces as 'public spheres'. Is the art world – the public arena in which 'we', reader and writer alike, are presently located – to be seen as one fragment of a generalized bourgeois public sphere, or is there a possibility of opposing spheres within it? And how are these related? If we analyse a particular public sphere called 'the art world' what are its delimitations, and how can it be employed strategically to engage with other public spheres? Finally, there is the question of how artworks and thinking around art can intervene in these different spheres - on the one hand taking its point of departure in the specific fragment, the art world, and on the other engaging in other spheres directly or indirectly.

Like the modernist conception of the singular artwork and spectator, the idea of the universal, bourgeois public sphere now seems purely historical. The well-ordered bourgeois public sphere is as much a fragment as other formations, and the question is rather whether it has ever existed as anything other than a projection, an ideal – a projection that does not seem useful in our multicultural and hyper-capitalistic, modular society. Perhaps this modulation of division of society into different areas and specialized disciplines should be seen as the foundation for the realization and fragmentation of the public sphere into different camps and/or counter-publics. Fragmented spheres that together form the 'imaginary institution of society' as described by Cornelius Castoriadis. For Castoriadis, society and its institutions are as much fictional as functional.

Institutions are part of symbolic networks and, as such, not fixed or stable but constantly articulated through projection and praxis. But by focusing on their imaginary character, Castoriadis also suggests that other social organizations and interactions can be imagined: that other worlds are indeed possible.[5]

When establishing the art world as a particular public sphere, we must explore this notion along two lines; firstly as a sphere that is not unitary, but rather agonistic and a platform for different and oppositional subjectivities, politics and economies: a 'battleground' as defined by Pierre Bourdieu and Hans Haacke. A battleground where different ideological positions strive for power and sovereignty. And, secondly, the art world is not an autonomous system, even though it sometimes strives and/or pretends to be, but regulated by economies and policies, and constantly in connection with other fields or spheres, which has not least been evident in critical theory and critical, contextual art practices.[6]

Since the formal, autonomous work is no longer a useful model, we have been witnessing a number of artistic projects that take their point of departure in the notion of different fields, if not in the notion of difference in itself: projects that relate to a specific set of parameters and/or a specific public as opposed to the generalized and idealized. In other words, we are speaking of works that do not employ the notion of the bourgeois public sphere, but rather different fragments, camp- and/or counter-publics. Or, at least, different ideas of a public, be they utopian or heterotopian. It is a question of to and for whom one is speaking, and on what premise. We see here a proliferation of formats, going well beyond the object-based, matrix-like artwork of modernism, but rather dealing with models of display and curatorial work in the exhibitionary complex, combining self-authorization with institutional critique. But also tactical employment of other spaces than traditional art spaces, such as the educational facility and pedagogy, alternative publishing, local and public television, street culture and more specifically the space of demonstrations, and finally the new sphere of net culture (for instance listservs and open source networks).

Efforts to construct new models, new public sphere formations, can be seen as, if not 'the answer' to such questions, then as attempts at indicating the routes one would follow to answer these questions. Such platforms must distinguish themselves by not creating single projects or interventions in (a generalized) public sphere, but rather try to constitute a continuous counter-public stream. Such a project must attempt to perceive and construct a specific public sphere and an (op)positional and/or participatory model for spectatorship as opposed to a (modernist) generalized one. And it entails a reconfiguration of the (bourgeois) notion of the public sphere into a different arena, into a potential multitude of different, overlapping spheres and formations. It must replace the notion of 'the' public sphere in the singular into plural sub- and/or counter-

publics. The task before us becomes, then, how such practices can conceive of their specific public, their interfaces with it and towards which aims? Relational publics are also always specific ones. We must thus map and define these different arenas and possibilities and methods for interaction within and between them. And, finally, question how this should relate to and alter artistic production, art's spaces and institutions, and their 'publics'. [...]

For the culture industry, the notion of 'the public', with its contingent modes of access and articulation, are replaced by the notion of 'the market', implying commodity exchange and consumption as modes of access and interaction. This also means that the notion of Enlightenment, rational-critical subjects and a disciplinary social order is replaced by the notion of entertainment as communication, as the mechanism of social control and producer of subjectivity. The classic bourgeois spaces of representation are likewise either replaced by markets, such as the mall replacing the public square, or transformed into a space of consumption and entertainment, as is the case in the current museum industry. In this sense, fragmentation and different spaces of experience are not as much a deconstructive threat to the culture industry as they are to the historical formation of the bourgeois public sphere. Rather, fragmentation and difference can be mapped in terms of consumer groups, as segments of a market with particular demands and desires to be catered to, and to be commodified. Indeed, fragmentation must be seem as one of the conditions of neoliberal market hegemony. This condition of simultaneous fragmentation and commodification also has direct consequences for art's spaces, be they bourgeois or otherwise inclined, in terms of public funding (always the main tool of cultural policies).

Interest in the upkeep of the bourgeois public sphere and its institutions, such as the traditional museum and exhibition space, is clearly in decline, from both left and right. And in a fragmented and differentiated public, we will have to define, address and establish both processes of self-representation and self-authorization, as well as their contestations in different always specified ways, and, perhaps, in terms of singularity and certainly articulation. Certainly, we cannot, nor even desire to, maintain, claim or return to the bourgeois category of the art space and subjectivity, and to its adjacent classical avant-gardist notions of resistance. Rather, we need not only new skills and tools but also new conceptions of 'the public' as relational, as articulatory and communicatory. I would suggest that we take our point of departure in precisely the unhinging of stable categories and subject positions, in the interdisciplinary and intermediary, in the conflictual and dividing, in the fragmented and permissive – in different spaces of experience, as it were. We should begin to think of this contradictory and non-unitary notion of a public sphere, and of the art institution as the

embodiment of this sphere. We can, perhaps, think of it as the spatial formation of, or platform for, what Chantal Mouffe has called an agonistic public sphere:

> According to such a view, the aim of democratic institutions is not to establish a rational consensus in the public sphere but to defuse the potential of hostility that exists in human societies by providing the possibility for antagonism to be transformed into 'agonism'.[7]

In her work on the agonistic public sphere, Mouffe significantly critizes Habermas for his separation between the private and public realm, and exertion of politics from the former, just as his belief in impartial public institutions (that is, in effect, impartial positions) amounts to a fundamental inability to deal with pluralism, with difference. Instead Mouffe argues for a 'conflictual consensus', multiplying the discourses, institutions and forms of democracy. We can thus begin to think not only of fragmentation and counter-publics, but also of the connections between them – what can be termed chains of equivalence between fragments, connecting different struggles and spheres. And we can attempt to posit the various public spheres or formats of cultural production – the exhibitionary complex, the educational facility, public televison, et al. – as precisely the arena for these contestations and articulations.

1 See Jürgen Habermas, *The Structural Transformation of the Public Sphere – An Inquiry into a Category of Bourgeois Society* (1962) (Cambridge, Massachusetts: The MIT Press, 1989).

2 See Oskar Negt and Alexander Kluge, *Public Sphere and Experience – Toward an Analysis of the Bourgeois and Proletarian Public Sphere* (1972) (Minneapolis: University of Minnesota Press, 1993).

3 George Chauncey, 'Privacy Could Only Be Had in Public', in Joel Sanders, ed., *Stud – Architectures of Masculinity* (New York: Princeton Architectural Press, 1996).

4 Michael Warner, *Publics and Counterpublics* (New York: Zone Books, 2002) 121–2.

5 See Cornelius Castoriadis, *The Imaginary Institution of Society* (1975) (London: Polity Press, 1987).

6 Pierre Bourdieu and Hans Haacke, *Free Exchange* (London: Polity Press, 1995).

7 Chantal Mouffe, 'For an Agonistic Public Sphere', in Okwui Enwezor et al., ed., *Democracy Unrealized* (Ostfeldern-Ruit: Hatje-Cantz Verlag, 2002) 90. For a more elaborate account of the notion of 'agonism', see Chantal Mouffe, *The Democratic Paradox* (London: Verso, 2000).

Simon Sheikh, 'In the Place of the Public Sphere? or, The World in Fragments' (June 2004); http://www.republicart.net

Ligna
Radio Ballet//2003

As a group, we are looking for ways of making radio that works with the potential inherent in the medium. One model that we have developed in this regard is the *Radio Ballet*. It does not entail much more than inviting people to public radio shows. The first *Radio Ballet* took place in Hamburg's main railway station in May 2002. Around 200 people – normal listeners of the local radio station FSK, not dancers – invaded the place equipped with small radios and headphones. The main station is a privatized space, which means that it is under video surveillance and security guard control. Their task is to detect people who behave in a way that contravenes the strict regulations of the space, and then throw the offenders out. The *Radio Ballet* in the main station consisted of a choreography that suggested gestures which contravened regulations – like holding out hands as if begging for money, sitting down – very simple things. It turned out that the security apparatus was powerless in this situation. Excluding all the people who participated would have been completely impossible without disturbing the usual comings and goings in the station. So the performance helped the excluded gestures to assume the nature of a nightmarish reappearance – everywhere at the same time.

We developed the model of a radio ballet for several different spaces and situations. A series that we called anormalization of everyday life did not happen in places subject to regulations like train stations, but in places that are still public in the traditional sense – like the shopping streets in the inner cities. But these are contested places right now. Most cities are working on different means to reduce the aspects of public space there and turn them into homogeneous places that are completely reserved for the exchange of commodities: homogenizing the appearance of the streets, rebuilding whole streets as shopping malls or turning streets into business improvement districts, to mention a few.

Political articulations like demonstrations became nearly impossible in the inner city of Hamburg. In the beginning of December last year we invited the listeners of our station into the main shopping street of Hamburg – Christmas shopping time. Usually buses and taxis are driving through this street – but because of a Christmas parade they changed the street into a pedestrian zone. The radio ballet asked 400 participants to explore how the place and its reduction to a single use – practising commodity fetishism – influences the gestures and behaviour of people. A strange phenomenon, as there are – so far – no regulations on how to behave. Nevertheless everybody is behaving normally.

Deviant gestures are excluded by the eternal repetition of the same gestures: walking down the street, stopping, looking into a shop window, walking into the shop, buying something, coming out again, walking down the street. The radio ballet repeated these well-known gestures at the same time. It is fairly normal when one consumer stops in front of a shop window but it is rather unusual when 400 radio consumers stop at the same time. When 400 people walk backwards instead of forward, everyday life in the shopping area becomes abnormal. These exercises in deviant behaviour enabled the listeners to find out how the normalization of public spaces works, and to get used to abnormal behaviour collectively. Gestures and bodily movements became possible that no one would have done alone. Even gestures that are forbidden for demonstrations, like jumping and then starting to run, could happen, and produced ghostly moments: an invisible mass of people became visible just for the few moments of the action. This dispersion of deviant behaviour produced an uncontrollable situation.

Ligna, *Radio Ballet* (2003) http://www.kuda.org/?q=en/node/444

Seth Price
Dispersion//2002–

[...] Some of the most interesting recent artistic activity has taken place outside the art market and its forums. Collaborative and sometimes anonymous groups work in fashion, music, video or performance, garnering admiration within the art world while somehow retaining their status as outsiders, perhaps due to their preference for theatrical, distribution-oriented modes. Maybe this is what Duchamp meant by his intriguing throwaway comment, late in life, that the artist of the future will be underground. [...]

The discourse of public art has historically focused on ideals of universal access, but, rather than considering access in any practical terms, two goals have been pursued to the exclusion of others. First, the work must be free of charge (apparently economic considerations are primary in determining the divide between public and private). Often this bars any perceptible institutional frame that would normally confer the status of art, such as the museum, so the public artwork must broadly and unambiguously announce its own art status, a mandate for conservative forms. Second is the direct equation of publicness with shared physical space. But if this is the model, the successful

work of public art will at best function as a site of pilgrimage, in which case it overlaps with architecture.

The problem is that situating the work at a singular point in space and time turns it, a priori, into a monument. What if it is instead dispersed and reproduced, its value approaching zero as its accessibility rises? We should recognize that collective experience is now based on simultaneous private experiences, distributed across the field of media culture, knit together by ongoing debate, publicity, promotion and discussion. Publicness today has as much to do with sites of production and reproduction as it does with any supposed physical commons, so a popular album could be regarded as a more successful instance of public art than a monument tucked away in an urban plaza. The album is available everywhere, since it employs the mechanisms of free market capitalism, history's most sophisticated distribution system to date. The monumental model of public art is invested in an anachronistic notion of communal appreciation transposed from the church to the museum to the outdoors, and this notion is received skeptically by an audience no longer so interested in direct communal experience. While instantiated in nominal public space, mass-market artistic production is usually consumed privately, as in the case of books, CDs, videotapes and Internet 'content'. Television producers are not interested in collectivity, they are interested in getting as close as possible to individuals. Perhaps an art distributed to the broadest possible public closes the circle, becoming a private art, as in the days of commissioned portraits. The analogy will only become more apt as digital distribution techniques allow for increasing customization to individual consumers.

The monumentality of public art has been challenged before, most successfully by those for whom the term 'public' was a political rallying point. Public artists in the 1970s and 1980s took interventionist praxis into the social field, acting out of a sense of urgency based on the notion that there were social crises so pressing that artists could no longer hole up in the studio, but must directly engage with community and cultural identity. If we are to propose a new kind of public art, it is important to look beyond the purely ideological or instrumental function of art. As Art and Language noted, 'Radical artists produce articles and exhibitions about photos, capitalism, corruption, war, pestilence, trench foot and issues.' Public policy, destined to be the terminal as-if strategy of the avant-garde! A self-annihilating nothing. [...]

Seth Price, extracts from *Dispersion* (2002–). With thanks to Bettina Funcke
http//www.distributedhistory.com

Hari Kunzru
This is the Public Domain//2004

In recent years, artistic and political engagements with the concept of the commons have tended to focus on the new possibilities emerging online. Digital media is forcing change in IP regimes. Models based on shared, free or open virtualities are proposed to salvage public space at a time when it is physically under threat. As the marketplace becomes a mall and the village green a branded leisure-space the customary rights of free speech and association traditionally attached to such places are also eroded. Amy Balkin, living in California, has opted to look again at real space. Her project *This is the Public Domain* has a simple aim: 'to create a public commons that will exist in perpetuity'. 'This land', she writes, 'will be permanently available, free, for use by anyone. Citizenship is not necessary to participate.' In a move which flies in the face of a social and legal system designed specifically to enforce land ownership, she has bought 2.5 acres of land near the Mojave desert and is instituting moves to transfer it out of her name into that of ... nobody. Everybody. All of us. The site is unpromising, squeezed next to a wind farm near the Edwards airforce base. Access is made difficult by the power company which owns the neighbouring area. The biggest challenge, however, is legal. One real estate lawyer advised Balkin that transferring ownership of land to 'the public' might involve exchanging signed contracts with everyone involved!

Balkin knows that her chances of achieving her aim under US law are slim. 'It could', she suggests, 'be argued that the success of the project would symbolically undermine the sovereignty of the state regarding territorial control, as the public domain would be an international commons within the borders of a state'. One possible legal strategy is the use of IP law. Unfortunately, a piece of land designated as a conceptual artwork is not considered IP. Another strategy under consideration is placing a sculpture on the land and extending the artwork's 'base' to the borders of the plot. Balkin is following this option by placing a bench on the land, with a small plaque announcing the site's status. Legal arguments continue. In the meantime if you want to go there, the location is:

Latitude: 35.082
Longitude: – 118.2785

Hari Kunzru, 'This is the Public Domain' (12 January 2004) http://www.metamute.org

Josephine Berry Slater
The Thematics of Site-Specific Art on the Net//2001

A Place Made of Space

[...] What could be said to constitute a place on the Internet? The word 'site', which in ordinary speech would designate a precise location in space, doubles as the technical term for a particular digital file or 'information object' which is only ever viewed in the form of a reassemblage.[1] That is to say, what we view in our browser window is the software's *interpretation* of a set of instructions, a string of 0s and 1s. On the Internet, although things can be designated a coordinate (an IP number or URL) nothing can ever be said to occupy a unique location. But even if we accept the distinction made by de Certeau and Marc Augé regarding place and space, and even though a website no longer occupies a singular location in the manner of a physical object, it is still possible to see certain equivalences to place. As with place, we know what we have to do to get there, as with place we can compare the experience of having been there with others, as with place our knowledge of it is always existential, dynamized by our passage across it, inflected with our intentions towards it, coloured by our encounters within it. But crucially, unlike place, we cannot build a sense of identity around a site on the Internet, we cannot belong to it and least of all attach foundation narratives to it. We cannot feel within it the echo of what Augé describes as 'anthropological place'.

Quoting from the ethnologist Marcel Mauss, Augé discusses the part-fictional character of anthropological place in terms of the relationship of 'average man' to the territory he inhabits. This man is born into a closed world, founded 'for once and all' and inscribed so deeply upon him that it does not have to be consciously understood. The 'total social fact' subsumes within itself any interpretation of it that its indigenous members may have:

> The 'average' man resembles 'almost all men in archaic or backward societies' in the sense that, like them, he displays a vulnerability and permeability to his immediate surroundings that specifically enable him to be defined as 'total'.[2] [...]

The connection between environmental permeability and a particular kind of identity are important subjects for the tactical practice of net art. The level of imperviousness which characterizes the 'average' user's relation to the Net is a point of investigation for these tacticians attempting to create a more bruising encounter between the space of the Net and its subjects. In order to

become the producers of idiolects (the personal/tactical mode of enunciation formed within imposed strictures), subjects must become sensible to the particularities of their environment and confident of their ability to find their own passage through it.

In 1996, Etoy, the Swiss net art group-cum-spoof-corporation, tried to provoke just such an awakening by targeting the supposedly neutral zone of the search engine with their artwork *Digital Hijack*.[3] Search engines are some of the most frequently 'visited' sites on the Net with Altavista, already drawing 32 million users per day by September 1998.[4] They act as huge centres of traffic convergence in the supposedly decentralized structure of the Net, but notably – similarly to airports – cannot be described as places of gathering. Although visitors frequently return, it is not in order to find something rooted in a singular location or to meet other visitors, but rather to use a service that spatializes the rest of the Net through the production of a set of URLs. Hartmut Winkler attributes their popularity to their perceived neutrality: 'Offering a service as opposed to content, they appear as neutral mediators'.[5] It is precisely because the search engine serves as a portal to elsewhere that it becomes a heavily frequented site. For this reason we can see the search engine as the quintessence of the transformation of place into space. The fact that a site's centrality is directly related to its distributive capacity tells us a great deal about the way in which spatial practices on the Net are characterized by passage rather than settlement.[6] Nothing could be further from the permeability of the subject to anthropological place than the indifference of the Net user to the putative neutrality of the search engine website.

It is precisely this neutrality that Etoy singled out for attack in their *Digital Hijack*. In tune with Winkler's criticisms, Etoy created a mechanism for alerting people to their unquestioning acceptance of the search engine's mode of selecting and hierarchizing URLs. The actual method of aggregating and organizing websites in accordance with the user's keyword is, in reality, anything but exhaustive or disinterested. In the early days of search engines, some companies (such as Yahoo) paid employees to categorize websites 'by hand', thus making available only a tiny proportion of the total number of websites on the Net. Of course what was made available was the final result of a series of subjective choices and corporate categorizations made by a team of coders.[7] The subsequent automation of this process has not, however, resulted in any fundamental increase in accuracy, comprehensiveness or compatibility between the keyword and the list of URLs displayed in response. Unable to master complex linguistic issues such as syntax, and therefore unable to interpret the meaning of strings of search terms, many search algorithms will simply prioritize URLs according to the number of times the search terms are mentioned.

This is just one example of how the map of the WWW produced by the search engine is deficient and, more importantly for us, how the system is vulnerable to manipulation. Realizing this point of leverage, Etoy began to analyse the top 20 sites returned by search engines in response to some of the most popular search terms such as 'porsche, penthouse, madonna ...'[8] Essentially, Etoy found a way to manipulate the system by updating an older practice called 'spamdexing'. This is a simple 'hacker's' trick by which a keyword is inserted repeatedly into an HTML document to ensure that a website is featured high up in the search engine display hierarchy.[9] Etoy used their 'Ivana bot' (probably an algorithm) to analyse the particular combination of keywords embedded in the top 20 websites returned to a keyword such as 'porsche'. They then generated thousands of 'dummy trap' pages, each of which contained combinations of thousands of popular keywords, thus ensuring that the pages would be returned in the top 20 category of numerous word searches. For a short period after March 1996, surfers using search engines were regularly 'hijacked' by dummy trap pages which, far from displaying information about a desirable car or pop star would harass hostages with the message: 'Don't fucking move – this is a digital hijack by etoy.com'. If the hostage/viewer decided to follow the links through the website, they would first discover what number hostage of the Etoy 'organization' they were, then view an animated GIF of a shaven-headed Etoy member in dark glasses[10] and ambiguously plugged into a cable at the navel, and finally receive a blunt mission statement:

> It is definitely time to blast action into the Net! Smashing the boring style of established electronic traffic channels.
> Welcome to the Internet Underground.

Today, after the search engines succeeded in terminating Etoy's action, the statement posted on a sample site concludes:

> Although officially stopped, we cannot protect you from getting hijacked.
> We lost control.
>
> PIRATES FIGHTING FOR A WILDER NET![11]

1 [footnote 3 in source] This term is used in Jon Ippolito, in 'The Museum of the Future: A Contradiction in Terms?' (July 1998) http://www.three.org/variable_media/vm–concept.html
2 [4] Marc Augé, *Non-Places: Introduction to an Anthropology of Supermodernity* (London: Verso, 1997) 49.
3 [5] http://www.hijack.org

4 [6] Hartmut Winkler, 'Search Engines: Metamedia on the Internet?, *Readme! ASCII Culture and the Revenge of Knowledge*, ed. Josephine Bosma, et al. (Autonomedia, 1999) 30.

5 [7] Ibid.

6 [8] Here I am referring to user behaviour or navigation not the registration of URLS and the production of content which could undoubtedly be likened to settlement. It is important to note, however, in the latter case, that settlement does not necessarily relate to time spent in a certain place but rather ownership of the right to be located or to mediate a certain message.

7 [9] Yahoo! named its categorization system 'the ontology', succinctly betraying the contradiction between its purported utility and underlying bias. See Winkler, 31.

8 [11] For Etoy's explanation of the Digital Hijack see http://www.hijack.org

9 [12] After search engine employees started to spot this trick merely by eye, spamdexers simply made the repeated word the same colour as the background and thus rendering it invisible. For a discussion of Etoy and the history of spamdexing see Andrew Leonard's 'Search Me', *Hotwired* (1996) http://hotwired.lycos.com//packet//leonard/96/32/index3a/html

10 [13] The Etoy team, in all public appearances, dress with complete uniformity. The entirely male group sport shaved heads and favour utility clothing such as municipal-style boiler suits. The picture of the Etoy member mentioned, through the anonymity of the dark glasses and casual connection to the cable – a cipher for the information technosphere – produces its member as a replaceable techno-cultural 'foot soldier' (a term later employed by the group). This mode of subject positioning creates a glamorized, possibly ironic surface to a post-humanist understanding of the erstwhile divide between nature and artifice.

11 [14] Etoy, http://www.hijack.org

Josephine Berry Slater, extract from 'The Thematics of Site-Specific Art on the Net', unpublished PhD thesis (University of Manchester, 2001) 152–8.

(AWAY FROM IT ALL)
HERE THERE & EVERYWHERE

(BENEATH IT ALL)
HERE THERE & EVERYWHERE

(ABOVE IT ALL)
HERE THERE & EVERYWHERE

Lawrence Weiner, HERE THERE & EVERYWHERE, 1989

Dan Graham
March 31, 1966//1966

1,000,000,000,000,000,000,000,000.00000000	miles to edge of known universe
100,000,000,000,000,000,000.00000000	miles to edge of galaxy (Milky Way)
3, 573,000,000.00000000	miles to edge of solar system (Pluto)
205.00000000	miles to Washington, DC.
2.85000000	miles to Times Square, New York City
.38600000	miles to Union Square subway stop
.11820000	miles to corner 14th St. and First Ave.
.00367000	miles to front door, Apart. 1, 153 1st Ave.
.00021600	miles to typewriter paper page
.00000700	miles to lens of glasses
.00000098	miles to cornea from retinal wall

Dan Graham, *March 31, 1966* (1966); one of the artist's works made for insertion in magazines, subsequently exhibited at Finch College, New York, in November 1967; reproduced in Lucy R. Lippard, *Six Years: The Dematerialization of the Art Object from 1966 to 1972* (New York, 1973; revised edition, Berkeley and Los Angeles: University of California Press, 1997) 14.

Martha Rosler
Immigrating//1975

For the first six months I sat around with the baby while Lenny went to grad school – pushing the stroller up the hill to moon over the sun-glazed water, eating lots of oranges and fresh vegetables, learning about health foods. I pulled a lot of crabgrass, planted and tended lots of plants. I lay around on wall-to-wall carpeting or on dichondra lawn, doing freelance editing, wandered through Fed-Mart, avoided the freeway, looked at all the funny houses, walked on the beach. I had come there hoping for 'peace'.

There was a wild overgrown garden within 15-foot-high hedges on the adjoining lot. I planted and shifted bulbs, pruned a huge knobby hibiscus bush, smelled the damp moss. Our landlord was a skinny young guy who worked in a machine shop. When we moved in he and his wife went on a three-week

vacation with a rented camper shell on the back of his truck and a cycle on the front. I'd never seen a camper up close before. He and his wife lived in the garage he'd fixed up behind our little house, and he rode an enormous Kawasaki to work. He came around one day to tell me not to go to Mexico because a friend's sister had vanished off the street of TJ and was found abused and demented in a Mexican jail months later. He said his wife had never been down there and he didn't plan to let her. He seemed like a gentle guy and pretty nice.

On a Sunday morning a small bulldozer removed the old garden. The landlord explained that he's decided to expand. He had big plans for the future. Two men came daily in a pickup truck to build a 'duplex'. In the following weeks I traded pleasantries with them during their breaks. One night I dreamed that one of them had been killed on a motorcycle. A few days later the young landlord told us that one of the carpenters had been riding his cycle out East on a road through the scrubby hills on his day off and had been hit by a car and killed. The other carpenter, his brother, had to finish the framing alone.

Lenny and I split up and I took the baby back East to the Lower East Side to an apartment where lead-paint dust filtered through the rooms and hundreds of cockroaches made their home, and the duplex was finished. The plans and a chunk of the financing were provided by an enterprising and jovial contractor and his wife. He worked for the county during the week and she took care of business, and on weekends they both oversaw their projects. They were sure they would get rich, and they had seemed confident and well fed, proud to show me some of their other multiple concrete dwellings surrounded by black asphalt on that very street, alternating with the older single-family houses.

The landlord moved into one of the two apartments in the duplex and rented out the other, as well as the house we had lived in and the fixed-up garage. His wife was pregnant. Six months later I moved back to the area, to a spot in Pacific Beach hemmed in by Navy housing. A year later I fled up the coast, 2.5 miles north to Leucadia. I got a tiny cement cottage for $100, at the end of a row of ten wooden garages, in a largely Mexican enclave on a dirt path. In one of the houses was an old Polish widow who used to own all the houses and thought she still did. She baked bread for the man who'd bought them, until she died. A few surfers had an unofficial business making surfboards in some of the garages. My little boy found a best friend, Jose, in one of the houses and his mother Maria and I became friends. We are the same age. Maria was learning English from the TV. Her husband, Pascual, worked in a flower-growing factory in Solana Beach. Our landlord was a smiling professional of some kind of enlightened liberal opinions; he became a McGovern campaign worker. He had a big house on the cliff facing the ocean and rented out a small apartment in it. My rent was lower than in Pacific Beach, which satisfied the welfare worker, and I liked the place

because it was semi-rural and rather peaceful. I stayed on after I got a job and went through grad school. Pascual went to jail for a year for drunken driving.

One day a fence was put across the path, separating us from the dirt lot lying between our houses and the paved street, where our mailboxes are. We could drive home only through a long narrow dirt alley off 101. The family who came to build the fence, a pinched-looking Anglo woman, a Chicano man, and their three kids, told me that they'd just bought the lot and would probably put apartments on it soon, when they got financing. The fence stayed for awhile but finally one of the surfers ripped it down in the middle of the night. The fence was soon rebuilt; it stayed a few months and someone else ripped it down, maybe me. A chain-link fence was set in cement. My landlord said he was sorry he hadn't bought that lot. He was thinking of putting apartments on the whole plot and was worried about street access. He has regretfully raised my rent 45% in four years. He says houses are uneconomical and ecologically wasteful. He's just repainted the dead widow's house and rented it for triple the rent to a young couple with dogs and a lot of plants. The chain-link fence is still up, and occasionally I see people pacing out the long empty piece of land behind my house. Pascual is out of jail.

All kinds of people want to move ahead in Southern California.

Martha Rosler, 'Immigrating', *LAICA Journal* [Journal of the Los Angeles Institute of Contemporary Art] (Spring 1975); reprinted in *Martha Rosler: Positions in the Life World* (Birmingham: Ikon Gallery/Vienna: Generali Foundation, 1999) 285–6.

Lucy R. Lippard
Notes from a Recent Arrival//1995

[...] Much has been written beyond the art world in the last twenty years about 'a sense of place' or 'the spirit of place', which are symbiotically related to a sense of displacement, 'longing and belonging', or longing to belong. I am ambivalent about such phrases even as I am touched by them. The sense or spirit of place has become not just a cliché, but a kind of intellectual property, a way for nonbelongers to belong, or to appropriate a place, momentarily, as long as it is convenient. Ideally there should be no stigma attached to being adaptable, to feeling most at home in someone else's home. But given the history of this hemisphere, such an emotion becomes alarmingly proprietary. At the same time,

a sensitivity to place is a valuable social and cultural tool, providing much-needed connections to what we call 'nature' and, sometimes, to cultures not our own.

When people move to a place they've only visited before, with any hope or illusion of staying there, they often become interested in their predecessors. It's like marrying into a family. Having lost or been displaced from their own histories, they are ready to adopt those of others, or at the very least, to be a prime audience for their stories. This may or may not be appropriate or courteous behaviour; it's a delicate balance. If place is defined by memory, but no one with memories is left to bring them to the surface, does a place become no-place? What if there are people with memories but no one to transmit them to? Are their memories invalidated by being unspoken? Are they still valuable to others with a less personal connection?

In the case of a restless, multi-centred and multi-traditional people, even as power of place is diminished and often lost in modern life, it continues, as an absence, to define culture and identity. When history fails a community, memory takes up the task. If history comes from above and outside, from teachers and governments, stories are told from the inside at ground level. When governments and dominant cultures prove inadequate, grandmothers become the authorities. And the landscape triggers their memories, becomes symbolic, conveys different messages in different cultural languages.

Cultural reciprocity is crucial to an understanding of the vernacular landscape which, as J.B. Jackson (the pioneer writer on the subject, also a New Mexican) insists, is a place where people live and work. Such reciprocity is often ignored by those who prefer the abstractions of 'nature' to lived experience. As William deBuys has pointed out in his illuminating book on Northern New Mexico, *Enchantment and Exploitation* (Albuquerque: University of New Mexico Press, 1985), we need to conserve traditional cultures in part because of 'the fresh new questions they pose about the relation of people to each other and to the land'.

The politics of place is layered with emotional and aesthetic resonance that is hard to analyse. Its reciprocal nature is better expressed within a circle than on (a) line. 'Around here' is a circular radiating notion/motion. 'Out there' is a line of sight, the view. Sitting at one's local centre, the pressing questions are about how to relate it to the peripheries. Or are the centre and the periphery indistinguishable, and if so, where does one stop and the other start? (Boundaries originally meant bonds rather than separations.) A multicentred society, understood as such (rather than as a dysfunctional society that will never find its home) might bring with it a new understanding of difference that comes from inside, and from lived experience of very different landscapes and histories. [...]

Where does an artist fit into this process? And how can people from the different cultures that formed this place and still live around here bring this

history to the surface again, without attracting the wrong kind of attention – eyesores of commerce and tourism? J.B. Jackson holds up the possibility of a landscape that would 'provide us with some symbols of permanent values ... landmarks to reassure us that we are not rootless individuals without identity or place, but are part of a larger scheme'. Isn't this something artists might tackle? The vernacular landscape in its ongoing formation has not often been the subject of innovative artforms, although human creativity is an integral part of the web formed by land, history, culture and place.

The reconstructive potential of an art practice that restores or reveals the meaning of a place to those who live within it cannot be underestimated. Few artists have gone beyond the reflective function of conventional artforms and beyond the reactive function of much activist art. As 'envisionaries', artists should be able to make connections visible: to be generous, to provide an alternative to the dominant culture's rapacious view of nature, to expose the social agendas that formed the land, to reinstate the mythical and cultural dimensions of 'public' experience and, at the same time, to become conscious of the ideological relationships and historical constructions of place. Artists from various backgrounds and foregrounds can bring out multiple readings of the places where they live – interpretations that mean different things to different people at different times rather than merely reflecting some of the places' beauty back into the marketplace or the living room.

The separation of art from context, art from place, art from audience, art from common ground and shared meanings has dominated the twentieth century. Nonetheless, context has been the key to much of the best art made in the past thirty years. Too often, however, it continues to be used in ways that are more rhetorical and theoretical than pragmatic or political. Social amnesia and a fear of art being swallowed up in 'real life' seem to infect even those artists who believe they want to reach new audiences. One reason for this is that art itself has lost its context in this society. It's no accident that *de*contextualization is the focus for many artists who *do* respect context. In this destabilized and multicentred society, for better or worse, a culture characterized by lack of grounding, lack of centre, determines what most of us think, do, and make. Displacement is as important as place, exile is as important as rootedness, and homelessness is as important as home.

These have become 'postmodern' insights, products of a trend that is itself the disturbed, overgifted child of a multicentred society. Postmodernism's pastiche anti-aesthetic, its acknowledgment of shifting focus and fragmented field of vision, are the products of an uprooted and alienated people who are often seeking new assurances in the ruins of the old, or in the back-turning embrace of the new. [...]

Site art and photography are the two artforms that seem at the moment to have the greatest potential as vehicles for a raised consciousness about where we 'find ourselves', and for collaboration with those who also live there: site art because it can augment, comment on, elucidate the place where it too is located; photography because, although it has a history of 'taking', it too can escape artificial exhibition spaces (into publications and other 'non-art' milieux) and can span time and space, offering multifaceted glimpses that at least suggest a place's 'reality'. But even in these forms there is not a great deal of work that directly communicates place – leads out, 'looks around', and either incorporates or carries its audience with it. Empathy and exchange are integral to what Wendell Berry calls a 'place ethic', which is (or should be) an essential component of all place-related art. [...]

Any place is diminished when it becomes a mere backdrop for mainstream art. Art that illuminates its location rather than just occupying it is place-specific rather than site-specific, incorporating people and economic and historical forces as well as topography. It usually 'takes place' outside of conventional venues that entice audiences through publicity and fashion. It is not closeted in 'white cubes', accessible only when admission is paid or boundaries are breached. It is not readable only to those in the know. It becomes at least temporarily part of or a criticism of the built and/or daily environment. It makes places mean more to those who live or spend time in them. [...]

Lucy R. Lippard, extracts from 'Notes From a Recent Arrival', in *Longing and Belonging: From the Faraway Nearby* (Santa Fe: SITE Santa Fe, 1995) 107–14.

James Lingwood
The Limits of Consensus//1996

[...] Rachel Whiteread's sculpture *House*, a concrete cast of the interior of the last remaining house in what had once been a long terrace, stood at the end of a rather tawdry park in London's East End. As the viewer moved around it, the sculpture presented its different sides. The front, unnervingly slim, featured blinded windows, an immovable door, two side elevations, one marked with six fireplaces, the other more bleak, punctuated only by the cuts of the stairs, and the rear, where the uneven forms of the back extension betrayed perhaps most acutely the vulnerability of domestic life.

Close to, the details of these walls, the traces of the original home left by the casting process, may have been all that the viewer saw. The sculpture overwhelmed the viewer with intimate domestic detail. But from further away, it had a different, less enveloping presence. As the viewer looked at *House* from a range of different perspectives, the gaunt cast seemed to be engaged in a mute dialogue with different architectural forms. Across the road, within a hundred yards of one another stood three different churches, Baptist, Jehovah's and Church of England. On one level, *House* appeared to mark the historical shift in Protestant culture from church to home as the main organizing agent of social stability. Looking from north to south, Canary Wharf, the tallest building in England, dominated the axis, a constant symbol of the transformations that the 1980s had wrought on this part of London and of the changing balance of the relationship of global and local. This was the side whose walls were a blank canvas of inevitable attraction to purveyors of graffiti; first 'Homes for All, Black and White'; then, a couple of weeks later, 'Wot for?', soon to be juxtaposed with an equally succinct response 'Why not?' And, from far away across the expanse of unused park, which had until the Second World War been row upon row of tenements, *House* became very small and vulnerable. Towering over it were concrete highrises, emblems of a later and less successful attempt to organize the local population into new urban masterplans, new visions of collectivity. *House* appeared to incorporate all of this into the experience of the work. During its brief life of eighty days, *House* never changed – it was as silent as the debate swirling around it was loud; it was mute and implacable. And yet it changed all the time as well; from side to side, from day to night, from standing alone to being besieged by crowds. As a sculpture should, it demanded attention to its detail as well as to its whole. And at the same time, its meaning was constantly shifting dependent upon the point of view (both physical and cultural). *House* could not be independent of its time and place. It was literally, physically, rooted to it. It could not be deracinated, only destroyed.

An aspiration for a ready-made consensus underpins the hopes of many of the agents of public art, commissioners and makers alike. As a precondition of existence, most commissions of public art must not be contentious. And why indeed should local councils or large corporations wish to court controversy, for there are very rarely dividends of votes or tangible returns there? They have a precautionary desire to insulate the work in the world outside from the harsh chill of exposure and controversy, to circumscribe its potential meaning. By contrast, the works of Stephan Balkenhol, Bethan Huws and Whiteread each created a substantial community of interest and each provoked indignation, media censure and political outrage, synthetic or otherwise. Anonymity was not a precondition of their existence. They were not sculptures in search of a consensus.

A little way down Grove Road, only a few hundred yards from the place where *House* was made, a group of wooden sculptures stood in an adjacent stretch of empty parkland. Carved from trees blown down in the great storm of 1987, they stood in a rather forlorn configuration. All the time I spent in Grove Road, meeting with the artist, with local councillors and residents, contractors, sponsors, helpers, students and journalists. I never saw anyone looking at the wooden sculptures. It seemed as if, moments after the commemorative plaque had been unveiled in front of the sculptures, meaning had evaporated from them as quickly as the councillors and local dignitaries had drifted from the opening ceremony.

In his observations about the status of the monument in the urban environment, Robert Musil wrote that 'the most striking feature of monuments is that you do not notice them. There is nothing in the world as invisible as a monument ... Like a drop of water on an oilskin, attention runs down them without stopping for a moment.' Musil was commenting on the emptying out of meaning from monuments over time. But the wooden sculptures down Grove Road had acquired that condition immediately; they were an emblem of instant anonymity. Rachel Whiteread's *House* could not aspire to that condition. In time, over decades, it may have become anonymous too. But time was something this sculpture did not have.

House was able to absorb into its fabric a multiplicity of convictions, a host of different thoughts and responses. It did not aspire to the consensual and it did not achieve it. By preparing to be open, by accepting a degree of exposure, it had the capacity to charge both its actual physical location, and the political and cultural landscape in which it was made and seen. It was like a lightning conductor drawing into its body the hopes and frustrations, emotions and memories, of the tens of thousands of people who saw it and debated it. It was not indifferent and few were indifferent to it.

One of the most interesting aspects of the *House* saga was the extent to which it eluded the familiar contours of cultural controversy. Seasoned press campaigners invoked precedents such as the Tate Gallery's acquisition of Carl Andre's 'bricks' and drew up familiar battle formations. Once more, they sought to range partisan blocs of opinion one against another – local against national, middle-class against working-class workers, the art world against the real world.

But these old formations and strategies appeared singularly inadequate to explain the range and complexity of response which *House* engendered. The simple truth about *House* was that, despite the enthusiastic alliances of a populist media and opportunist local politicians keen to engineer such a confrontation, *House* did not accentuate divisions between diametrically opposed constituencies. There were passionately different responses, of course, but the differences were always *within* identifiable groups of people, rather than

between them. People spoke for themselves, rather than being spoken for. There was no consensus on the street, in the neighbourhood or in the letter pages of the newspapers. There was no consensus amongst the ruling Liberal Democrats of Bow Neighbourhood Council who had first agreed for the sculpture to be made, then refused an extension to its life; or amongst local residents' associations; nor in the Houses of Parliament (where an early day motion condemning the decision to demolish it, the same day that Whiteread won the Turner Prize, attracted considerable support). There was, finally, no consensus even within the Gale family whom the Council had moved out of the home which became *House.* With absolute clarity, *House* laid bare the limits of consensus. It did not expect to be ring-fenced from the contingencies and passions of everyday life. [...]

James Lingwood, extract from 'The Limits of Consensus', in Pavel Büchler and Nikos Papastergiadis, eds, *Random Access 2: Ambient Fears* (London: Rivers Oram Press, 1996) 65–9.

Doreen Massey
A Global Sense of Place//1991

This is an era – it is often said – when things are speeding up, and spreading out. Capital is going through a new phase of internationalization, especially in its financial parts. More people travel more frequently and for longer distances. Your clothes have probably been made in a range of countries from Latin America to South-East Asia. Dinner consists of food shipped in from all over the world. And if you have a screen in your office, instead of opening a letter which has taken some days to wend its way across the country, you now get interrupted by e-mail.

This view of the current age is one now frequently found in a wide range of books and journals. Much of what is written about space, place and postmodern times emphasizes a new phase in what Marx once called 'the annihilation of space by time'. The process is argued, or – more usually – asserted, to have gained a new momentum, to have reached a new stage. It is a phenomenon which has been called 'time-space compression'. And the general acceptance that something of the sort is going on is marked by the almost obligatory use in the literature of terms and phrases such as speed-up, global village, overcoming spatial barriers, the disruption of horizons, and so forth.

One of the results of this is an increasing uncertainty about what we mean by 'places' and how we relate to them. How, in the face of all this movement and intermixing, can we retain any sense of a local place and its particularity? An (idealized) notion of an era when places were (supposedly) inhabited by coherent and homogeneous communities is set against the current fragmentation and disruption. The counterposition is anyway dubious, of course; 'place' and 'community' have only rarely been coterminous. But the occasional longing for such coherence is none the less a sign of the geographic fragmentation, the spatial disruption, of our times. And occasionally, too, it has been part of what has given rise to defensive and reactionary responses – certain forms of nationalism, sentimentalized recovering of sanitized 'heritages', and outright antagonism to newcomers and 'outsiders'. One of the effects of such responses is that place itself, the seeking after a sense of place, has come to be seen by some as necessarily reactionary.

But is that necessarily so? Can't we rethink our sense of place? Is it not possible for a sense of place to be progressive; not self-closing and defensive, but outward-looking? A sense of place which is adequate to this era of time-space compression? To begin with, there are some questions to be asked about time-space compression itself. Who is it that experiences it, and how? Do we all benefit and suffer from it in the same way?

For instance, to what extent does the current popular characterization of time-space compression represent very much a western, colonizer's, view? The sense of dislocation which some feel at the sight of a once well-known local street now lined with a succession of cultural imports – the pizzeria, the kebab house, the branch of the middle-eastern bank – must have been felt for centuries, thought from a very different point of view, by colonized peoples all over the world as they watched the importation, maybe even used, the products of, first, European colonization, maybe British (from new forms of transport to liver salts and custard powder), later US, as they learned to eat wheat instead of rice or corn, to drink Coca-Cola, just as today we try out enchilades.

Moreover, as well as querying the ethnocentricity of the idea of time-space compression and its current acceleration, we also need to ask about its causes: what is it that determines out degrees of mobility, that influences the sense we have of space and place? Time-space compression refers to movement and communication across space, to the geographical stretching-out of social relations, and to our experience of all this. The usual interpretation is that it results overwhelmingly from the actions of capital, and from its currently increasing internationalization. On this interpretation, then, it is time space and money which make the world go around, and us go around (or not) the world. It is capitalism and its developments which are argued to determine our understanding and our experience of space.

But surely this is insufficient. Among the many other things which clearly influence that experience, there are, for instance, 'race' and gender. The degree to which we can move between countries, or walk about the streets at night, or venture out of hotels in foreign cities, is not just influenced by 'capital'. Survey after survey has shown how women's mobility, for instance, is restricted – in a thousand different ways, from physical violence to being ogled at or made to feel quite simply 'out of place' – not by 'capital', but by men. [...]

The current speed-up may be strongly determined by economic forces, but it is not the economy alone which determines our experience of space and place. In other words, and put simply, there is a lot more determining how we experience space than what 'capital' gets up to.

What is more, of course, that last example indicated that 'time-space compression' has not been happening for everyone in all spheres of activity. [As Deborah Birkett writes] of the Pacific Ocean:

> Jumbos have enabled Korean computer consultants to fly to Silicon Valley as if popping next door, and Singaporean entrepreneurs to reach Seattle in a day. The borders of the world's greatest ocean have been joined as never before. And Boeing has brought these people together.
>
> But what about those they fly over, on their islands five miles below? How has the mighty 747 brought them greater communion with those whose shores are washed by the same water? It hasn't, of course. Air travel might enable businessmen to buzz across the ocean, but the concurrent decline in shipping has only increased the isolation of many island communities ... Pitcairn, like many other Pacific islands, has never felt so far from its neighbours.[1]

In other words, and most broadly, time-space compression needs differentiating socially. This is not just a moral or political point about inequality, although that would be sufficient reason to mention it; it is also a conceptual point. Imagine for a moment that you are on a satellite, further out and beyond all actual satellites; you can see 'planet earth' from a distance and, unusually for someone with only peaceful intentions, you are equipped with the kind of technology which allows you to see the colours of people's eyes and the numbers on their number plates. You can see all the movement and tune in to all the communication that is going on. Furthest out are the satellites, then aeroplanes, the long haul between London and Tokyo and the hop from San Salvador to Guatemala City. Some of this is people moving, some of it is physical trade, some is media broadcasting. There are faxes, e-mail, film distribution networks, financial flows and transactions. Look in closer and there are ships and trains, steam trains slogging laboriously up hills somewhere in Asia. Look in closer still

and there are lorries and cars and buses, and on down further, somewhere in sub-Saharan Africa, there's a woman – amongst many women – on foot, who still spends hours a day collecting water.

Now, I want to make one simple point here, and that is about what one might call the *power geometry* of it all; the power geometry of time-space compression. For different social groups, and different individuals, are placed in very distinct ways in relation to these flows and interconnections. This point concerns not merely the issue of who moves and who doesn't, although that is an important element of it; it is also about power in relation to the flows and the movement. Different social groups have distinct relationships to this anyway differentiated mobility: some people are more in charge of it than others; some initiate flows and movement, others don't; some are more on the receiving end of it than others; some are effectively imprisoned by it.

In a sense at the end of all the spectra are those who are both doing the moving and the communicating and who are in some way in a position of control in relation to it – the jet-setters, the ones sending and receiving the faxes and the e-mail, holding the international conference calls, the ones distributing films, controlling the news, organizing the investments and the international currency transactions. These are the groups who are really in a sense in charge of time-space compression, who can really use it and turn it to advantage, whose power and influence it very definitely increases. On its more prosaic fringes this group probably includes a fair number of western academics and journalists – those, in other words, who write most about it.

But there are also groups who are also doing a lot of physical moving, but who are not 'in charge' of the process in the same way at all. The refugees from El Salvador or Guatemala and the undocumented migrant workers from Michoacan in Mexico, crowding into Tijuana to make a perhaps fatal dash for it across the border into the US to grab a chance of a new life. Here the experience of movement, and indeed of a confusing plurality of cultures, is very different. And there are those from India, Pakistan, Bangladesh, the Caribbean, who come half way round the world only to get held up in an interrogation room at Heathrow.

Or – a different case again – there are those who are simply on the receiving end of time-space compression. The pensioner in a bedsit in any inner city in this country, eating British working-class-style fish and chips from a Chinese take-away, watching a US film on a Japanese television; and not daring to go out after dark. And anyway the public transport's been cut.

Or – one final example to illustrate a different kind of complexity – there are the people who live in the favelas of Rio, who know global football like the back of their hand, and have produced some of its players; who have contributed massively to global music, who gave up the samba and produced the lambada

that everyone was dancing to last year in the clubs of Paris and London; and who have never, or hardly ever, been to downtown Rio. At one level they have been tremendous contributors to what we call time-space compression; and at another level they are imprisoned in it.

This is, in other words, a highly complex social differentiation. There are differences in the degree of movement and communication, but also in the degree of control and initiation. The ways in which people are placed within 'time-space compression' are highly complicated and extremely varied.

But this in turn immediately raises questions of politics. If time-space compression can be imagined in that more socially formed, socially evaluative and differentiated way, then there may be here the possibility of developing a politics of mobility and access. For it does seem that mobility, and control over mobility, both reflects and reinforces power. It is not simply a question of unequal distribution, that some people move more than others, and that some have more control than others. It is that the mobility and control of some groups can actively weaken other people. Differential mobility can weaken the leverage of the already weak. The time-space compression of some groups can undermine the power of others. [...]

But this way of thinking about time-space compression also returns us to the question of place and a sense of place. How, in the context of all these socially varied time-space changes do we think about 'places'? In an era when, it is argued, 'local communities' seem to be increasingly broken up, when you can go abroad and find the same shops, the same music as at home, or eat your favourite foreign-holiday food at a restaurant down the road – and when everyone has a different experience of all this – how then do we think about 'locality'?

Many of those who write about time-space compression emphasize the insecurity and unsettling impact of its effects, the feeling of vulnerability which it can produce. Some therefore go on from this to argue that, in the middle of all this flux, people desperately need a bit of peace and quiet – and that a strong sense of place, or locality, can form one kind of refuge from the hubbub. So the search after the 'real' meanings of places, the unearthing of heritages and so forth, is interpreted as being, in part, a response to desire for fixity and for security of identity in the middle of all the movement and change. A 'sense of place', of rootedness, can provide – in this form and on this interpretation – stability and a source of unproblematical identity. In that guise, however, place and the spatially local are then rejected by many progressive people as almost necessarily reactionary. They are interpreted as an evasion; as a retreat from the (actually unavoidable) dynamic and change of 'real life', which is what we must seize if we are to change things for the better. On this reading, place and locality are foci for a form of romanticized escapism from the real business of the world.

While 'time' is equated with movement and progress, 'space'/'place' is equated with stasis and reaction.

There are some serious inadequacies in this argument. There is the question of why it is assumed that time-space compression will produce insecurity. There is the need to face up to – rather than simply deny – people's need for attachment of some sort, whether through place or anything else. None the less, it is certainly the case that there is indeed at the moment a recrudescence of some very problematical senses of place, from reactionary nationalisms to competitive localisms, to introverted obsessions with 'heritage'. We need, therefore, to think through what might be an adequately progressive sense of place, one which would fit in with the current global-local times and the feelings and relations they give rise to, and which would be useful in what are, after all, political struggles often inevitably based on place. The question is how to hold on to that notion of geographical difference, of uniqueness, even of rootedness if people want that, without being reactionary. [...]

There are a number of distinct ways in which the 'reactionary' notion of place described above is problematical. One is the idea that places have single, essential, identities. Another is the idea that place – the sense of place – is constructed out of an introverted, inward-looking history based on delving into the past for internalized origins, translating the name from the Domesday Book. [...] A particular problem with this conception of place is that it seems to require the drawing of boundaries. Geographers have long been exercised by the problem of defining regions, and this question of 'definition' has almost always been reduced to the issue of drawing lines around a place. I remember some of my most painful times as a geographer have been spent unwillingly struggling to think how one could draw a boundary around somewhere like the 'east midlands'. But that kind of boundary around an area precisely distinguishes between an inside and an outside. It can so easily be yet another way of constructing a counterposition between 'us' and them'.

And yet, if one considers almost any real place, and certainly one not defined primarily by administrative or political boundaries, these supposed characteristics have little real purchase.

Take, for instance, a walk down Kilburn High Road, my local shopping centre. It is a pretty ordinary place, north-west of the centre of London. Under the railway bridge the newspaper stand sells papers from every county of what my neighbours, many of whom come from there, still often call the Irish Free State. The postboxes down the High Road, and many an empty space on a wall, are adorned with the letters IRA. Other available spaces are plastered this week with posters for a special meeting in remembrance: Ten Years after the Hunger Strike. At the local theatre Eamon Morrissey has a one-man show; the National Club

has the Wolfe Tones on, and at the Black Lion there's *Finnegan's Wake*. In two shops I notice this week's lottery ticket winners: in one the name is Teresa Gleeson, in the other, Chouman Hassan.

Thread your way through the often almost stationary traffic diagonally across the road from the news stand and there's a shop which as long as I can remember has displayed saris in the window. Four life-sized models of Indian women, and reams of cloth. On the door a notice announces a forthcoming concert at Wembley Arena: Anand Miland presents Rekha, live, with Aamir Khan, Salman Khan, Jahi Chawla and Raveena Tandon. On another ad, for the end of the month, is written, 'All Hindus are cordially invited'. In another newsagents I chat with the man who keeps it, a Muslim unutterably depressed by events in the Gulf, silently chafing at having to sell the Sun. Overhead there is always at least one aeroplane – we seem to have on a flight-path to Heathrow and by the time they're over Kilburn you can see them clearly enough to tell the airline and wonder as you struggle with your shopping where they're coming from. Below, the reason the traffic is snarled up (another odd effect of time-space compression!) is in part because this is one of the main entrances to and escape routes from London, the road to Staples Corner and the beginning of the M1 to 'the North'.

This is just the beginnings of a sketch from immediate impressions but a proper analysis could be done of the links between Kilburn and the world. And so it could for almost any place.

Kilburn is a place for which I have a great affection; I have lived there many years. It certainly has 'a character of its own'. But it is possible to feel all this without subscribing to any of the static and defensive – and in that sense reactionary – notions of 'place' which were referred to above. First, while Kilburn may have a character of its own, it is absolutely not a seamless, coherent identity, a single sense of place which everyone shares. It could hardly be less so. People's routes through the place, their favourite haunts within it, the connections they make (physically, or by phone or post, or in memory and imagination) between here and the rest of the world vary enormously. If it is now recognized that people have multiple identities then the same point can be made in relation to places. Moreover, such multiple identities can either be a source of richness or a source of conflict, or both. [...]

Not only does 'Kilburn', then, have many identities (or its full identity is a complex mix of all these) it is also, looked at in this way, absolutely *not* introverted. It is (or ought to be) impossible even to begin thinking about Kilburn High Road without bringing into play half the world and a considerable amount of British imperialist history (and this certainly goes for mining villages too). Imagining it this way provokes in you (or at least in me) a really global sense of place.

And finally, in contrast the way of looking at places with the defensive reactionary view, I certainly could not begin to, nor would I want to, define 'Kilburn' by drawing its enclosing boundaries.

So, at this point In the argument, get back in your mind's eye on a satellite; go right out again and look back at the globe. This time, however, imagine not just all the physical movement, nor even all the often invisible communications, but also and especially all the social relations, all the links between people. Fill it in with all those different experiences of time-space compression. For what is happening is that the geography of social relations is changing. In many cases such relations are increasingly stretched out over space. Economic, political and cultural social relations, each full of power and with internal structures of domination and subordination, stretched out over the planet at every different level, from the household to the local area to the international.

It is from that perspective that it is possible to envisage an alternative interpretation of place. In this interpretation, what gives a place its specificity is not some long internalized history but the fact that it is constructed out of a particular constellation of social relations, meeting and weaving together at a particular locus. If one moves in from the satellite towards the globe, holding all those networks of social relations and movements and communications in one's head, then each 'place' can be seen as a particular, unique, point of their intersection. It is, indeed, a meeting place. Instead then, of thinking of places as areas with boundaries around, they can be imagined as articulated moments in networks of social relations and understandings, but where a larger proportion of those relations, experiences and understandings are constructed on a far larger scale than what we happen to define for that moment as the place itself, whether that be a street, or a region or even a continent. And this in turn allows a sense of place which is extroverted, which includes a consciousness of its links with the wider world, which integrates in a positive way the global and the local.

This is not a question of making the ritualistic connections to 'the wider system' – the people in the local meeting who bring up international capitalism every time you tryto have a discussion about rubbish-collection – the point is that there are real relations with real content – economic, political, cultural – between any local place and the wider world in which it is set. In economic geography the argument has long been accepted that it is not possible to understand the 'inner city', for instance its loss of jobs, the decline of manufacturing employment there, by looking only at the inner city. Any adequate explanation has to set the inner city in its wider geographical context. Perhaps it is appropriate to think how that kind of understanding could be extended to the notion of a sense of place.

These arguments, then, highlight a number of ways in which a progressive concept of place might be developed. First of all, it is absolutely not static. If places

can be conceptualized in terms of the social interactions which they tie together, then it is also the case that these interactions themselves are not motionless things, frozen in time. They are processes. One of the great one-liners in Marxist exchanges has for long been, 'Ah, but capital is not a thing, it's a process.' Perhaps this should be said also about places, that places are processes, too.

Second, places do not have boundaries in the sense of divisions which frame simple enclosures. 'Boundaries' may be of course be necessary, for the purposes of certain types of studies for instance, but they are not necessary for the conceptualization of a place itself. Definition in this sense does not have to be through simple counterposition to the outside; it can come, in part, precisely through the particularity of linkage to that 'outside' which is therefore itself part of what constitutes the place. This helps get away from the common association between penetrability and vulnerability. For it is this kind of association which makes invasion by newcomers so threatening.

Third, clearly places do not have single, unique 'identities'; they are full of internal conflicts. Just think, for instance, about London's Docklands, a place which is at the moment quite clearly defined by conflict: a conflict over what it past has been (the nature of its 'heritage'), conflict over what should be its present development, conflict over what could be its future.

Fourth, and finally, none of this denies place nor the importance of the uniqueness of place. The specificity of place is continually reproduced, but it is not a specificity which results from some long, internalized history. There are a number of sources of this specificity – the uniqueness of place.[2] There is the fact that the wider social relations in which places are set are themselves geographically differentiated. Globalization (in the economy, or in culture, or in anything else) does not entail simply homogenization. On the contrary, the globalization of social relations is yet another source of (the reproduction of) geographical uneven development, and thus of the uniqueness of place. There is the specificity of place which derives from the fact that each place is the focus of a distinct *mixture* of wider and more local social relations. There is the fact that this very mixture together in one place may produce effects which would not have happened otherwise. And finally, all these relations interact with and take a further element of specificity from the accumulated history of a place, with that history itself imagined as the product of layer upon layer of different sets of linkages, both local and to the wider world. [...]

It is a sense of place, an understanding of 'its character', which can only be constructed by linking that place to places beyond. A progressive sense of place would recognize that, without being threatened by it. What we need, it seems to me, is a global sense of the local, a global sense of place.

1 [footnote 2 in source] Deborah Birkett, in *New Statesman and Society* (15 March 1991) 38.

2 [4] Doreen Massey, *Spatial Divisions of Labour: Social Structures and the Geography of Production* (Basingstoke: Macmillan, 1984).

Doreen Massey, 'A Global Sense of Place', in *Marxism Today* (June 1991) 24–9; reprinted in Trevor Barnes and Derek Gregory, eds, *Reading Human Geography: The Poetics and Politics of Inquiry* (London and New York: Arnold, 1997) 315–23.

Marc Augé
From Places to Non-Places//1995

[...] The hypothesis advanced here is that supermodernity produces non-places, meaning spaces which are not themselves anthropological places and which, unlike Baudelairian modernity, do not integrate the earlier places: instead these are listed, classified, promoted to the status of 'places of memory', and assigned to a circumscribed and specific position. A world where people are born in the clinic and die in the hospital, where transit points and temporary abodes are proliferating under luxurious or inhuman conditions (hotel chains and squats, holiday clubs and refugee camps, shanty towns threatened with demolition or doomed to festering longevity); where a dense network of means of transport which are also inhabited spaces is developing; where the habitué of supermarkets, slot machines and credit cards communicates wordlessly, through gestures, with an abstract, unmediated commerce; a world thus surrendered to solitary individuality, to the fleeting, the temporary and ephemeral, offers the anthropologist (and others) a new object, whose unprecedented dimensions might usefully be measured before we start wondering to what sort of gaze it may be amenable. We should add that the same things apply to the non-place as to the place. It never exists in pure form; places reconstitute themselves in it; relations are restored and resumed in it; the 'millenial ruses' of 'the invention of the everyday' and 'the arts of doing', so subtly analysed by Michel de Certeau, can clear a path there and deploy their strategies. Place and non-place are rather like opposed polarities: the first is never completely erased, the second never totally completed; they are like palimpsests on which the scrambled game of identity and relations is ceaselessly rewritten. But non-places are the real measure of our time; one that

could be quantified – with the aid of a few conversions between area, volume and distance – by totalling all the air, rail and motorway routes, the mobile cabins called 'means of transport' (aircraft, trains and road vehicles), the airports and railway stations, hotel chains, leisure parks, large retail outlets, and finally the complex skein of cable and wireless networks that mobilize extraterrestrial space for the purposes of a communication so peculiar that it often puts the individual in contact only with another image of himself.

The distinction between places and non-places derives from the opposition between place and space. An essential preliminary here is the analysis of the notions of place and space suggested by Michel de Certeau. He himself does not oppose 'place' and 'space' in the way that 'place' is opposed to 'non-place'. Space, for him, is a 'frequented place', 'an intersection of moving bodies': it is the pedestrians who transform a street (geometrically defined as a place by town planners) into a space. [...]

Space, as frequentation of *places* rather than a place, stems in effect from a double movement: the traveller's movement, of course, but also a parallel movement of the landscapes – which he catches only in partial glimpses, a series of 'snapshots' piled hurriedly into his memory and, literally, recomposed in the account he gives of them, the sequencing of slides in the commentary he imposes on his entourage when he returns. Travel (something the ethnologist mistrusts to the point of 'hatred'[1]) constructs a fictional relationship between gaze and landscape. And while we use the word 'space' to describe the frequentation of *places* which specifically defines the journey, we should still remember that there are spaces in which the individual feels himself to be a spectator without paying much attention to the spectacle. As if the position of spectator were the essence of the spectacle, as if basically the spectator in the position of a spectator were his own spectacle. A lot of tourism leaflets suggest this deflection, this reversal of the gaze, by offering the would-be traveller advance images of curious or contemplative faces, solitary or in groups, gazing across infinite oceans, scanning ranges of snow-capped mountains or wondrous urban skylines: his own image in a word, his anticipated image, which speaks only about him but carries another name (Tahiti, Alpe d'Huez, New York). The traveller's space may thus be the archetype of *non-place*. [...]

1 [footnote 5 in source] 'Je haïs les voyages et les explorations ...' – Claude Lévi-Strauss, *Tristes Tropiques* (Paris: Plon, 1955). [Tr.]

Marc Augé, extract from *Non-Places: Introduction to an Anthropology of Supermodernity* (Paris, 1992); trans. John Howe (London and New York: Verso, 1995) 78–80; 85–6.

Arjun Appadurai
The Production of Locality//1996

[...] It is one of the grand clichés of social theory (going back to Ferdinand Tönnies, Max Weber and Émile Durkheim) that locality as a property or diacritic of social life comes under siege in modern societies. But locality is an inherently fragile social achievement. Even in the most intimate, spatially confined, geographically isolated situations, locality must be maintained carefully against various kinds of odds. These odds have at various times and places been conceptualized differently. In many societies, boundaries are zones of danger requiring special ritual maintenance; in other sorts of societies, social relations are inherently fissive, creating a persistent tendency for some neighbourhoods to dissolve. In yet other situations, ecology and technology dictate that houses and inhabited spaces are forever shifting, thus contributing an endemic sense of anxiety and instability to social life.

Much of what we call the ethnographic record can be rewritten and reread from this point of view. In the first instance, a great deal of what have been termed *rites of passage* are concerned with the production of what we might call *local subjects*, actors who properly belong to a situated community of kin, neighbours, friends and enemies. Ceremonies of naming and tonsure, scarification and segregation, circumcision and deprivation are complex social techniques for the inscription of locality onto bodies. Looked at slightly differently, they are ways to embody locality as well as to locate bodies in socially and spatially defined communities. The spatial symbolism of rites of passage has probably been paid less attention than its bodily and social symbolism. Such rites are not simply mechanical techniques for social aggregation but social techniques for the production of 'natives'. [...]

What is true of the production of local subjects in the ethnographic record is as true of the processes by which locality is materially produced. The building of houses, the organization of paths and passages, the making and remaking of fields and gardens, the mapping and negotiation of transhuman spaces and hunter-gatherer terrains is the incessant, often humdrum preoccupation of many small communities studied by anthropologists. These techniques for the *spatial* production of locality have been copiously documented. But they have not usually been viewed as instances of the production of locality, both as a general property of social life and as a particular valuation of that property. Broken down descriptively into technologies for house building, garden cultivation, and the like, these material outcomes have been

taken as ends in themselves rather than as moments in a general technology (and teleology) of localization.

The production of locality in the societies historically studied by anthropologists (on islands and in forests, agricultural villages and hunting camps) is not simply a matter of producing local subjects as well as the very neighbourhoods that contextualize these subjectivities. As some of the best work in the social logic of ritual in the past few decades so amply shows [...], space and time are themselves socialized and localized through complex and deliberate practices of performance, representation and action. We have tended to call these practices *cosmological* or *ritual* – terms that by distracting us from their active, intentional and productive character create the dubious impression of mechanical reproduction. [...]

Much that has been considered local knowledge is actually knowledge of how to produce and reproduce locality under conditions of anxiety and entropy, social wear and flux, ecological uncertainty and cosmic volatility, and the always present quirkiness of kinsmen, enemies, spirits and quarks of all sorts. The locality of local knowledge is not only, or even mainly, its embeddedness in a non-negotiable here and now or its stubborn disinterest in things at large. [...] Local knowledge is substantially about producing reliably local subjects as well as about producing reliably local neighbourhoods within which such subjects can be recognized and organized. In this sense, local knowledge is what it is not principally by contrast with other knowledges – which (from some non-local point of view) the observer might regard as less localized – but by virtue of its local teleology and ethos. We might say, adapting Marx, that local knowledge is not only local in itself but, even more important, for itself. [...]

I have so far focused on locality as a phenomenological property of social life, a structure of feeling that is produced by particular forms of intentional activity and that yields particular sorts of material effects. Yet this dimensional aspect of locality cannot be separated from the actual settings in and through which social life is reproduced. To make the link between locality as a property of social life and neighbourhoods as social forms requires a more careful exposition of the problem of context. The production of neighbourhoods is always historically grounded and thus contextual. That is, neighbourhoods are inherently what they are because they are opposed to something else and derive from other, already produced neighbourhoods. In the practical consciousness of many human communities, this something else is often conceptualized ecologically as forest or wasteland, ocean or desert, swamp or river. Such ecological signs often mark boundaries that simultaneously signal the beginnings of non-human forces and categories or recognizably human but barbarian or demonic forces. Frequently, these contexts, against which neighbourhoods are produced and figured, are at once seen as ecological, social and cosmological terrains. [...]

The task of producing locality (as a structure of feeling, a property of social life and an ideology of situated community) is increasingly a struggle. There are many dimensions to this struggle, and I shall focus here on three:

(1) the steady increase in the efforts of the modern nation state to define all neighbourhoods under the sign of its forms of allegiance and affiliation;

(2) the growing disjuncture between territory, subjectivity and collective social movement; and

(3) the steady erosion – principally due to the force and form of electronic mediation – of the relationship between spatial and virtual neighbourhoods.

To make things yet more complex, these three dimensions are themselves interactive.

The nation state relies for its legitimacy on the intensity of its meaningful presence in a continuous body of bounded territory. It works by policing its borders, producing its people, constructing its citizens, defining its capitals, monuments, cities, waters and soils, and by constructing its locales of memory and commemoration, such as graveyards and cenotaphs, mausoleums and museums. The nation state conducts throughout its territories the bizarrely contradictory project of creating a flat, contiguous and homogeneous space of nationness and simultaneously a set of places and spaces (prisons, barracks, airports, radio stations, secretariats, parks, marching grounds, processional routes) calculated to create the internal distinctions and divisions necessary for state ceremony, surveillance, discipline and mobilization. These latter are also the spaces and places that create and perpetuate the distinctions between rulers and ruled, criminals and officials, crowds and leaders, actors and observers.

Through apparatuses as diverse as museums and village dispensaries, post offices and police stations, tollbooths and telephone booths, the nation state creates a vast network of formal and informal techniques for the nationalization of all space considered to be under its sovereign authority. States vary, of course, in their ability to penetrate the nooks and crannies of everyday life. Subversion, evasion and resistance, sometimes scatological, sometimes ironic, sometimes covert, sometimes spontaneous and sometimes planned, are very widespread. Indeed, the failures of nation states to contain and define the lives of their citizens are writ large in the growth of shadow ecnomies, private and quasi-private armies and constabularies, secessionary nationalisms and a variety of nongovernmental organizations that provide alternatives to the national control of the means of subsistence and justice. [...]

The three factors that most directly affect the production of locality in the world of the present – the nation state, diasporic flows, and electronic and virtual communities – are themselves articulated in variable, puzzling, sometimes contradictory ways that depend on the cultural, class, historical and

ecological setting within which they come together. In part, this variability is itself a product of the way that today's ethnoscapes interact irregularly with finance, media and technological imaginaries. [...]

The many displaced, deterritorialized and transient populations that constitute today's ethnoscapes are engaged in the construction of locality, as a structure of feeling, often in the face of the erosion, dispersal and implosion of neighbourhoods as coherent social formations. This disjuncture between neighbourhoods as social formations and locality as a property of social life is not without historical precedent, given that long-distance trade, forced migrations, and political exits are very widespread in the historical record. What is new is the disjuncture between these processes and the mass-mediated discourses and practices (including those of economic liberalization, multiculturalism, human rights and refugee claims) that now surround the nation state. This disjuncture, like every other one, points to something conjunctural. The task of theorizing the relationship between such disjunctures and conjunctures that account for the globalized production of difference now seems both more pressing and more daunting. In such a theory, it is unlikely that there will be anything mere about the local. [...]

Arjun Appadurai, 'The Production of Locality', *Modernity at Large: Cultural Dimensions of Globalization* (Minneapolis: University of Minnesota Press, 1996) 179–80; 182–3; 189–90; 198.

Geeta Kapur
subTerrain: Artworks in the Cityfold//2007

Politics of Place

As art gains ever higher visibility through globalization, the politics of place – community, country, region, nation, even the margin or exile – tends to lose the privilege of direct address. I suggest an investigation of the interstices of urban archipelagos to obtain subversive signs of place and belonging in and through the practice of art.

The rights of belonging were won by large populations of ordinary people as new continents of possibility in the process of decolonization. The ideologies of these liberatory claims were subsequently elaborated and critiqued by postcolonial discourse. With the triumph of global capital, the ground won in the cause of self-determination may have become only a marker of national territory.

Further, the global malediction of greed is likely to encourage elites of the world to make common cause with the twenty-first century's super-imperialist nations.

I propose to situate the artist (here, the Indian artist) in an uneasy 'subterrain' of the contemporary where she/he reclaims memory and history; where the levelling effect of the ahistorical no-nation, no-place phenomenon promoted by globalized exhibition and market circuits is upturned to rework a passage back into the politics of place. Then, as we reckon with the loss and gain of place, we may discover forms of absence mediated by a public performance of subjectivity whereby the artist tries to re-place the self in the contemporary historical moment. But even such an expression of subjectivity that can count for political is now likely to be ironical and elusive rather than direct. [...]

My larger theoretical and curatorial intention is to unmask the postmodern aesthetic of global negotiation and rescue at least a residual politics wherein the artist as citizen dreams of a more democratic and just society. My focus is on art practice in the social, political and psychic 'subterrain' of Third-World 'global cities'. Here too the contemporary surfaces in the wake of a deconstructed modernity that once valorized the rebel artist and set up a masquerade around Freud's theme of 'civilization and its discontents'. The revolutionary working-class history of the twentieth century and subsequent history of decolonization added new contours to civilizational discourse by revealing the vast limitations of a Eurocentric universe. Differently situated modern artists emerging across the Third World reshaped the political unconscious of the contemporary. The relatively privileged interlocutor – the artist – now assumed the position of an underprivileged subject in an unequal social order characterizing the Third World, and this led to located interventions in and through art.

In India, artists have often identified with the bearer of subaltern consciousness (peasants, but also workers, women, and categories of the oppressed such as religious minorities, caste-ordained 'untouchables' and modern-day *dalits*). In this transaction of identities, the artist as citizen accepts the pressures of a turbulently unsettled society and makes it the very task of art practice to try and hold off oppressive ideologies: in present-day India, those of right-wing nationalism and coercive globalization. The recognition of new forms of marginalization, promoted by hegemonic combines of the national and global, sharpens the language of art.

The responsible and transgressive artist-citizen is one who can imagine appropriate forms of praxis in historically specific situations and also wider solidarity with exemplary artists across the world. The twentieth-century figure of the romantic exile or flâneur is now too easily subsumed by global travellers. I speak instead on behalf of artists who struggle from within the rapidly changing and competitive but systematically ravaged Third World and who make art

practice a politically viable proposition by articulating criticism, dissent and transformation in the 'norms' of civil society at the level of the everyday. [...]

Return to Place

The metropolis has faced almost two hundred years of critique based primarily on the single complex issue of alienation; but it has also for as long and in equal measure attracted the most passionate and often utopian engagement. The metropolitan exile has defined the very terms of modernity, especially those of representation in modernist art practices and most emphatically in the cinema. Now, in the vastly extended, less romantic but still obsessional discourse, the city virtually exhausts the resources of every discipline.

A contemporary telescoping of city, place and circumstance is found in Vivan Sundaram's 2003 installation project *New New Delhi: Room with Bed,* constructed in collaboration with Romi Khosia, Ram Rahman, Raqs Media Collecive, Shantanu Lodh and Manmeet. In an adjoining set of rooms (small in actuality but relatively monumental in a gallery space), the basic unit of a habitat, a room with a bed, is presented as a dismantlable 'site-specific' structure and a condensed site for viewers' participation in the poetics and politics of urban space: *situation Delhi.* [For detail please see *Third Text* source cited below, 293–5]

Delhi has taken decades to assume its shape as a metropolis in the cultural imaginary of the nation and has only recently become an urgent topic of discourse and activism. Now it is time to talk about a new New Delhi – beyond the mediaeval city of Islamic dynasties, beyond its imperial status as a twentieth-century colonial capital and even beyond the post-Partition city of north Indian refugees – a city that has become the territorially expanding, annexing and globalizing capital of the Indian state. Delhi's new middle class has overrun indigenous small industry and trading communities by multiplication of politicians, civil servants and service-sector employees, but is in turn imbricated in terms of labour, services and space with poor migrants, usually impoverished villagers, coming in great waves from the hinterland to work as daily-wage labour. These disparate groups carve out sector after sector of new housing colonies – from elite enclaves to 'slums', from extra-legal real estate gambles to 'illegal squatter' colonies. It is this Delhi, spreading into the vast neighbouring provinces like a corporate and suburban giant, that encourages the creation of an aggressive neo-native identity and a new ethics of survival. And this is at the hub of a representational drive by artists and media practitioners situated in Delhi. [...]

Geeta Kapur, extract from 'subTerrain: artworks in the cityfold', *Third Text*, no. 86 (vol. 21, no. 3) (2007) 277; 278; 292–3; 295. First version published in *Body. City: Siting Contemporary Culture in India*, ed. Indira Chandrasekhar, Peter C. Seel (Berlin: House of World Cultures/Delhi: Tulika Books, 2003).

T.J. Demos
Desire in Diaspora: Emily Jacir//2003

'If I could do anything for you, anywhere in Palestine, what would it be?' This question was recently posed to Palestinian exiles by Palestinian American artist Emily Jacir. Taking advantage of her ability to move about relatively freely in Israel with an American passport, Jacir promised to realize the desires of those forbidden entry into their homeland. A series of texts, black lettering on white panels, describes the various requests. Colour photographs, presented by their side, document Jacir's actualization of them. The project is titled *Where We Come From* (2003). 'Go to my mother's grave in Jerusalem on her birthday and put flowers and pray', reads one plea in Arabic and English. The text tells us that the man who made it, Munir, lives a few kilometers away in Bethlehem but was denied access to Jerusalem by the Israeli authorities. Consequently, he could not visit his mother's grave on the anniversary of her death. Jacir could. A photograph shows her shadow floating over the tombstone as she carries out the task. It is a fleeting presence that is rather a painful absence. If it fulfils a desire, it remains phantasmic, vicarious.

As with the work of Ayreen Anastas, Mona Hatoum and Rashid Masharawi, other artists who deal with the Palestinian diaspora, it is perhaps the complexity of exile that drives Jacir to neo-conceptual strategies: the photo-text presentation, the linguistic dimension, the task-based performance, the statistical survey of responses, the use of the newspaper advertisement, the artist as service provider. Through such models, the condition of exile that is her subject emerges within her work, drifting between mediums, producing material dislocations, necessitating physical travel, leading to collaborations with diasporic communities. More, Jacir takes up recent reconfigurations of site specificity, in which the once-grounded art object, moored to its geographical site (as in post-Minimalist sculpture), has given way to deterritorialization in artistic practices of the 1990s. The stress now falls on 'discursive' redefinition of site, on recognitions of the impossibility of geographical delimitation due to institutional or capitalist pressures that throw the object – or its uprooted reproductions – into a circulating marketplace, or again, alternately, change the context of the site-specific work.[1] Jacir's project, similarly, is thoroughly defined by the experimental crisis of displacement, far from the self-assuring phenomenology of site specificity and the access to location that it took for granted. But this turn away from site specificity is due not only to the discursive, legalistic, economic and national conditions of the framework she investigates – the Palestinian diaspora – which obviously resists

any reductive geographical delimitation. And it arises not only from the fragmented status of her objects and performances – which stretch across a variety of mediums (sculpture, text, photography, video, and so on), distribution mechanisms (galleries, newspapers, commercial outlets), and geographical sites (Israel/Palestine, Texas, New York City). It is also because, in one sense, there is no such thing as site specificity for exiles.

The impossibility of sitedness explains why exile is such a ravaging experience, resulting even in a form of mutilation, as those who have experienced it testify: exile represents 'the unhealable rift between a human being and a native place, between self and its true home', a rift that separates one from 'the nourishment of tradition, family, and geography'.[2] Were the exile to latch on to any site, it appears, the attachment would too easily be exposed as compensatory or nostalgic, reactionary or escapist. Consequently, *Where We Come From*, like much of Jacir's work, concerns the (im)possibility of movement, rather than the plausibility of sitedness. Its locus – where we come from – can only be imagined, not physically occupied. It is the forbidden centre around which exiles perpetually revolve. Yet, movement too – whether in terms of migration, exchange, travel or translation – is profoundly troubled in this work, even while often desired. Viewers face a project that is first of all divided between text panels and photographs. But how to get from one to the other? The visual transition from language to image seems simple enough. A mere shift of the eyes will do. And the descriptions involve things we often take for granted: visiting one's mother, eating food in a restaurant, playing soccer. Yet it is just this translation, written out in clear language and then realized photographically, that for many is insurmountable. Getting from written description to photographic actualization can be easy enough for some, like Jacir, who have American passports. But for other unfortunates caught up in the politics of the Israeli-Palestinian conflict that has been raging since 1948, when so many were exiled from their land, the terrain between text and photograph, description and realization, represents an unbridgeable chasm, an impossibility on which a complex of desire is built.

The piece operates, it would seem, by fulfilling desire. But whose desire? We learn, first of all, about the desires of exiles from their own requests: they yearn for family (seeing one's mother, visiting a parent's grave), they pine over homesickness (visiting the family home, recalling the old land), they wish to participate in simple everyday activities (playing soccer, walking in Nazareth), they even hold banal pragmatic concerns (paying bills, watering a tree). The requests can also be intimate. Rami asks: 'Go on a date with a Palestinian girl from East Jerusalem that I have only spoken to on the phone. As a West Banker, I am forbidden entry into Jerusalem.' The photograph shows the date that took

place at a restaurant. Across the table sits the woman, clearly not thrilled. The sometimes bureaucratic tone of the descriptions reveals the fact that even diasporic desires can become routine after so long, which is yet another tragic element: the banality of exile.

We also learn about the artist's desires: to somehow provide connections through an artistic mediation that would draw together a diasporic community, shed light on the absurdity of displacement, show the privations exiles suffer over things that most of us take for granted. Jacir's wish, it seems, is to reassemble the splinters of diaspora into a single place, into some form of narrative continuity, into an interconnected history. Yet often Jacir's performance, informed by the notes she appends to the bottom of the texts, only ends in bathos, or still more confrontations with the degraded status of Palestinian suffering, as when she fulfilled Munir's request: 'When I reached the grave of his mother, I was surprised to see a circle of tourists surrounding a grave nearby. It was the grave of Oskar Schindler … buried next to a woman whose son living a few kilometres away is forbidden to pay his respects without a permit'. The artist's own identification with the subjects is clear, as she acts out their gestures, becomes an extension of their will, becomes them, which points to the mobility of exile itself as a shifting form of identification. Polymorphous, it drifts from geographical displacements to psychic splits to ethical contradictions, and it is inhabited by the exiled and the empathic, even while the two are far from equal. [...]

The vicarious, not victorious, realization of diasporic desires that *Where We Come From* performs is, in the end, no substitute for the basic rights denied to those in exile. It is exactly that failure that wins the success of this piece. Through it we confront the absences that Jacir's service cannot fill. These instill a yearning in us, its viewers, to see some sort of resolution, to wish for an answer to the inequities of movement outside of the piece. 'If I could do anything for you, anywhere in Palestine, what would it be?' The desire this question elicits is ultimately very difficult to occupy, at least for us who are not exiles, as we can only understand it – vaguely – on the basis of what we can do. What would it be like not to be able to do these things? But neither is it a position that power can occupy, for power produces it in the first place: the structure of exile is already responsive to various occupations. A feeling of sitelessness, of a damaged life, results from the experience of requiring another to carry out the wishes that can't be performed by oneself. Consequently, one is denied the feeling of being at home in exile due to thoughts of the loss of one's home. But this is a sitelessness that is frequently relished in exile as well, a paradox perpetuated in Jacir's work: to refuse to feel at home while homeless and – perhaps perversely – to stubbornly own that homelessness, for the converse would only be a mark of resignation or of capitulation.[3]

Edward Said points out the troubling uncanniness of the Palestinian diaspora: 'to have been exiled by exiles'. What results is a mirroring frequently answered with aggressivity – to deny exile even to the exiled. For it produces a double displacement, not only of bodies from territories, but of stories from history, nations from narration. But is this not a repression that only continues the mimetic cycle, eliciting aggression in turn? Said notes, 'It is as if the reconstructed Jewish collective experience, as represented by Israel and modern Zionism, could not tolerate another story of dispossession and loss to exist alongside it – an intolerance constantly reinforced by the Israeli hostility to the nationalism of the Palestinians, who for forty-six years have been painfully reassembling a national identity in exile.'[4] The poignancy of *Where We Come From* is that it begins to tell the story of the Palestinian diaspora in a way that is both humanizing and tragic, so that an identification might take place outside of threat, an itinerant desire without hostility.

1 On this complicated history, see Miwon Kwon, *One Place after Another: Site-Specific Art and Locational Identity* (Cambridge, Massachusetts: The MIT Press, 2002).

2 Edward W. Said, 'Reflections on Exile', *Granta*, no. 13 (Autumn 1984) 159.

3 [footnote 8 in source] Theodor Adorno, writing in exile from Nazi Germany, reached a similar conclusion: 'It is part of morality not to be at home in one's home'. *Minima Moralia: Reflections from a Damaged Life*, trans. E.F.N. Jephcott (London and New York: Verso, 1991) 39.

4 [9] Said, op. cit., 164.

T.J. Demos, extract from 'Desire in Diaspora: Emily Jacir', *Art Journal* (Winter 2003) 68–78.

Patricia Falguières
Archipelago//2007

One ventures from home on the thread of a tune.[1]

It would seem that there are (at least) two ways of approaching the work of Allora and Calzadilla. Via the island where the two artists spend most of their time – one of those 'enchanted isles' located less in the Caribbean than on the outskirts of New York: Puerto Rico. Or via the itineraries that have taken them from Peru to China, from Boston to Paris, following the thread of the 'art of opportunities' that is now the regime of artists with international reputations.

But this opposition is deceptive, first of all because it opposes a 'home' to an 'elsewhere', a 'given' or a 'particular' to a 'foreign'. For, however far back their respective relations to the island may go, it does not function in their work as an 'origin'; rather, they have constructed it. To do so, they broke off a bit, a ready-made parcel isolated by American imperial history, a few cable lengths away from Puerto Rico, and identified by a long legal dispute between the Navy and a population of despoiled fishermen: the military base of Vieques.

Returning a Sound (2004) [in which a moped is shown being driven around Vieques by one of the island's residents with a trumpet attached to the exhaust pipe] traces out this territory – that is to say, it invents a map, not land, but an artefact (the territory does not pre-exist its qualifying mark; it is the mark that makes the territory). 'Home turf does not pre-exist; first you must trace a circle, just as a child walking in the dark makes his or her own Ariadne's thread by whistling. On his moped, Homar (the young fisherman whose beauty gathers about itself the heroic beauties of Eisenstein's *Que viva Mexico*) completes the triumphal circuit that acclaims the fishermen's victory over the Administration and their re-conquest of the island. But the sound that gives the triumph substance (the triumphant expressiveness of brass) is overlaid with a pattern that is very different from the familiar ribbon of the road, a grotesque and vaguely obscene hiccupping noise)[2] jumping and jolting to the jerky rhythm of the revving and accelerating, conveyed through the exhaust pipe to which it is attached. The sound is entrusted with what Deleuze called the 'line of flight' that makes the refrain (*ritornelle*): this 'marking out of a home space' is, at the same time, an invitation to leave it, to expose oneself to the great wide world by paying out the thread of an uncertain itinerary.

What, for Allora and Calzadilla, is the 'local'? It is a place that offers a grip. So many activists have readily cast themselves in the role of teacher or missionary, revealing, on-site, the local variant of a universal form of alienation (the local then becomes 'the case'). In contrast, Allora and Calzadilla approach local struggles as specific, concrete situations from which they can learn; investigation, which is the specifically human modality of knowing, has become a moment in the work of art.[3] What is at stake here is not mobilization or consciousness raising. (The fishermen did not wait for the artists to come along to be active, and Puerto Rico has a rich tradition of territorial claims, which has even extended to the American continent.)[4] To borrow the felicitous formula used by Isabelle Stengers and Philippe Pignarre in their analysis of the new modalities of political action following the 1999 G-8 Summit in Seattle, it is not a matter of convincing the misled but of finding interested partners, of finding a grip, a handle.[5] The 'problem' (here, the 'Vieques problem') is not so much what needs to be solved as what unites. The common challenge is to introduce a learning trajectory that

actually engenders the local. In other words, the local is not opposed to the universal but instead offers a handle on a collective and individual experiment; it is both a risk and a resource – a *milieu.* Allora and Calzadilla 'think through the milieu'; their relation to it is at once experimental and speculative.

Land Mark (Foot Prints) (2001–2) demonstrates this operation of capturing or gripping involved in the learning trajectory that Allora and Calzadilla apply to the Vieques enclave. [In this project the artists collaborated with individuals and activist groups to make customized shoe soles etched with personalized images and messages. The shoes were worn by participants as they walked in the off-limits militarized zone as an act of civil disobedience, leaving impressions in the sand]. *Land Mark* does not represent an event; it is the event or the occasion, the means of the event – the *event par excellence* that is the demonstration. It lasts no longer than it takes for the traces left by the demonstrators on the sand to be erased. It is the demonstration as event that signifies. The artists' intervention is a technical arrangement: the making of soles, each with different treads that demonstrators can fix to their shoes. The artists do not mobilize, they underscore the divergences within a crowd that has gathered temporarily, and thereby become a force: 'There were evangelical groups, representatives of various political parties, conservationists, students, people whose families once lived in this area, there were members of the Ricky Martin fan club who had learned about the struggle through their local website, there were anti-military activists, environmentalists of all sorts, and even a few celebrities, such as Robert F. Kennedy Jr. and Jesse Jackson from North America, just to name a few. We wanted to find a way to convey the diversity of this group in the photographs, as shown through the actual marks being produced in the sand – going in so many different directions, cancelling each other out as one footprint replaced the one that was made before'.[6]

The artists' job is to construct, for all these singularities, the plane of a shared experience: alone together. In other words, they must offer each person a handle on the event: the event is grasped from the standpoint of each person's experience of it, never in an overview that might claim to tell the truth or expose their illusions. Nothing is guaranteed, neither the future of resettlement nor of re-appropriation. On the contrary, *Returning a Sound* (2004) registers the limits of the restitution of Vieques – it observes the devastation of this enclave that must now be resettled. Nothing has been restored, reclaimed; one can only walk between and around the bomb craters and rocket silos, in the interstices of a contaminated environment. Allora and Calzadilla have learned from Matta-Clark (the Matta-Clark of the *Reality Properties: Fake Estates* [1973–74], who bought up useless slivers of land between New York buildings, on which nothing could be built) the art of approaching their material as a milieu (medium) for

interstices, fault lines, and fissures. This, according to Isabelle Stengers, illustrates the meaning of Deleuze's expression, 'penser par le milieu' (thinking through the milieu, but also the middle): 'the interstice is defined neither against nor in relation to the block to which it nevertheless belongs. It creates its own dimensions out of the concrete processes that give it its substance and its scope, its import and that for which it is important'.[7] To make an interstice or make the interstice work, to 'think through the milieu', is to be capable of following and creating the dimensions required by a 'situation'.

The word 'situation' is often misunderstood. A kind of cultivated reflex associates it with Situationism (which label is itself dubious, as a close reading of Guy Debord shows). But Allora and Calzadilla do not cast themselves in the role of those who have understood, of those who pit themselves against the world by identifying with the theory of demystification. They do not distinguish between two worlds, the world of reality and the world of experience (with the former pre-existing the latter, and the latter acquiring legitimacy in so far as it verifies the ineluctability of the former) – In the work of Allora and Calzadilla we recognize the radical empiricism of a very different philosophical tradition: there is nothing beyond experience, beyond the never-ending process of learning about the world as one experiences it – a philosophical phylum for which the empirical is the transcendental, and which obliges us to do away with the categories form/matter, truth/appearance, and substance/attributes. As William James puts it, 'What really exists is not things made, but things in the making.'[8] It is this process which, after the event, distributes functions and roles and names like so many local accents of the experience, like so many coordinates or positional names that make it possible to go from the initial 'this' to the 'here', 'there', 'now', 'I', 'we'.[9] [...]

1 Gilles Deleuze, Félix Guattari, *A Thousand Plateaux*, trans. Brian Massumi (London: Continuum, 2004) 344.

2 The French word 'pétarader' usually employed to describe the racket of mopeds with neutralized silencers neatly underscores the incongruity of the association of exhaust pipe and trumpet.

3 See the Vieques dossier put together by C & A in *Land Mark* (Paris: Palais de Tokyo, 2006).

4 See the Young Lords movements in Chicago and New York during the 1960s, which have become a model of contemporary urban ecology movements. CF. Matthew Gandy, *Concrete and Clay: Reworking Nature in New York City* (Cambridge, Massachusetts: The MIT Press, 2002); Benedikte Zitouni, 'Ecologie urbaine: mode d'existence? mode de revendication?', in *Cosmopolitiques*, no. 7 (August 2004).

5 Philippe Pignarre and Isabelle Stengers, *La sorcellerie capitaliste: Pratiques de désevoûtement* (Paris: La Découverte, 2006).

6 *Land Mark*, op. cit.

7 *La sorcellerie capitaliste*, op. cit.

8 William James, *A Pluralistic Universe* (Whitefish: MT Kessinger Publishing, 2005) 263.

9 See the excellent commentary by David Lapoujade, in *William James: Empirisme et pragmatisme* (Paris: Les Empêcheurs de penser en rond, 2007).

Patricia Falguieres, extract from 'Archipelago: Jennifer Allora and Guillermo Calzadilla', trans. Charles Penwarden, *Parkett*, no. 80 (2007) 30–35.

Daniel Birnbaum
The Lay of *the land*//2005

It's already evening when I arrive by car at *the land*, an artists' community in northern Thailand initiated by Kamin Lertchaiprasert and Rirkrit Tiravanija in 1998. Dusk is falling, and the fire that keeps the water buffalo warm at night will soon be lit. The buffalo themselves are already on their way to a familiar spot next to a small pond; slowly and majestically they approach across the vast rice fields. Behind them, in the distance, are the mountains that surround these agricultural flatlands. This is the village of Sanpatong, some twenty minutes outside the northern provincial capital, Chiang Mai, a rapidly growing city of some two hundred thousand people. Hot rain is falling from the skies – in fact, it's pouring – and we find shelter in one of the pavilions huddled around the pond. I entered this structure once before, in its previous life as a work of art in a European institution. Designed by Tobias Rehberger, it was displayed at Stockholm's Moderna Museet in 2000, before being dismantled and shipped across the globe to this rural and, needless to say, less visible site. It now serves as temporary home to one of the inhabitants of *the land*. It may still be a sculptural work, but now it has been put to use. A few belongings (a backpack, sneakers, a few books) make clear that someone is, in fact, living in this basic but elegant three-story wooden structure on stilts overlooking the pond. Spread out in the landscape are a number of other modest structures designed by Lertchaiprasert and Tiravanija themselves and by artist friends from around the world. [...] *The land* isn't a commune in the normal sense, because the artists realizing projects there have done so primarily for the benefit of others. The inhabitants – perhaps 'users' is a better term – are a mix of local artists, a few farmers, and a small group of students.

The land [is] to be cultivated as an open space, though with certain intentions toward community, toward discussion, and toward experimentation in [various]

fields of thought', according to an official – and no doubt deliberately vague – statement of intent that makes clear that other fields besides art are part of the experiment. So, what is *the land*? A sculpture garden? A huge artist-run space emphasizing interdisciplinary and collaborative practices? A commune in search of new forms of being in the world? Or is it, if not a collaborative artwork by Tiravanija and his colleagues, then at least an extension of his practice beyond the institution? Probably all of these things, but not quite in the way we tend to understand them in Europe and the United States, where the very idea of a commune simultaneously gives rise to a murky nostalgia and to skepticism, even to a sense of revulsion – conjuring thoughts of monstrous gurus, psychological terror and sexual oppression. The truth, however, couldn't be less dark.

The land's land – no one seems to know the precise acreage, but you can walk the length of it in three or four minutes – was acquired seven years ago for a modest sum (roughly ten thousand US dollars) by the two founders, but each is eager to point out the irrelevance of the notion of property to their endeavour. Lertchaiprasert, who is showing me around, is critical of the art world's rush to label the collective effort an art project, thus defining it according to standards set elsewhere. 'It's more about finding new ways of being together', he says. 'That's how it started, and that is the real significance of what's going on here. A group of artists has come together to find out if there are other ways of working together and producing things. Not just art but, more important, things to eat, like fruit, herbs, greens, and other vegetables.' Lertchaiprasert emphasizes that the projects on *the land* all have a practical function. 'They actually do work', he emphasizes, 'and that's important. It's about learning by doing.'

The projects at *the land* are not primarily meant to be contemplated aesthetically but rather to be used. So what does the praxis consist in? On the one hand, farmers and local artists work the fields together. With the support of a student group from Chiang Mai University, rice is harvested not seasonally but year-round. Some three thousand pounds are consumed by the community at *the land* and by a number of AIDS patients in the local village. [...]

People come for short periods to realize works', Tiravanija observes. 'Often they're just here for a few days. Then they have to leave, and return only two years later to attend to what they've built. It's all very different from an exhibition – more unpredictable, more open.' And yet Tiravanija does recognize that his position at *the land* is not so different from his role in the art world. 'In both contexts', he notes, 'I play the host.' *The land* is proof more of the extension of today's art world to places far from the centres of commerce rather than of Tiravanija's ambition to break out of the traditional art circuit. Even if many aspects of *the land* don't fit the typical art-world categories, what is happening there is – whatever else it may be – also unavoidably art.

Like most of Tiravanija's projects and interventions, *the land* is also about integrating and reacting to the local. In Sanpatong, he is something of an ambassador who travels the world and brings back interesting people and ideas, whereas Lertchaiprasert is more closely involved with the local community and has strong ties in Chiang Mai as well. The international presence of artists, writers and curators at *the land* can be quite intense, even overwhelming to some of the more long-term inhabitants, and Lertchaiprasert, who on occasion complains about 'art tourism', sometimes gets bored with giving people like myself guided tours. Since most of the art stars whose projects have made *the land* famous in art circles are seen here only on rare occasions, the arrival of a small but steady stream of critics and curators can only be disturbing to Lertchaiprasert and the other artists and students who work here day in, day out.

Perhaps what unites the diverse practices of the international cast of artists brought together at *the land* is a longstanding effort to engage the objects and actions of everyday life, and Sanpatong has provided them a unique opportunity to extend that effort, without limitations. In this way, *the land* may be seen as a physical manifestation of how far artistic production today has come to exceed the boundaries of the autonomous object and the institutions that support it. And given the motivation of artists all over the world to realize projects here, one gathers that there is something specially attractive about this site exterior to the world of institutions and commerce. Is the allure simply the possibility of working outside the system – or of working within an altogether novel system of one's own devising. [...]

When I leave Sanpatong by car, it's pitch black and the buffalo are asleep. The fires are glowing in the dark. In my mind I keep turning over something Tiravanija once said. Asked if his nomadic way of life should be seen as an attempt to create many centres, he replied that, on the contrary, he's much more interested in the multiplication of peripheries. 'Because then you will understand', the artist offered gnomically, 'that the centre lies on the outside'.

Daniel Birnbaum, 'The Lay of *the land*: An Experiment in Art and Community in Thailand', *Artforum*, vol. 43, no. 10 (Summer 2005) 270; 271; 274; 346.

Ava Bromberg and Brett Bloom
Hamburg Action: A Field Guide: *Park Fiction*//2004

Park Fiction

The *Park Fiction* project began in 1994 when a small open patch of land with views from the St Pauli neighbourhood to the Elbe River came under threat of being sold by the city. The city wanted the space developed into high-rise corporate offices but the people living in St. Pauli wanted the space and their river view to remain unobstructed. The *Park Fiction* group organized to preserve the open space for use as a public park. In Margit Czenki's film about *Park Fiction*, a participant named Sabine says about the project:

> It wasn't just about having the park as a green area, but also about parks and politics, about the privatization of public space, about parks all over the world, about skateboarding and the pace of the city and accordingly it was about community conferences and democratic planning procedures.

Park Fiction used a variety of methods to facilitate what they call 'collective wish production', a process whereby the desires of the people of St Pauli could 'take to the streets'. *Park Fiction* began a participatory design process for the contested open space parallel to the design process pursued by the city. Residents were invited to articulate designs for the park that contained elements they desired. From early on in the process the park already had what group member Christoph Schaefer described in an interview as 'a social reality'. It was used continuously for public events such as open-air screenings, billboard demonstrations, and concerts. The core *Park Fiction* group, which expanded and contracted over the eight year course of the project, consisted of artists, musicians and neighbours working with social institutions, the church adjacent to the park, squatters with a long history of activity in the neighborhood, and shop and café owners. A planning container on the site held an archive of desires, a garden library, and an 'action kit' which functioned as a portable planning studio that could be taken to apartments in the neighborhood. Since 1997 *Park Fiction*'s efforts were financed by the Art in Public Space programme of the municipal culture department of Hamburg. Yearly, *Park Fiction* held major events at the park and presented the project outside of Hamburg in international art and music circles building cultural capital for the ideas outside of Hamburg before bringing their demands to city officials. As Christoph Schaefer adds, also in Czenki's film:

Films, performances and lectures brought art, town-planning and politics together, or rather created political discussions about art and vice versa questioned the standardized forms of political practice.

The energy behind the project was hard for one prominent city official to ignore when he attended a later *Park Fiction* event. When people in the neighborhood and the group became involved in widespread protests against the closing of the Harbor Hospital in St Pauli in 1997, the city knew it had to start negotiating with the residents of St Pauli. Round table discussions about the park began with politicians. After a long bureaucratic process the park, as planned by *Park Fiction*, is presently under construction. The project insisted on residents effecting desired changes to their environment. The result is an important landmark of successful planning from below where top-down bureaucracy traditionally dominates the decision-making processes.

Ava Bromberg and Brett Bloom, 'Hamburg Action: A Field Guide: *Park Fiction*', *Journal of Aesthetics and Protest*, vol. 1, no. 3 (2004); also available at http://www.journalofaestheticsandprotest.org

Graeme Evans and Phyllida Shaw
The Contribution of Culture to Regeneration
in the UK//2004

[...] The term 'impact study' is now widely used in relation to the 'contribution' or 'role' or 'importance' of cultural activity to another objective. Much of the literature on the contribution of culture to society now uses the language of impacts. Studies that look beyond the project itself traditionally use one (and seldom more than one) of the following fields of impact, which are generally tested using particular measurements:

Environmental (physical) – Land values and occupancy (versus vacant premises/voids), design quality, environmental/quality of life, e.g. air/water pollution, noise, liveability, open space, diversity, sustainable development.
Tests – e.g. Quality of Life; Design Quality Indicators; Re-use of brownfield land.

Economic – Multipliers (jobs, income/expenditure – direct, indirect, induced), cost benefit analysis, contingent valuation (i.e. willingness to pay for 'free'

activities such as parks, museums, libraries), inward investment and leverage, distributive effects.

Tests – e.g. Employment/unemployment rates, income/spending and wealth in an area, and distribution by social group and location, employer location, public-private leverage.

Social – Cohesion, inclusion, capacity, health and well-being, identity.
Tests – e.g. Participation (penetration rates – catchment, profile, frequency), perceptions, networks, self-help, crime rates/fear of crime, health/referrals.

Researchers and writers in this field have begun to look also at a fourth type of impact – *cultural impact.*

This term is already being used to describe two rather different effects. One is the impact on the cultural life of a place. For example, the opening of a gallery where there was none before has an impact on the cultural life of that place. The other use refers to the impact of cultural activity on the culture of a place or community, meaning its codes of conduct, its identity, its heritage and what is termed 'cultural governance' (i.e. citizenship, participation, representation, diversity). [...]

Graeme Evans and Phyllida Shaw, extract from *The Contribution of Culture to Regeneration in the UK: A Report to the Department of Culture, Media and Sport* (London: Metropolitan University, 2004) 6.

Peter Liversidge
Proposal//2006

I propose to twin Edinburgh, Scotland, with Glasgow, Montana.

Peter Liversidge, project for 'Festival Proposals', Ingleby Gallery, Edinburgh, 2006

It's important to examine the institutional as well as curatorial aims, which may work in concert, despite a curator's perhaps idealistic **intentions**, when an overriding theme is proposed. In some instances invited artists might witness a sort of 'curatorial domination' to be in effect. But I think it's necessary actually to analyse the group shows individually; differentiations need to be made between those that occur locally, nationally and internationally. What are the stated **intentions** of the curators and the institution? What **intentions** are left unspoken? What kinds of institutions are the exhibitions held in? Museums, housing projects, city streets? What sorts of sponsorship do they receive, private or public funds? These are some of the basic questions which need to be asked.

Renée Green, from 'Eighteen Aphoristic Statements', *Vor der Information*, no. 1–2, 1994

Wim Beeren
From Exhibition to Activity//1971

The plans for the exhibition [Sonsbeek 71] were based on the desire to give expression to a number of directions in plastic art that have been manifesting themselves during the last five years. The tendency towards an expansion of scale, towards maximization as one of the determining features of a work, made us decide to use as the criterion for the selection of sculptures for the park the degree of involvement of a work with the given properties of the park architecture. In concrete terms this means that a number of artists have been asked to design a work for a location of their own choosing. In cases where the costs involved were too high, agreements concerning rent, sponsoring, etc. were reached. In this way the principle of *making* this exhibition could be accepted and maintained; we departed from the usual procedure of collecting sculptures and deciding how they should be arranged. All artists, with the exception of Ronald Bladen, who worked with photographs, have seen the park and decided on a location before designing a work or having an existing design carried out. This working method and our awareness of the necessity of such a method has given the exhibition its theme: spatial relations.

In view of this theme, we became particularly interested in the many artists who would regard the park not as an optimal but rather as a somewhat unnatural environment. That is why we went 'beyond the pale' of Sonsbeek and included the entire country as our field of operation so that we could offer artists the location that could truly engage their interest. By making numerous contacts we succeeded in forming a group of participants – institutions, government departments, private persons – who joined in the organizational activities of 'Sonsbeek buiten de perken'. Out of the many discussions between participants and artists (for which our organization acted as intermediary, as indeed in applying for practical, material and financial aid) projects were born such as that of Michael Heizer (Limburg), Richard Long (Groningen), Ed Ruscha (Groningen), Robert Morris (Noord-Holland), which are intended for an existing landscape situation in spite of the considerable degree of autonomy they possess. We have also acted as intermediary for various city situations; Dan Flavin (Rotterdam), Richard Artschwager (Utrecht), Daniel Buren, Ger Dekkers, Hans Koetsier (Amsterdam). A sculpture is an independent entity, but it is also one of the elements by which we can conceive of space. Other matters, too, contribute to our conception of space: trees, parks, buildings and roads of course, but also the means by which space is experienced, such as television, which shows

thousands of aspects of that space on its screen. All these are elements which make us aware of the scale that is being employed, which determine how involved we are with one another, or how detached, and which influence our behaviour. Projects such as those designed by the Noord-Brabant group and carried out by a number of artists and architects at Enschede, have paid special attention to this aspect of the space we live in.

It has become one of Sonsbeek's aims to stimulate a greater public in the awareness that such things as visual phenomena exist, and that those phenomena often concern space. Until recently those visual phenomena were confined to the realm of science or to the grounds of museums. But now the time has come that artists are deeply involved in those spatial relations, and the attention they pay to it has long since ceased to be expressed in mass alone. Spatial relations means also: to be involved.

And the way of involvement can determine the way it is observed. What it is the space between Amsterdam and London? The line between two abstract points on a map? The space you hurtle through in an aeroplane? The space that can be experienced somewhat more rationally when travelled in a train or a boat? The space by day or by night? Or perhaps the space that is seen through an intermediary? The space that impresses us on TV, or that hardly appeals to our imagination any more on the telephone?

We have very consciously not mounted this Sonsbeek as a sculpture exhibition because, as stated, there is so much more that enables the artist to give stature to a particular space. And also because a sculpture and certainly a 'sculpture exhibition' is yet another subject of agreement. This work group did not exist in order that previously made agreements might be kept or that the discussion of a similar topic – modern sculpture since Rodin – might be continued.

Therefore we have accepted the fact that the communication media (modern or old) have contributed greatly to our conception of space. And that in addition these media have forged an indestructible link between the time factor and space. A considerable portion of world events comes across to us by those means of communication and nothing else. Information is becoming an almost independent phenomenon. [...]

It is evident that the term exhibition is only partly relevant. We have turned to the word 'manifestation' and subsequently to 'activity'. Sonsbeek 71 is more like a workshop than a show. This means that the Dutch public will not be able to take a walk amongst impressive statues, but that it will have the opportunity of a much closer involvement. A project on the Groningen mudflats cannot attract the masses (unless via the medium of film), but a project in a daily newspaper such as *De Volkskrant* or *De Telegraaf* is a direct confrontation with Sonsbeek for hundreds of thousands of people.

The publications, films, events, and the communication centres ensure intensive contact. [...]

We went from product to process. That is what we wanted and still want. The invited artists did not come to Sonsbeek as to the inevitable end of the road, but as to a place where they could start out from. The public that will visit Sonsbeek will have to use what they see to form their own ideas – they must not expect to see a collection of aesthetic sights. [...]

Wim Beeren, extract from 'From Exhibition to Activity', *Sonsbeek 71: Sonsbeek builen de perken, part 1* (Arnhem: Centrum/centre: Park Sonsbeek, 1971) 11; 13.

Tony Foster, Jonathan Harvey, James Lingwood
New Works for Different Places//1990

[...] The [TSWA Four Cities] project is both geographically dispersed and aesthetically diverse. It embraces the commissioning both of a permanently closed exhibition (Ilya Kabakov in Derry) and a permanent monument (Ian Hamilton Finlay's inscribed columns in Glasgow). To describe it as a public art project is to suggest that a consensus exists about what public art is or might be. However, what defines the heterogeneous range of works which at one moment or another are incorporated into the body of public art is only its status as not being in a museum or gallery. This paradox is a commonplace given that the motivating drive behind the construction and opening of museums in Europe in the nineteenth century was precisely to enhance public access and consequently public edification and morality.

The paradox is also revealed by the extent to which artists can move between museums and other public spaces without any dramatic change in language. The debate about public meaning and private language moves from inside to outside and back again. It is not limited by walls or buildings. The engagement with, and investigation of, codes of public meaning is a project far wider than either its most vociferous opponents or proponents will allow.

It is nonetheless possible to situate our initiative most accurately by what, or more precisely, where it is not. The places for which works have been made are different from the museum and different from the conventional site of the monument. Few of these places would habitually be regarded as places for art projects. Such conventional places, city squares for example,

tend to be officially controlled and as such are the least accessible, even for temporary works.

The brief to the artists invited to make proposals, who realized about three-quarters of the commissions, and those who submitted proposals through a process of open submission, was necessarily open. We encouraged interest both in places where local history and experience was manifest, and in those from which such history or experience had been erased or repressed – airports and shopping centres as much as air-raid shelters or battleships. Some works were the result of a short visit, and of confirmed preconceptions, others resulted from a determination to research the history of the place or locality with almost archaeological precision. Neither attitude is of course a prerequisite for a successful work, and although this was a source of debate, we did not seek to privilege process over production, over the work itself. Each work seeks to make its own place, and make its own audience – it does not passively occupy space any more than it actively seeks to satisfy a preordained set of expectations.

Such disparate activity, and such different works, offer their own caution against thematizing. It is however possible to draw attention to two fundamental questions: the idea of material, and the question of autonomy. Tony Cragg has written of the main act of the artist being 'the reorganization (sometimes only proposed) of materials into images and forms, which offer themselves as complex symbols for new experiences, insights and freedoms'.[1] In many of the works made for the Four Cities Project, the material with which the artist worked or reorganized was not simply metal or wood, light or laser. It was equally the material of the place, physical and environmental but more importantly cultural and historical. Such a process does not comfortably coalesce with the conventional twentieth century aspiration for sculpture, the aspiration for autonomy. This is not to say that the works sought to give themselves to their surroundings, to sacrifice their status as artworks, but that they have a *raison d'être* derived from a consideration of the place. The collaboration of artist and place does not necessarily have to result in the absorption of the work into environmental harmony or educational expediency. In their resistance to an immediate functional legitimation, the works also assert, sometimes uncomfortably, a place for themselves, as artworks, in the world.

This understanding of material, either transformed or used as context, often embraced a particular concern with collective memory. In sculptural terms, collective memory has been embodied and enclosed by monuments, both those consciously created for such a purpose, and those inadvertently created by successive generations. The monument constitutes, alongside the museum, the second consideration of which the works for the project have been aware, consciously or subconsciously. The use and abuse of the monument by successive

totalitarian regimes has endowed it with a dubious status. Such a problematic condition continues to offer fertile material with which to work, either through the strategy of the anti-monument, or through the further exploration of the investigation initiated by Claes Oldenburg to make the monument mundane. In Glasgow, for example, it is a concern which runs through the realized works of Stuart Brisley, Janet Emery and Kevin Rhowbotham, Ian Hamilton Finlay, Fischli & Weiss, Rosemarie Trockel and the unrealized proposal by Cildo Meireles.

The repressed needs to be exposed, the invisible made visible, and the forgotten remembered. This concern is amplified by the heritage industry's desire to sanitize and homogenize the past. The need for the dominant culture to control memory and history is not restricted to the reformulation of a curriculum for history in schools. The examination of the mechanisms of memory, particularly within the arena in which memory has been embodied in the official monument, has been explored from different perspectives by artists in this project.

With the exception of the works by Richard Deacon and Ian Hamilton Finlay, the works created for the Four Cities Project are temporary. But they also leave a memory, a residue, as well as their image through the photographic documentation which constitutes the greater part of this catalogue. We were unable and unwilling to gauge the immediate popularity of any individual work we commissioned; similarly we are unable to gauge the usefulness or fertility of this residue. It is undeniably there however, a sedimentation from which other initiatives, new ideas, might emerge. The proposals we commissioned, but were unable to realize, in Derry, Glasgow and Plymouth, constitute as important a part of the project as the works which were realized, and we have consequently included these proposals in this publication. The processes through which proposals are deemed appropriate or otherwise by various authorities often appear unreasonable or irrational, but they conform to a pattern of invoking the public interest as a masquerade for private or political purposes which is regrettably repetitive. The recurrence of such patterns, the results of which are embedded within the documentation of this publication, was both disappointing and illuminating. [...]

We do not expect to repeat this, TSWA's second collaborative project committed to the making of works outside the gallery. This is not to suggest that we believe we have done anything except offer a few co-ordinates, a number or works, in a landscape which remains essentially uncharted. But a repetition, or worse an institutionalization, might paradoxically encourage a perception of such work as marginal. We would prefer to encourage a fluidity and an exchange between the foci of the art world. The artists, and the discourses, move more fluidly and more adroitly between the institutions of public art and the museum than these institutions might prefer to allow. The chosen position for the Four

Cities Project has been in-between, and such a position does not benefit from any expectation that these concerns will be addressed on a biennial or triennial basis. Ideally, it needs more constant address and exploration in each locality, through initiatives which cut across the divides of official and unofficial, temporary and permanent. For although one accepts that, in iconic terms, the monument and the museum are the twin towers which dominate the landscape and condition the space we have been able to create with this project, it does not mean that this space in-between is not fertile territory.

1 [footnote 2 in source] Tony Cragg, in cat., *Pre-conditions* (Hanover: Kestner Gesellschaft, 1985).

Tony Foster, Jonathan Harvey, James Lingwood, extract from introduction, *New Works for Different Places: TSWA Four Cities Project* (Newcastle, 1990).

Mary Jane Jacob
Places with a Past//1991

One can now speak of a category of contemporary art called 'projects' and a new genre known as site exhibitions. The keystone of attitudes and trends since the late 1960s was the move away from the conventional gallery space, leading to a burgeoning of alternative options and special exhibitions that pointed to the unsuitability of the museum for emerging forms such as installation, earth art, concept art and performance. While this has not proven to be wholly true – art bearing these labels has found a place in museums, too – the development of art over the last two decades has led to new exhibition forums that themselves are formative. Among these new modes, the city- or site-exhibition event, and its more permanent manifestation in public art programmes, have become, if not styles, then types of an art form. [...]

The juxtaposition of city site to sculpture and the commissioning of works on the occasion of an exhibition can be traced to an early precedent undertaken as part of the Spoleto Festival in Italy. In 1962 ten contemporary sculptors (Alexander Calder, David Smith, Beverly Pepper, Lynn Chadwick, Eugenio Carmi, Ettore Colla, Pietro Consagra, Nino Franchina, Carlo Lorenzetti, and Arnoldo Pomodoro) made new works in the Italian foundries in a collaboration of art and industry for the exhibition 'Sculture nella Citta'. Along with studio pieces by 42

other artists selected by curator Giovanni Carandente, a total of 102 sculptures were placed like a stage set against the backdrop of this mediaeval town. The commissioned aspect of this show and the idea of the city as a modern sculpture museum, with 'works being placed in common, utilitarian, otherwise undistinguished locations and not just the piazza, link this show to those of the 1980s; the exhibition was a far-sighted precedent for what became a new genre.

The most widely known example of the city as exhibition site occurred in Münster, Germany, in 1987, with 'Skulptur Projekte'. While the first instalment of this show ten years earlier – a survey with Rodin and Picasso and ten artists' projects – had followed along the lines of the Spoleto model, by the 1980s art had changed sufficiently so that the manner in which artists took up the challenge to show in Münster made the commissioning of new site work the primary mode. As a forum for new art, the Münster exhibition evidenced the widespread phenomenon of working both outside the studio and outside the museum – a trend that constituted a kind of movement itself. Significant this time was the introduction of the word 'project' by Münster's organizers, Kasper König and Klaus Bussmann. The overall involvement of artists in planning projects for Münster led to the exploitation of contextual rather than purely formal relationships, and resulted in some installations, or other artistic interventions, that drew their meaning from the site that the artist selected. Thus, this exhibition also marked an important step in the critique of traditional public art. While the show included sitings of abstract sculpture, there were also those that related to design and architecture, or questioned landscape and city planning, and a few dealt with the history and culture of this conservative German city. Most memorable among this last category, which expanded further what site-specific could mean, was Rebecca Horn's use of a prison and execution site from the Middle Ages that were reactivated during the Nazi era. Jeff Koons also dealt successfully with history and the idea of the monument by commenting on the reconstruction of the town centre. He made a stainless-steel replica of a beloved public sculpture of a country peddler whose original bronze version had been destroyed in the war and then re-created by popular demand in the 1950s.

In Ghent in 1986, the year before Münster, the homes of 51 families had been opened as exhibition spaces with 'Chambres d'amis', organized by Jan Hoet of the Museum van Hedendaagse Kunst. This format had earlier been used for 'Pour vivre heureux, vivons cachés', organized by the Association pour l'art contemporain in Nevers, France, where fourteen artists made work *in situ* in nine local houses and apartments. Here, on a large, international scale, private space for a time became public, though in Ghent few artists dealt with the social implications of the space and, with few women included, little attention was given to issues of domesticity.

The particular character of a place and the use of spaces charged with historical or cultural associations were the organizing principles around Britain's 'TSWA 3D', whose primary sponsor was Television South West with curators Tony Foster, Jonathan Harvey and James Lingwood. Although overshadowed by the Münster show and by the art community's focus on Germany where it coincided with Documenta, the direction established by the eleven works in nine British cities made an important step in developing location as a part of the concept as well as part of the physicality of a work. Outstanding among these was Antony Gormley's installation at the city walls of Derry. An uncompromising symbol of British presence in Northern Ireland, this Protestant fortification became the site of four cast-iron double figures, arms outstretched in cruciform position, which faced outward in two directions over Catholic and Protestant territory. With reference to Christ's suffering, they stood as a metaphor for the grief of these long-divided communities, and as a plea for reconciliation; as powerful statements, they were also, not surprisingly, the object of vandalism. These organizers and sponsor again joined forces, in 1990, for the presentation of 'TSWA Four Cities Project: New Works for Different Places', in Derry, Glasgow, Newcastle and Plymouth. Their focus this time was on questions of public art, public meaning and public language. Artists were encouraged to deal with issues of history, reinvestigating places where it was evident but presented in a conventional way, and looking to places where it was absent. The city of Amsterdam in 1987 hosted a related exhibition, 'Century '87 – Today's Art Face to Face with Amsterdam's Past', which aimed to deal with the stereotypes of this popular tourist city and made use, among its non-museum venues, of a church, a jail and a brothel (a well-known attraction in this city) as exhibition sites.

The curator's direction of the use of place is neither so arbitrary nor so conveniently thematic as it is appropriate to art today, since the issues of identity and culture that these sites raise are addressed by artists in their work. [...]

It is when exhibitions speak about issues related to or inspired by a chosen site, pointing to the contemporary power of the past, and making connections between art and society, that they most fulfil a role that befits their real-life situation, that demonstrates the necessity for this art to be outside museum walls, and, at the same time, impacts upon the theoretical discourses of art today.

Such was the goal in creating an exhibition for Charleston. While some of the artists chosen had been featured in shows named above or in related exhibitions, others had been inspired to work in this way. Liz Magor, for example, had been moved by Münster. Ann Hamilton had been so impressed by the concept of 'Chambres d'amis' that she worked to initiate a similar project in 1988 with the Contemporary Arts Forum in Santa Barbara, California, where she was living. The Charleston exhibition presented artists with a new challenge and

a new opportunity – to enter into the dialogue of a genre that had already had an impact on their ideas.

'Places with a Past' was the first exhibition in the United States to use the city fully as a site, and the latest instalment in furthering that dialogue. Charleston proved to be fertile ground. Among the timely issues were those of gender, race and cultural identity, considerations of difference, the notion of the colonizer-colonized paradigm, ideas of domination and exploitation. These are subjects much in the vanguard of criticism and art-making. Also, for reasons varying from those of critical interest and inquiry to development and public relations expediency, these issues have swept across the museum scene in the US, not always to be incorporated in meaningful or appropriate programmes, but sometimes to satisfy institutional demographic profiles. The actuality of the situation, the fabric of the time and place of Charleston, offered an incredibly rich and meaningful context for the making and siting of publicly visible and physically prominent installations that rang true in their approach to these ideas.

In most cases the artists succeeded in creating works that were truly site-specific, that is, they could not be located elsewhere, or if physically possible to do so, they would have been diminished in the relocation. All but a few were necessarily temporary. The artists chose their sites after a tour of possibilities and from the conversation and research that ensued during their initial visits. The result was art that addressed a location, not just from a design and physical point of view, but also in relation to a social and cultural past. The installations became like chapters in a book that together told a larger, more complete and alternative story of Charleston.

The artists chosen, while prominent and established in their own right, as a group comprised an unusual ratio of gender, race and nationality representation. Twelve of the 23 artists were women – and women played a major role in Charleston life, but one historically hidden; six black artists responded to the African diaspora that so affected Charleston's and eventually all of American history; and seven artists from other countries (some also former British colonies) reflected upon their culture's presence through the various immigrant groups that came to build this grand city of the South. At a time in the arts when one speaks of a balance of genders, multicultural representation and internationalism, this exhibition offered an important opportunity to show what these concepts can mean in the realization of a show.

Today there is also a shift towards work that has a mission and makes a social statement, staking out a moral position, perhaps in reaction to the prior decade as a period of intensified commercialism and shallowness of content. And while Charleston's subjects and locations brought up social and conceptual issues central to art-making today and to the academic arena in general, ethical and

philosophical issues arose that gave pause to the artists during their investigation: can an artist speak for people of another place with whom he or she does not share a common history or cultural tradition; even if one shares a heritage, can he or she alone speak for the community; can a white artist deal with an African-American subject; what rules are operative when working collaboratively with a member of the community; how can a community voice and an artistic voice coexist sympathetically; and if artists collaborate with a member or members of the community, do they speak for the community at large?

Because of their scale and technical complexity, collaboration often characterizes installations. The Charleston community proved to be a resource that shaped the projects and brought the notion of collaboration to a local level, at times extending the viewpoint of the artist to a collective one, involving historians, archaeologists, tour guides, re-enactors, artists, tradespeople, city officials, festival staff and crew, gospel singers, ministers, neighborhood residents, rag dealers, gourmets, painting contractors and pool specialists. By way of example, Ann Hamilton collaborated with artists Kathryn Clark and Harry Reese at the early stages of her project in order to talk out approaches to giving form to her ideas, and then chiefly with Rebecca DesMarais and Debra Durst in the process of building her piece. Yet, local blue-collar workers also played a role as they stopped by daily to see the spectacle, thereby infusing the work with a relevance and life that became incorporated into the sensibility of the overall installation. David Hammons, on the other hand, encouraged local participation in the actual decision-making about how to finish the single house that he had had the festival crew frame out.

The specificity of techniques and materials also grounded these artists within the everyday world of Charleston. Art that appears like and is close to life must necessarily look to the everyday as a resource. In doing so, it does not demean the commonplace but rather pays respect to ordinary materials and references to the common person, and to other voices. One will look differently at workers' blue shirts after Ann Hamilton. Indigenous forms such as the Charleston single house gained new interpretation through David Hammons, and Kate Ericson and Mel Ziegler. Charleston's pluff mud [dark soft marsh soil] was a key romantic element for Antony Gormley and Elizabeth Newman. Techniques of Civil War photography and of stereography, while not specific to Charleston, evoked the larger history of the South in the works of James Coleman, Ronald Jones, Liz Magor and Cindy Sherman.

Redefining, at times rewriting, history was a theme of the exhibition. An issue of postmodernism, the interest in and regard for history – using and deconstructing with such questions as whose history is presented, what is written in and written out of history, and the idea that there is not one history

but many – was given artistic realization with these projects. The mode of inquiry that began with an analytical tour of Charleston by artists and curator set the tone for the creation of provocative and thoughtful works. After visiting the usual tourist sites [...] artists decided to depart from the conventional sites and prominent stories that are Historic Charleston, and go to the edges of that history. They did not choose to deal with the heroic view of history nor to enshrine further the usual figures and names that have a continuing presence in Charleston, but to focus on those who had been marginalized and whose stories had been forgotten over time. Their sites reflected this as well, as the artists chose buildings not already part of a Charleston tour, but alternative sites they recognized and reclaimed. [...]

The temporary exhibition format that includes 'Places with a Past', Münster, TSWA and others may be today's most important laboratory for questions about art and its public, its surroundings, ideas about commemoration and monument, architecture, design and identity. Such programmes have a vitality and timeliness, and together bring a fresh eye to the critical issues of the moment. They stimulate a dialogue that continues long after the works have been disassembled. They allow artists to take risks, further the discourse and change the nature of art, in exhibitions that are as much experiments as presentations of works of art. As Antony Gormley said of this and other exhibitions of this genre, they are 'to explore the place of art in the world and create a mental space that gets people thinking about their own history'. In such a forum, artists' decisions matter and ideas are allowed to grow unfettered by a drawn-out time frame or logistical problems that lead to compromises. Public art of a permanent nature, particularly that executed under governmental auspices, is required to be defensible and therefore often degenerates into a formulaic solution that excludes the most exciting and powerful statements. By contrast, the Charleston exhibition was undertaken by an art patron, Spoleto Festival USA, thus ensuring freedom of artistic expression in the same way museums operate, but with one major difference – it brought in a more diverse, and not art-expectant, population.

Charleston was the bridge between the works of art and the audience. When there are no doors and admissions are taken away, the audience changes. When an exhibition goes to the public, art may be encountered unwittingly. 'Places with a Past', while a profound artistic statement rather than a social manifesto, dealt with issues that directly touch one's daily life. As with all great art, it drew its meaning from human experience, and turned its temporal and spatial particularity into a universal experience.

Mary Jane Jacob, extracts from 'Making History in Charleston', in *Places with a Past: New Site-specific Art at Charleston's Spoleto Festival* (New York: Rizzoli, 1991) 13; 15–19.

Andrea Fraser
What's Intangible, Transitory, Mediating, Participatory and Rendered in the Public Sphere?//1997

[...] The project 'Services: The Conditions and Relations of Service Provision in Contemporary Project-Oriented Artistic Practice', undertaken at the beginning of 1994, was a response to a specific situation and the largely practical and material concerns that arose as a result of that situation. The introduction of the term 'services' as a way of describing certain aspects of contemporary project work was largely strategic. It was not intended to distinguish a particular body of work as new or as a substitute for any of the labels at that time in use, from 'institutional critique' to 'post-studio art', 'site-specific art', 'context art', 'community-based art', 'public art', the more generic 'project art', or the even more generic 'cultural production'. 'Services', rather, was intended to identify one aspect of many, but not all, of the practices described with those terms: the status of the work, or labour, of which they consist and the conditions under which that work is undertaken. While most project work does, in the end, take a physical form, the contention of the proposal for 'Services' was that, in addition to the work of production, all site or situationally specific projects involve 'an amount of labour which is either in excess of, or independent of, any specific material production and which cannot be transacted as ... a product'. The strategic value of using the term 'services' to describe that labour was that it provided a basis for identifying the value of that portion of an artist's activity which did not result in a transferable product. Motivating the project 'Services' was the conviction that this dimension of contemporary artistic work, as something intangible in an apparatus still dominated by the physical and visible, was going largely unrecognized and uncompensated. But the notion of services also provided the basis for understanding or describing important as well as troubling aspects of the relations these activities appeared to presuppose and imply – relations that seemed to represent a significant shift in the status, meaning and function of artistic activity. [...]

What Does an Artistic Service Serve?
Supply and Demand or Demand and Supply

The specific situation that the project 'Services' was organized in response to was the emergence of what appeared to be, by 1993, a consistent and durable demand for project work. The particularity of that demand – and that which would render it durable – was that it did not appear to be conditioned simply by the supply offered by a distinct artistic group. As noted in the proposal for 'Services', the

practices characterized as 'project work' did not seem to share a formal, procedural, thematic or ideological basis. Nor could 'project artists' be grouped along generational lines. Furthermore, many 'project exhibitions' – exhibitions in which artists were asked to undertake work in response to specific sites and situations – consisted of work largely by artists with no history of situational or post-studio activity. The demand for project work, therefore, seemed to be based rather on something like a need for what it is that projects provide.

This need, if one may call it that, appeared to have a number of different dimensions, depending on the character of the given situation. The demand for community-based projects appeared to be related to a need by publicly funded organizations to satisfy the public service requirements of their funding agencies. The demand for institutional interventions appeared to be related to a need on the part of museum professionals to engage artists in a kind of collaborative effort at public education and institutional reflection. The demand for projects undertaken in response to specific curatorial concepts could be related to a need on the part of curators and their organizations to induce the 'usual suspects' to produce something special in the context of the exponential expansion of contemporary art venues – and thus exhibitions – in the 1980s, as well as of the corps of curators, swelled by the graduates of at least a half dozen new curatorial training programmes.

The appearance of this demand for project work had a number of important and troubling implications. It represented a state of affairs in which artists were undertaking projects not only for specific sites and situations, but also within specific relations to organizations and their representatives, curators and other arts professionals. And it appeared to be the specificity of these relations – more than the physical or temporal specificity of the works themselves – that distinguished these contemporary 'projects' from other forms of artistic activity.

The term 'services' was introduced, above all, to describe these relations in their economic and social aspects. The emergence of the fee or honorarium as the standard form of compensation for project work appeared to mark less the emergence of a new form of practice than a shift in the character of that practice. Whether or not the result of a project is itself transferable – and most often it is, in some form – a fee is provided, generally, as compensation for that portion of the work which is assumed not to be transferable. Payment of a fee does not usually imply that the organization will own project results. In many cases, sponsoring organizations do not even have collections. When they do, the accessioning of objects resulting from projects usually remains a separate administrative procedure requiring a separate contract. The project fee is payment for the artist's work itself, not for a work of art: it is not an advance on an abstract value to be realized at a future date, but a

payment for the final consumption of a value extinguished in some form of immediate use.

Whether or not a project is undertaken at the invitation of a particular organization and compensated with a fee, whether or not it is a contractually defined response to an external demand, projects appear to be distinguishable from the broad range of post-studio practices by the degree to which they are constituted in relationship to externally determined interests or needs. Projects undertake to respond to (and perhaps, but not necessarily, to satisfy) those interests and needs, not through the production of a utility embodied in an object but through the execution of particular functions. These functions were identified in the 'Services' proposal as including the work of interpreting, the work of presenting, arranging and installing, the work of educating, and the work of advocating and organizing.

Andrea Fraser, extract from 'What's Intangible, Transitory, Mediating, Participatory, and Rendered in the Public Sphere?', in *October*, no. 80 (Spring 1997) 111–12; 115–16 [footnotes not included].

Bik Van der Pol
Changing the System Unexpectedly//1995

In Rotterdam, many artists operate in a situation that is typical of this pragmatic city: they are tolerated. They permanently find themselves in a sort of transition zone. However, making a virtue of necessity, the artists use this transition zone to their advantage: because of the lack of a really efficient system of work and exhibition areas for artists and designers in Rotterdam, they have developed a form of self-organization and self-determination. They have been moving into buildings and abandoned spaces, often at unique locations in the port area or city, and have developed studios, guest studios and/or activities. They have organized themselves in a joint consultative body to bring the importance of such places to the attention of the municipal authorities, to set up exhibition areas to display work, or they have combined, either temporarily or in the longer term, in joint ventures. In this way, the seed has been sown for operating with a certain degree of pragmatic independence and – as a by-product of this – for a critical questioning of the existing systems of exhibiting and working.

Instead of participating in a system that functions inadequately, and to ensure freedom from bureaucratic regulations and a variety of undeclared interests, they

created an active, more flexible system of co-operation, mutual involvement and interdependence – taking the initiative, generating added value. They had, and still have, nothing to lose. From the transition zone in which they find themselves, they skim past the institutes, move inside or put up resistance, create a negotiating position or distance themselves completely from the existing systems. Whichever position they choose, their strength lies in the generation of energy, which is often a catalyst for both short and long-term partnerships and alliances.

This Rotterdam situation is nothing special: in many cities, artists are in some sense in this transition zone: neglected if they are unknown, needed as pragmatic instruments in connection with all sorts of political platforms in urban planning. And they themselves more or less have to manoeuvre strategically between integrity and opportunism, with nothing to lose, but with a lot of unexpected by-products.

Change should not be expected from artists in particular: sometimes they change the system through their work, sometimes they do not. Beuys doubted whether artists would be the ones to change the concept of art, because most of them have an interest in perpetuating the traditional concept for selfish reasons (financial, stylistic, etc).

And an art practice within the structure of an artists' initiative or collective is no guarantee of curiosity about other, wider interests beyond the assessment of the position of 'the rival' – hardly the most interesting of positions.

Artists have developed a very hierarchical consciousness of power. Because of all our different positions, and the feeling of being dependent on the existing system of mediators, critics and institutes, communication tends not to be open. Different agendas are at work: artists, curators, critics and the public are all in the game for different reasons. This creates vulnerability, big talk and sometimes anguish among the participants, but more specifically in the relationship with the structure and the people one feels dependent on.

They have come from a place where they felt no dependence on any system, on anyone; but now that they have come this far, they suddenly find themselves part of the system. And now there seems to be a lot to lose. So, a lot of things are usually not said, and a lot of things are said that do not really matter.

In order constantly to generate action, to try to find solutions (real or imaginary) we sincerely believe in the huge potential and positive impact of not expecting anything: not expecting change, not expecting fame, not expecting respect, not expecting love, not expecting hate, not expecting …

A lot of changes depend on the talent for making exciting and unexpected discoveries entirely by chance. When one has no expectations beforehand, one may be able to have freedom of action and sensitivity towards each situation.

The only important thing is to create – in a very precise, but at the same time improvised manner – the situation where open communication can flourish, a situation that builds trust and generates circumstances where intelligent criticism and support can contribute equally to change.

Bik Van der Pol, 'Changing the System Unexpectedly', in *Changing the System? Artists Talk about Their Practice* (Helsinki: NIFCA, 1999) 55–6.

Susan Buck-Morss, Ivo Mesquita, Osvaldo Sanchez, Sally Yard
Fugitive Sites//2000

In art projects reiterated globally, the radical has become predictable. The city has been used as a large-scale gallery, a stage for the display of aesthetic objects and/or artistic interventions. inSITE2000–01 intends to break the limits of this model. It will install artistic processes on site in the San Diego/Tijuana area in order to reframe the notion of cultural practice in public space. Taking the city as a laboratory, inSITE2000–01 will challenge concepts that have oriented previous versions of inSITE and similar international exhibitions: site specificity, community engagement, artistic practice and public space.

In the laboratory model, not the object but the process is important. The role of the public shifts from audience to co-investigator. Institutions, no longer display cases, become co-laboratories. Rather than merely entering urban space, the works of artists reconfigure it. If cities are laboratories, if artists are practitioners, if the public energizes new cultural meanings, then how will these imaginings give visibility to the urban landscape? How will knowledge of the city be transformed?

The collaborative impact of the inSITE2000–01 projects will be to challenge the syntax of the city that orders and organizes the multiple economies of daily life, determining circulation, power lines and institutional access. If syntax is the structure by which meaning assumes form, its disruption can be a political act, providing space for new cultural articulations.

Our idea is to expose the patterns of traffic that road maps conceal in order to observe the permanent motion of this urban protoplasm, for which borders and

destinations remain fragile. We want to trace the activities that cause the transnational metropolis to expand and contract – the daily trafficking in goods and people, frustrations and dreams. When cultural practices are injected into these flows, or when they redirect them by detours, they open up new possibilities of linking people and places. Here artists' laboratories become experiments in the removal of institutionalized blockages, providing remedies against the inertia of everyday life.

We are interested in how public space has been kidnapped by modern state discourse within the syntax of national identity. We want to disarm the historical notion of landscape – perceived as a geopolitical determination of entrenched territories and motherlands – and encourage practices that map its contemporary dynamics, revealing its interwoven differences and ragged similarities, enabling unpredictable exchange.

Susan Buck-Morss, Ivo Mesquita, Osvaldo Sanchez, Sally Yard, 'Curatorial Statement', in Sanchez and Cecilia Garza, eds, *Fugitive Sites: inSITE 2000–01* (San Diego: Installation Gallery, 2002) 22–3.

Lu Jie and Qiu Zhijie
The Long March Glossary//2003

Long March: 1) a process of movement through space, time or thought without a fixed beginning or end, particularly one that involves excessive hardship or multiple transformations; 2) short form of *The Long March - A Walking Visual Display*, a series of activities designed to interrogate Chinese visual culture and revolutionary memory, circa 2002; 3) an historic event in which Mao Zedong led a flailing Red Army over six thousand miles from their base in Ruijin, Jiangxi province to Yan'an, Shaanxi province, simultaneously suffering tremendous casualties and developing the ideological and organizational structures which would come to serve as the basis of the People's Republic of China.

Long Marcher: 1) one who partakes of a Long March involving him/herself alone or in cooperation with others; 2) a member of the artistic, curatorial or documentary teams of *The Long March - A Walking Visual Display*.

Long March Methodology: A curatorial and organizational praxis that: a) stresses adaptation to local and temporal circumstances; b) continues to seek the

implementation of its aims particularly in the face of seemingly insurmountable setbacks; c) sees no boundary between work and leisure or theory and reality; d) seeks a dialogue with history through space, believing that space has memory.

Long Marchist: A particularly tenacious adherent to the Long March Methodology, either in the course of *The Long March – A Walking Visual Display* or elsewhere.

Long March Discourse: Linguistically articulated dialogue, debate or ideas arising during, as a result of, or in relation to *The Long March – A Walking Visual Display*. Examples include: the proceedings of the Long March curatorial symposium in Zunyi (8–10 August 2002); an article published in a Chinese newspaper about a Long March Event in Kunming; a lunchtime conversation among residents of Maotai about the Long March Event in which they were participating; an idea that occurs to an artist or viewer as a result of their participation in or knowledge of The Long March.

Long March Object: Material objects created during or incorporated into *The Long March – A Walking Visual Display*. (Key to this concept is the non-distinction between 'artworks' created by 'artists' selected for participation and objects which enter the collective consciousness of The Long March by happenstance.)

Long March Remains: Objects, ideas or images left along the route of *The Long March – A Walking Visual Display*. Examples include an installation work by Feng Qianyu left as a bridge across a river in Guangxi province, the countless Long March postcards, stickers and T-shirts distributed to people encountered on the march, and images left in the collective memories of communities in which Long March Events occurred.

Long March Event: A happening along the route of *The Long March – A Walking Visual Display*, either premeditated or spontaneous. Completed temporarily, the event continues indefinitely to condition the memory as well as the progress of The Long March.

Long March Installation: Different from a typical installation in that its creator is a scholar, critic or curator as opposed to an artist in the traditional sense, it seeks directly to address issues or themes that have arisen during The Long March in visual form. Analogous to a visual artist's written statement, it seeks to give the power of visual language to thinkers generally confined to written language.

Lu Jie and Qiu Zhijie, 'Long March Glossary' in *Long March – A Walking Visual Display* (New York: Long March Foundation, 2003).

Charles Esche and Vasif Kortun
The 9th Istanbul Biennial//2005

Audience question Charles, you recently stated in *frieze* that the most interesting thing about the present boost of new 'non-western' biennials is the fact that the latest ones (Kwangju, Havana, Tirana, Johannesburg) present a new tendency: a relative distance from a purely commercial system and an engagament with local political conditions. Is that what you both strive for in the Istanbul Biennial too? How is this put into practice?

Charles Esche I was describing a condition that can be used by artists and curators to create a different space for the work to be seen. In general, I am not sure we want or can really imagine to have a full distance from a 'purely commercial system' in the sense that commerce makes things possible that would not be otherwise. Anyway, Istanbul is more integrated than Tirana. Our project is more to emphasize the specific and singular within a work of art by relating it to the time and place where the work is done. In that sense, some of the work in Istanbul will not be so portable and easily consumed because it emerges following a residency and therefore out of a specific set of conditions. Those conditions are not only geographic but also about personal identity and economic possibility. What we have tried to do is to frame these conditions in a certain way and then support the response of the artists in whichever direction they went. What comes out may well be sellable and we have nothing against that. It's just not very interesting for us, except if it brings money into the biennial itself.

Question What are the main characteristics of this biennial?

Charles Esche/Vasif Kortun Modesty, access, difference and ingenuity. The aim is to form a relationship between the Biennial as a whole and as a composition of many works, people, events and perspectives with its lived context and audience of Istanbul. The city should itself be a part of the experience of the biennial in the sense that around half the works are made here and will reference the surrounding environment in different ways. The other half will reference other sites and places in the world, mostly from the regions around Istanbul, from the Balkans to Central Asia and the Middle East.

Question Much emphasis is given to the fact that you don't want to use monumental historical places as exhibition site, but sites that have a more

common reference to the everyday and are linked more directly to the urban, economic reality of the city. Next to that you both stated explicitly that in this biennial you prefer to work with site-specific commisions, residencies and educational models, i.e. more intimate forms of exchange which react on the particularities of a place. Is this working model them only solution to meet the demands of being more concerned with a local historical and political context?

Esche/Kortun There is no solution in art, we are more interested in a proposal for the very specific situation of Istanbul at this time of the radical transformation of the city. In part the reason to disappear the exhibition into the city fabric came as a result of the transformation where spaces of scale that we first selected were absorbed into privatization and such. We realigned the exhibition to slow its speed in relation to the speed of the city, connecting the various sites with passages through the city itself. We also wanted to locate the project outside pure event culture, hoping that some of the initiatives will have longer term resonance. The exhibition presents a departure from its predecessors because it is not indexed to the previous models. For instance, it was important for us to avoid a touristic reading of the city and its relation to contemporary art by avoiding the old Byzantine and Ottoman sites. Istanbul is interesting in that it is both an extremely old European imperial capital and a city that has experienced growth rates in the last 50 years that are unimaginable in the rest of Europe.

Question [...] Could you explain the mutual relations between artists in your selection? Were there specific selection criteria involved?

Esche/Kortun The exhibition inevitably builds up along a process of research shaping itself as scattered parts of a puzzle that comes together as a biennial. It is not only about geography but about building a specific, intimate relation to the city, for the residency artists at first and hopefully for viewers afterwards. The second element of the biennial, the 'Not-Istanbul' if you like, are artists whose work reflects a particular and different urban or even rural context, to show what is absent in Istanbul as well as reveal something of what is there by default. The relations between artists come together around these twin poles of Istanbul Not Istanbul, to misquote René Daniëls, but will remain individual responses. [...]

Question How do the artists you invited react to the local conditions of Istanbul with their projects?

Esche/Kortun A number of artists were invited following their own long-standing connections with the city through residency experiences, deep personal interest and research. For example Karl-Heinz Klopf has been visiting Istanbul on and off for years and his extremely site specific proposal reflects this extended period of observation. During the Biennial a number of spotlights will fall on specifically selected broken, uneven, misleading and adapted steps in the hilly area leading from the Bosphorus water-side to Istiklal Caddesi. Under the spots invited street musicians, shoe-cleaning boys and street sellers will continue their daytime activities after dark.

Other artists who have spent time in Istanbul include Wael Shawky, Phil Collins, Solmaz Shahbazi and Erik Gongrich, all of whom are making new work based on their individual experiences. Someone even more familiar with the city, Serkan Ozkaya will reflect on the lack of a continuous art structure in Istanbul that has left its artists and art lovers to rely on reproductions as their only source material. His work, a double-height Statue of David painted in gold, will stand on a roundabout in Beyoglu a marker of his own desire to see this sculpture in the flesh and to make it available to others. An equal proportion of artists have been invited to present work that deals with very different urban and rural situations. Together these two approaches will create a dialectic from which the reality of Istanbul as a lived experience will emerge.

Question This is the first time the Istanbul Biennial is being organized under the direction of two artistic directors […]; how is your collaboration being put into practice? Do you have different responsibilities?

Esche/Kortun We worked with the assistant curators Esra Sarigedik and November Paynter, in an organic manner, and the hierarchies dissolved along the way. The two of us have known each other for longer than the biennial and we share certain interests and confidences that would probably be essential to working like this. It's important to remember that the selection process is but only one of the many aspects of organising the exhibition. We test each other's decisions, choices and preferences at all stages and seek to strengthen them through discussion. Any collective action of course implies a degree of compromise but the project itself is not compromised because there are some fundamental agreements. Ours was not a conflictual or selfish process, or a territorial one. That one of us is positioned in Istanbul helps a lot. […]

Charles Esche and Vasif Kortun, extract from interview on 9th Istanbul biennial, *MetropolisM* (Amsterdam, September 2005).

Hou Hanru
Towards a New Locality//2006

Biennials of contemporary art inevitably have cultural and geopolitical ambitions. They seek to be nationally and even internationally significant, by putting forward particular and supposedly incomparable local characteristics, what we might call 'locality'. Ideally, the concept of locality should be culturally related to the local tradition but innovative and open to international exchanges. The introduction of artworks by international artists is an efficient strategy to achieve this end and is often introduced as a catalyst to accelerate this process. (Geo)politically, this newly constructed locality should demonstrate its singularity when compared to other similar events, especially those happening in surrounding areas. The Busan Biennial, for instance, has direct and indirect rivals or peers in Korea, such as the Gwangju Biennial, Seoul Media City, etc., and across the Pacific Ocean, with the Fukuoka Asian Art Triennial, Yokohama Triennial, Taipei Biennial, or Shanghai Biennial and even, going a bit further, the Asia-Pacific Triennial in Brisbane and the Biennale of Sydney. To configure the locality of such events in contradistinction to their ever-increasing number of national and international counterparts means emphasizing something quite particular to the context of the locale – city, region, or 'neighbourhood', as Arjun Appadurai would say.[1] This is true of most biennial or triennial organizations across the world today, including the Havana Bienal, Johannesburg Biennial, or Manifesta, to name just a few. The problem of locality provides us, as curators and artists directly involved with such events, a unique opportunity to explore the creative and innovative possibilities offered by the occasion. The challenge that we face is how to imagine and realize a biennial that is culturally and artistically significant in terms of embodying and intensifying the negotiation between the global and the local, politically transcending the established power relationship between different locales and going beyond conformist regionalism. More than ever, biennials of the future should be an occasion to conceive and construct new localities capable of responding to the age of globalization. [...]

This vision or reality no doubt implies contradictions, conflicts and chaotic elements, but it also offers an optimistic, futuristic picture of the local scene. Artistically, biennials naturally reflect such a reality. However, it is important that the projects and works presented not only respond to such a reality, but also emphasize the real meaning of their engagement with the event, to articulate the experimentality and vitality necessary to the invention of the new locality.

It has become increasingly evident in today's globalized world that it is impossible to talk about the question of locality without relating it to globality. Historically and especially in the contemporary world, locality is always a product of the confrontation and negotiation of the locale (or the neighbourhood) with the global (or 'Other'). This vital and intense process of self-reflection, autocritique and self-innovation allows the individual to continue to survive and obtain meaning within global modernization. The process is automatically one of breaking down and re-establishing territorial borders as well as cultural boundaries at large, whether they have been recently politically determined or historically granted. In our age of globalization when every locale is struggling hard to turn itself into either a member of the global village or a key point on the network of global cities, this becomes drastically intensified and even urgent. Producing new localities is the most imminent task for locales. If the boundaries of locales were once relatively clearly defined and conceivable as being like islands on the world map, today this island-based concept is no longer sustainable. Everyone must leave his or her island and merge into the border-crossing, translocal ocean of global restructuring.

Globalization is a necessary first step in the process of expanding the global economy and its related effects: migrations across borders – from economic and political refugees to technological and intellectual global travellers, as well as the development of new technologies of global communication. Accordingly, the globalized culture of electronic media, with multimedia images and languages at its centre, becomes the dominant, 'mainstream' culture. It has penetrated almost every corner of the world and caused profound changes in local cultures. As a result, established economies, social relationships and politics, as well as collective and individual imaginations, visions, values and languages, are all affected, contaminated and transformed. For the sake of survival, every locale has to develop new strategies to face such a new reality.

Politically, we are seeing a kind of reorganization of regional, translocal alliances. Aspirations for peace and the impossibility of coexistence between nations and communities are working hand-in-hand, drawing new geopolitical maps of different scales, from the unification of West and East Germany to the Balkan conflicts, from the tension between China and Taiwan to the latest constitutional change redefining the relationship between the French government and Corsican nationalists.

In terms of culture, a new phenomenon, as Appadurai emphasizes, is the unprecedented acceleration of the destruction of local cultures and the formation of new communication and cultures based on the 'virtual neighborhood', which brings people from different parts of the world in closer contact than they are with their actual neighbours, thanks to the Internet and other electronic media.[2] In

this context, the process of inventing new localities in every locale is inevitably open to global or other cultures. Everyone has to live a kind of 'unhomely' life, as Homi Bhabha puts it.³ Events like contemporary art biennials, initiated by local authorities to promote the position of locales on the global map, are then global events by nature, while they claim to be locally meaningful and productive in terms of new localities. The introduction of 'foreign', international knowledge, cultures, artworks and discourses is not only proof of the capacity to master international cultural exchanges and thereby better defend local characteristics. More significant yet, this process reveals that international or global cultures influence and even condition the new reality of the locales. The home is being voluntarily turned into a kind of non-home, a constantly changing and evolving in-between space, a kind of 'glocal' land. The new localities being generated are definitively impure, hybrid, and therefore innovative. Accordingly, the question of cultural identity is no longer based on the logic of the nation state. Instead, it is about transnationalism, and identities themselves continuously transform. Even taken-for-granted distinctions between Eastern and Western cultures, for instance, are definitely losing their meanings. Permanent confrontation, negotiation and hybridization between different cultures and identities are all that remain. [...]

Eventually, contemporary art created from and for different localities but immediately involved with the swirl of global information, communication and displacement can become an efficient means of resistance, interruption and deconstruction of the established, dominant, hegemonic power of global capitalism and its ideology. And it should remain so. To resist the materialist values of consumerism and evolve along with the possibilities that new communication technology offers, contemporary art is now being explored and developed increasingly towards immateriality, interactivity, instability, uncertainty and spatial temporalization. This process, inevitably affecting the global communication network, produces fragmentation, interrupting critical moments in the flow of communication and the production of value. It always plays the role of the Other, an alternative to the 'mainstream', voicing different and unexpected feelings, understandings, knowledge and projects. As a consequence, artworks constantly create vacant spaces or voids. The works are then open to free interpretation, interactive participation by the public, and the constant reinvention of meanings through endless negotiations between different individual and collective experiences and aspirations on their equally endless journeys between the global and the local, between history and the present, between reality and projection.

Projects to produce new localities should start by considering the dynamism of the global-local nexus. This is the very context of locality production today. If Appadurai is right and localities are the product of specific contexts and, at the

same time, present new contexts for the generation of social life, then cities can potentially become the most vital spaces for the production of localities, when they introduce international or global artistic biennials.

1 Arjun Appadurai, *Modernity at Large: Cultural Dimensions of Globalization* (Minneapolis: University of Minnesota Press, 1996).

2 [footnote 3 in source] Ibid.

3 [4] Homi K. Bhabha, *The Location of Culture* (New York: Routledge, 1994).

Hou Hanru, extract from 'Towards a New Locality', in Barbara Vanderlinden and Elena Filipovic, eds, *The Manifesta Decade: Debates on Contemporary Art Exhibitions and Biennials in Post-Wall Europe* (Cambridge, Massachusetts: The MIT Press, 2006) 57–9; 61–2.

Jan Verwoert
Forget the National: Perform the International in the Key of the Local (and vice versa)//2007

Rather than asking what a biennial represents, it may be worthwhile to shift the emphasis of the question and examine how it represents. That is: How is it experienced? On what level does the experience of an international art exhibition like a biennial register and in which parameters does that experience then come to figure as relevant and meaningful? Is it within parameters set by the national, the international or the local context of its reception? Which of these contexts does, can or should such an exhibition therefore address? [...]

What collective subject could be said to experience and be addressed by an international art exhibition such as a biennial? Does it make sense at all to consider collective subjects as possible addressees and subjects of an art experience? Or is the mere thought of such abstract entities already nonsensical at best or ideologically constructed at worst? Is it not much safer to assume that the experience of even a major exhibition will at the end of the day always only be a personal experience made by different people in different ways, so that the audience of any show can by definition be never more than an audience of one. And one. And one. And one. And so on. As a corrective to overblown fantasies and demands of collective acceptance – for shows are deemed to be failures if the audience attendance figures do not support the belief that 'the nation was watching' – the modest empirical insight that no audience can and will ever be more than one of one (and one and one and one and so on) may serve as a

welcome remedy. Still, it seems hard to deny that international exhibitions would, could or should not create the possibility for some sort of a collective experience or experience addressed to more than only ever just one recipient after another.

If there is one collective subject of experience whose presence is clearly felt in the place of the exhibition, it is the local. The local is out on the streets, in the pubs and family homes and speaking its mind with the tongue of cab drivers and local journalists. No doubt, the public opinion is a questionable abstraction. Still, who could deny that it exists and produces very real effects? The collective subject of the local effectively determines the mood in which an exhibition is received and this mood is bound to linger in every corner of its venues. If this mood of the city turns against the show, it is a bad omen that will affect also the experience of those who travel from far to see it. If the mood is good, however, the general feeling of overall celebration is likely to lighten up the spirit of the whole show. At the same time, it seems equally difficult if not impossible to say how the collective subject of the local actually constitutes and composes itself. How and when do you become eligible to be part of it? How much time does it take to become a local? Is it a matter of months, years, decades or, strictly speaking, of generations? More fundamentalist positions on this thorny issue have traditionally been offset by the customs and ethics of hospitality, that is, by the ways in which temporarily and without further questions someone may be accepted as a member of the community. Hosting is difficult to grasp as a form of agency since it is a proactive form of allowance, the act of leaving it to the guest to act, as if he or she were at home.

There is still a lot that could and would have to be said in favour of the true appreciation of hospitality as a form of cultural agency. Much of this would in fact force us to reconsider the very nature and role of representation in the context of international exhibitions hosted by local institutions in specific cities. [...] Symptomatically, most local conflicts over biennials do erupt around issues of representation, that is, around the question of how and by whom the cultural scene of the local host city is represented in the exhibition, and if this representation is adequate. There is no denying that the promise of international recognition which a biennial automatically generates puts the question of inclusion and exclusion onto the agenda. No matter then how respectful curators may proceed; the universal promise of representation which any biennial generates by itself can never be universally fulfilled and is therefore bound to provoke mixed feelings or animosities somewhere along the way. Foregrounding the significance of hospitality as a genuine form of creative agency will not solve this problem but it might help to cast things in a different light since it forces us to reconsider, as Irit Rogoff has suggested, whether it is actually justified to think exclusively of participation in terms of representation.[1]

Hospitality is a compelling counter-example because by virtue of manifesting itself primarily on the level of modest performative gestures and vernacular ceremonial exchanges it has comparatively little to do with representation.[2] Still it is arguably one of the most potent forms of cultural participation precisely because it creates the very possibility of (and forum for) participation. Obviously, hosting is an activity primarily performed by individual people who have a space to welcome guests in. Still, there is also a more general sense in which a place is felt to be hospitable or a city found to be welcoming. In this sense the collective subject (or genius loci) of the local can incarnate itself and become an agent of hospitality. This agency simply manifests itself in any random encounter between guests and locals in the city and the particular atmosphere, spirit and humour of these exchanges. So even before the issue of the inclusion and exclusion of the local in an exhibition comes to figure on the level of representation, the collective subject of the local may in fact always already be included and implicated, present and represented in the show through its performance in the role of the collective host. The crucial point would then be to find ways to appreciate and activate the collective practical intelligence of this performance – by enacting it publicly in and around the exhibition. Performing the local would then be a joint performance in which hosts and guests improvise intuitively to make their sense of humour chime and find ways of provoking and taking pleasure in each other. That mutuality is essential for this performance to get off the ground at the same time throws into relief how the international can only be performed in the key of the local – and vice versa. In art the collective subjectivity of the international exists in a complex state of diaspora. The international is embodied by people who either circulate physically and emotionally by travelling or who put their ideas and experiences into circulation by making their works and writings travel. At the same time, the only way these ideas, experiences and emotions can ever truly manifest themselves is in the local context in which they are received, presented – and of course produced (in the end we all settle down somewhere, even if is just temporarily, to work something out or pull things together). Conversely, the local tends to only perform itself as a collective subject when it is provoked by a visiting stranger to do so. The arrival of the guests make the hosts convene in committees of different sorts, official and unofficial. The local performance of the international brings the local into its own precisely by confronting and punctuating it with the reality of a diaspora which equally only comes into its own by struggling with the idiosyncrasies of the localities it tries to inhabit.

Curiously, the international is often perceived as the centre and source of power within the arts, when in effect the international is always needy and in want of the support by the local without which it can literally not incarnate itself.

Apart from the art and ideas that it may bring to the table, the international usually arrives with empty hands, incapable of instantly producing the surprises it is expected to deliver, First of all it awaits to be welcomed, taken care of and fed, because the international usually arrives, not from the centre, but from the margins it inhabits, that is, from urban spaces (maybe quite close to the centres of capital but always rather in the niches and cracks that occur in and around them) which allow for improvised living, offer rents cheap enough to make flats, studios and studies affordable and are within reach of an airport that low fare airlines fly to. The return which the local can expect from the international for hosting these needy guests is therefore not the temporary promotion to the rank of a centre but rather the invitation to join the margins. In a sense this offer to take a ride on the margins is precisely the experience an international biennial can provide by assembling artists, works and ideas under the auspices of the local.

In terms of its psychic geography, the trajectory of the exhibition could then be a sliding motion around globally interconnected margins. The mutual performance of the local and international would then lie in the making and enacting of that very connection between margins in the process of the experience of the show. This does not have to be a success story. The international and local approximate each other precisely in the moment when they mutually realize their respective marginality. And margins can touch, overlap, rub up against each other, but due to the different shapes of their limits they are bound to never fit into each other completely. So some element of slapstick will inevitably inhere in the way in which the international performs the local and the local performs the international. But that's alright. A moment of mutual empowerment may in effect result from the very circumstance that by playing roles you are not quite used to, you end up giving what you thought you did not have to others who didn't think they actually wanted it like this … but now that it has turned out the way it has, it kind of makes sense.

1 Irit Rogoff made this provocative point in a volatile discussion with the local audience at the Manifesta Coffee Break conference in Nikosia, Cyprus in early 2006.

2 Of course you can represent hospitality in grand public gestures, yet such grand gestures inevitably also violate a certain protocol of modesty, which only validates hospitality as a genuine concession to be the guest if the host refrains from capitalizing on his generosity.

Jan Verwoert, extract from 'Forget the National: Perform the International in the Key of the Local (and vice versa)! On the Experience of International Art Shows', in Steve Dutton and Jeanine Griffin, eds, *AN Research Papers: Biennials and City-Wide Events* (Newcastle, England: AN [Artists' Newsletter], 2007) 10–11.

Biographical Notes

Vito Acconci founded the New York-based architecture practice Acconci Studio in 1988. Formerly he was internationally known as a conceptual artist since the 1960s. Retrospectives include Museum of Contemporary Art, Chicago (1980); Museu d'Art Contemporani de Barcelona (2004).

Giorgio Agamben is Professor of Aesthetics at the University of Verona. His books include *Remnants of Auschwitz: The Witness and the Archive* (1989), *The Coming Community* (1990), *Homo Sacer: Sovereign Power and Bare Life* (1995) and *State of Exception* (2003).

Francis Alÿs is a Belgian-born artist who has lived and worked in Mexico City since the late 1980s. His projects include *The Collector* (1991–92), *The Leak* (1995) and *Paradox of Praxis* (1997). Solo exhibitions include Museo de Arte Moderno, Mexico City (1997), Kunstmuseum Wolfsburg (2005), MALBA, Buenos Aires (2006) and UCLA Hammer Museum, Los Angeles (2007).

Arjun Appadurai is John Dewey Professor in the Social Sciences and Senior Advisor for Global Initiatives at The New School, New York. His books include *Modernity at Large: Cultural Dimensions of Globalization* (1996).

Hannah Arendt (1906–75) was a German-Jewish-born political theorist whose works include *The Origins of Totalitarianism* (1951), *The Human Condition* (1958) and *On Revolution* (1963).

Artist Placement Group (APG) was founded in London in 1966 by the artists John Latham, Barbara Steveni and others, arranging for artist interventions in both public and private corporate institutions over more than two decades. APG was included in Documenta 6, Kassel (1977)

Michael Asher is a conceptual artist based in California who was instrumental in the development of institutional critique. Solo exhibitions include Centre Georges Pompidou, Paris (1991), Los Angeles County Museum of Art (2003) and Santa Monica Museum of Art (2008).

Marc Augé is a French cultural theorist and ethnologist, and director of the École des Hautes Études en Sciences Sociales, Paris. His books include *Non-Places: Introduction to an Anthropology of Supermodernity* (1992).

Wim Beeren is a Dutch curator who has organized numerous international group exhibitions since the 1960s. He was Director of the Stedelijk Museum, Amsterdam, from 1985 to 1993.

Josephine Berry Slater is editor of *Mute/Metamute* digital culture and politics on/offline magazine (http://www.metamute.com) and collaborator on the self-institutional theory resource (http://www.ourganisation.org).

Bik Van der Pol is the Rotterdam-based practice of the Dutch artists Liesbeth Bik and Jos Van der Pol, who have collaborated since 1995. Solo exhibitions include Seccession, Vienna (2005) and Van Abbemuseum, Eindhoven (2007). Their website is at http://www.bikvanderpol.net.

Daniel Birnbaum is Curator of the 2009 Venice Biennale and has since 2001 been Rector of the Städelschule and curator of Portikus, Frankfurt-am-Main. He has been a regular contributor to *Artforum, frieze* and *Parkett.* His books include *Chronology* (2007)

Brett Bloom is an artist and activist who works with the Chicago-based groups Temporary Services and Space and Land Reclamation, and the Hamburg-based projektgruppe.

Robin Bone is a physical therapist and **Shep (Shepherd) Steiner** is Visiting Assistant Professor in

Modern and Contemporary Art at the University of Florida. He is the co-editor of *Cork Caucus: On Art, Possibility and Democracy* (2007).

George Brecht (1926–2008) was an American artist and composer, based in Europe from 1965 onwards, who was one of the central figures in the international Fluxus movement. Retrospectives include Ludwig Museum, Cologne, and MACBA, Barcelona (2005–6).

Ava Bromberg is a writer, curator and urban activist. She is a co-founder of Mess Hall, an experimental cultural space in a Chicago storefront (www.messhall.org), and with Brett Bloom co-edited *Belltown Paradise/Making Their Own Plans* (2005).

Markus Brüderlin is a curator and art theorist, and Chief Curator at the Fondation Beyeler, Basel. He is the author of *Ornament and Abstraction: The Dialogue between Non-Western, Modern and Contemporary Art* (2002).

Susan Buck-Morss is Professor of Political Philosophy and Social Theory, Department of Government, and Professor of Visual Culture, Department of Art History, Cornell University.

Daniel Buren is a French conceptual artist who began to interrogate the status of painting in 1965 and has made in situ work in relation to its urban and architectural environment since 1967. Retrospectives include Musée d'Art Moderne Lille Métropole (2000).

Victor Burgin is a British artist, teacher and writer on representation and visual culture practising since the 1960s. Retrospectives include Fundacío Antoni Tàpies, Barcelona (2001). His books include *In/different Spaces: Place and Memory in Visual Culture* (1996).

Jon Bywater is Programme Leader for Critical Studies and Programme Leader for Studio One at the Elam School of Fine Arts, The University of Auckland, New Zealand. He is also active as a curator, and as a writer on art, music and theory. He is New Zealand correspondent for *Artforum*.

Michel de Certeau (1925–1986) was a French scholar of theology, history, psychoanalysis and sociology. His works include *The Practice of Everyday Life* (*L'Invention du quotidien, vol. I*, 1974).

Adam Chodzko is a British artist based in Whitstable, Kent, who has been included in numerous international group exhibitions since 1991. Solo exhibitions include Tate St Ives, Cornwall (2008).

Matthew Coolidge is the Founder and Director of the Center for Land Use Interpretation (CLUI) in Los Angeles. He lectures widely in the United States and Europe and is a faculty member in the Curatorial Practice Program at the California College of the Arts, San Francisco and Oakland.

Douglas Crimp is Professor of Art History, Visual and Cultural Studies at the University of Rochester. His works include *On the Museum's Ruins* (1993), *AIDS: Cultural Analysis/Cultural Activism* (1998) and *Melancholia and Moralism* (2002).

Tacita Dean is a British artist based in Berlin. Solo exhibitions include Witte de With Center for Contemporary Art, Rotterdam (1997), Institute of Contemporary Art, Philadelphia (1998), ARC Musée d'art moderne de la Ville de Paris (2003), Solomon R. Guggenheim Museum, New York (2007) and Dia: Beacon, Riggio Galleries, Beacon, New York (2008).

Guy Debord (1931–94), the French writer, theorist and filmmaker, formed the Situationist International with the artist Asger Jorn and others in 1957. His works include *The Society of the Spectacle* (1967), *Comments on the Society of the Spectacle* (1988) and the collection *Guy Debord and the Situationist International*, ed. Tom McDonough (2002).

Gilles Deleuze (1925–95) the French philosopher, and **Félix Guattari** (1930–92), the psychoanalyst and political activist, collaborated on a number of works including *Capitalism and Schizophrenia* (vol. 1, 1972; vol. 2, 1980) and *A Thousand Plateaux* (1980).

T.J. Demos is a writer, critic and lecturer in the department of history of art at University College London. He is a regular contributor to art journals including *Grey Room* and *October*. His books include *The Exiles of Marcel Duchamp* (2007).

Rosalyn Deutsche is Adjunct Professor of Modern and Contemporary Art at Barnard College, Columbia University, New York. Her books include *Evictions: Art and Spatial Politics* (1996).

Charles Esche is a curator and writer. Since 2004, he has been Director of the Van Abbemuseum, Eindhoven. He is co-founding editor, with Mark Lewis, of *Afterall* journal and publications.

Graeme Evans is Director of the Cities Institute at London Metropolitan University and was formerly Dean of Research at Central St Martins, University of London. He is the author of *Cultural Planning: an Urban Renaissance?* (2001).

Patricia Falguières is a Professor at the École des Hautes Études en Sciences Sociales, Centre de Sociologie du Travail et des Arts, Paris. A Renaissance scholar, she has also written extensively on contemporary art for exhibition catalogues and journals including *Parkett*.

Hal Foster is Townsend Martin Professor of Art and Archaeology at Princeton University, an editor of *October* and a contributor to *Artforum* and the *London Review of Books*. His works include *Compulsive Beauty* (1993), *The Return of the Real: The Avant-Garde at the End of the Century* (1996) and *Prosthetic Gods* (2004).

Michel Foucault (1926–84) was a French philosopher and historian of systems of thought. His works include *Madness and Civilization* (1961), *The Order of Things* [*Les Mots et les choses*] (1966), *The Archaeology of Knowledge* (1969) and *Discipline and Punish: The Birth of the Prison* (1975).

Andrea Fraser is an American artist based in Los Angeles. Her projects include *Official Welcome* (2001), *A Visit to the Sistine Chapel* (2005) and *Projection* (2009). Her collected writings are published in *Museum Highlights* (2005).

Hamish Fulton is a British artist based in Kent whose work since the late 1960s has been centred on walking in wilderness locations around the world. Retrospective exhibitions include Tate Britain, London (2002).

Caroline Goodden (now Caroline Goodden Ames) is an American photographer and dancer who performed with Trisha Brown among others. Goodden was Gordon Matta-Clark's partner and principal collaborator during the period of their *Food* café in New York (1971–73).

Dan Graham is a New York-based American artist and writer since the mid 1960s on visual and popular culture. His writings are collected in *Rock My Religion* (1993) and *Two-Way Mirror Power* (1999). Retrospectives include The Museum of Contemporary Art, Los Angeles (2009).

Renée Green is an American artist, filmmaker and writer. Solo exhibitions include The Museum of Contemporary Art, Los Angeles (1993), Fundació Antoni Tàpies, Barcelona (2000), Portikus, Frankfurt am Main (2002) and National Maritime Museum, London (2009).

Group Material was founded in 1979 as an artists' collaborative group in New York. Its core artists were Julie Ault and Tim Rollins (founders), Doug Ashford (from 1982), Felix Gonzalez-Torres (1957–96;

included in the group from 1987) and Karen Ramspacher (from 1989). Projects include *The People's Choice* (1980), *Americana* (1985), *Democracy* (1988) and *Aids Timeline* (1989–92).

Hou Hanru is a Chinese-born international curator and critic. He is Director of Exhibitions and Public Programmes at the San Francisco Art Institute. Among the numerous international exhibitions he has curated are the 10th Istanbul Biennial (2007) and the Biennale de Lyon (2009).

Jonathan Harvey is Chief Executive of ACME Studios, London, founded by artists as a charity to provide studio space in 1972. He was also instrumental in establishing ACME's former exhibitions programme and International Visual Artist Exchange Programme in the late 1970s.

Mark Hutchinson is a British artist, writer and curator who has organized exhibitions such as, with Dave Beech, 'There is Always an Alternative: Possibilities for Art in the Early Nineties', temporary contemporary, London (2005). His writings include contributions to *the first condition*. (http://www.thefirstcondition.com)

Robert Irwin is an American artist and influential teacher who abandoned studio practice in 1970 to evolve 'site generated' works in public spaces. Solo exhibitions include Museum of Contemporary Art, San Diego (2007). Recent projects include the architectural design and grounds for DIA: Beacon at Beacon, New York.

Mary Jane Jacob is an American curator who was foundational in the advancement of publicly situated curated projects in the early 1990s. She is Chair and Professor of Sculpture at The School of the Art Institute of Chicago. She is the author of *Buddha Mind in Contemporary Art* (2004).

Allan Kaprow (1927–2006) was an American artist who established Happenings in 1959, a term he abandoned in 1967, after which he explored other participatory models. His early 1960s works are documented in his *Assemblages, Environments and Happenings* (1966); his writings are collected in *Essays on the Blurring of Art and Life* (1993). Retrospectives include Haus der Kunst, Munich (2006) and The Geffen Contemporary at MOCA, Los Angeles (2008).

Geeta Kapur is an international curator, art critic and cultural theorist based in New Delhi. Among the exhibitions she has curated are the Bombay/Mumbai section of 'Century City', Tate Modern, London (2001) and 'subTerrain: artworks in the cityfold', House of World Cultures, Berlin (2003). She is a founder-editor of *Arts & Ideas* and advisory editor to *Third Text*.

Július Koller is a Slovakian artist based in Bratislava. From 1965 onwards he developed 'Anti-Pictures' and 'Anti-happenings', moving in 1970 into 'Universally Cultural Futurological Operations' (U.F.O.). In 1990 he established the art asociation 'New Seriousness'. Since 1993 he has engaged with multimedia technology in bodies of work including *Up-down* and *Nets Cultural Situations*.

Vasif Kortun is the director of Platform Garanti Contemporary Art Centre, Istanbul. He was the curator of the 3rd Istanbul Biennial (1992) and the Turkish Pavilion, Venice Biennale (2007), and co-curator of the 9th Istanbul Biennial (2005) and the 2008 Taipei Biennial.

Hari Kunzru is a British novelist and writer on art, music and culture based in London. As a journalist he has written for numerous newspapers and magazines and is a contributing editor of *mute*. His books include *The Impressionist* (2002), *Transmission* (2005) and *My Revolutions* (2008).

Miwon Kwon is an American art historian and critic who was a founding editor of *Documents* and serves on the advisory board of *October*. She is the author of *One Place after Another: Site-*

Specific Art and Locational Identity (2002), and is Associate Professor in the Department of Art History, University of California at Los Angeles.

Langlands & Bell (Nicky Bell and Ben Langlands) are British artists based in London who have collaborated since 1978. Their projects include *Negotiating Table* (1991), *www* (2000), *Marseille* (2001), *The Ministry* (2002) and *The House of Osama bin Laden* (2004). Their website is www.langlandsandbell.com

Ligna is a collective established in 1995 by the media theorists and radio artists Ole Frahm, Michael Hueners and Torsten Michaelsen, who are based at the Freies Sender Kombinat (FSK), a public non-profit radio station in Hamburg. Their project *Radio Ballet* was initiated in 2002.

James Lingwood is an independent curator and writer based in London and has since 1992 been Co-Director of Artangel, which commissions and produces major projects by contemporary artists. Artists whose work he has curated include Roni Horn, Robert Smithson and Rachel Whiteread.

Lucy R. Lippard is an American art historian, critic and curator who was closely associated with the emergence of conceptualism and feminism in the 1960s and seventies. Her books include *Six Years: The dematerialization of the art object from 1966 to 1972 ...* (1973; revised edition 1997).

Peter Liversidge is a British artist whose diverse works are initiated via the form of proposals. Projects include *Festival Proposals*, Ingleby Gallery, Edinburgh (2006), *Proposals for Liverpool*, Tate Liverpool (2008) and *Proposals for Barcelona*, Centre d'Art Santa Monica, Barcelona (2008).

Lu Jie is a Chinese-born international curator and writer and the founder and director of the *Long March Project*, exhibited in many international locations including museums in Oslo and Lyon, and biennials at Shanghai, Taipei (2004), Yokohama (2005), Sao Paulo and Brisbane (2006).

Gordon Matta-Clark (1943–78) was an American artist who trained as an architect, developing the theory and collaborative practice of 'Anarchitecture' in the late 1960s. His projects include the *Food* café, with Caroline Goodden (1971–73), *Splitting* (1974) and *Conical Intersect* (1975). Retrospectives include Whitney Museum of American Art, New York (2007).

George E. Marcus is Professor of Political Science at Williams College, Pennsylvania State University. His books include (with Michael M.J. Fischer) *Anthropology as Cultural Critique* (1999) and (with Paul Rabinow) *Designs for an Anthropology of the Contemporary* (2008).

Doreen Massey is Professor of Geography at the Open University, England, specializing in globalization. Her books include *Space, Place and Gender* (1994) and *For Space* (2005). Collections she has co-edited include *A Place in the World: Places, Cultures and Globalization* (1996).

Cildo Meireles is a Brazilian artist based in Rio de Janeiro who was an early exponent of installation in the late 1960s. Solo exhibitions include the New Museum of Contemporary Art, New York (1999; retrospective, touring to Rio de Janeiro and São Paulo) and Tate Modern, London (2008).

James Meyer is Associate Professor of Art History at Emory University, Atlanta. He is the author of *Minimalism: Art and Polemics in the Sixties* and *Minimalism* (both 2001). Works he has edited include Gregg Bordowitz, *The AIDS Crisis is Ridiculous and Other Writings 1986–2003* (2004) and Carl Andre, *Cuts = Texts 1999–2004* (2005).

Jonathan Monk is a British artist based in Berlin who has exhibited work since the early 1990s. Solo exhibitions include Museum Kunst Palast, Düsseldorf (2003), Institute of Contemporary Arts,

London (2005) and Palais de Tokyo/Musée d'art moderne de la Ville de Paris (2008).

Robert Morris is an American artist based in New York whose interrogations of established aesthetic positions from 1960 to the late 1970s were central to the emergence of conceptual art and Minimalism. Retrospectives include Centre Georges Pompidou, Paris (1995).

Ivo Mesquita is an international curator and critic based in São Paulo. He was Chief curator of the 2008 São Paulo Bienal and is also curator of the São Paulo State Pinacotheque and a visiting professor at the Center for Curatorial Studies, Bard College, Annandale-on-Hudson, New York.

Constant Nieuwenhuys (1920–2005), known as Constant, was an artist and co-founder of the experimental Cobra group in the late 1940s. In 1957 he allied himself with the Situationist International, leaving in 1960. He worked on his utopian city model *New Babylon* from 1959–74.

Brian O'Doherty is an Irish-born artist and writer on art based in the United States since the late 1950s. A former editor-in-chief of *Art in America*, he is Professor of Fine Arts and Media at the Southampton College campus of Long Island University.

Gabriel Orozco is a Mexican-born artist who lives and works in New York, Paris and Mexico City. Retrospectives include The Museum of Contemporary Art, Los Angeles (2000) and Museo del Palacio de Bellas Artes, Mexico City (2006).

Craig Owens (1950–90) was an art critic and theorist and a political activist who was instrumental in developing visual studies and the theoretical perspectives associated with critical postmodernism. His writings are collected in *Beyond Recognition: Representation. Power and Culture*, ed. Scott Bryson, Barbara Kruger, Lynne Tillman, Jane Weinstrock (1994).

Adrian Piper is an American artist and also a Kantian philosopher, who was an original member of the New York conceptualists of the late 1960s. Her writings are collected in *Out of Order, Out of Sight* (2 vols) (1996). Retrospectives include the New Museum of Contemporary Art, New York (2000).

Seth Price is an East Jerusalem-born artist based in New York. His 'redistribution' practice includes collaborations with the art and publishing collective Continuous Project, formed in 2003 with Bettina Funcke, Wade Guyton and Joseph Logan. Solo shows include the Whitney Biennial (2008).

Qiu Zhijie is a Chinese artist based in Beijing. His exhibitions include Museum of National Academy of Fine Arts, Hangzhou (1992), Centre Georges Pompidou, Paris (2003), Shanghai Biennial (2004), Taipei Museum of Contemporary Art (2005) and Shanghai Zendai Museum of Modern Art (2008). He has collaborated with Lu Jie on the *Long March* project.

Walid Ra'ad is a Lebanese born artist based in New York who founded The Atlas Group, an imaginary foundation whose objective is to research and document Lebanon's contemporary history. The work of The Atlas Group is presented through lectures, films, photography exhibitions, videos, and a variety of documents from the group's archives. Website: www.theatlasgroup.org

Jane Rendell is Professor in Architecture and Art at The Bartlett School of Architecture, London. Her books include *The Pursuit of Pleasure* (2002) and *Art and Architecture* (2006).

Paul Rooney is a British artist who was a founder member of the artist group Common Culture in 1999. His projects include *I Am Not Going to America* (2002), *Know Your Place* (2004), *There Are Two Paths* (2003) and *Let Me Take You There* (2003).

Martha Rosler is an American artist and writer on representation and contemporary culture.

Retrospectives include 'Positions in the Life World' (1998–2000), shown in five European cities and, concurrently, at the International Center of Photography and the New Museum of Contemporary Art, New York. Rosler teaches at Rutgers University, New Jersey.

Osvaldo Sanchez is a Cuban-born art historian, museum director and curator based in San Diego and Tijuana, for which cities he was Artistic Director of inSite_05 and Co-curator of inSITE 2000–01.

Georg Schöllhammer is an Austrian curator, writer and editor. He was the founding editor of the journal *Springerin* and of the documenta 12 magazines.

Phyllida Shaw is an Associate of the Cities Institute at London Metropolitan University, where she is a team member in arts/cultural policy and strategy development for local authorities in England.

Simon Sheikh is a curator and critic and Assistant Professor of Art Theory and a Coordinator of the Critical Studies Programme, Malmö Art Academy, Sweden. He has contributed writings to *Afterall, AnArchitectur, Springerin* and *Texte zur Kunst.*

The Situationist International is primarily associated with the Paris 1968 revolution and Guy Debord but was founded in an Italian village in 1957 by Debord and other representatives of small Marxist and avant-garde groups from diverse parts of Europe. The first Situationist International was disbanded in 1972. The Bureau of Public Secrets website documents available Situationist works in translation at http://www.bopsecrets.org

Tony Smith (1912–80) was an American sculptor, painter, architect and art theorist. Retrospectives include The Museum of Modern Art, New York (1998).

Robert Smithson (1938–73) was an American artist whose work intersected with conceptual art, Land art and Minimalism, and whose wide-ranging writings made a significant contribution to art discourse in the late 1960s and early 1970s. Retrospectives include Museée d'art moderne de la Ville de Paris (1982) and Centro Julio González, Valencia (1993).

Shep Steiner (see Robin Bone and Shep Steiner).

Jan Verwoert is an art critic based in Berlin. He is a contributing editor of *frieze* and has contributed essays for numerous catalogues and monographs and to the journals *Afterall* and *Metropolis M.* He is the author of *Bas Jan Ader: In Search of the Miraculous* (2006).

Peter Weibel is an Austrian artist, theorist and curator who has worked since the mid 1960s in the fields of conceptual art, participatory actions and electronic media. He is Director of ZKM/Centre for Art and Media Technology, Karlsruhe.

Lawrence Weiner is an American artist based in New York and Amsterdam who has been working as a sculptor with language and situation since the late 1960s. Retrospectives include Stedelijk Museum, Amsterdam (1988) and Whitney Museum of American Art, New York (2007).

Krzysztof Wodiczko is a Polish-born artist and urban theorist based in New York and Cambridge, Massachusetts, who since 1980 has investigated urban monuments and sites and their historical and political associations. He is Director of the Center for Art, Culture and Technology at MIT.

Sally Yard is Art History Coordinator at the University of San Diego. She has written extensively on postwar art and on artists such as Robert Irwin and Carl Andre. Exhibitions she has co-curated include inSite97: Public Space in Private Time (San Diego/Tijuana, 1997) and inSite2000: fugitive spaces (San Diego/Tijuana, 2000–01).

Bibliography

This section comprises further reading and does not repeat the bibliographic references for writings included in the anthology. For these please see the citations at the end of each text.

'Situations', *Cahiers du Musée National d'Art Moderne*, no. 27 (1989) (French)

Albert, Saul, 'Locative Literacy', 2004 (<http://www.metamute.org/en/Locative-Literacy>)

Andreotti, Libero, and Costa, Xavier, eds, *Theory of the Dérive and Other Situationist Writings on the City* (Barcelona: MACBA, 1997)

Association of Freed Times, The, 'El Diario del Fin del Mundo: A Journey That Wasn't', *Artforum* (Summer 2005) 297–300

Aupetitallot, Yves, Blazwick, Iwona and Christov Bakargiev, Carolyn, eds, *On taking a normal situation and retranslating it into overlapping and multiple readings of conditions past and present. Antwerp 93* (Antwerp: E. Antonis, 1993)

Andrews, Max, ed., *LAND, ART: A Cultural Ecology Handbook* (London: RSA [Royal Society for the Encouragement of Arts, Manufactures and Commerce], 2006)

Archer, Michael, 'Invisible Yearnings: TSWA 3D New Works for Public Places', *Artscribe* (January/February 1991) 60–63

Asher, Michael, *Writings, 1973–1983, on Works, 1969–1979*, ed. Benjamin H.D. Buchloh (Halifax, Nova Scotia: Nova Scotia College of Art and Design, 1983).

Badiou, Alain, *Being and Event* (1988) trans. Oliver Feltham (London: Continuum, 2005)

Barley, N., ed., *Leaving Tracks: Arttranspennine98* (London: August Media, 1999)

Bassett, Keith, 'Walking as an Aesthetic Practice and a Critical Tool: Some Psychogeographic Experiments', *Journal of Geography in Higher Education*, 28, 3 (2004) 397–410

Bennett, Sarah, and Butler, John, eds, *Locality, Regeneration and Divers(c)ities* (Bristol: Intellect Books, 2000)

Bharucha, Rustom, 'The Limits of the Beyond: Contemporary Art Practice, Intervention and Collaboration in Public Spaces', *Third Text*, vol. 21, issue 4 (July 2007) 397–416

Biemann, Ursula, *Mission Reports: Artistic Practice in The Field – Ursula Biemann Video Works 1989–2008*, (Umea: Bildmuseet/Bristol: Arnolfini, 2008)

Bishop, Claire, 'Antagonism and Relational Aesthetics', *October*, 110 (Fall 2004) 51–79

– 'As if I was lost and someone suddenly came to give me news about myself' in Gerrie van Noord, ed., *Off-Limits: 40 Artangel Projects* (London: Artangel and Merrel, 2002) 22–29

– *Installation Art: a Critical History* (London: Tate, 2005)

– 'The Social Turn: Collaborations and its Discontents', *Artforum* (2006) 178–83

Blamey, David, ed., *Here, There, Elsewhere: Dialogues on Location and Mobility* (London: Open Editions, 2002)

Bourriaud, Nicolas, *Relational Aesthetics* (Dijon: Les Presses du réel, 2002)

Buchloh, Benjamin H.D., 'Michael Asher and the Conclusion of Modernist Sculpture', in Buchloh, *Neo-Avantgarde and Culture Industry: Essays on European and American Art from 1955 to 1975* (Cambridge, Massachusetts: The MIT Press, 2000) 1–39

Buren, Daniel, 'Can Art Get Off Its Pedestal and Rise to Street Level?' in Bussman, König and Matzner, eds, *Contemporary Sculpture: Projects in Münster* (Ostfildern-Ruit: Verlag Gerd Hatje, 1997)

Bush, Kate, 'Provisional Authority', *Artforum*, XLVI, 1 (September 2007) 419–423

Bussmann, K., König. K., and Matzner, F., eds, *Sculpture Projects in Münster 1997* (Ostfildern-Ruit: Hatje Cantz Verlag, 1997)

Careri, Francesco, *Walkscapes: Walking as an aesthetic practice* (Barcelona: Gustavo Gilli, 2001)

Carson, John and Stewart, Susanne, eds, *Out of the Bubble: Approaches to Contextual Practice within Fine Art Education* (London: London Institute, 2000)

Cartiere, Cameron and Willis, Shelly, eds, *The Practice of Public Art* (London: Routledge, 2008)

Casey, Edward, *Getting Back into Place: Towards a Renewed Understanding of the Place-World* (Bloomington and Indianapolis: Indiana University Press, 1993)

Chambers, Iain, *Migrancy, Culture, Identity* (London: Routledge, 1994)

Clifford, James, *Routes, Travel and Translation in the Late Twentieth Century* (Cambridge, Massachusetts: Harvard University Press, 1997)

Coles, Alex, ed., *Site-Specificity: The Ethnographic Turn* (London: Black Dog Publishing, 1999)

Condee Nancy, Enwezor, Okwui, and Smith, Terry, eds, *Antinomies of Art and Culture: Modernity, Postmodernity, Contemporaneity* (Durham: Duke University Press, 2009)

Cook, Sarah, 'Down in the Woods: New Media Art Outdoors', *Public Art Journal* (Spring 2001)

Crang, Mike and Thrift, Nigel, eds, *Thinking Space* (London: Routledge, 2000)

Cresswell, Tim, 'Theorizing Place' in Tim Cresswell and Ginette Verstraete, eds., *Mobilizing Place, Placing Mobility: the Politics of Representation in a Globalized World*, (Amsterdam/New York: Rodopi, 2002)

– *Place: A Short Introduction* (Oxford: Blackwell, 2004)

Crickmay, Chris, 'Art and Social Context: Its Background, Inception and Development', *Journal of Visual Arts Practice*, vol. 2, no. 3 (2003)

Cumberlidge, Clare and Musgrave, Lucy, *Design and Landscape for People* (London: Thames and Hudson, 2007)

Cummings, Neil, and Lewandowska, Marysia, 'A Shadow of Marx', in Amelia Jones, ed., *A Companion to Contemporary Art since 1945* (Oxford: Blackwell Publishing, 2006)

Dean, Tacita and Millar, Jeremy, eds, *Place* (London: Thames and Hudson, 2005)

Debbaut, Jan, Verhulst, Monique and Vermoortel, Pieternel, eds, *Out of the Studio! A Symposium on Art and Public Space* (Hasselt: Z33 Art Centre, 2007)

Decter, Joshua, 'Transitory Agencies and Situational Engagements: The Artist as Public Interlocutor?' in Osvaldo Sanchez, ed., *InSite_05: Situational Public* (San Diego: inSite_05, 2006) 289–301

De Duve, Thierry, 'Ex Situ' in Andrew Benjamin, ed., *Installation Art* (London: Academy Editions, 1993) 24–30

Del Lago, Francesca, 'Space and Public: Site-Specificity in Beijing', *Art Journal*, (Spring 2000) 74–87

Deleuze, Gilles, 'What Is an Event?' in *The Fold: Leibniz and the Baroque* (London: Athlone, 1993) 76–8

Dell, Simon, ed., *On Location: Siting Robert Smithson and his contemporaries* (London: Black Dog Publishing, 2008)

Demos, T.J., 'Rethinking Site-Specificity', *Art Journal* (June 2003) 98–100

Deutsche, Rosalyn, *Evictions: Art and Spatial Politics* (Cambridge, Massachusetts: The MIT Press, 1996)

Doherty, Claire, ed., *As it is* (Birmingham: Ikon Gallery, 2000)

– ed., *Contemporary Art: From Studio to Situation* (London: Black Dog Publishing, 2004)

– 'New Institutionalism and the Exhibition as Situation' in Adam Budak and Christine Peters, eds., *Protections Reader* (Graz: Kunsthaus Graz, 2006)

– 'Curating Wrong Places... or Where Have all the Penguins Gone?' in Paul O'Neill ,ed., *Curating Subjects* (Amsterdam and London: De Appel & Open Editions, 2007) 100–108

– 'Public Art as Situation: Towards an Aesthetics of the Wrong Place in Contemporary Art Practice and Commissioning', in Jan Debbaut et al., *Out of the Studio! Art and Public Space* (Hasselt: Z33, 2008)

Drabble, Barnaby, Richter, Dorothee and Schmidt, Eva, *Curating Degree Zero, an International Curating Symposium* (Nürnberg: Verlag für moderne Kunst, 1999)

Dutton, Steve and Jeanine Griffin, 'Biennials and city-wide events', *Research Papers* (Newcastle: AN, 2007)

Ehrlich, Ken and LaBelle, Brandon, *Surface Tension: Problematics of Site* (Copenhagen and Los Angeles: Errant Bodies Press, 2003)

Ferguson, Bruce W., Greenberg, Reesa, and Nairne, Sandy, 'Mapping International Exhibitions', in Iwona Blazwick et al., *On Taking a Normal Situation*, op. cit.

Finkelpearl, Tom, *Dialogues In Public Art* (Cambridge, Massachusetts: The MIT Press, 2000)

Foote, Nancy, 'Situation Esthetics: Impermanent Art and the Seventies Audience', *Artforum*, 18 (January 1980) 22–3

Foster, Hal, et al., 'On Site Specificity', *Documents*, 4/5 (Spring 1994) 11–22

Franzen, Brigitte, König, Kasper, and Plath, Carina, eds, *Skulpture Projects Muenster 07* (Cologne: Walther König, 2007)

Gintz, Claude, 'Michael Asher and the Transformation of "Situational Aesthetics"', *October*, no. 66, (Autumn 1993) 113–31

Glahn, Philip, 'Public Art: Avant-Garde Practice and the Possibilities of Critical Articulation', *afterimage* (November/December 2000) 10–12

Grasskamp, Walter, 'Art and the City', in Bussmann, Klaus, König, Kasper, and Matzner, Florian, *Contemporary Sculpture Projects in Münster 1997*, op. cit.

Grayson, Richard, ed., *This Will Not Happen Without You: From the Collective Archive of The Basement Group, Projects UK and Locus+ (1977–2007)* (Newcastle: Locus+, 2007)

Green, Renée, *Site-Specificity Unbound: Considering Participatory Mobility* (Buffalo: CEPA Gallery, 1998)

– 'Scenes from a Group Show: *Project Unité*,' in: *Site-Specificity: The Ethnographic Turn* (de-, dis-, ex- vol. 4) ed. Alex Coles (London: Black Dog Publishing, 2000).

– ed., *Negotiations in the Contact Zone* (Lisbon: Assírio and Alvim, 2003)

Griffin, Tim, 'Global Tendencies: Globalisation and the Large-Scale Exhibition', *Artforum*, 206, 212 (November 2003) 152–63, 206, 212

Grzonka, Patricia, 'Situationismus' *Kunst-Bulletin*, 1/2, (German) 2008, 20–27

Gupta, Akhil and Ferguson, James, eds, *Culture, Power, Place: Explorations in Critical Anthropology* (Durham, North Carolina: Duke University Press, 1997)

Hannula, Mika, 'The Blind Leading the Naked – the Politics of Small Gestures', in Deniz Ünsal, ed., *Art, City and Politics in an Expanding World* (Istanbul Biennial, 2005) 184–194

Harding, Anna, ed., *Curating: the Contemporary Art Museum and Beyond* (London: Academy, 1997)

Harding, David, ed., *Decadent: Public Art, Contentious Term and Contentious Practice* (Glasgow: Foulis Press, 1997)

Heartney, Eleanor, 'The Dematerialization of Public Art', *Sculpture* (March/April 1993)

Ingold, Tim, *The Perception of the Environment: Essays in Livelihood, Dwelling and Skill* (London and New York: Routledge, 2000)

Jacob, Mary Jane, Brenson, Michael, *Conversations at the Castle: Changing Audiences and Contemporary Art* (Cambridge, Massachusetts: The MIT Press, 1998)

Kaprow, Allan, *Essays on the Blurring of Art and Life* (Berkeley and Los Angeles: University of California Press, 2003)

Kastner, Jeffrey, ed., *Land and Environmental Art* (London and New York: Phaidon Press, 2005)

Kaye, Nick, *Site Specific Art: Performance, Place and Documentation* (London and New York: Routledge, 2000)

Kester, Grant, *Conversation Pieces: Community and Communication in Modern Art* (Berkeley and Los Angeles: University of California Press, 2004)

Krauss, Rosalind, 'Sculpture in the Expanded Field', *October*, vol. 8 (Spring 1979) 30–44

Kwon, Miwon, 'Public Art and Urban Identities' in Cheryl Younger, ed., *Public Art Strategies: Public Art and Public Space* (New York: New York University, 1998)

– 'The Wrong Place', *Art Journal*, 59.1 (Spring 2000) 33–43

– *One Place After Another: Site-Specific Art and Locational Identity* (Cambridge, Massachusetts: The MIT Press, 2002)

Lacy, Suzanne, ed., *Mapping the Terrain: New Genre Public Art* (Seattle: Bay Press, 1995)

Lange, Christy, 'Walking the Land', *Afterall*, 13 (Spring 2006)

Bruno Latour, 'On the Difficulty of Being Glocal', *Domus*, March 2004, no 2, republished in *Art-e-Fact* no. 4, 2005

Lee, Pamela M., *Chronophobia: On Time in the Art of the 1960s* (Cambridge, Massachusetts: The MIT Press, 2006)

Lefebvre, Henri, *The Production of Space* trans. Donald Nicholson-Smith (Oxford: Blackwell, 1991)

Lind, Maria, 'Spatial Facsimiles and Ambient Spaces: Some Reflections on Site-Specificity in Contemporary Art', *Parkett*, 54 (1998/99) 186–7

Lingwood, James, ed., *Seven Walks: Francis Alÿs* (London: Artangel, 2005)

Lippard, Lucy, *The Lure of the Local: Senses of Place in a Multicentered Society* (New York: The New Press, 1997)

– *On the Beaten Track: Tourism, Art & Place* (New York: The New Press, 1999)

Mackey, Sally and Whybrow, Nicolas, 'Taking Place: Some Reflections on Site, Performance and Community', *Research in Drama Education*, 12.1 (February 2007) 1–14

Massey, Doreen, 'Power-Geometry and a Progressive Sense of Place', *Mapping the Futures: Local Cultures, Global Change*, ed. John Bird, et al. (London and New York: Routledge, 1993)

– *For Space* (London: Sage, 2005)

Matzner, Florian, ed., *Public Art: A Reader* (Ostfildern-Ruit: Hatje Cantz, 2004)

McCarthy, J., 'Regeneration of Cultural Quarters: Public Art for Place Image or Place Identity', *Journal of Urban Design*, 11.2 (June 2006) 243–62

McFadden, Jane, 'Toward Site', *Grey Room*, 27 (Spring 2007) 36–57

McGonagle, Declan, 'A new necessity: The importance of art outside the gallery', *Artscribe* (Summer 1990) 63–6

Miles, Malcolm, *Art, Space and the City* (London and New York: Routledge, 1997)

Miles, Malcolm and Hall, Tim, eds., *Interventions: Advances in Art and Urban Futures, Volume 4* (Bristol: Intellect Books, 2005)

Mouffe, Chantal, 'Art and Democracy: Art as an Agnostic Intervention in Public Space', in Jorinde Seijdel, ed., *Art as a Public Issue, Open* No. 14, 2008 (Rotterdam: NAi Publishers) 6–13

Mosquera, Gerardo, and Samos, Adrienne, eds., *Ciudad Multiple: Arte Panama* (2003)

Munck, Ronaldo, 'The poets are, as always, in the vanguard', in Paul Domela, ed., *The International*, (Liverpool: Liverpool Biennial, 2006), 154–5

Negt, Oskar, and Kluge, Alexander, *Public Sphere and Experience: Toward an Analysis of the Bourgeois and Proletarian Public Sphere*, trans. Peter Labanyi (University of Minnesota Press, 1993)

Pearson, Michael, and Shanks, Michael, *Theatre/Archaeology* (London and New York: Routledge, 2001)

Peltson, Ruth A., ed., *Creative Time: The Book, 33 Years of Public Art in NYC* (New York: Princeton Architecture Press, 2007)

Pinder, David, 'The Arts of Exploration', *Cultural Geographies*, 12 (2005) 383–411

Piraniom Michelle, ed., *How Latitudes Become Forms: Art in the Global Age* (Minneapolis: Walker Art Center, 2003)

Prince, Nigel and Wade, Gavin, eds, *In the Midst of Things* (Birmingham, 1999)

Raven, Arlene, *Art in the Public Interest* (New York: Da Capo Press, 1993)

Reiss, Julie H., *From Margin to Center: The Spaces of Installation Art* (Cambridge, Massachusetts: The MIT Press, 2001)

Rendell, Jane, *Art and Architecture: A Place Between* (London: I.B. Tauris, 2006)

Rogoff, Irit, *Terra Infirma: Geography's Visual Culture* (London: Routledge, 2000)

– 'The where of now', in Jessica Morgan and Gregor Muir, eds, *Time Zones: Recent Film and Video* (London: Tate Publishing, 2004) 84–97

Rugg, Judith and Hinchcliffe, Daniel, eds, *Advances in Art and Urban Futures, Volume 2: Recoveries and Reclamations* (Bristol: Intellect Books, 2003)

Sanchez, Osvaldo and Conwell, Donna, *[Situational] Public Público [situacional]* (San Diego: Installation Gallery, 2005)

Schneider, Arnd and Wright, Christopher, eds, *Contemporary Art and Anthropology* (Oxford: Berg, 2006)

Selwood, Sara, *The Benefits of Public Art* (London: Policy Studies Institute, 1995)

Shapiro, Gary, *Earthwards: Robert Smithson and Art after Babel* (Berkeley, California: University of California Press, 1995)

Sheikh, Simon, ed., *In the Place of the Public Sphere? On the Establishment of Publics and Counter-Publics* (Berlin: b_books, 2005)

Smith, Bob and Roberta, *Art u need: My Part in the Public Art Revolution* (London: Black Dog Publishing, 2007)

Smith, Terry, 'Contemporary Art and Contemporaneity', *Critical Inquiry*, 32 (2006) 681–707

Smith, Terry, Enwezor, Okwui, and Condee, Nancy, eds, *Antinomies of Art and Culture: Modernity, Postmodernity, Contemporaneity* (Durham, North Carolina: Duke University Press, 2009)

Soja, Edward, ed., *Postmodern Geographies: The Reassertion of Space in Critical Social Theory* (London: Verso, 1989)

– *Thirdspace: Journeys to Los Angeles and Other Real-and-Imagined Places* (Oxford: Blackwell, 1996)

Solnit, Rebecca, *Wanderlust: A History of Walking* (New York: Penguin, 2000)

Stallabrass, Julian, ed., *Locus Solus: Site, Identity, Technology in Contemporary Art* (London: Black Dog Publishing, 2000)

Suderburg, Erika, ed., *Space, Site, Intervention: Situating Installation Art* (Minneapolis: University of Minnesota Press, 2000)

Szeemann, Harold, *When Attitudes become Form: Works-Concepts-Process-Situations-Information* (Bern: Kunsthalle/London: Institute of Contemporary Arts, 1969)

Thompson, Nato and Scholette, Gregory, *The Interventionists: Users' Manual for the Creative Disruption of Everyday Life* (Cambridge, Massachusetts: The MIT Press, 2004)

Tuan, Yi-Fu. *Space and Place: The Perspective of Experience* (Minneapolis: University of Minnesota, 1977)

Vadén, Tere and Hannula, Mika, *Rock the Boat: Localized Ethics, the Situated Self, and Particularism in Contemporary Art* (Cologne: Salon Verlag, 2003)

Vanderlinden, Barbara, and Filipovic, Elena, eds, *The Manifesta Decade: Debates on Contemporary Art Exhibitions and Biennials in Post-Wall Europe* (Cambridge, Massachusetts: Roomade/The MIT Press, 2006)

Verhagen, Marcus, 'Nomadism', *Art Monthly*, no. 300 (October 2006) 710

Verwoert, Jan, 'Looking Forward: Sculpture Projects Muenster 2007', *frieze* (2007)

Vesic, Jelena, 'Miraculous Mass-communication *Radioballet* by LIGNA', *Variant* 31 (Spring 2008) 5

Von Hantelmann, Dorothea, *How to Do Things with Art* (German) (Zurich, Diaphanes, 2007)

Wagner, Anne M., 'Being There: Art and the Politics of Place' *Artforum* (Summer 2005) 264–69, 346

Warwick, Rhona, *Arcade: Artists and Place-Making* (London: Black Dog Publishing, 2006)

Wollen, Peter, 'Mappings. Situationists and/or Conceptualists', in Michael Newman and Jon Bird, eds, *Rewriting Conceptual Art. Critical Views* (London: Reaktion Books, 1999) 27–65

Yard, Sally, ed., *A Dynamic Equilibrium: In Pursuit of Public Terrain* (Tijuana, San Diego: inSITE, 2007)

Index

ACKNOWLEDGEMENTS

Editor's acknowledgements

With thanks to Iwona Blazwick, Katie Daley-Yates, Ian Farr, Harriet Godwin, Frances Loeffler, Katherine Orsini, Michael and Ruby Prior and Hannah Vaughan for all their support and assistance in the preparation of this book; also thanks to Geoff Cole and the staff of the School of Creative Arts library, University of the West of England, Bristol; the Research Library, Getty Research Institute and the Tate Archive and Research Library, and to the following individuals for inspirational conversations: Iain Biggs, Claire Bishop, Paul Bonaventura, Daniel Buren, Nathan Coley, David Cross, James Dixon, Juliana Engberg, Brigitte Franzen, Paul Gough, Dan Hicks, Mary Jane Jacob, James Lingwood, Miwon Kwon, Maddie Leach, Maria Lind, Heather and Ivan Morison, Simon Morrissey, Roman Ondák, Carina Plath, Paul O'Neill, Hilary Ramsden, Jane Rendell, Lucy Steeds, Javier Téllez, Jan Verwoert, Richard Wentworth, Mick Wilson and Catherine Wood.

Publisher's acknowledgements

Whitechapel Gallery is grateful to all those who gave their generous permission to reproduce the listed material. Every effort has been made to secure all permissions and we apologize for any inadvertent errors or ommissions. If notified, we will endeavour to correct these at the earliest opportunity.

We would like to express our thanks to all who contributed to the making of this volume, especially: Vito Acconci, Giorgio Agamben, Francis Alÿs, Arjun Appadurai, Michael Asher, Marc Augé, Julie Ault, Wim Beeren, Josephine Berry Slater, Bik Van der Pol, Daniel Birnbaum, Brett Bloom, Ava Bromberg, Markus Brüderlin, Susan Buck-Morss, Daniel Buren, Victor Burgin, Jon Bywater, Adam Chodzko, Matthew Coolidge, Douglas Crimp, Tacita Dean, T.J. Demos, Rosalyn Deutsche, Charles Esche, Graeme Evans, Patricia Falguières, Hal Foster, Tony Foster, Andrea Fraser, Hamish Fulton, Dan Graham, Renée Green, Hou Hanru, Jonathan Harvey, Mark Hutchinson, Robert Irwin, Mary Jane Jacob, Geeta Kapur, Július Koller, Vasif Kortun, Hari Kunzru, Miwon Kwon, Langlands & Bell, Ligna, James Lingwood, Lucy R. Lippard, Peter Liversidge, Lu Jie, George E. Marcus, Doreen Massey, Cildo Meireles, Jack Wendler, Ivo Mesquita, James Meyer, Jonathan Monk, Robert Morris, Brian O'Doherty, Gabriel Orozco, Adrian Piper, Seth Price, Qiu Zhijie, Walid Ra'ad, Jane Rendell, Paul Rooney, Martha Rosler, Osvaldo Sanchez, Georg Schöllhammer, Phyllida Shaw, Simon Sheikh, Shepherd Steiner, Barbara Steveni, Jan Verwoert, Peter Weibel, Lawrence Weiner, Kirsten

Weiner, Krzysztof Wodiczko, Sally Yard. We also gratefully acknowledge the cooperation of: 38th Street Publishers; Afterall; a-n The Artists Information Company; ARS; Artangel, London; Artforum; Bureau of Public Secrets; University of California Press; University of Chicago Press; DACS; Dia Foundation, New York; DuMont verlag; Sam Francis Foundation; Frith Street Gallery; GB Agency; Generali Foundation, Vienna; Marian Goodman Gallery, New York; Hatje Cantz Verlag; Indiana University Press; The Johns Hopkins University Press; Ikon Gallery, Birmingham; Ingleby Gallery, Edinburgh; Journal of Aesthetics and Protest; Estate of Allan Kaprow; Kölnicher Kunstverein, Cologne; Verlag der Buchhandlung Walther König; Lapis Press; Galerie Lelong, New York; Lisson Gallery, London; The London Institute and Central Saint Martins College of Art and Design; London Metropolitan University; Long March Foundation; MACBA, Barcelona; Metropolis Books; The MIT Press; Morning Star; Mute; University of Minnesota Press; Henry Moore Institute; NIFCA; Press of the Nova Scotia College of Art and Design; Craig Owens Literary Estate; Parkett; Adrian Piper Research Archive; Princeton University Press; Rizzoli International; Rivers Oram Press; Spike Island, Bristol; Studio International; Tate Archive; Thames & Hudson; Third Text; VAGA; Verso; John Weber Gallery, New York; White Columns, New York; White Cube, London; Zone Books.

Whitechapel Gallery is supported by